The Complete Photographer

Revised Edition

by Andreas Feininger

Prentice-Hall, Inc., Englewood Cliffs, N.J.

The Complete Photographer, Revised Edition
by Andreas Feininger
Copyright © 1978, 1969, 1965 by Andreas Feininger

Library of Congress Cataloging in Publication Data

Feininger, Andreas
The complete photographer.

"Portions of this book originally appeared
in The color photo book by Andreas Feininger."
1. Photography. I. Title.
TR146.F415 1978 770'.28 78-6522
ISBN 0-13-162222-6

Printed in the United States of America
Plates printed in West Germany

Prentice-Hall International, Inc., London
Prentice-Hall of Australia, Pty. Ltd., Sydney
Prentice-Hall of Canada, Ltd., Toronto
Prentice-Hall of India Private Ltd., New Delhi
Prentice-Hall of Japan, Inc., Tokyo
Prentice-Hall of Southeast Asia Pte. Ltd., Singapore
Whitehall Books Limited, Wellington, New Zealand
Second Printing..........December, 1978

Books by ANDREAS FEININGER

Experimental Work (Amphoto)	1978
New York in the Forties (Dover)	1978
The Mountains of the Mind (Viking)	1977
Light and Lighting in Photography (Amphoto)	1976
Roots of Art (Viking)	1975
The Perfect Photograph (Amphoto)	1974
Darkroom Techniques (Amphoto)	1974
Principles of Composition in Photography (Amphoto)	1973
Photographic Seeing (Prentice-Hall)	1973
Shells, with text by Dr. W. Emerson (Viking)	1972
Basic Color Photography (Amphoto)	1972
The Color Photo Book (Prentice-Hall)	1969
Trees (Viking; reissued by Viking Penguin, 1978)	1968
Forms of Nature and Life (Viking)	1966
Lyonel Feininger: City at the Edge of the World, with text by T. Lux Feininger (Frederick A. Praeger)	1965
The Complete Photographer (Prentice-Hall)	1965
New York, with text by Kate Simon (Viking)	1964
The World Through My Eyes (Crown)	1963
Total Picture Control (Crown; Amphoto, 1970)	1961
Maids, Madonnas, and Witches, with text by Henry Miller and J.Bon (Harry N. Abrams)	1961
Man and Stone (Crown)	1961
The Anatomy of Nature (Crown)	1956
Changing America, with text by Patricia Dyett (Crown)	1955
The Creative Photographer (Prentice-Hall)	1955
Successful Color Photography (Prentice-Hall)	1954
Successful Photography (Prentice-Hall)	1954
The Face of New York, with text by Susan E. Lyman (Crown)	1954
Advanced Photography (Prentice-Hall)	1952
Feininger on Photography (Ziff-Davis)	1949
New York, with text by John Erskine, Jacqueline Judge (Ziff-Davis)	1945
New Paths in Photography (Amer. Photogr. Publishing Co.)	1939

Many of the photographs used in *The Complete Photographer,
Revised Edition,* had prior publication in *Darkroom Techniques
I and II, Total Picture Control, Basic Color Photography,*
and *Light and Lighting,* said books having been published by

AMPHOTO
Garden City, New York 11530

The diagram and caption on page 269 originally appeared on
page 81 of *Light and Lighting.*

The author and publisher gratefully acknowledge permission
for the use of all the above material.

Author's Note

I see photography as picture-language, a form of communication. A photograph that fails to "speak" to the viewer, to convey a message of interest, is, in my opinion, worthless.

In my view, the key to good photography is concern on the part of the photographer, not with photography but with his subject. If I am not moved by what I see before me, how can I hope to make pictures capable of evoking a response in others?

Photographs, like words, can make statements well or badly. The better the presentation, the more effective the message. In photography, this means paying close attention to the technical aspects of picture-taking. But I want to stress my conviction that while photo-technique is important, it should never be more than a means to an end. Excessive preoccupation with photo-technology shifts the emphasis from the end to the means. In my opinion, an interesting visual statement, even when poorly executed, is preferable to the technically most accomplished picture that says nothing. The first has real meaning, while the second is a waste of the viewer's time.

To me, good presentation means three things: clarity, simplicity, organization. I have found these qualities most easily achieved by keeping my equipment simple.

I always strive to produce images which show the viewer more than he would (and often could) have seen had he been confronted with the subject himself. A photograph which limits itself to mirroring external "reality" is visually less valuable than one which teaches us something by expanding our vision in ways we had never considered. The first kind of picture is merely a record, while the second can enrich and stimulate the mind.

v

Contents

Dear Reader

Why, you may ask, should anyone need a book as comprehensive as this one in order to make good photographs? After all, cameras are becoming more automated with each new model, speedlights quench themselves after delivering precisely the right amount of light, and lenses and films are now so "fast" that pictures can be taken under virtually any light conditions. In addition, film development in accordance with the time-and-temperature method has become as easy as boiling an egg. And those photographers who don't want to bother with darkroom work can let one of the many commercial photo-finishers do their lab work, if necessary via the mail.

Furthermore, every new camera, speedlight, light meter, filter, color analyzer, and other piece of photographic equipment today is accompanied by explicit instructions for use provided by the manufacturer. The same applies to film, sensitized paper, and developer. After all, the manufacturer's interests coincide with yours. He wants to ensure that you get the best possible results, are satisfied with his product, and come back for more. Why, then, the need for this voluminous book?

The reason is simply this: there is a world of difference between a photograph which is merely "technically perfect" and one that deserves the label excellent, memorable, perhaps even great. A technically perfect photograph is one that is correctly focused, exposed, developed, and printed, period. But despite these desirable qualities, it can still be the world's most boring picture. Subject selection can be unfortunate, subject approach awkward, and subject presentation ineffective. Actually, no matter how great his technical expertise, a photographer is more likely than not to produce disappointing pictures *unless he knows how to use his "technical" options in accordance with the pictorial requirements of the subject and the specific impression he wishes to create.* In other words, he must be able to exert not only *technical* but also *creative* control over every aspect and step of picture-making, from subject selection on the basis of photogenic qualities to the making of the slide or final print.

1

Exerting creative control means making the right decisions. This begins with choice of subject matter. A photographer almost invariably has a wide range of potential subjects, as well as numerous ways to treat them from which he must select those that are most suitable to express his intentions. Each of these options in turn can be captured on film and paper in a literally unlimited number of different ways, some of which, of course, are apt to be more effective than others. It makes a great difference, for instance, from what distance a subject is photographed; whether it is shown in the context of its surroundings or in tightly cropped close-up; whether it is photographed square-on, or from the side, from above or below, or perhaps even from the back; whether a lens of standard focal length, a wide-angle, or a telephoto lens is used to depict the subject in a specific form of perspective; to what degree the lens is stopped down for greater or lesser extension of the zone of sharpness in depth in the picture; whether the exposure is made with a higher or lower shutter speed for the purpose of either "freezing" the subject's motion on the film or indicating it with some degree of blur; whether or not a specific filter is used in black-and-white photography to control the transformation of color into shades of gray or in color photography to determine the overall tint of the slide; whether the subject is illuminated by front-, side-, or back-light, light from above or from below; whether the illumination is direct or indirect, contrasty or softly diffused, producing harsh and sharply defined or soft and grayish shadows; whether the shot is made on relatively grainy high-speed film, an all-purpose film of moderately fine grain, or a fine-grain film capable of yielding virtually grainless enlargements or slides; whether the duration of film development is normal, longer or shorter than standard, producing negatives of normal, higher, or lower contrast, respectively; whether a standard, rapid, or fine-grain film developer is used; whether the negative is printed on paper of normal, soft, or hard gradation for positive control of the overall contrast in the print; whether an enlargement is or isn't dodged during exposure for contrast control on a local scale; whether the shot was made in color or in black-and-white.

The foregoing should make it abundantly clear that the potential of photographic control—the number of options which a photographer has at his disposal in order to create in his pictures precisely the effects he wants—is almost unlimited, especially in view of the fact that each of the possibilities listed above can be used in conjunction with one, several, or all of the others. In order to exploit this wealth of opportunities to the fullest, a photographer must, of course, be familiar with all of them, their scope and their limitations—he must know what he can and cannot do.

But photo-technical knowledge is not enough to assure the creation of outstanding photographs. An equally important factor is artistic sensitivity—a feeling for when to do what. Indeed, in photography, as in any other field of creative endeavor,

know-how is useless unless guided by know-why.

Only if "technique" is supplemented by "art" can a perfect synthesis be achieved and knowledge be transformed into performance.

Within the covers of this book I have assembled all the information I believe necessary for the making of *good* photographs. Please note the emphasis on "good." Those photographers who are satisfied with pictures that are "technically unassailable" and subjects that are "recognizable" do not need this or any book. They can simply read the manufacturer's instructions which accompany the photographic products they buy.

But if you see photography as more than merely a pleasant weekend hobby; if you hope to create images that are meaningful, aesthetically satisfying, and emotionally appealing; if, in the interest of achieving the most powerful possible effects, you want to know what difference it makes whether you use a wide-angle or a telephoto lens, a red filter or a blue one, a fine-grain or a high-speed film, front-, side-, or back-light, direct or indirect illumination, a larger or smaller diaphragm stop, a higher or lower shutter speed; rectilinear, cylindrical, or spherical perspective; an overall view or a close-up; one brand of film or another . . . in short, if you wish to make photographs that are not only technically satisfactory but also visually informative, graphically exciting, emotionally appealing, and truly worthy of your subject, you will understand why this volume must be so thick—and will appreciate its completeness. The following pages summarize everything I learned during my twenty years of work as a staff photographer for *Life*. I hope they will tell you all that you want and need to know.

Andreas Feininger

About this book

My main consideration in writing this book was to produce a thoroughly modern text in accordance with the new trends in photography. These include:

1. The steadily increasing popularity of color.

The greatest barrier to widespread use of color in photography, the slow speed of color films, has been removed, and the dream of instant color photography is no longer a dream—thanks to Polaroid and Kodak. As a result, there has been an enormous increase in the number of photographs taken in color.

2. The emergence of photgraphic services.

The time when the amateur had either to do his own darkroom work or take his film to a drugstore for processing and be satisfied with poor results is past. Today, the services of highly competent custom laboratories are available locally or through the mail for those who do not wish to do their own darkroom work. Consequently, lack of darkroom facilities or the interest in doing one's own film or print processing is no longer a barrier to serious photographic work.

3. The automation of equipment and techniques.

The instruments and processes by which photgraphs are made are constantly being refined and automated. This makes it possible for photographers to get technically excellent results with less and less experience and skill. Consequently, today's photographers need devote little attention to technicalities and can concentrate instead on the more important aspects of subject approach and interpretation—the content and meaning of their pictures.

These advances make it necessary to re-evaluate where emphasis in instruction should be placed in a modern photgraphic text. The following areas seemed of particular importance to me and I have stressed them accordingly:

1. The use of color instead of black-and-white.

2. Those problems which the photgrapher alone can solve. Procedures which can be carried out by a custom lab (developing, printing, and enlarging) are therefore given less space than problems related to the selection of the right kind of equipment and the taking of photographs.

3. The creative aspects of photography—the visual and emotional effect of the picture—rather than the technical problems featured in most photographic texts.

Although this book is the equivalent of a complete home-study course in photography and consequently starts with elementary information on cameras, film, developers, and so on, it dispenses with the kind of photgraphic baby talk so often found in beginners guides and which I feel is superfluous here. Nor do I include those simple step-by-step illustrations beloved by many other authors which allegedly make certain operations easier to perform but, in my opinion, are no more than a needless pictorial duplication of written instructions. On the other hand, I make it a point to show in picture form anything that cannot be adequately dealt with in words as, for example, the effects of various filters on both black-and-white and color films, and the different effects in printing that can be achieved through appropriate choice of paper gradation in conjunction with longer or shorter exposures. Such picture series are usually not found in this kind of book but, in my experience, indispensable to anyone interested in creative photgraphy.

I avoid shortlived information as well. Such material as listings of the ASA speeds of specific films, guide numbers for specific flash lamps, instructions for development of color films in accordance with specific process like Kodak E-4 or E-6 is the province of photographic magazines and manufacturer's manuals. Although indispensable to the photographer, such information has no place in a photographic textbook. By the time the book is out, it may be partially obsolete. I therefore include only information that is sure to wear with time.

4. An emphasis on the *why* of photography over the *how*. It is this that I feel gives my book its greatest value, far transcending that of the average photographic text, which teaches technique but keeps the reader groping for *reasons*. Again I must stress my deep conviction that making *effective* photographs requires *more* than familiarity with photo-technical procedures. Consequently, I have devoted entire chapters to discussions of such fascinating, vitally important but generally neglected subjects as photographic seeing, photogenic and unphotogenic qualities and techniques, the nature of color and color perception, concept and means of photographic control, the symbols of photography, composition, originality and style, and other creative aspects of picture-making. Because only those people who are aware of these aspects of our craft, who can respond creatively to the WHY, WHEN, and WHAT of the occasion, will produce photographs that are effective, memorable, and occasionally even great.

The Importance of Attitude

**This is the most significant chapter in this book.
Please, read it with care.**

So you want to become a photographer—a good one. And like most students of photography, you probably believe that the key to good photgraphy is mastery of photo-technique. Unfortunately, this assumption is at best a half-truth and at worst, a trap, a one-way road to failure. Surprised? Let me explain.

In my considerable experience there are two kinds of photographers: one, whose concern is with photgraphy; the other whose interest is in pictures. The first (and, unfortunately, most amateurs belong to this group) is mesmerized by the *technical* aspects of the craft—precision cameras, sparkling lenses, fine-grain development, and so on. He owns the finest equipment, the latest cameras, the sharpest lenses, a full line of accessories. He is a walking encyclopedia of photo-technical information, and inordinately proud of the fact that he can produce virtually "grainless" 16 × 20-inch blowups from 35 mm negatives. He knows everything there is to know about the merits and shortcomings of the various "system cameras," regularly trades up to the latest model (bravely absorbing the financial loss), but seldom knows *what* to photgraph and rarely, if ever, makes a worthwhile picture.

At the other end of the spectrum we find the photographer whose sole interest is in the *subjects* he intends to photograph. In contrast to the first type, who is fascinated by gadgets and technology, he is concerned with people, natural objects, landscapes, street scenes, architecture, insects, birds or some other specific category. And because of this passion he tries to capture representatives in picture form to take home and enjoy again and again, perhaps sharing his enthusiasm with others. It is only because alternative means of visual recording like drawing or painting seem less suitable (or are beyond his ability) that he resorts to photography; and only the realization that technically

6

perfect photographs are bound to be *better* interpretations of the subjects he loves than poor ones will involve him in the technical aspects of photography. Yet, despite this lack of deep interest in the medium itself, he is the better photographer of the two and his are the images which command attention. If *you* are this second kind of person, we should get along well.

COMMON PITFALLS AND HOW TO AVOID THEM

Before we get down to particulars, I would like to examine certain popular misconceptions and prejudices about photography which, unless corrected, can seriously impede the development of an aspiring photographer. I therefore hope you will consider the following with care:

Technique and art. In my opinion, as I stress again and again, one of the basic truths in photography is that *every good photograph is the result of a successful synthesis of technique and art*. Art, in the sense I use the term here, means that the subject has been chosen with regard to photogenic qualities (I realize, of course, that this is not always possible; but in cases where it is not, the picture will probably fall into the category of *record shots*, where artistic merits are a luxury and it will be correspondingly dull); that the subject is presented in a visually attractive form; that the picture is well composed; that the quality of the illumination is compatible with the nature of the subject, the purpose of the picture, and the intentions of the photographer; that the rendition is graphically satisfactory; and that the photgraph is meaningful, informative, and emotionally appealing. Unfortunately, too many photographers either pay no attention to such considerations or are not sufficiently aware of them. They usually realize that a photograph which is technically inadequate—fuzzy where it should have been sharp, off-color, grainy instead of smooth, too flat or too contrasty—is somehow lacking; but they fail to recognize the absence of or need for "art." While realizing the role of *technical* excellence, they fail to see the necessity for an *artistically* satisfying impression. The result, of course, is a deluge of lackluster pictures which more convincingly than a thousand words prove my contention that, in photography,

technique is nothing unless complemented by art.

The great illusion. Most people consider photgraphy a naturalistic medium of reproduction. This, in my opinion, is a fallacy and explains why there are so

many poor photographs. Most photographs cannot by any stretch of the imagination be called naturalistic reproductions of the subject they depict. A naturalistic reproduction is a copy which duplicates the original in all important respects. But reality is three-dimensional, whereas a photograph has only two dimensions—depth and space are missing. Furthermore, motion is one of the most obvious aspects of reality and life, but photographs are "still." In reality, objects have color, but a black-and-white rendition consists only of shades of gray. A light-source is radiant and bright but in picture form can be rendered only as the "color" white. And so on.

These limitations seem to me to lead to the following obvious conclusion: since a photograph by its very nature can never be entirely "naturalistic," it is pointless to strive for a quality which is beyond the scope of the medium. Instead, photographers should make fullest use of all the means and techniques that an ever-advancing technology places at their disposal to create images which are stimulating and new—which depict familiar subjects in new and interesting forms or show us things we could not see without the camera's eye—thereby widening the scope of our visual experience. The photographer's aim is to create illusions—the illusion of depth and space, of color (in black-and-white), of movement, of radiant light, of life.

The means for doing this—including perspective and controlled diminution, selective focus, specific combinations of f-stop and shutter speed, lenses of different focal lengths, color filters, speedlights and stroboscopic lights—will pp. 247–249 be discussed later. What I want to establish here, at the start, is the necessity for the student photographer to free himself from obsolete preconceived ideas about "how a photograph should look" and, more important, from such antiquated taboos as the notion that in photographs of buildings "converging verticals" are always a fault (actually, they are the perfectly normal manifesta- p. 344 tion of perspective in the vertical plane); that all wide-angle lenses "distort" (this form of distortion is actually the symbol for nearness); that a 180-degree p. 347 "fish-eye perspective" is "unnatural" (it is in fact a form of seeing commonly found in many birds, fishes, and insects); that color pictures can appear "natural" only if the spectral composition of the light by which they are made corresponds to the type of light for which the color film is balanced (if this were true, all pictures taken in golden afternoon or reddish sunset light would be p. 271 "unnatural"); that flare and halation caused by brilliant light striking the lens are *ipso facto* faults which must be avoided at any price (actually, they symbolize the brightness and radiance of direct light); that telephoto lenses

8

"compress space" and produce an "exaggerated" form of perspective (in p. 345 truth, we can experience the same kind of perspective with the naked eye if we observe a subject through a small, rectangular opening cut in a piece of cardboard, but are usually not aware of this phenomenon because of the relatively small scale of such a view); that graininess in a picture is always a fault (in its proper place, it can become an expressive means of creation, symbolizing certain subject qualities which otherwise could not be depicted, or could not be depicted as well); that blur is a sure sign of sloppy camera work (it p. 361 is perhaps the most compelling signal of motion); and so on. I'll have more to say about the symbolic aspects of photography later.

Creative use of options. Most amateurs, upon encountering an appealing subject, reach for the camera and shoot, usually only once. In contrast, a creative photographer—unless he is faced with a fleeting, once-in-a-lifetime opportunity—will study his subject carefully from various distances and angles. He will consider how it would look in another light, perhaps under different atmospheric conditions. He will give thought to his means of rendition— which type of lens, film, or filter to use. Already seeing the finished image in his mind's eye (a process known as previsualization and practiced by every creative photographer), he will choose his subject approach and means of rendition accordingly. And once he has reached specific conclusions he will not stop with one shot but will explore all the promising possibilities the situation presents because he knows that two of the tenets of any successful photographer are

**You always have a choice. Don't waste this precious privilege.
If a subject is worth photographing, it deserves a perfect job—
something which rarely can be accomplished with
only a single shot.**

Working toward a whole. Any experienced photographer knows that all the factors which contribute to the effect of his pictures are inextricably related, forming an interlocking entity no part of which can be changed without affecting the rest, often dramatically. Suppose, for example, a photographer wants to photgraph a monument. After careful study of the sculpture, he finds the camera position from which his subject will appear to best advantage. Unfortunately, from this particular angle the illumination as manifested in the distribution of light and shadow is unsatisfactory and a change of plans is indicated. A different angle of approach is found but, this time, the back-

ground may be unacceptable, perhaps because it is too similar in color or tone to the subject, because it is frankly unappealing, or because it is simply garish. Sometimes, the problem can be solved by making the shot with a relatively large f-stop—thereby deliberately decreasing the extent of the sharply rendered zone in depth and depicting the background with sufficient unsharpness to make it pictorially acceptable. But this remedy, in turn, would affect the film exposure time (which now must be shortened). Similarly, use of a filter to improve color translation in terms of black-and-white, or use of a smaller f-stop to extend the zone of sharpness in depth in the picture, would require a corresponding adjustment in exposure time. The slower shutter speed now required would in turn affect the degree to which subject motion is "frozen" in the picture and might become the cause of unwanted blur. Or, in black-and-white photgraphy, if subject contrast is either so high that it exceeds the scope of the film, or too low for satisfactory subject characterization, it can be decreased or increased, respectively, through appropriate changes in the

p. 330 times of film exposure and negative development, as will be explained later. But here, too, a change in one factor must be followed by a corresponding adjustment in another if the desired result is to be obtained, since the elements involved are inextricably interrelated. I cannot stress strongly enough that a photographer must always consider each factor which may affect the outcome of his picture in relation to all the others.

Black-and-white or color? One of the most popular fallacies in photography is the notion that a rendition in color, because it is more "naturalistic," is *ipso facto* superior to one in black-and-white. In reality, neither form of subject presentation is "superior"; they are merely different. However, in a *specific* case, one process might very well produce better results and hence be considered preferable.

Normally, a rendition in color is likely to prove the best solution if color is the subject's most outstanding characteristic (brightly-hued flowers, birds, insects, fruit; women's fashions; food arrangements; blazing sunset skies; paintings; outdoor scenes photographed in an unusual light); or, if a high degree of "naturalism" is required (identification and scientific photography). On the other hand, black-and-white pictures will normally be most effective if a

p. 254 creative-interpretative subject approach is used and a more graphic-abstract rendition required, since the black-and-white medium normally offers the photographer much greater opportunity for control. And almost any graphically powerful black-and-white photograph will be superior to a color photograph whose tones appear distorted due to poor technique.

10

Photographic seeing. The old proverb "The camera does not lie" is both true p. 223 and false. True—because the camera will objectively render in picture from *everything* within its field of view. False—because the eye, subject to guidance by the brain, is *not* consciously all-seeing but perceives the world in a highly subjective way, noting only that subject matter in which the observer is interested. As a result, most photographs "show too much," including all the visual flotsam which the selective eye automatically discards in reality. Furthermore, people tend to "see" things the way they think they *ought* to look, particularly in regard to subject coloration, with the result that the truest color can appear "unnatural" in a transparency. This can be the case, for example, p. 319 in portraits shot outdoors in the open shade which, illuminated only by light reflected from the blue sky, appear excessively blue; portraits shot under trees which seem too green because the light was filtered by green leaves; and portraits shot at sunset which, due to the redness of evening light, appear too red—and this despite the fact that in each case color rendition accurately reflected the prevailing light conditions.

Indeed, the ability to assess correctly *all* the factors that influence the outcome of a picture—including color of the ambient light (to avoid an undesirable color cast), perspective (to avoid unwanted "distortion"), subject distance and scale (to prevent important subject matter from appearing unnaturally small), and contrast (to avoid having black-and-white pictures turn out too contrasty or too flat and color either washed-out or murky)—is one of the most important factors that determine the outcome of *any* picture. I will therefore discuss it in depth later in Part VI. What is important here is that the photographer realize that photgraphic seeing—the ability to "see like a camera," to see reality in photographic terms—is an indispensable quality which he must cultivate from the start.

Light and lighting. Light is the photographer's medium and, apart from p. 260 outright mistakes, perhaps the most important single factor which determines the effect of his pictures. It has three main functions: it decides the film exposure; it aids in creating illusions of depth and space through the disposition of shadows; and it sets the picture's mood: cheery or subdued, warm or cold, colorful, dramatic, or misty.

Unfortunately, too many photographers pay attention to only the first function of light and disregard the others, with predictable consequences. Because there is more to light than any light meter or the most careful compliance with the so-called Zone System can reveal. Correct film exposure is, of course, an

indispensable prerequisite for any technically satisfactory photgraph, but the resulting image can still be a dud. Only too often, it is the character of the illumination which, in the rendition, gives the subject "depth," makes it stand out from its background, gives it eye appeal, defines its mood, and makes it come to life. Consequently, a photographer should make it a habit right from the start to evaluate light not only *quantitatively* (in terms of exposure: how bright?), but also *qualitatively* (in creative terms: what kind of light?). For unless the light is "right" for the occasion, not even the most accomplished "technique" can make the picture effective and all your efforts will have been in vain.

CONCLUSION

Photography is as simple or complex as you choose to make it. Nothing is easier than snapping a simple subject and, a few days later, picking up at the store where you left your film, a set of pretty pictures. Any bright five-year-old can do it.

On the other hand, few things demand more patience and skill, more sensitivity and devotion, more tenacity and plain hard work, than the making of great photographs. The quality of your pictures is in direct proportion to the demands you make upon yourself and your work—your values.

Many students of photography are convinced that the better and more expensive their equipment is, the better and more expressive the pictures they make will be. "If only I had a Nikon . . . ," they say: or, "No wonder that picture is good, it was made with a Hasselblad." How wrong they are!

In itself, a camera is no more creative than a lump of clay. But like clay, it becomes a means of creation when placed in inspired hands. "Prize-winning cameras" and "cameras that can do everything" exist only in the fevered imagination of promotors. There are only prize-winning photographers. Meaningful pictures can be made with *any* camera regardless of brand name, type, or price. Great pictures have been taken with a lowly "box." Some cameras, of course, are more suitable for certain kinds of work than others, or more versatile, or more reliable. But again I must stress that it is the photographer's imagination, his ability to see in photographic terms, his artistic sensitivity, and the degree of his involvement with his subject—in other words, his attitude, his vision—which guides the hand that guides the tool and is ultimately responsible for the quality of his pictures.

One of the curses of our time is that most people want to bother only with things that are "easy." How often have you seen ads like the following: "You, too, can paint, write, make great photographs, earn good money . . . all you have to do is subscribe to this home-study course, buy this inexpensive kit, follow these simple instructions . . . IT'S EASY!"

Contrary to fashion, I do not offer you a formula for easy results, in the pages that follow, nor should any book on photgraphy. You will find all the pat information you need neatly summarized in the instructions packed with your new camera, light meter, and film—and it's free.

However, if you belong to that breed of photographers who still believe in quality, devotion to a cause, and truly meaningful results, then you will find the guidance you seek in the pages and pictures of this book. To give more is impossible: the rest is up to you. That final ingredient for success—creativity—cannot be taught.

From the substance of his surroundings, a photographer gathers impressions which he evaluates in the light of his own experience, interest, and personality. Discrimination, selection, and rejection precede the making of his pictures. Organization, clarification, and technical skill transform his raw material into a form which, in intensity of seeing, symbolic suggestiveness, and dramatic impact, can surpass by far the experience of the actual event. When this is achieved, the photograph is successful in the truest sense—reality has been transformed into art.

Equipment and Material

Like any other artist or craftsman, a photographer cannot perform without specific tools and materials; but the kind of equipment he requires, and its cost can vary enormously depending on his needs. What kind of subject does he want to photograph? How much can he afford to pay? How much time and effort is he willing to invest in photography? The future photographer must clearly make some very important decisions early in his career and they had better be the right ones, because making the wrong choice can be expensive and disconcerting, frustrating his efforts and taking the fun out of photography.

Since acquiring the kind of equipment and material that is right for you is a vitally important prerequisite for your future success as a photographer, all purchases must be considered with care. Confronted with the almost unbelievable number of cameras, accessories, lenses, speedlights, films, and so on displayed in any major photo store—apparently so similar and yet so different—beginners (and also experienced photographers, who ought to know better) often make the mistake of selecting *their* camera, lens, and other equipment primarily on the basis of prestige, popularity, or advertising pressure, buying the most expensive camera and fastest lens they can afford, or one publicized by a famous photographer, heedless of whether or not their purchase suits their own personality and type of work. This is a sure way to get off to a bad start.

To avoid handicapping yourself from the beginning, listen to one who has made every mistake in the book and, during a lifetime in photography, finally learned that the only way to acquire the *right* kind of equipment is to select it on the basis of two qualities:

Suitability
Simplicity

Suitability

People sometimes ask me: "Which is the best type of camera?"—a question as pointless as asking, "Which is the best type of automobile?" Is a sedan "better" than a station wagon, or a convertible "better" than a jeep? What good is a sedan to a person who needs the space of a station wagon? Or a four-wheel-drive vehicle to someone who never gets off the paved road? Are oranges "better" than apples, or peaches "better" than plums?

No—the only criterion of whether or not a camera or lens is "good" is *suitability*. Is it suited to *your* needs, the kind of work *you* intend to do? If the answer is yes, the camera or lens is "good" as far as you are concerned; if it is no, it isn't.

Suitability has nothing to do with brand name or price. For example, as far as an architectural photographer is concerned, a used forty-dollar 4 × 5-inch view camera equipped with a "slow" f/6.3 pre-World War II lens is infinitely p. 27 "better" than the latest model of the finest 35-mm single-lens reflex camera fitted with a high-speed lens, an outfit costing perhaps ten times as much. Why? Because it is in the nature of architectural photography that the picture must contain an abundance of fine detail, which makes it necessary that a relatively large film size must be used; that perspective must be controlled and distortion avoided, which means that the camera must be equipped with individually adjustable front and back movements which 35-mm cameras lack; p. 336 that sharpness in depth must be extensive, which requires that the picture is made with a small-diaphragm aperture—so why pay the much higher price of a large-aperture or high-speed lens?

In determining suitability, special consideration should be given to a camera's growth potential—the degree to which it can be expanded into a "system." Does it take only the lenses provided for it by its manufacturer or does it accept certain independent manufacturers' lenses as well, thereby increasing its scope and, perhaps, saving the photographer money? What is the range of its accessories? Do these include extension tubes or bellows, different types of interchangeable viewfinder screens, angle viewers, prisms for eye-level viewing? Will it take a motor drive, and, if the camera's design permits such options, does it provide for the use of interchangeable film magazines for alternative use of color film and black-and-white, rear-focusing for extreme close-up photography, provisions for perspective control?

pp. 18, 25 In addition to the mechanical and design features of cameras, which I'll discuss later, there are intangible qualities which make a camera more or less *suited to you*. It is almost like falling in love—why do we choose one person and not another? What is it that makes a certain camera particularly desirable (and here I am not speaking of differences in quality or cost, which would be understandable, but thinking of cameras that are similar in regard to design, workmanship, and price). This is what I mean—the way a camera "feels" in your hands, whether your fingers do or do not fall naturally on the various controls, whether the shape of the camera body does or does not fit your grip, how well you like its viewfinder (this is particularly important if you wear glasses—some finders permit bespectacled photographers to see the entire area of the future picture, other don't); whether you prefer a lighter or heavier model, much chrome trim or little, or perhaps an all-black job; how you react to bulkiness. There are additional considerations as well: the pleasure that comes from handling a camera that fits one in every respect, versus the constant annoyance over little things that are not quite right, like a grip that feels uncomfortable, an awkward film transport lever or rewind handle, numerals that are too small to be read easily, or an annoying viewfinder eyepiece. It is to make sure that your future camera *suits you in every respect* that I suggest you handle a number of *potentially suitable* cameras in the photo store before you decide, and NOT order by mail the camera you fell in love with because it is "famous." Never mind what other photgraphers do who might be very different from you, or just plain foolish. Buy what suits YOU— SUIT YOURSELF!

Simplicity

One of the most valuable *practical* lessons that twenty years of work as a staff photographer for *Life* taught me was to keep my equipment simple. The simpler the equipment, the faster it is ready for use; the fewer pieces one carries, the less one has to keep track of, particularly while traveling. Photographers who load themselves down with equipment rarely bring home good photographs. Notwithstanding the well-filled photo stores, only a few pieces of equipment are truly indispensable for making good photographes; certain kinds of addtional gear, although not essential, can help you to broaden the scope of your work; still other equipment is of very limited usefulness. The remainder of the chapter is devoted to a detailed examination of the first two categories.

INDISPENSABLE EQUIPMENT

>**Camera**
>**Lens**
>**Lens shade**
>**Cable release**
>**Light (exposure) meter**
>**Color filters**
>**Gadget bag**
>**Film**

THE CAMERA

Regardless of design, size, make, or price, a camera—any camera—is basically nothing but a light-tight box or sleeve connecting two vitally important components:

>**The lens that produces the picture**
>**The film that retains it**

Most of its other components are merely auxiliary devices that control the three operations by which the picture is made:

>**Viewing**
>**Focusing**
>**Exposing**

The fact that despite their fundamental similarities cameras come in such a profusion of different models is due to three factors: design, size, and quality. Each of the various control devices can be designed in different ways, each type having advantages which make them particularly suited to certain photographic purposes as well as drawbacks which make them less suitable to others. Each camera design can be executed in different sizes depending on the film size which it must accommodate, different film sizes in turn having specific advantages and drawbacks. And finally, cameras identical in design and size can be of low, medium, or high quality—quality, of course, being a decisive factor in manufacturing cost and retail price.

17

No wonder that the number of possible combinations of design, size, and quality is so great and our photo stores are filled with such an abundance of different camera models. To be able to find his way through this profusion, a photographer must be familiar with the advantages and drawbacks of the various camera designs described in the following, and he must know what he needs, which depends on the kind of work he intends to do.

Viewing controls

What gun sights are to the marksman, viewfinders are to a photographer: devices to pinpoint a target. Without an accurate viewing device, no photographer can accurately compose his subject, nor can he isolate it effectively from its surroundings and be sure that the picture will be a self-contained unit. A viewfinder enables him to do this.

Distinguish between the following types of viewfinders:

Off-the-lens viewfinders
 Combination viewfinder-rangefinder
 Frame finders
 Nonfocusing optical finders
Through-the-lens viewfinders
 Groundglass panel
 Reflex finder
 Prism-reflex finder
 Twin-lens reflex finder
 and
Eye-level viewfinders
Waist-level viewfinders

Off-the-lens viewfinders, in comparison with through-the-lens viewfinders, have two fundamental drawbacks:

1. They are subject to parallax—that is, they show the subject from an angle which is different from that at which it is "seen" by the lens. The consequence, of course, is a discrepancy between the picture as seen by the eye in the finder and the picture as it will appear on the film. While this difference is negligible as long as subject distances are greater than approximately ten feet, it becomes increasingly serious with decreasing subject distance, making cameras equipped with off-the-lens viewfinders that don't feature parallax

compensation unfit for close-up photography unless they are also equipped with a groundglass panel or permit the use of a reflex housing.

2. They do not permit a photographer to check visually the extent of the sharply covered zone in depth—that is, he is unable to see the effect of his stopping down the lens upon the depth of field of his future picture.

Off-the-lens viewfinders come in two types: those which have the great advantage that they DO, and those which have the drawback that they do NOT, measure the distance between subject and camera and therefore can, or cannot, be used in focusing the picture. Exponents of the first type are the familiar combination viewfinder-rangefinders—nowadays always coupled directly to the focusing mechanism of the lens—employed in 35-mm RF (range-p. 26 finder) and large-format press-type cameras. Nonmeasuring viewfinders come in two different designs: frame finders (also called sports finders because they are particularly "fast" in use and therefore especially well suited to fast-changing action photography) which consist of a metal frame attached to the front and a peep sight attached to the back of the camera; and simple optical nonfocusing viewfinders of various designs used mainly on simple inexpensive cameras and also as accessory finders for use in conjunction with extreme wide-angle lenses.

Through-the-lens viewfinders make use of a groundglass screen onto which the lens-produced image is projected; this screen serves simultaneously for viewing and focusing. Since the image which the eye sees is produced by the same lens that makes the picture (exception: twin-lens reflex cameras), there is p. 27 no parallax. The image seen in the viewfinder and the picture will coincide, and cameras equipped with through-the-lens viewfinders are fundamentally suited to every kind of photography, including close-ups, and come in four designs:

Groundglass panel. This is the familar "old-fashioned" focusing screen attached in the film plane to the back of a press-type or view camera. Particular advantages are: appearance of the image in the full size of the future negative or transparency; direct, visible indication of the extent of the sharply covered zone in depth, the so-called depth of field; unlimited range of operation with any type of lens at any subject distance. In addition, a groundglass panel is the only type of viewfinder which permits the installation and use of independent front and back camera adjustments—the tilts, slides, and swings indispensable for perspective control, which is essential in architec-pp. 336, 341 tural, industrial, commerical, and interior photography and, under certain conditions, for extending the sharply covered zone in depth without the necessity for resorting to undesirably small diaphragm stops.

Disadvantages: The image appears upside-down and reversed; insertion of the film holder blocks out the groundglass image—a serious drawback which makes groundglass-panel-equipped cameras, unless they possess a second viewfinder like the combination rangefinder-viewfinder used on all press cameras, unfit for photographing dynamic subjects: since they turn "blind" the moment the film holder is inserted, they cannot be hand-held but must be used on a tripod. Typical representatives: all view cameras.

p. 27

A reflex finder consists of a mirror mounted inside the camera body behind the lens at an angle of 45 degrees which intercepts the image produced by the lens, reflects it upward, and projects it onto a horizontal groundglass panel, where it is viewed from above with the camera normally held at waist-level. Immediately before the exposure, the spring-loaded mirror flips up (or slides down) to get out of the way of the light coming from the lens. Following the exposure, the mirror either returns automatically to its 45-degree position (the so-called instant-return mirrors employed in all modern 35-mm single-lens reflex cameras), or it is returned to its position manually by the photographer.

This is the viewfinder employed by all large, medium-sized, and a few now obsolete 35-mm single-lens reflex cameras. It combines most of the advantages of the groundglass-panel viewfinder with the added advantage that it makes the so-equipped camera eminently suitable to hand-held operation. Minor drawbacks are that the image, although right-side up, is reversed left and right; that certain individual adjustments for perspective control cannot be incorporated into a reflex-finder-equipped camera; and that the finder image is not visible during the moment of exposure. A more serious disadvantage is that, unless the camera has a revolving or reversible back, vertical pictures can be taken only by turning oneself 90 degrees from the subject, turning the camera on its side, and looking into it sideways—a position which makes fast and accurate shooting impossible. Single-lens reflex cameras, which produce square pictures, do not have this inconvenience, which is why most modern, medium-size SLR cameras are designed to produce square pictures. Typical representative: Hasselblad.

A prism-reflex finder consists of an ordinary reflex finder with a so-called pentaprism mounted on top. It is the most popular and successful viewing and focusing device for general photography available today and, in comparison with the reflex finder, has the following advantages: The image appears right-side up and is NOT reversed; the camera is held at eye level, which makes for faster operation and, in many cases, a more natural-appearing perspec-

20

tive in the photograph; and vertical pictures can be made simply by turning the camera into a vertical position. Its main drawback is that is precludes the use of individual camera-back adjustments for perspective control which, therefore, are never found on cameras equipped with prism-reflex finders. Typical representative: Nikon.

Twin-lens reflex finder. The image-viewing and picture-taking parts of the camera are separated, each equipped with a lens of identical focal length, with the image-viewing part designed in the form of a reflex-finder. This is the principle of the twin-lens reflex camera, which has the following advantages and drawbacks: The image appears right-side up but reversed. It is *continuously* visible—before, during, and after the exposure—since the viewing system employs a *stationary* mirror, which does not cause "mirror blackout." Normally, the image is viewed from above with the camera held at waist-level. However, if so desired, the camera can also be held in an upside-down position above the head and the image viewed from below in cases in which it is desirable to shoot from a higher angle—for instance, when trying to take pictures over the heads of a crowd that otherwise would block the view. Typical representative: Rolleiflex.

Eye-level viewfinders—rangefinder-viewfinders, frame finders, many non-focusing optical viewfinders, groundglass panels, and prism-reflex finders —make it necessary to hold the camera at eye-level when taking the picture. Although normally the most natural position for making photographs, it is not always desirable. For example, when working very close to the ground, an eye-level viewfinder can be inconvenient because it would force the photographer to work in an uncomfortable position.

Waist-level viewfinders—reflex finders, twin-lens reflex finders, and some nonfocusing optical viewfinders—make it necessary to hold the camera at waist-level or lower when taking the picture. Depending on the work to be done, this may or may not be an advantage. Addition of a right-angle finder to the eyepiece of a prism-reflex finder converts a camera from eye-level to waist-level operation.

Combinations. Because no viewing system is equally satisfactory for every kind of work, many cameras are equipped either with more than one viewfinder (most press cameras, for example, have three: a rangefinder-viewfinder, a frame [sports] finder, and a groundglass panel), or so designed that certain changes in their viewing systems can be made—for instance, the addition of a pentaprism to a reflex finder, which converts a camera from

waist-level to eye-level operation. Any photographer whose work requires different types of viewfinders should make sure that the camera of his choice offers this convenience.

Focusing controls

To yield sharp pictures, a camera must be properly focused—that is, the distance between lens and film must be adjusted in accordance with the distance between subject and lens. This is done with the aid of two devices:

A *mechanical device* (in most small cameras, a helical lens mount; in most larger cameras, a rack and pinion drive in conjunction with a bellows) that makes it possible to vary the distance between lens and film.

An *optical control,* which tells the photographer when the distance between lens and film is correctly adjusted. Distinguish between three designs, each with specific advantages and drawbacks:

Lens-coupled rangefinder. Two partly superimposed images of the subject appear in the finder window and move relative to one another when the lens is moved back and forth during focusing; when the two images are in register, the subject is in focus and the lens at the proper distance from the film to produce a sharp picture. Rangefinders come in several designs and, in good light and provided the subject contains sharply defined edges or lines, are the fastest and easiest means of focusing a camera precisely.

Lens-coupled rangefinders have several characteristics which may make a so-equipped camera unsuitable for certain types of work. The image which they present is usually quite small, making it difficult to check details of composition. They cannot be used at distances shorter than approximately three feet or in conjunction with the more extreme types of telephoto lenses. Although they are able to pinpoint the plane on which the lens is focused, they do not indicate the extent in depth of the sharply covered zone. They are difficult or impossible to use if the subject does not contain sharply defined edges or lines or if the light is dim. And synchronization between rangefinder and lens may fail without the photographer noticing it in time, resulting in unsharp pictures.

Reflex systems. Since the image is produced by the lens that makes the picture, the photographer perceives the subject in the form in which it will subsequently appear on film. As a result, he not only can check sharpness of

focus but the extent of sharpness in depth, since the effect of stopping down the diaphragm is visible in the groundglass image. Additional advantages of reflex focus-control systems over lens-coupled rangefinders are: the larger size of the image (identical with that of the future negative or transparency), which facilitates evaluation in regard to optical quality and composition; complete freedom from parallax; and the fact that this type of focus-control can be used in conjunction with almost any lens at any subject distance.

Unfortunately, there are drawbacks as well. Determination of the moment when critical sharpness is achieved is somewhat more difficult and time-consuming, and sometimes more uncertain, with a reflex-system than with a lens-coupled rangefinder. The image appears progressively darker the more the lens is stopped down and "blacks out" completely during the exposure. And in comparison to rangefinder-equipped cameras, reflex cameras are mechanically more complex and therefore more prone to breakdowns, noisier since the sound of the upflipping mirror is added to that of the shutter, and heavier and larger. Finally, there is the danger of "mirror shock"— inadvertent camera movement during the exposure caused by the upflip of the mirror, which could impair the sharpness of the picture.

To mitigate or eliminate these drawbacks, the basic reflex design has been improved in several ways. To facilitate critical focusing, all kinds of aids have been incorporated into the focusing screen, one of these being a Fresnel lens (appearing as fine concentric circles), which improves the evenness of the illumination by brightening the corners of the groundglass image; in addition, a circular split-image rangefinder may be built into the center of the screen, or a focusing grid consisting of a multitude of microprisms which fracture the image but snap into clarity when proper focus is achieved (although very helpful in conjunction with lenses of more or less standard focal lengths, both devices work badly, or entirely fail to work, when used with telephoto lenses). Automatic diaphragms permit the photographer to focus with the lens wide open (bright finder image), automatically close down to a predetermined aperture (dark finder image) shortly before the shutter is released, and open up again (bright image) once the exposure is made. An instant-return mirror shortens the moment of "image blackout."

Groundglass panel. This simplest of all focusing controls would rank at or near the top of the list were it not for the fact that, as previously explained, a p. 20 groundglass-equipped camera which has no other viewfinder (for example, a view camera) can only be used mounted on a tripod. However, in all cases in

which circumstances and the nature of the subject permit making the photograph with the camera mounted on a tripod, a groundglass-equipped camera is unsurpassed because it offers the following advantages: It presents a large and easily "readable" image in the full size of the negative or transparency, which is completely free from parallax, clearly shows the extent of the sharply covered zone in depth, and can be used in conjunction with any type of lens of any focal length. In addition, only groundglass-panel-equipped cameras can be fitted with the back adjustments, the so-called swings indispensable for complete perspective control.

A fixed-focus camera has no focusing controls because it does not need them; its lens is permanently focused at a subject distance of approximately twelve feet which, in conjunction with its relatively short focal length and small diaphragm aperture (which is also usually nonadjustable), results in pictures that are evenly though only moderately sharp from about six feet to infinity. Because of these design limitations and the fact that only very simple lenses are used, the "sharpness" of pictures made with fixed-focus cameras, although sufficient for modest demands, is always inferior to that of photographs made with more sophisticated equipment.

Exposure controls

Exposing is admitting the amount of light to the film that is required to produce a negative of correct density or a transparency of satisfactory color. The combined use of two devices enables a photographer to achieve this:

The diaphragm, a variable aperture built into the lens, controls *the amount of light* which is admitted to the film. Depending on the camera design, it is operated either manually or semi- or fully automatically.

The shutter, in conjunction with a built-in timing mechanism, controls *the length of time* light is admitted to the film. Distinguish between two main types of shutters with different characteristics which must be considered when selecting a camera:

Between-the-lens shutters are built into the lens (primarily those designed for use in larger-size cameras). In comparison with focal-plane shutters they are, as a rule, more reliable and have the further advantage that they can be

24

synchronized for ordinary as well as electronic flash at *any* shutter speed. However, in 35-mm and rollfilm cameras that feature interchangeability of lenses, their use involves technical complications that are sometimes avoided by a leaf-type or rotary-type "behind-the-lens" shutter.

Focal-plane shutters are built into the camera body and used mostly in 35-mm cameras. They allow for shorter exposures than between-the-lens shutters and considerably simplify the construction of 35-mm and rollfilm cameras that feature interchangeability of lenses. On the other hand, they are less reliable, subject to uneven exposure or "wedging" (exposing one side of the film progressively more than the other), require a special type of flashbulb p. 99 (Class FP), and can be synchronized for electronic flash only at relatively slow p. 99 shutter speeds.

Adjusting the diaphragm and shutter speed is done either manually on the basis of data furnished by an exposure meter, or with the aid of an exposure meter built right into the camera itself which usually is coupled to, and forms an integral part of, the exposure control system.

Built-in light meters, powered by a light-sensitive photocell, in conjunction with a tiny battery, measure the light that is reflected by the subject after it has passed through the lens. They come in two types—spot meters and integrating meters—each in a variety of different designs. Spot meters measure the light p. 62 of a small area (usually in the center of the focusing screen) and can be used to establish the contrast range of the subject; integrating meters measure the light p. 61 over the entire picture area and give an average reading. Location of the photocell varies widely with meter design; although each manufacturer claims specific advantages for his own design and derides those of competitors, experience has shown that all work equally well provided they are used by a knowledgeable photographer in accordance with the instructions that accompany his camera.

Types of camera design

Selection of the most suitable camera becomes relatively simple if the various designs are arranged in groups in accordance with the following scheme and the final choice is made under consideration of the suggestions given on pp. 36–38. Photographers who engage in more than one type of work may need more than one type of camera for best results.

Cameras for general photography

Cameras equipped with a lens-coupled rangefinder
Single-lens reflex cameras
Twin-lens reflex camera

Semispecialized cameras

View cameras
Instant-picture cameras
Simple rollfilm and box-type cameras

Highly specialized cameras

Super-wide-angle cameras
Panoramic cameras
Aerial cameras
Subminiature cameras

Cameras for general photography

All cameras belonging to this group are designed for hand-held operation although they can, of course, also be used with a tripod. Most feature interchangeability of lenses, and can be fitted with a good selection of wide-angle and telephoto lenses.

Rangefinder (RF) cameras represent the "fastest" design, the one best suited to photgraphing dynamic subjects, people, and action. Advantages and p. 22 drawbacks of the rangefinder-viewfinder system are discussed above.

In addition to general photography, the RF design lends itself well to wide-angle and moderate telephotography but does not permit the use of zoom lenses and is unsuitable to close-up photography and extreme telephotography unless the lens can be focused either by means of an accessory reflex-housing (35-mm camera), or with the aid of a groundglass panel (press-type camera); in the latter case, the shot cannot be made hand-held but only with the camera set on a tripod. Some press-type RF cameras are equipped with individually adjustable front and back movements for perspective control and are therefore well suited to any kind of architectural, commercial, and industrial photography.

Single-lens reflex (SLR) cameras, although in operation perhaps not quite as "fast" as RF cameras, represent the most universally useful camera design

available today and the only one permitting the use of zoom lenses. Advantages and drawbacks of the reflex viewing and focusing systems were mentioned above. In 35-mm size, the SLR is at present the most popular of all p. 22 cameras. In addition to general photography, particularly of dynamic subjects, the SLR design is especially well suited for close-up and telephotography but is totally unsuited to work that requires perspective control. In the medium, $2\frac{1}{4} \times 2\frac{1}{4}$-inch format, the SLR is the "workhorse" of may top-flight advertising, commercial, and industrial photographers.

Twin-lens reflex (TLR) cameras, in comparision with SLR cameras, have four advantages: The viewfinder image is continuously visible, even *during* the exposure; it stays bright no matter how far the taking-lens is stopped down; camera operation is quiet and vibration-free since this design involves a stationary instead of a movable mirror and a between-the-lens instead of a focal-plane shutter; and, due to the fact that a between-the-lens shutter is employed, TLRs can be used in conjunction with regular flashbulbs (instead of special Class FP bulbs) and synchronized at *any* shutter speed, *even with electronic flash*.

On the other hand, the TLR design has the following drawbacks: Cameras are larger and heavier than SLRs of the same film size; visual observation of the extent of the sharply rendered zone in depth is normally not possible; the usefulness of all models for close-up photography is severely restricted either because of limited focusing range (although special close-up lenses can mitigate this) or because of parallax problems. And finally, at least at the time of this writing, only one make (Mamiya) allows for interchangeability of lenses.

Nevertheless, for general photography, provided that the restrictions listed are not objected to, this is, although perhaps not the most versatile, one of the most practical of all camera designs and, in my opinion, the one most suited to the needs of the serious beginner.

Semispecialized cameras

Cameras included in this group are particularly suitable for specific types of photographic work, but have certain limitations which will be pointed out in the following survey. *They are not suitable for general photography,* and to avoid disappointment anyone considering the purchase of such models should be aware of their uses and limitations.

View cameras, *because they cannot be hand-held but must be used on a*

tripod, represent a design that is eminently suitable for photographing static but totally unfit for photographing dynamic subjects. A view camera—theoretically, the larger the better, although practical considerations make the 4 x 5-inch format the most common size—should therefore be the first choice of anyone wishing to specialize in architectural, commercial, industrial, or interior photography. Likewise, view cameras are unsurpassed for copywork and the reproduction of objects of any kind, including works of art, for catalogue work, and for technical and many phases of scientific photography.

All view cameras are equipped with a groundglass viewing and focusing panel. All permit interchangeability of lenses. The most sophisticated models are constructed in accordance with the module or building-block principle; their basic components—tracks, bellows, lens support, back, and so forth—are detachable and interchangeable with other parts of similar function but different construction or dimensions. As a result, a photographer can "custom-build" his own camera from standardized parts in accordance with the special requirements of his work. And should the nature of his work change, or should he wish to branch out into other photographic fields, as long as he started out with a modular design and restricts himself to static subjects he will always be able to adapt his view camera to the new demands, including a change from a smaller to a large film size.

Instant-picture cameras can be used only with special Polaroid and Kodak instant-picture films. Furthermore, most of these films, at least at this time, do not produce a usable negative and thus duplicate prints can be obtained only by copying the original.

Instant-picture cameras are designed primarily for photographing dynamic subjects—people, children, family events. They come in a number of different models that vary from simple to elaborate, although none offers interchangeability of lenses. Because they yield finished color prints on paper in only sixty seconds after the exposure has been made (and black-and-white prints in fifteen), they are ideally suited for anyone wishing or needing to see results in a hurry—whether it be parents shooting color at their daughter's graduation, professionals trying to show their appreciation to someone who helped them in their work by presenting him on the spot with courtesy pictures, or a scientist who needs to see the result of an experiment in a hurry.

Although originally designed for amateurs and hobbyists, instant-picture

cameras—and to an even higher degree accessory Polaroid Land camera backs which, like ordinary sheet-film holders, can be used in conjunction with most 4 x 5-inch cameras—are highly prized by many professional photographers as invaluable aids in making instant tests for a last-minute check of everything from the distribution of light and shadow to the correctness of the contemplated exposure before taking a difficult picture.

Simple rollfilm and box-type cameras are semispecialized tools in the sense that they are designed to serve only a very limited purpose: to fill the needs of people who wish to make acceptable "snapshots" of family and friends with the least expenditure of money, effort, and technical know-how.

Highly specialized cameras

Cameras belonging to this group are designed with a specific purpose in mind; they are perfectly suited to one narrowly defined type of work and useless for anything else. These are the "additional" cameras which ambitious and versatile photographers acquire to broaden the scope of their work and outdo their less imaginative or resourceful competitors.

Super-wide-angle cameras are equipped with lenses which cover unusually large angles of view that may range from 90-plus to a full 180 degrees. (For comparision: standard lenses encompass angles of view in the neighborhood of 45 degrees.) Lenses that cover angles up to 130 degrees (Goerz Hypergon) are designed to produce renditions in which perspective is rectilinear; those that cover a full 180 degrees, the so-called fish-eye lenses, produce renditions in which perspective is spherical.

p. 334

p. 347

Super-wide-angle cameras are used for one of two purposes: to include the largest possible angle of view in a photograph; to deliberately show the subject in an exaggerated or "distorted" form for the purpose of greater emphasis or to provide the picture with stopping-power. In either case, only a knowledgeable photographer who combines imagination with restraint will be able to come up with effective pictures since wide-angle lenses are notoriously tricky. More will be said about this later.

p. 344

Panoramic cameras are a special type of super-wide-angle camera whose lens swings in an arc during the exposure, scanning the film through a slitlike aperture. They encompass an angle of view of 140 degrees and produce

renditions in which perspective is cylindrical: straight lines running parallel to the plane of the arc are not rendered straight, but in the form of curves. This form of rendition, of course, can be rather objectionable and may restrict the use of panoramic cameras to photographing subjects without straight lines—particularly landscapes—or those in which such curving would not be too pronounced and hence less objectionable; for example, overall views of ball parks or interiors of convention halls.

Aerial cameras are of rigid, bellowless construction and their lenses are permanently focused at infinity. As a result, they cannot be used for anything except taking photographs from the air. Frequently, "surplus" aerial cameras are advertised in photo-magazines at fantastic "savings." But they are bargains only to photographers who need an aerial camera or lens since it is virtually impossible to convert them to any other use.

Subminiature cameras. Many of the cameras in this category are precision instruments equipped with every imaginable refinement. They are invaluable when smallness and lightness are essential, but otherwise virtually useless.

Between the subminiature and the standard (or double-frame) 35-mm cameras lie the so-called single-frame 35-mm cameras, which produce negatives half as large (18 x 24 mm) as the standard (24 x 36 mm) 35-mm negative. These cameras are somewhat smaller, lighter, cheaper, and usually less versatile than the average standard 35-mm camera.

How to select your camera

I have given significant space to a discussion of the different camera components and designs because it has been my experience that *selection of the right kind of camera is the first condition for success in photography*. To give an analogy: nobody in his right mind who needs a saw would go into a hardware store and simply ask for "a saw" without specifying type and size. There are simply too many varieties: ripsaws, crosscut saws, bucksaws, buzz saws, jigsaws, butcher's saws, big saws, little saws, handsaws, powersaws, saws designed to cut wood, or metal, or plastic, or foam rubber. . . . And the same is true in photography: there are so many kinds of cameras because each was designed for a slightly different purpose. And only if your purpose and the purpose for which your camera was designed coincide will you be able to realize your full potential as a photographer.

Selection of one's camera should be made with consideration of the following factors:

> The type of subject which is to be photographed
> The viewing and focusing system of the camera
> The film size for which the camera is built
> The personality and purpose of the photographer
> The price the photographer is willing to pay

All these factors are, of course, intimately interrelated, each influencing the others. It may even happen that two factors are mutually exclusive. For example, a photographer specializing in landscapes who is a fiend in regard to sharpness and detail of rendition may need a camera to take on a mountain-climbing expedition. The nature of his subject and his own personality would clearly prescribe a camera that takes a large film size, but the circumstances under which the work will be done just as clearly make selection of a small and light camera preferable. In such a case, either the photographer or the photographs will suffer—the photographer, because he must either burden himself with a large and heavy camera, or accept unsatisfactory pictures; the photographs, because they were made with an unsuitable camera, as a result of which they are not as sharp, detailed, and grainless as they might have been. A compromise—use of a medium-size camera—is not much better because, in that event, both the photographer and the photographs are bound to suffer although, perhaps, to a somewhat lesser degree.

The type of subject which is to be photgraphed determines the viewing and focusing system of the camera. In this respect, distinguish between two types of subject:

> *Dynamic subjects*—subjects characterized by movement—require a "fast" that is, relatively small and light —camera which possesses a viewing and focusing system that permits hand-held operation.

> *Static subjects*—primarily inanimate subjects which do not move—can be photographed with any kind of camera although, as a rule, a large format will generally produce the best results.

The viewing and focusing system. As far as speed of operation is con-

cerned, the fastest system is one that incorporates a lens-coupled combination viewfinder-rangefinder, closely followed by the single-lens and twin-lens reflex systems (especially if the first is augmented by an automatic exposure-meter-controlled diaphragm). All three are ideally suited for hand-held operation. The slowest viewing and focusing system (which, however, has other advantages) is that based upon a groundglass panel. Unless they also possess a second finder, groundglass-equipped cameras cannot be hand-held but must be used with a tripod. Other factors which must be considered are:

p. 26

p. 19

The size of the finder image—The rule here is the larger the better, because large ones most clearly show the desirable as well as the undesirable features of the contemplated picture and thereby facilitate composition. Reflex systems and groundglass panels provide large finder images; rangefinder systems, small ones.

Control of sharpness in depth. Single-lens reflex systems and groundglass panels show the extent of the sharply rendered zone in depth (SLRs with automatic diaphragms must be equipped with a depth-preview button for manual diaphragm control); twin-lens reflex systems and viewfinder-rangefinders do not.

pp. 20, 19 *The problem of parallax.* Single-lens reflex systems and groundglass panels are free from parallax; twin-lens reflex systems and rangefinder viewing systems are basically subject to parallax, which makes the so-equipped camera less suitable for close-up photography. However, different kinds of parallax-compensating devices are often built into such cameras, which somewhat ameliorate this disadvantage without completely eliminating it.

Compatibility with different lenses. A groundglass panel is the *only* viewing and focusing device which enables a photgrapher to use the so-equipped camera in conjunction with *any* lens regardless of type and make. Single-lens reflex systems can theoretically be used with any type of lens. However, if the camera is equipped with an automatic diaphragm, only lenses which are compatible with the respective system can be used unless the photographer is prepared to relinquish this feature. Cameras equipped with a lens-coupled rangefinder and twin-lens reflex cameras that provide for interchangeability of lenses accept only lenses that are compatible with the respective make, a fact which may limit the number of available lenses severely.

Visibility. The viewfinder image is continuously visible and bright at all times in cameras equipped with a viewfinder-rangefinder or a twin-lens reflex system. It is always bright but disappears momentarily during the exposure in

single-lens reflex cameras equipped with instant-return mirrors and automatic diaphragms. In single-lens reflex cameras equipped with manually operated mirrors and diaphragms, it turns increasingly darker the more the lens is stopped down and disappears entirely during and following the exposure.

Finder-image visibility is further affected by the construction of the finder eyepiece. Spectacle-wearers in particular should consider that the eyepieces of certain makes of rangefinders and prism-reflex viewing systems may cut off part of the image since eyeglasses may make it impossible to bring the eye close enough to the eyepiece. Other makes, which provide for more eye relief, do not have this fault.

Operational position. Cameras equipped with a viewfinder-rangefinder or a prism-reflex system are held at eye-level during shooting; SLRs without a prism finder and twin-lens reflex cameras are held at waist-level during shooting. Groundglass-panel-equipped cameras require eye-level operation. p. 21
p. 21

The film size for which the camera is built. For our purpose, it is sufficient to distinguish between three sizes: small (35-mm), medium (no. 120 rollfilm), large (4 x 5-inch). Each has specific advantages and drawbacks:

Small (35-mm) film is least expensive per shot and 35-mm cameras have the most capacious film magazines, factors which make 35-mm cameras particularly suited to action and documentary photography where fluid situations make rapid shooting of large numbers of pictures a necessity. High-resolution Kodachrome 25, of which more will be said later, is available only in 35-mm size, which also is the most popular and practical size for slides intended for projection. Working with 35-mm film makes it possible to use superfast and zoom lenses which are available *only* for 35-mm cameras. Six rolls of 35-mm film—material for over 200 shots—take about the same space as two sheets of 4 x 5-inch film in a holder. pp. 51, 56

A serious drawback of 35-mm film is that the sales appeal of the small color slides is very much lower than that of larger transparencies. As a matter of fact, surprisingly large numbers of potential buyers of color photographs refuse even to look at 35-mm color slides, their minimum acceptable size usually being 2 ¼-inch x 2 ¼-inch, with 4 x 5-inch transparencies preferred. This prejudice, of course, does not apply to users of 35-mm color slides intended for projection—lecturers, supervisors of training programs, teachers, hobbyists, and such. Photographers who hope to make some money from their hobby, and particularly those who intend to make photography their career, should take notice of this.

Medium-size film is available in the form of both rollfilm and sheet film, with nos. 120 and 220 rollfilm the most popular sizes for serious work. As far as advantages and drawbacks are concerned, these intermediate sizes stand about halfway between 35-mm and 4 x 5-inch films, making them particularly suitable to photographers with a wide spectrum of photographic interests.

Large (4 x 5-inch) film is quite expensive per shot, and 4 x 5-inch cameras are comparatively large, heavy, and slow in operation. Furthermore, there is no 4 x 5-inch rollfilm (although holders which take no. 120, no. 220, or perforated 70-mm rollfilm, respectively, are available for use with most 4 x 5-inch cameras); the only kind of color film made in this size is sheet film, and sheet film must be loaded into (and unloaded from) holders piece by piece in a darkroom (or at least a dark room). Sheet-film holders are bulky and heavy—half a dozen holders with material for only twelve shots, one-third of the number contained in a single roll of 35-mm film—take almost as much space as an entire 4 x 5-inch camera.

On the positive side, if made by a knowledgeable photographer, 4 x 5-inch negatives and color transparencies by far surpass those of smaller size in every respect: sharpness, richness of color, smoothness of tone, and precision and wealth of detail—qualities which give 4 x 5-inch color transparencies a very high degree of sales appeal. As a matter of fact, I have noticed again and again that a relatively poor 4 x 5-inch transparency will be preferred over a much better 35-mm slide or 2 ¼ x 2 ¼-inch shot, bought by an editor, and printed full-page in a magazine or book. It is primarily for this reason that, in my opinion, as far as color photographs are concerned, the "best" camera is usually the *largest* one that is practicable given the circumstances.

The personality and purpose of the photographer. Photographers differ widely in several respects. Some are casual, others methodical. Some are adventurous and compelled to "see the world," others prefer to work near their homes. Furthermore, there are differences of purpose. Some people are satisfied recording the highlights of their own lives—children, family, special events. Others find in photography a stimulating hobby that permits them to express themselves and, through their pictures, communicate with other people. Still others make their living by photography. Such differences in personality and purpose are, of course, reflected in a photographer's attitude toward his craft and the kind of photographs he intends to take and each calls for a different means of realization.

For example, a photographer who is more interested in capturing the essence

of people, action, and "life" in his photographs than in producing pictures that are above all noteworthy for their photo-technical quality, will only be satisfied—and able to express himself—with a fast and responsive 35-mm camera. Conversely, a slow and deliberate worker with a highly developed sense for technical quality—precision of rendition, beauty of color and tone—will need a relatively large camera to realize his photographic aims (and probably be glad to pay the price in the form of greater weight and bulk and a reduction in operational speed). Also, a camera perfectly suited to the needs of a family man whose purpose is limited to photographing his children on Sundays and taking occasional vacation shots will probably be insufficient in scope for a serious amateur; and one that satisfies an amateur may be too limited or delicate for a professional who shoots fifty times as many pictures. All these factors must, of course, be considered when selecting one's camera because, unless personality, purpose, and photographic means are in harmony, the photographer will be dissatisfied and his pictures fail.

Considerations of this kind may seem obvious, yet I was present when a friend of mine, a master of the 8 x 10-inch view camera, a photographer who is world-famous for his outstanding large-camera work, a superlative craftsman who makes a fetish of precision and tonal quality, fell in love with a 35-mm camera and bought it along with a full line of lenses and accessories. He worked with it for several months, captivated by its precision workmanship, trying in vain to reconcile the exquisite quality of the tool with the technically poor quality of its products. And it took him a surprisingly long time to accept emotionally what intellectually he must have known all the time: that a camera infinitely more complex and precise than his familiar instruments—big 4 x 5s, 5 x 7s, and 8 x 10s—produces photographs that are inferior in every technical respect to those which his comparatively primitive means enabled him to create with such apparent ease.

The lesson is clear, and every photographer should heed it: There are "fast" and "nervous" cameras—the quick and always ready 35s; there are "all-purpose" cameras for "average" temperaments—the no. 120 rollfilm and medium-size sheet-film kind; and there are "slow" and "perfectionistic" cameras—view cameras, 4 x 5s, 5 x 7s, 8 x 10s. And each type is designed not only for a different purpose, but also for a different type of personality, a different kind of photographer. Don't let yourself be sidetracked by the choice of others whose work you respect, or seduced into buying a camera that is not suited to your personality or type of work by glamour and fame. Here, as in all creative work, complete honesty with oneself—knowledge of one's strengths and limitations—is indispensable for success.

The price a photographer is willing to pay. Many photographers believe that, where photographic equipment is concerned, the more they pay, the more they get. Although this may be true under certain circumstances, at other times it is not. Actually, it is possible that a very expensive camera can be totally unsuitable for a particular type of work whereas one designed specifically for the respective task may be relatively cheap. However, what should a photographer do when the best-suited camera is also the most expensive?

I suggest he buy a used camera instead of a new one. I know that this practice is commonly frowned upon, but I have followed it many times and never regretted it. Because advances in photo-technology are so rapid nowadays, photostores are full of "like new" used equipment that sells at considerably reduced prices. Provided one buys at a reputable photostore, where the used merchandise is guaranteed, chances are excellent that a knowledgeable buyer will get himself "a deal." Most photo stores agree to a three-day or more trial period with a "money-back" guarantee should the equipment prove to be defective. Utilizing such offers is the smart man's way of acquiring a fine camera, lens, or other kind of equipment at a relatively low price.

Summary relating camera design and purpose

The first of the two following summaries lists the most important camera qualities numbered from one to fifteen, together with the designs in which they are most strongly pronounced; the second lists twenty different fields of photography, each followed by a series of numbers, each number referring to the respective quality listed in the first summary. By correlating these two summaries and evaluating their contents in the light of the facts provided above, the reader should be able to find the camera best suited to his personality, purpose, and photographic interests.

1. *Fastest lense*—Super-fast lenses with speeds of f/2 and higher are available only for 35-mm cameras.

2. *Flash synchronization*—Between-the-lens shutters are most suitable for synchronization with conventional flashbulbs and electronic flash; focal plane shutters require special Class FP flashbulbs and synchronize with electronic flash only at relatively slow shutter speeds.

3. *Highest shutter speed*—Focal plane shutters are potentially faster than between-the-lens shutters.

4. *Longest telephoto lenses*—The most extreme telephoto lenses with focal lengths of 1000-mm (approximately 40 inches) and more are available only for 35-mm and some 2 ¼ x 2 ¼-inch cameras, all of which must be of the single-lens reflex type (35-mm RF cameras by means of reflex housings).

5. *Parallax*—SLRs and groundglass-panel-equipped cameras are free of parallax; RFs and TLRs are not but usually feature limited parallax compensation devices; a reflex housing transforms a 35-mm RF camera into a parallax-free SLR.

6. *Perspective control*—Swing-equipped view cameras permit most complete perspective control, closely followed by swing-equipped press-type cameras.

7. *Portability and weight*—Considerable differences in weight and bulkiness exist between cameras of similar design that take the same size film. In 35-mm size, most RF cameras are smaller and lighter than SLRs. SLRs are smaller and lighter than most TLRs of the same film size.

8. *Quietness*—Between-the-lens shutters are quieter than focal-plane shutters; TLRs are quieter than SLRs; in the 35-mm size, most RF cameras are quieter than most SLRs.

9. *Sequence shooting*—A few cameras either have built-in battery- or spring-driven motors, or can be used in conjunction with accessory motors.

10. *Sharpness of rendition*—Potentially, 4 x 5-inch and larger cameras are capable of producing the sharpest pictures; next in order are 120 rollfilm cameras in conjunction with fine-grain film and 35-mm cameras with high-resolution Kodachrome film.

11. *Speed of operation*—Fastest design is that of a 35-mm SLR with built-in exposure meter and fully automatic, light meter-coupled diaphragm; RFs are usually somewhat faster than SLRs and TLRs lacking a built-in diaphragm-coupled light meter.

12. *Suitability for close-ups*—Indispensable requirements are freedom from parallax, long extension and, in larger cameras, rear focusing. Suitable camera designs: SLRs and 35-mm RFs with reflex housings in conjunction with extension tubes or auxiliary bellows; for static subjects, groundglass-panel-equipped cameras.

13. *Suitability for telephotography*—SLRs and reflex-housing-equipped

35-mm RFs are best suited; groundglass-panel-equipped cameras if subjects are static.

14. *Suitability for wide-angle photography*—Special wide-angle cameras; SLRs in conjunction with retrofocus wide-angle lenses; 35-mm RF cameras; view cameras equipped with special wide-angle bellows; press-type cameras with drop-bed and recessed lens board.

15. *Widest wide-angle lenses*—180-degree fish-eye lenses for 35-mm cameras; accessory fish-eye lenses which convert most standard lenses of most cameras into 180-degree wide-angle lenses. Goerz Hypergon 130-degree lenses which, however, can only be used in special boxlike 5 x 7- and 8 x 10-inch view cameras; because of their very slow speeds, they are suitable only for photographing static subjects.

List of twenty different fields of photographic activity and kinds of subjects arranged in alphabetical order. The numbers, which refer to the camera qualities cited in the preceding summary, are not necessarily given in order of importance.

Animals: 2, 7, 8, 11, 12, 13.
Architecture: 6, 10, 14.
Close-ups: 5, 12.
Copywork and reproductions: 5, 6, 10, 12.
Fashion: 1, 2, 5, 7, 11.
Food: 5, 6, 10, 12.
General photography: 2, 11, 13, 14.
Glamour and figure photography: 1, 2, 5, 7, 11.
Industrial and technical photography: 2, 5, 6, 10, 11, 12, 14, 15.
Interiors: 2, 5, 6, 10, 14, 15.
Landscapes: 6, 10.
Nature (general): 2, 3, 4, 5, 7, 8, 9, 11, 12, 13.
News and documentary photography: 1, 2, 3, 4, 7, 8, 9, 11.
Objects and works of art: 5, 6, 10, 12.
People (general): 1, 2, 7, 8, 9, 11.
Portraiture: 2, 5, 11.
Sports photography: 1, 2, 3, 7, 9, 11, 13.
Theater and stage photography: 1, 2, 8, 11.
Travel photography: 2, 7, 8, 11.
Wildlife photography: 2, 4, 7, 8, 9, 11, 13.

THE LENS

A recently published survey of interchangeable lenses currently available in the United States for 35-mm and 2 ¼ x 2 ¼-inch cameras—that is, exclusive of lenses designed to cover films of larger sizes—contains over 1,000 entries. No wonder a photographer can get confused when confronted with the problem of selecting the right kind of lens for his camera or choosing an additional interchangeable lens. Fortunately, however, the task of selecting a suitable lens is not as formidable as it might seem because all lenses, regardless of type or make, have certain common characteristics and obey the same optical laws. Furthermore, to make an intelligent choice, a photographer does NOT have to know how a lens produces an image or what such frequently used terms as "node of emission," "chromatic aberration," "coma," and so on mean. For practical purposes, it is sufficient to evaluate a lens on the basis of the three following factors:

> **Lens characteristics**—focal length, speed, etc.
> **Lens performance**—sharpness, color correction, etc.
> **Lens type**—standard, wide-angle, telephoto, etc.

Lens characteristics

Any lens, whether wide-angle, telephoto, or other, has three fundamental characteristics with which a photographer must familiarize himself because they describe what the lens can and cannot do:

> **Focal length**
> **Relative aperture or "speed"**
> **Covering power**

Focal length. *The focal length of a lens determines the size of the image on the film.* Other factors like subject distance and camera position being equal, a lens with a relatively long focal length will render the subject in larger scale than a lens with a shorter focal length. Focal length and image size are directly proportional: a lens with twice the focal length of another produces an image that is twice as high and wide as that produced by a lens of half its focal length. Therefore, if a photograher wishes to increase the scale of rendition without shortening the distance between subject and camera, he must make the picture with a lens of longer focal length.

39

The focal length of a lens, normally engraved on the lens mount, is measured in inches, centimeters, or millimeters. It is the distance from approximately the center* of the lens to the film at which the lens produces a sharp image of an object that is infinitely far away—for example, a star. It is also the shortest distance between lens and film at which the respective lens can produce a sharp image.

Focal length has nothing to do with film size. A lens with a focal length of, say, 6 inches, will render a given subject at a given distance, for example a person 12 feet from the camera, in the same scale no matter whether the lens is used on a 35-mm RF camera, a 2 ¼ x 2 ¼-inch SLR, or an 8 x 10-inch view camera. Naturally, if the lens is used in conjunction with a small film size, only part of the subject might appear in the picture; conversely, if used in conjunction with a very large film size, the lens, unable to cover the entire size, would produce a circular picture in the center of which the image of the subject would appear. But—and this is the important point—no matter whether the subject is shown in its entirety or only in part, whatever is shown would appear in exactly the same scale and, if the various negatives or transparencies were superimposed one upon another, their images would register.

According to their focal lengths, lenses are frequently referred to as standard, short focus, or long focus. Such a classification, however, is relative. A lens that has a *relatively* short focal length when used with one film size has a *relatively* long focal length when used with a *smaller* film size, although its *actual* focal length remains unchanged.

For example, a wide-angle lens that covers an 8 x 10-inch negative may have a focal length of 6 inches (which, obviously, is rather short *relative* to the size of the film). If used on a 4 x 5-inch camera, the same lens, however, would *behave* like a standard lens (because the normal focal length of a standard lens for 4 x 5-inch film is 6 inches), thus making it *in effect* a lens of standard focal length. And if used with a 2 ¼ x 2 ¼-inch SLR camera, the same 6-inch lens that was designed (and still is) as a wide-angle lens, would now *behave* like a long-focus or telephoto lens since the focal length of a standard lens designed for use with 2 ¼ x 2 ¼-inch film is 3 inches. A *standard lens* is customarily defined as a lens with a focal length equal to (or *slightly* shorter or longer than) the diagonal of the film size with which it is to be used.

Relative aperture or "speed." *The relative aperture indicates the maximum*

*More precisely, from the node of emission (which normally lies slightly behind the center of the lens) to the film, when the lens is focused at infinity. In telephoto and retrofocus wide-angle lenses, the node of emission lies outside the lens.

light transmission or "speed" of a lens. It is expressed in the form of a ratio usually engraved on the lens mount: focal length (f) divided by effective lens diameter (which explains why the term includes the word "relative": by themselves, neither focal length nor effective lens diameter can give an indication of the light transmission or "speed" of a lens; only when one is evaluated relative to the other does the result become meaningful). For example, if a lens with a focal length of 6 inches has an effective diameter of ¾ inch, its relative aperture would be 6 : ¾ = 8 and expressed in the familiar form of f/8. However, if a lens of 6-inch focal length has a *larger* effective diameter, say, 2 inches instead of ¾ inch (that is, a higher degree of light transmission), its relative aperture would be 6 : 2 = 3 and expressed as f/3, which, as every photographer knows, designates a much "faster" lens.

To understand how the "speed" of a lens is computed is important because it explains something which often confuses the beginner: the fact that the speed of an f/3 lens is *higher* than that of an f/8 lens although its f-number is *lower*. If two lenses have equal focal lengths but different effective diameters, the f-number of the "faster" lens is always *lower* than that of the "slower" lens because the focal length of the "faster" lens, as shown in the following drawing, can be divided by its (relatively large) effective diameter *fewer* times than the focal length of the "slower" lens can be divided by its (relatively small) effective diameter.

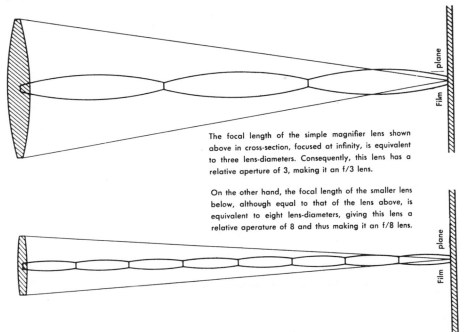

Film plane

The focal length of the simple magnifier lens shown above in cross-section, focused at infinity, is equivalent to three lens-diameters. Consequently, this lens has a relative aperture of 3, making it an f/3 lens.

On the other hand, the focal length of the smaller lens below, although equal to that of the lens above, is equivalent to eight lens-diameters, giving this lens a relative aperature of 8 and thus making it an f/8 lens.

Film plane

Other factors being equal, a fast lens has over a slower one the advantage that it permits a photographer to take the picture at a higher shutter speed. When light conditions are marginal or rapid motion requires an unusually high shutter speed to avoid blur, lens speed can make the difference between a possible and an impossible situation, between a picture "in the bag" and a picture missed. On the other hand, in comparison with slower lenses of equal focal length, fast lenses have certain disadvantages, which will be discussed later.

p. 51

p. 115 *The concept of f-stops.* In practice, for reasons that we shall see below a lens is seldom used at its maximum aperture or "speed." Usually, its effective diameter is reduced to a greater or lesser extent with the aid of a variable aperture called *the diaphragm,* which is built into the lens. Reducing the effective lens diameter by reducing the diaphragm opening is called *stopping down the lens (or the diaphragm).* To enable a photographer to know precisely how far his lens is stopped down (a vital necessity for computing the exposure), the diaphragm is calibrated in f-numbers (usually called *stops*) which are computed by dividing the focal length of the lens by the diameter of the respective diaphragm opening. These f-numbers or stops are figured in such a way that each consecutive f-number requires *twice the exposure of the preceding smaller f-number* (which, of course, represents a *larger* diaphragm opening). In other words, each time the lens is stopped down from one f-number to the next, the film must be exposed twice as long if the result in terms of density and color of the transparency is to remain constant.

F-numbers are indicators of the brightness of the image on the groundglass or film. The same f-number, say f/8, indicates for *most* practical purposes (because there may be slight but normally negligible differences due to manufacturing tolerances or differences in the construction of different lenses) the same degree of image brightness, no matter whether the image is produced by an f/8 lens at maximum aperture ("wide open"), or by a f/1.4 lens stopped down to f/8. Nor does it make any practical difference whether the lens is a tiny wide-angle or a huge telephoto lens. As long as each has a relative aperture of f/8 or, if it is a faster lens, is stopped down to f/8, there is no practical difference as far as image brightness and consequently exposure are concerned.

Covering power. The covering power of a lens determines whether it can or cannot be used with a specific film size. The greater the covering power of a lens, the relatively larger (relative in comparison with the focal length of the lens) the film size it will cover satisfactorily in regard to uniformity of sharpness and brightness.

Most lenses produce a circular image whose quality in regard to sharpness and brightness is not uniform: it is sharpest and brightest near the center, becoming progressively less sharp and bright toward the rim of the circle. This image deterioration is primarily due to three factors: 1) the effects of residual lens aberrations become progressively more pronounced toward the edges of the image. 2) when viewed obliquely, the circular aperture of the diaphragm appears as an ellipse, as a result of which the edges of the film receive less light than the center. 3) the marginal areas of the film are farther away from the center of the lens than the central area and, in accordance with the inverse-square law, receive proportionally less light.

For photographic purposes, of course, only the inner, relatively sharp and bright part of the circular image produced by the lens should be used. Consequently, the film size must always fit within the useful inner part of the circle, the diameter of which must never be smaller than the diagonal of the negative or transparency.

Although most long-focus lenses cover larger film areas than short-focus lenses and therefore will cover larger film sizes, this is not always true. For example, the covering power of most 135-mm telephoto lenses designed for use with 35-mm cameras is sufficient only to cover satisfactorily the tiny 1 x 1½-inch area of 35-mm film, whereas several 90-mm wide-angle lenses exist that cover the much larger size of 4 x 5 inches. The ultimate in covering power is the 75-mm-(3-inch) Goerz Hypergon wide-angle lens, which will cover the relatively enormous film size of 8 x 10 inches.

The covering power of most lenses is barely sufficient to cover satisfactorily the film size for which they are designed. While this is acceptable as long as such lenses are used in cameras without independent front and back adjustments (the swings, slides, and tilts necessary for complete perspective control), lenses that are to be used in cameras that have such adjustments must have greater-than-average covering power. Otherwise, use of these adjustments may cause part of the film to be outside the sharply covered circle, with the result that this part will be rendered unsharp in addition to being underexposed or even blank. To avoid this, experienced photographers, instead of using a standard lens designed for the respective film size, *use a wide-angle lens of equal focal length designed to cover the next-larger film size*. For example, with a 4 x 5-inch view camera, instead of using the regular 6-inch standard lens, they use a 6-inch wide-angle lens designed to cover 5 x 7-inch film—the next-larger size. The focal length of both lenses would be identical—producing images of identical scale—but the additional covering power of the 6-inch wide-angle

pp. 336, 341

43

lens would enable the photographer to make fullest use of the swings, slides, and tilts of his view camera without inviting trouble.

The covering power of a lens is not an unalterable factor. *It increases in direct proportion to increases in the distance between lens and film.* This phenomenon can advantageously be utilized in the making of close-up photographs in near-natural, natural, and more-than-natural size. Should the available focusing range of a camera be insufficient to allow the necessary lens-to-film distance required for such close-ups with a lens of standard focal length, the problem may be solved by using a lens with a shorter focal length. With a 4 x 5-inch camera, lenses of 2 to 5 inches in focal length are particularly useful for close-up photography. As a matter of fact, a lens with a focal length of only one inch, originally designed to cover nothing larger than a 16-mm motion-picture frame, will sharply cover a 4 x 5-inch film at a distance of 10 inches from the film and, under these conditions, produce an image nine times natural size.

The covering power of many lenses increases somewhat as the diaphragm is stopped down. In a few lenses (for example, the Goerz Dagor), this increase is so great that the fully stopped down lens will cover a film one size larger than the size it covers at full aperture, making such lenses particularly suitable for use with swing-equipped view cameras.

Lens performance

Any ordinary magnifying glass or positive spectacle lens will produce an image and could be used to make a photograph, but the quality of the rendition would be extremely poor: it would be fuzzy, distorted, and infested with color fringes. Only a properly corrected photographic lens can produce pictures that are sharp, undistorted, and free from color fringes.

Correcting a lens means reducing, as far as practicable, the seven basic faults inherent in any lens (the so-called aberrations: spherical and chromatic aberration, astigmatism, coma, curvature of field, distortion, diffraction). To achive this, lens designers use combinations of individual lens-elements consisting of different types of glass with different refractive indices and different curvatures, which may be either cemented together or separated from one another by air spaces, to form an optical system—the lens—which combines a maximum of desirable qualities such as sharpness, high degree of color correction, "speed," wide angle of view, and so forth with a price tag which is still within the means of a large number of photographers.

Lens performance is directly related to lens design. Unfortunately, it is impossible to design a "perfect" lens, a lens that is completely free from aberrations. Nor is it practicable to design a lens which combines *all* the desirable qualities to the highest degree; this is the reason why, at least for the present, a high-speed lens at maximum aperture is never as sharp as a good lens of somewhat lower "speed," nor a wide-angle lens as free from distortion as a standard lens which includes a lesser angle of view. Nevertheless, lenses of remarkably high performance belonging to any one of the different categories (of which we will hear more later) exist today; but at the cost of fantastic p. 51 complexity, extraordinarily high manufacturing standards, and, as any photographer knows, a whopping price.

For practical purposes, the performance of any lens is determined by five factors:

> The degree of **sharpness**
> The degree of **color correction**
> The degree of **flare and fog**
> The evenness of **light distribution**
> The degree of **distortion**

Sharpness. A len's sharpness depends on the degree to which its designer was able to reduce the five aberrations which combine to cause unsharpness: spherical and chromatic aberration, curvature of field, astigmatism, and coma. Each of these faults manifests itself in a specific type of unsharpness, and since each has to be corrected separately—often with varying success—different lenses may produce pictures not only with different *degrees* but with different *kinds* of sharpness (or rather, unsharpness, because if examined under sufficient magnification, not even the sharpest negative or color transparency will be found to be equally sharp over its entire area).

Furthermore, lenses designed for use with different film sizes are computed in accordance with different standards for the obvious reason that small negatives and transparencies, because they must be able to stand higher degrees of magnification, have to be sharper than large ones. As a result, lenses intended for use with 35-mm cameras have, on the average, twice the resolving power of lenses intended for use with larger cameras, which explains why, normally, it is undesirable to use large-camera lenses for small-film photography.

To pick a sharp lens, a photographer does not have to know why certain aberrations cause certain types of unsharpness; he need only know the following:

45

It is more difficult to bring the light rays that pass through the peripheral areas of a lens into sharp focus than those that pass through areas closer to the optical axis. This has several practical consequences:

High-speed lenses (which, relative to their focal lengths, have large diameters and therefore make use of a large proportion of peripheral rays for the production of the image), if used at maximum aperture, generally yield pictures that are less sharp than those made by lenses of lower speed (which, relative to their focal lengths, have smaller diameters and therefore use mainly rays that pass closer to the optical axis for the production of the image). Photographers who are primarily interested in sharpness should therefore stay away from high-speed lenses and select instead a good lens of somewhat lower speed.

Stopping down a lens cuts off the peripheral rays that are the main spoilers of sharpness. As a result, the same lens, stopped down two to four stops beyond its maximum aperture, will as a rule (there are exceptions, as we shall see) produce sharper pictures than if used at a larger aperture. However, excessive stopping down will again cause deterioration of image sharpness, this time partly for reasons of lens design and partly because of diffraction, as light rays bend at the edges of the diaphragm aperture.

The sharpest lenses (the so-called process lenses used in copywork and photo-engraving) are always relatively slow because, in the interest of maximum sharpness (as well as smaller size, weight reduction, and lower cost), their peripheral areas have, so to speak, already been removed during designing, with the result that the finished lens consists only of a "central area" (equivalent to the area that would remain active had a faster lens of equal focal length been stopped down to the relative aperture of the process lens). Since such lenses yield maximum sharpness at maximum apertures, stopping down will not increase the sharpness of the image although, if three-dimensional subjects are photographed, it will increase the extent of the sharply covered zone in depth.

Curvature of field is the most common cause of unsharpness in modern lenses. It is particularly prevalent in most high-speed lenses and manifests itself in the form of an image that is not flat (like the plane of the film), but concave—three-dimensionally curved like the inside of a saucer. Lenses suffering from this fault do not have what is called a "flat field" (in contrast to process lenses, which are designed especially to photograph flat subjects). In practice, curvature of field is most noticeable in photographs of flat subjects

(for example, a lens test chart or a brick wall) but—and this is important—it is much less obvious, and may even be entirely unnoticeable, in pictures of subjects that have depth. Photographers not familiar with this fact frequently reject otherwise fine lenses because they perform poorly when subjected to the traditional test: a photograph of a brick wall or a page of newsprint. The *practical* value of such lenses, however, is determined by the degree of sharpness in the center of the image at full lens aperture (the sharper the better), the amount of stopping down (the less the better) needed to produce even distribution of sharpness, and the degree of sharpness of the image made by the lens moderately stopped down.

Different types of lenses may reach their maximum sharpness at different subject distances. Lenses intended for general photography, for example, are computed to yield maximum sharpness at "average" distances of 10 to 50 feet. Lenses for aerial cameras are corrected for maximum sharpness when focused at infinity. Process lenses—lenses specifically designed for near-distance reproduction work and photo-engraving—are computed to produce maximum sharpness at distances of a few feet. And special close-up lenses—the true macro-lenses like the Carl Zeiss Luminars—are corrected to give their best performances at subject distances measured in inches.

Color correction. Light of different color is not uniformly refracted by glass. As a result, a simple lens—for example, a positive spectacle lens or a magnifier—would produce pictures that look like badly printed four-color reproductions that are out of register: each line and contour of the subject would be surrounded by color fringes due to the fact that *different* colors located at the *same* distance in front of the lens are brought into focus at *different* distances behind the lens. As a result, those colors that are out of focus would *not* appear, say in the form of sharply outlined dots and lines, but as fuzzy disks and bands, and the parts of the subject that are white (which is a mixture of all colors) would be edged by colorful fringes.

Adequate color correction is therefore one of the prime requisites for any lens and especially for lenses intended for use in color photography. Nowadays, all except some simple box camera lenses are color-corrected to some extent, the degree varying with the design of the lens and its price. Basically, however, as far as color correction is concerned, two types of lenses must be distinguished:

Achromatic lenses, the group to which the majority of modern lenses belong,

are corrected to bring *two* colors (usually blue and green) into sharp focus and perform satisfactorily for all average photographic purposes.

Apochromatic lenses are corrected to bring *three* colors (blue, green, red) into sharp focus and are therefore superior to achromats as far as color rendition is concerned. They are designed specifically for the most critical color work—top quality color photography for high-grade reproduction, the making of color enlargements from color negatives, color separations, and photo-engraving—but are available only in a limited number of makes and focal lengths, most of which are designed for use with relatively large cameras.

Flare and fog. Not all the incident light that strikes a lens reaches the film in the form of an image. Some of it is reflected by the surfaces of the lens elements, the inside of the lens mount, or internal parts of the camera, bounced back and forth and reflected again until it falls upon the film in the form of flare and fog.

Flare manifests itself as dark spots in the negative or light spots in the transparency which can have almost any form and size but are most often circular, fan- or crescentlike, or repeating the shape of the diaphragm aperture.

Fog is flare that has been scattered so thoroughly that it arrives at the film plane in the form of an overall haze. Its effect upon the picture is that of an overall degradation of color combined with a reduction in contrast, similar to that caused by overexposure.

Although lens coating has considerably reduced the incidence of flare and fog, and use of an efficient lens shade can further reduce the likelihood of their appearance, these faults still prevail to various degrees in modern high-speed (and other types of) lenses and may be particularly annoying when shooting high-contrast subjects or taking pictures against the light. Lenses with a more-than-average number of glass-to-air surfaces are particularly prone to flare and fog, but only tests can reveal which one of several lenses similar in regard to speed and focal length but different in construction is least affected by this annoyance.

Evenness of light distribution. Uneven exposure—resulting in negatives that are darker and color transparencies that are lighter in the center than around the edges—can be due to one of two factors:

Because the edges and corners of the film are farther away from the lens than the center, in accordance with the inverse square law, the marginal areas of

the film receive less light than the central parts and consequently appear darker. This kind of illumination fall-off, which is inherent in any lens but normally insignificant in lenses with standard or longer focal lengths, is a common fault of many wide-angle lenses, although some possess it to a more pronounced degree than others. Only a test can reveal the seriousness of this affliction, which generally is the more pronounced, the wider the angle encompassed by the lens. Illumination fall-off reaches a high point in the Goerz Hypergon wide-angle lenses, which cover angles of view of up to 130 degrees, creating an unevenness so pronounced that these lenses had to be equipped with a star-shaped spinner driven by an air pump. Mounted over the center of the lens, the function of this spinner is to keep the light off the center of the film during part of the exposure to give the edges sufficient exposure without overexposing the center.

The second cause of uneven light distribution at the film plane is vignetting, which is usually caused by a badly designed lens mount that prevents the corners of the film from receiving their full share of light. Vignetting is most often found in lenses with long and narrow, tubelike mounts, particularly telephoto and certain kinds of old-fashioned lenses, but can also occur if a lens is used in conjunction with a camera for which it was not designed.

Whereas unevenness of light distribution is usually only a minor annoyance to a black-and-white photographer, who can correct this fault by dodging his prints during enlarging, it should be a matter of concern to the color photographer, who works with reversal-type color films; having no recourse to corrective methods like dodging, he usually is better off leaving lenses with pronounced illumination fall-off alone.

Distortion. There are four distinct and unrelated types of distortion:

Perspective distortion. Familiar examples are noses that appear unproportionally big in portraits, or hands that loom toward the camera. This kind of distortion—more precisely: exaggerated perspective—is not caused by any fault of the lens, but is the fault of the photographer, who took his picture with the wrong type of lens from a subject distance which, under the circumstances, was too short to produce a natural-appearing impression. In all such instances it will be found that the picture had been made with a lens of relatively short focal length—most commonly a wide-angle lens—a fact which has led to the erroneous conclusion that "all wide-angle lenses distort." What actually happened was that the photographer, in an attempt to compensate for the relatively small scale of the image produced by the short-focus lens, went too

close to his subject. Had he instead made the same shot with a lens of longer focal length from a correspondingly greater distance, he would have gotten more or less the same view in the same scale but in a natural-appearing perspective. More will be said about this later.

p. 344

Unnatural elongation of actually spherical or cylindrical objects that appear near the edge of the picture in shots taken with extreme wide-angle lenses, although a form of "distortion," is not the result of any "lens fault," but is the natural consequence of projecting a three-dimensional object obliquely into a flat surface, the film; see the following illustration.

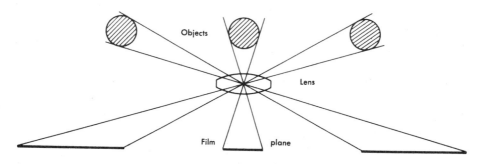

Again, a wrongly used wide-angle lens is blamed for a phenomenon that is not due to a lens fault but stems from bad judgment on the part of the photographer, who should have arranged his subject differently, taken the picture from a different point of view, or used a lens with a longer focal length.

Barrel and pincushion distortion are the only forms of distortion that result from inherent faults of the lens. They manifest themselves by rendering actually straight lines as curves, an effect that becomes more pronounced with increasing distance of the image of the straight line from the center of the picture (where straight lines are rendered straight). If barrel distortion is present, a lens will make a square's sides appear to bulge; in the case of pincushion distortion, the same sides will appear to curve inward.

Barrel and pincushion distortion are faults most often found in wide-angle and zoom lenses. They make the so-afflicted lenses unsuitable to architectural, interior, and commercial photography, in cases where straight lines must be rendered straight, but not to general photography because, in the absence of straight lines, the distortion effect goes unnoticed.

The curving of actually straight lines, which is typical of spherical and
p. 346 cylindrical perspective (of which more will be said later), is another type of

distortion not attributable to a lens fault since the responsible lenses or optical systems were deliberately designed to produce this kind of perspective.

Lens type

As in camera selection, the most important quality of a lens is *suitability*. Neither "speed" nor appearance, brand name nor price, is of the slightest value if a lens is unsuited to the type of work it must do. The following survey, which classifies lenses in terms of purpose, shows the reader what different types of lenses can do and should help him determine his needs.

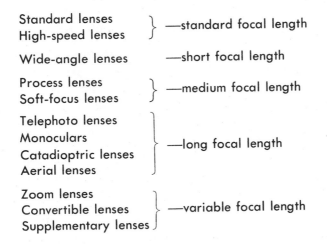

Standard lenses High-speed lenses	—standard focal length
Wide-angle lenses	—short focal length
Process lenses Soft-focus lenses	—medium focal length
Telephoto lenses Monoculars Catadioptric lenses Aerial lenses	—long focal length
Zoom lenses Convertible lenses Supplementary lenses	—variable focal length

Standard lenses have a focal length more or less equal to the diagonal of the film size for which they are designed, fairly high speeds ranging from f/2 and f/2.8 (35-mm and 2. ¼ x 2 ¼-inch cameras, respectively) to f/5.6 and lower (4 x 5-inch cameras and larger), and moderate covering power encompassing angles from approximately 45 to 60 degrees. They represent the best practicable compromise between sharpness, speed, and covering power and produce pictures that in regard to angle of view and perspective approximate most closely the impression received by the eye at the moment of exposure.

A standard lens is the first lens which a photographer who buys a camera that features lens interchangeability should acquire because it is the lens most suitable to a wide range of different tasks.

High-speed lenses are superior to standard lenses in terms of speed, similar in focal length, but often inferior in regard to sharpness and covering power;

they are also bigger, heavier, more expensive, and more prone to flare and fog. True high-speed lenses are commercially available only for 35-mm cameras and have relative apertures that range from f/0.95 to f/1.8.

Whereas standard lenses represent a compromise in order to combine in one design as many desirable qualities as possible, high-speed lenses are designed with only one objective in mind: speed. To attain this goal, other useful lens qualities must be sacrificed to a higher or lesser degree, as a result of which high-speed lenses are unsuited to general photography. On the other hand, their two outstanding qualities—unsurpassed speed and extremely shallow depth of field at maximum apertures—make them valuable tools in the hands of creative photographers when light conditions are marginal or it is desirable to keep the sharply covered zone in depth very shallow.

Wide-angle lenses have more covering power than standard lenses. They are subject to distortion and suffer to a greater or lesser degree from illumination fall-off toward the edges of the picture (uneven light distribution at the film plane). Like high-speed lenses, they are designed with one prime objective in mind, in this case covering power, with angles of view ranging from approximately 60 to 100 degrees. The ultimate are the Zeiss Ikon 35-mm Ultrawide camera equipped with a 15-mm f/8 Hologon lens covering an angle of 110 degrees, and the Goerz Hypergon lenses for 5 x 7 and 8 x 10 inch view cameras covering 130 degrees.

p. 334 Distinguish between two types of wide-angle lenses: ordinary wide-angles which produce pictures in which perspective is rectilinear—that is, actually straight lines are rendered straight (not counting any curving due to possible distortion); and "fish-eye lenses"—super-wide-angle lenses covering an angle of view of 180 degrees—which produce pictures in which perspective is p. 347 spherical—that is, actually straight lines are rendered in the form of curves.

In my opinion, wide-angle lenses are more difficult to use than any other lens type and, unless special considerations prevail, I would make a wide-angle lens the third in order of acquisition for use with a camera that features lens interchangeability, after the telephoto and high-speed lens. Nevertheless, it nowadays is a common practice among documentary photographers to shoot the majority of candid pictures of people with a moderate wide-angle instead of a standard lens. They reason that, equality of f-stops provided, a wide-angle lens produces more sharpness in depth than a lens of standard focal length. However, this is true only as long as the two comparision pictures are made at the same subject distance. In that event, of course, the wide-angle,

because of its shorter focal length, produces an image in smaller scale than the standard lens. In other words, a gain on one side—additional sharpness in depth—is offset by a loss on the other side—smaller image size—a loss for which the photographer usually tries to compensate by approaching his subject more closely. Unfortunately, this practice, although it will increase the image size, invariably causes the subject to be rendered in more or less distorted form—the inevitable price that has to be paid whenever the distance between the subject and a lens with a wider-than-average angle of view becomes too short. To avoid such unsightly effects, I recommend that wide-angle lenses be used for only two reasons: when circumstances make it impossible to include in the picture a sufficiently large angle of view with a standard lens; or when the typical "wide-angle distortion effect" is deliberately desired for extra emphasis.

Process lenses are designed with only one goal in mind: sharpness. They are usually apochromats computed for near-distance photography and are characterized by the possession of a particularly flat field, resulting in uniform distribution of sharpness at full aperture over the entire film area; less than average covering power and therefore longer than average focal lengths; and lower than average speeds with maximum relative apertures of f/9.

True process lenses (but not apochromats) are available only for 4 x 5-inch and larger cameras. They are unsurpassed for making reproductions of two-dimensional objects and, if slow speed is no objection, superbly suited to commercial photography, particularly in color and, if cameras with sufficient bellows extension are used, to close-up photography.

Soft-focus lenses are highly specialized lenses of very limited usefulness. They produce pictures which are neither sharp nor unsharp in the ordinary sense of the word—subject detail seems to consist of a fairly sharp nucleus surrounded by a halo of unsharpness. This effect increases with increasing subject contrast and is particularly pronounced (and can be very beautiful) in backlighted shots.

This is an "old-fashioned" type of lens which, nevertheless, still ranks high with certain pictorialists and portrait photographers of women. Only a few such lenses are still being produced. However, similar effects can be achieved with the aid of supplementary soft-focus lenses and disks which, used in front of a standard lens, temporarily convert it into a soft-focus lens. Used on low-contrast subjects and in the hand of a tyro, soft-focus lenses and devices are an invitation to disaster.

Telephoto lenses, used from the same camera position, produce images in larger scale than standard lenses designed for the same film size, but include, of course, correspondingly smaller angles of view. They are long-focus lenses of unique design which, unlike ordinary long-focus lenses, when focused at infinity, require less extension between lens and film than their focal lengths indicate. For example, an ordinary lens of, say 32 cm focal length, when focused at infinity, requires a camera extension of approximately 32 cm, whereas a telephoto lens of the same focal length, say a Zeiss Tele-Tessar with a focal length of 32 cm, when focused at infinity, requires an extension of only 20 cm. This compactness clearly gives telephoto lenses a valuable practical advantage over ordinary lenses of comparable focal lengths (which, from the same camera position, would produce images in the same scale).

Telephoto lenses are used when distances between subject and camera are so great that a standard lens would render the subject too small, or when the special effect of the characteristic telephoto perspective is desired. Moderate telephoto lenses are particularly well suited to portrait photography. Extreme telephoto lenses are difficult to use successfully because atmospheric haze (which turns colorful subjects into blue monochromes) and thermal disturbances (the heat waves that turn static subjects into wobbly apparitions) limit conditions under which sharp pictures can be obtained at the great distances at which these lenses are commonly used.

Binoculars, monoculars, and prism scopes can be used in conjunction with almost any 35-mm or 2 ¼ x 2 ¼-inch SLR and TLR camera, including those with leaf-type shutters and nonremovable lenses, to produce pictures in greatly and even enormously enlarged scale. Although some monoculars and scopes screw directly into the front thread of the standard lens of an SLR 35-mm camera or attach to the camera's lens mount, most instruments have to be connected to the respective camera with the aid of special adapters or mounts. Distinguish between two methods of use:

Monophotography. The photograph is taken using only the monocular or scope. Since this necessitates removal of the camera lens and focusing through the monocular or scope, only focal-plane shutter-equipped single-lens reflex cameras featuring lens interchangeability can be used. The image is focused directly on the groundglass of the SLR (a split-image viewfinder or microprism focusing screen cannot be used since, because of the high focal length values involved they would black out. A clear center spot with cross-hairs is best). In comparison to binophotography, monophotography has the following advantages:

54

The setup is simpler, more rigid, less cumbersome, and faster to assemble and take down. Since the monocular or scope is directly connected to the camera body via an adapter tube, no special adjustment for accurate alignment is necessary. The optical quality of the pictures is better and vignetting unlikely to occur with even the most extreme focal lengths.

Binophotography. The photograph is taken using both the regular camera lens and a binocular, monocular, or scope. This method permits the use of a much wider variety of equipment, including twin-lens reflex cameras and cameras with nonremovable lenses but, in comparison with monophotography, has the following disadvantages:

Picture quality is inferior in terms of sharpness and shows increased illumination fall-off toward the edges of the film; generally, a high degree of vignetting occurs, which may result in almost circular images, considerably reducing the available film area; relatively clumsy adapter mounts are required to connect camera and instrument, which furthermore must be carefully aligned each time before the setup can be used.

Although any binocular, monocular, or prism scope is adaptable to this kind of telephotography, best results are always achieved if instruments specifically designed for photographic purposes are used. But even then, quality of the pictures in regard to sharpness and uniformity of illumination will generally be found to be inferior to that of photographs taken with true telephoto lenses of equal focal lengths. The best that can be said for these instruments is that they permit a photographer to enjoy the practice of telephotography with relative ease at reasonable cost and produce pictures in 15 to 60 times larger scale than those made by his standard lens.

Catadioptric lenses are mixed lens-mirror systems built according to the principle of the reflecting telescope and employing a parabolic mirror as the main component of their design. "Cat" systems, as they are also called, are practicable only in focal lengths of 500 mm and longer, a range in which they have over true telephoto lenses of comparable focal lengths the advantages that they are much more compact, weigh only a fraction as much, and are almost completely color corrected. Unfortunately, these advantages are partly offset by some serious drawbacks, the main one being that cat systems preclude the use of a diaphragm. As a result, catadioptric lenses cannot be stopped down but must always be used at full aperture. The consequences, of course, are that the sharply covered zone in depth is always very shallow and exposures can be regulated only by changing the shutter speed; in cases in

p. 69

which the fastest available shutter speed is still too slow for a correct exposure, the light transmission of the system can be reduced by several stops with the aid of appropriate neutral density filters supplied by the manufacturer. A further disadvantage is that out-of-focus images of dots of light—sun-glittering water or street lights at night—will be rendered not in the usual form of disks or stars, but in the form of bright rings that look like miniature doughnuts, an effect that can be disconcerting.

The main advantages of cat systems are lightness and portability plus the fact that, in conjunction with magnifying eyepieces, enormous degrees of magnification can be achieved. (For example, the Questar, probably the best known of all catadioptric systems, has a focal length of 7 feet compressed by optical folding into a tube only 8 inches long, yet weighs less than 7 pounds. In conjunction with 80x eyepiece projection, magnification equivalent to a focal length of 31 feet (!) can be achieved; on this scale, the moon would be 2 feet in diameter.) Whether or not the advantages of cat systems over true telephoto lenses outweigh their drawbacks is, of course, something each photographer must decide for himself.

Aerial lenses. Although photographs from the air can be made with any good standard and many wide-angle lenses, special aerial cameras are usually equipped with special aerial lenses. These, of course, should be the choice of the aerial photographer. However, surplus aerial lenses are sometimes advertised in amateur photo magazines, and I am frequently asked whether such lenses, which are usually offered at bargain prices, can be used for portrait, close-up, and other types of nonaerial photography.

My answer is a qualified no. Although a few aerial lenses with relatively short focal lengths have been adapted successfully to portrait photography with large cameras, most aerial lenses have drawbacks which make them unsuitable to general photography. They are usually too heavy to be truly "portable" and too big to fit into conventional leaf-type shutters (and can therefore be used only in focal-plane shutter equipped cameras). They are computed for maximum sharpness at infinity and usually perform badly at near-distances. Many suffer from severe chromatic aberration and are therefore useless for color photography. And most are designed for use in conjunction with a deep red filter and corrected accordingly, which means that without such a filter they are not very sharp.

Zoom lenses are complex optical systems with variable focal lengths which, within the limits of their minimum and maximum focal lengths, provide an

infinite number of intermediary focal lengths. Depending on the design, the longest available focal length is 2, 3, and, exceptionally, even 4 times as long as the shortest. Changing focal length—zooming—is done either by sliding or rotating a collar that forms part of the lens mount, an operation during which the image should stay in focus no matter what the focal length. Unfortunately, however, this is not necessarily the case with all zoom lenses, a few of which require a certain amount of focus adjustment after the focal length has been set. Advantages of zoom lenses are that they provide within one unit the equivalent of *several* lenses, thus saving the photographer both space, weight, money, and the time required to switch from one lens to another; they also enable him to study his subject from the same camera position in many different scales and forms of cropping simply by sliding a collar or turning a ring. However, there are drawbacks: zoom lenses can be used only on single-lens reflex cameras and, at the time of writing, are available only for 35-mm SLRs. They are rather heavy, clumsy, and long, which means that even if a photographer wishes to use a standard focal-length effect, he must make the picture with a lens as big and heavy as a medium-size telephoto lens. In addition, zoom lenses are generally not quite as sharp as standard and true telephoto lenses of equal focal length, and most of them are, at least at certain settings, subject to distortion—that is, actually straight lines that appear near the margins of the picture will be rendered slightly curved.

Convertible lenses represent an "old-fashioned" lens type which, depending on the design, combines within one unit two or three different focal lengths. This has been achieved by separately correcting each of the two lens elements: if the convertible lens is of symmetrical design (that is, if front and rear elements are identical), its front and rear elements each have twice the focal length and one-quarter the speed of the complete system. If the two elements are asymmetrical, they have different focal lengths as well as speeds, as a result of which such a lens combines three focal lengths within one unit.

Disadvantages of convertible lenses are that they can be used only in conjunction with groundglass-panel-equipped or single-lens reflex cameras; that, in order to produce acceptably sharp pictures, they require a considerable amount of stopping down; and that the "speed" of the individual elements is always very slow. They are designed for use with 4 x 5-inch and larger cameras and, by modern standards, are obsolete.

Supplementary lenses are designed for use in conjunction with regular lenses, primarily for the purpose of changing their focal lengths (and, inciden-

tally, also speeds) and have the following attractive features: at only a fraction of the cost of an additional and different lens, a photographer can acquire what in effect (and in many respects) amounts to a second lens with different characteristics; users of cameras with fixed lenses (including TRLs) can, to a certain extent, enjoy the advantages which cameras that feature lens interchangeability provide; in addition to being money-savers, they also save space and weight. But supplementary lenses also have disadvantages: in comparison with regular lenses, they produce pictures that are generally less sharp and subject to illumination fall-off toward the edges; in addition, supplementary lenses that *increase the focal length* of the regular lens also *reduce its speed* (at any diaphragm setting) in accordance with the inverse-square law. On the other hand, supplementary lenses that reduce the focal length of the regular lens simultaneously increase its speed; however, in the case of close-ups (the most common purpose to which positive supplementary lenses are put), such gains can be neglected in computing the exposure because they are offset by p. 128 an equal loss due to the distance factor, by which the light-meter-derived exposure must be increased. Distinguish between the following types of supplementary lenses:

Supplementary lenses designed to be used in front of the regular lens (preferably a lens of standard focal length). Their purpose is to alter the focal length of the lens: a positive supplementary lens shortens, and a negative one increases, the focal length of the regular lens. Whereas positive supplementary lenses can be used in conjunction with any camera, negative supplementary lenses can be used only with cameras that have sufficiently long extensions or permit the use of extension tubes or auxiliary bellows. For twin-lens reflex cameras, matched sets of positive supplementary lenses are available for close-ups which provide for parallax compensation by means of a wedge built into the supplementary lens intended for the camera's finder lens. Positive supplementary lenses enable a photographer to adapt any camera to close-up photography within certain limits; negative supplementary lenses, in conjunction with sufficient lens-to-film extension permit adaption to telephotography. Instructions for use, including exposure calculation, commonly accompany each supplementary lens.

Focal length extenders (or tele converters) are negative supplementary lens systems that fit between the camera body and the regular lens, increasing the focal length of the regular lens by a factor which, depending on the extender, ranges from 1.85 to 3. Unlike the negative supplementary lenses that attach to the front of the regular lens, tele converters don't require

additional extension and can therefore be used in conjunction with any 35-mm single-lens reflex camera (but not others) that provides for lens interchangeability. Simultaneously with any increase in focal length, of course, a corresponding decrease in lens speed (at any diaphragm stop) takes place. For example, a 135-mm telephoto lens in conjunction with a 2x converter acquires an effective focal length of 135 x 2 = 270 mm; unfortunately, its f-number must also be multiplied by the converter factor and, if it is an f/5.6 lens, would in effect turn into an 5.6 x 2 = f/11.2 lens that is, a lens of only one-quarter its former speed.

Tele converters come in a variety of qualities that range from poor to remarkably good although, even under the best conditions, the combination of regular lens and tele converter produces pictures which in regard to phototechnical quality are never quite as good as those made with a good telephoto lens of equal focal length. They work best in conjunction with lenses of 135-mm focal length and over, except in certain instances of portrait photography where the increased softness and sharpness fall-off toward the edges of the picture, which seems to occur whether tele converters are combined with lenses of standard focal lengths, might occasionally enhance the effect of the picture. Tele converters are also available for use in conjunction with lenses equipped with an automatic diaphragm, permitting a photographer to retain use of this valuable feature when working with this type of supplementary lens.

If extreme focal lengths are required, two tele extenders can be used simultaneously in tandem arrangement. But image quality will deteriorate even further while exposure times increase by leaps and bounds. For example, if two 2x extenders are used together, to arrive at the correct exposure the photographer must divide the ASA number of his film by (2x2) x (2x2) or 16; if a 2x and a 3x extender are used simultaneously, by (2x2) x (3x3) or 36; and if two 3x extenders are used in combination, by (3x3) x (3x3) or 81. However, such losses may well be worth his while, for the attainable degrees of magnification are staggering: in conjunction with two 2x extenders, a 200-mm telephoto lens acquires an effective focal length of 800 mm; if one 2x and one 3x extender are used, it becomes the equivalent of a 1200-mm lens and, with two 3x extenders, 1800-mm. Whether the resulting picture quality makes such magnification practicable depends on several factors: the quality of the regular lens; the quality of the tele extenders; how well lens and extenders work in combination (some extenders work well with certain lenses, perform poorly with others); how still the camera is held during exposure; and

finally, how good "seeing" conditions are—that is, whether or not thermal disturbances make it impossible to achieve sharp pictures no matter how favorable all other conditions may be.

Supplementary fish-eye lenses are now available for use in conjunction with all standard lenses to which they can be fitted, including those of 4 x 5-inch and larger cameras. They convert the so-equipped regular lens into a fish-eye lens, which covers an angle of view of 180 degrees and produces pictures in which perspective is spherical.

p. 347

Soft-focus supplementary lenses, disks, or devices convert a regular lens temporarily into a soft-focus lens without altering its focal length or speed. They must be fitted to the front of the regular lens and are available in several different designs for slightly different effects. The limitations and dangers of soft-focus renditions have already been discussed.

p. 53

LENS SHADE

Ideally, only light reflected by the subject or emitted by a source within the field of view of the lens should fall upon the lens and produce the picture. All other light is potentially dangerous as a source of lens-flare and fog and it should be kept from striking the lens by a lens shade.

To be effective, a lens shade must be long enough to shield the lens from unwanted light (most lens shades are too short for this purpose); on the other hand, it must not be so long that it cuts off part of the picture. To be practical, it must permit use of a color filter. Some lenses, especially the more expensive telephoto lenses, have built-in lens shades. Advances in lens-coating, of course, have greatly reduced the need for a lens shade and in many cases limited its usefulness to that of a protector against raindrops, snowflakes, and fingerprints.

CABLE RELEASE

Movement of the camera during the exposure is one of the most common causes of unsharp pictures. To avoid movement, exposures longer than 1/25 sec. should be made with the camera mounted on a tripod or supported by another firm base. However, in conjunction with relatively long exposures, even when the camera is firmly supported unsharp pictures can result if it is accidentally jarred when the shutter release button is pressed. This can be avoided if a cable release is used to operate the shutter.

LIGHT (EXPOSURE) METER

A prerequisite for technical excellency is a correctly exposed negative or color transparency. To make an exposure by guesswork or experience is *not* a mark of a seasoned photographer but an evidence of foolishness. The human eye is not a good instrument for measuring light intensities. It adapts so quickly and automatically to small changes in brightness that they usually pass unnoticed. Professional photographers are aware of this and use exposure meters. They cannot afford to miss an exposure. Amateurs will do well to follow their example.

Exposure tables, guides, or charts don't measure light intensities. They interpret light conditions in terms of everyday experience. They are reliable only within the limits of their applicability. Because of their simplicity, they are often more useful to the beginner than an exposure meter which is much more accurate but also more difficult to use. Exposure charts are included with every package of film.

Extinction-type exposure meters can be used to measure any kind of illumination except speedlight and flash, but their accuracy depends to a high degree on the skill and experience of the user.

Photo-electric light meters are completely automatic. They measure the intensity of the light and tell you how to set your camera's diaphragm aperture and shutter speed. The instructions accompanying every new light meter tell you precisely how to use it to best advantage. Nowadays, of course, many cameras have built-in light meters which are coupled, semi- or fully automatically, to the exposure controls. If this is the case (check your camera's instruction booklet), you may not need a separate light meter. Self-contained light meters come in four different types:

Reflected-light meters measure the light reflected by the subject. All light meters built into a camera are of this type. To take a reading, point the meter at the subject from the camera position.

This type of meter permits the photographer to take individual readings of specific subject areas and thereby establish contrast range, but may give misleading results if incorrectly used. Most common mistake: pointing the p. 123 meter to include too much sky, with the result that the reading will be too high and the picture underexposed.

Incident-light meters measure the light that falls upon the subject. To take a

reading, point the meter from the subject position at the camera.

This type of meter is somewhat easier to use because it automatically integrates the light that falls upon the subject. On the other hand, meters of this kind do not permit a photographer to take individual readings of specific subject areas and therefore cannot be used to establish contrast range. For example, a light reading taken off the face of a girl (very light tone) and another one taken off her dark green sweater (very dark tone), if illuminated identically, would be identical.

Light meters for spot-reading. These meters, which measure *reflected light*, are in effect a combination of a simple SLR camera and a photo-electric light meter. The image of the subject and the meter dial with pointer are visible simultaneously on a groundglass that has a small circle in its center. The meter "reads" the subject area visible within the circle which corresponds to an angle of acceptance of only a few degrees. As a result, very small subject areas can be measured for brightness with a high degree of accuracy. The advantage of this is obvious.

Strobe meters are specifically designed for use with electronic flash. They have their own power supply and provide the only truly accurate means for determining speedlight exposures, regardless of the number of flashlamps involved. However, they are relatively large and heavy and rather expensive.

COLOR FILTERS

A color filter changes the response of a photographic emulsion to light and color. Its function is to alter the rendition of color in terms of either black-and-white or color to produce a picture that is clearer, more accurate, more interesting, or more beautiful than it would be if no filter were used.

A filter permits light of certain wavelengths to pass through it and absorbs light of other wavelengths; which will be transmitted and which will be absorbed depend primarily on the filter's color. Roughly stated, a filter transmits light of its own color and absorbs light of a complementary color. Complementary color pairs are:

>red and blue-green
>orange and blue
>yellow and purple-blue
>green and red-purple

Use of a filter affects a photograph in three ways:

A filter affects the response of the film to light and color, as stated above.

A filter affects the exposure. Since every filter absorbs a certain amount of light, when a filter is used the exposure reading given by an exposure meter must be increased to compensate for the light loss if underexposure is to be avoided. The increase required depends upon four factors:

The color sensitivity of the film (orthochromatic, panchromatic Type A, panchromatic Type B, etc.)

The spectral composition (color) of the light (daylight, tungsten light, etc.)

The color of the filter (red, yellow, blue, etc.)

The density of the filter (light, medium, dark, etc.)

To give a photographer a basis for calculating exposures, filter manufacturers assign specific factors to each filter by which the exposure must be multiplied when the filter is used with specific types of film and light. For example, if the correct exposure without a filter is 1/100 sec. at f/16 and a filter is used that in conjunction with the respective type of film and light has a factor of 2, the exposure would be either 1/50 sec. at f/16 or 1/100 sec. at f/11.

A filter affects the contrast gradient of a black-and-white negative. As a rule, a red filter produces a strong increase in contrast and a yellow filter a moderate increase in contrast, whereas a blue filter reduces contrast in comparison with an unfiltered shot, other factors being equal.

The designation of filters

Unfortunately, manufacturers of filters use designations which give no clue to the color or properties of a filter. For instance, yellow filters that are almost identical are designed by Kodak as Wratten Filter K2, by Enteco as G15, by Lifa as G2, and by Tiffin as 8. The only recourse is to study the filter manufacturer's literature.

The material of filters.

Filters are made from different materials and in different forms, each having specific advantages and disadvantages:

Gelatin. The filter dye is applied to a thin foil of gelatin. Because of their

extreme thinness, gelatin filters have excellent optical qualities which make them particularly suitable for use with high-speed and extreme telephoto lenses which might, if used with filters of lower quality, produce pictures of less satisfactory definition. Gelatin filters are sensitive to abrasion, scratching, and finger marks, and they are easily damaged by moisture (one should never breathe on a gelatin prior to cleaning it). The least expensive of all filters, they are available in the greatest number of different colors.

Gelatin cemented between glass and other laminates. Depending upon the quality of the glass, the optical qualities of this type of filter range from excellent to poor. Such filters are much less sensitive to damage and they are easier to handle and clean than gelatin filters. They are also more expensive.

Solid glass filters. Here, the filter dye is incorporated in the glass. This kind of filter comes in two types: optical flats of superb performance characteristics, which can be recognized by their unusual thickness (up to ¼ inch); and relatively inexpensive, thin filters whose performance is often rather poor. Because of difficulty in manufacture in regard to color control (spectral absorption), the number of different solid-glass filters is quite small.

Acetate. This type of filter is suitable only for use in safelights, enlargers (used between light source and negative for making color prints), and with photolamps to change the overall color of light at its source. Filters of this type, stapled to wooden frames and placed in front of the lamp, are professionally known as "gelatins." If used at the camera, acetate filters, because of their poor optical qualities, would cause unsharpness.

The effects of reflection

Not all light that strikes a filter is transmitted or absorbed; some is lost through reflection from the front and back surfaces of the filter. The minimum light-loss through reflection is 4 percent per filter; often, it is considerably higher. In glass filters, light-loss can be reduced through anti-reflection coating. Reflected light may also contribute to flare and attendant decrease in contrast of the transparency or the negative. Consequently, it is important to use as few filters simultaneously as possible (in color photography, and especially in color printing, simultaneous use of several filters is often necessary for proper light balance).

pp. 179–181

Color stability of filters

The dyes used in the manufacture of gelatin filters, like the dyes used in color films, are organic—and all organic dyes are basically unstable and subject to

gradual deterioration. To prevent premature fading, filters should not be exposed unnecessarily to bright light, dampness, or heat.

Filters for different purposes

Filters designed for color photography are usually rather pale, some appear almost colorless, and a few are entirely colorless; many of these filters, if used with black-and-white films, would produce no noticeable effect. On the other hand, most filters designed for black-and-white photography have strong, saturated colors, and if used with color films, would produce transparencies which would be monochromes in the color of the respective filter. A few filters can be used for both black-and-white and color photography.

Filters for black-and-white photography only

Correction filters. The purpose of a correction filter is to change the response of a *panchromatic film* so that *all* colors are rendered in approximately the same brightness values as those seen by the eye. Although panchromatic films are *sensitive* to all colors, they do not necessarily record color in gray shades that *correspond in brightness* to the brightness seen in reality. All panchromatic films are unproportionally sensitive to blue and ultra-violet, and Type C pan films are also unproportionally sensitive to red. Unless this excessive sensitivity is reduced proportionally, blue and red are rendered unproportionally light in the print.

The following table lists the correction filters which must be used with Kodak panchromatic films if accurate translation of color into gray shades of corresponding brightness is desired:

Panchromatic film	Illumination	Wratten Filter	Filter factor
Pan Type B	Sunlight	K2	2 x
	Tungsten	X1	3 x
Pan Type C	Sunlight	X1	4 x
	Tungsten	X2	4 x

Contrast filters. The purpose of a contrast filter is to change the response of a film so that it will render a specific color either lighter or darker than it would

pp. 225,
322

have been rendered if no filter were used. When such changes in rendition are desirable will be discussed later.

To render a color *lighter in the print,* use a filter of *the same* (or closely related) color; to render a color *darker in the print,* use a filter of the *complementary* (or a nearly complementary) color. The following table shows how Kodak Wratten contrast filters affect the principal colors. If several filters are listed, the first will make the least change and the last the greatest change in color rendition.

Color of subject	Wratten Filter that will make color lighter	Wratten Filter that will make color darker
Red	G, A, F	C5, B
Orange	G, A	C5
Yellow	K2, G, A	80, C5
Green	X1, X2, B	C5, A
Blue	C5	K2, G, A, F
Purple	C5	B

[NOTE: The Wratten Filters A (light red), F (deep red), and B (green) can *only* be used with panchromatic films.]

pp. 78–79 **Infrared filters.** As we will discuss in more detail later on, to make use of the typical characteristics of this medium, infrared sensitized films must be used with special filters that transmit infrared radiation and absorb most or all visible light. For many purposes, and particularly in making hand-held shots with an SLR camera, red filters (Wratten A or F) are sufficient. These filters, which completely absorb blue and most of blue-green and green, transmit red and infrared. Their advantage is that, although a monochrome in red, the SLR finder image is visible, whereas it would not be if one of the infrared filters which absorb all visible light were used.

If the picture is to be taken entirely by infrared radiation, a Wratten Filter No. 87A, 87B, 88A, or 89B must be used unless the shot is made in darkness or by infrared flashbulb illumination. To the eye, these filters appear black.

Filters for color photography only

p. 263 **Color-conversion filters.** As will be explained later, natural-appearing color rendition can be expected only if color film is used in conjunction with the kind

66

of light for which it is "balanced." Occasionally, however, it may become unavoidable to make on the same roll of color film photographs by different kinds of light, or to use a color film balanced for one type of light in conjunction with another type of light. Under such circumstances, satisfactory color rendition can still be achieved if the shot is made through the appropriate color-conversion filter. The following Kodak Wratten Color Conversion Filters must be used:

80A if a daylight-type color film is exposed by 3200 K tungsten lamps
80B if a daylight-type color film is exposed by 3400 K photoflood lamps
80C if a daylight-type color film is exposed by clear flashbulbs
85 if a Type A (3400 K) color film is exposed by sunlight
85B if a type B (3200 K) color film is exposed by sunlight

Notice, however, that all these filters reduce the effective speed of color films; instead of basing your exposure upon the listed ASA speed of the respective film, you now must calculate it in accordance with the new reduced speed. See the film or filter manufacturer's instructions.

p. 74

Light-balancing filters enable a photographer to change the color (spectral composition) of "off-color light" and make it conform with the type of light for which the color film is balanced. Daylight, for example, can have many colors: it is yellowish in the early morning and late afternoon, reddish at sunset, bluish in the shade if the sky is clear, and so on. Daylight-type color film, however, is balanced to give natural-appearing color rendition only in one specific kind of daylight: *a combination of direct sunlight and light reflected from a clear blue sky with a few white clouds during the hours when the sun is more than 20 degrees above the horizon.* If outdoor pictures are taken on daylight color film in "daylight" that does not conform to these specifications, the resulting colors, no matter how closely they may correspond to reality, will fail to appear "natural." Under such conditions, to ensure a natural-appearing color rendition the picture must be taken through the appropriate light-balancing filter.

Two kinds of light-balancing filters are available: the Kodak Wratten Filters No. 81, which are red, come in eight different densities, and must be used if the daylight contains too much blue; and the Kodak Wratten Filters No. 82, which are blue, come in four different densities, and must be used if the daylight contains too much yellow or red. The correct use of these filters is explained on pp. 266–269.

Color-compensating filters enable a photographer to deliberately change the overall color balance of the transparency. Such changes may be necessary for the following reasons: to compensate for reciprocity failure caused by abnormally short (electronic flash) or abnormally long exposure times; to compensate for deviations from normal color balance of a specific color-film emulsion which, if uncorrected, would give the transparency an overall color cast; to correct deficiencies in the illumination caused, for example, by a greenish spotlight condenser lens; or to purposely change the overall color balance of a transparency to achieve a specific effect.

Kodak Color Compensating Filters, designed as Series CC filters, are available in the colors yellow (Y), magenta (M), cyan (C), red (R), green (G), and blue (B), most in six and some in seven different densities. The correct use of these filters is explained on pp. 318–321.

Filters for color and black-and-white photography

Ultraviolet filters. All photographic emulsions are sensitive to ultraviolet radiation, which is invisible. Ultraviolet radiation increases with altitude and contributes to the bluish haze that veils distant views when the day is clear (this haze must not be confused with mist and fog, which are white). In black-and-white photography, the effect of ultraviolet radiation manifests itself in unexpectedly dense negatives and in distance views in which detail is obscured and sharpness is inferior (this is particularly objectionable in small negatives); in color photography, in distant views that appear abnormally blue.

These effects can be mitigated or eliminated through use of filters which absorb ultraviolet radiation, among others the Kodak Wratten Filters Nos. 1A and 2B.

Polarizing filters. The purpose of this kind of filter is to mitigate or eliminate glare and reflections. The reader is probably familiar with Polaroid sunglasses and the way they reduce glare. Polarizers work in the same way. Through their use, unwanted glare and reflections can be partly or completely eliminated from a photograph, the degree of reduction depending on the angle of the reflected light. At angles of approximately 30 degrees, glare reduction is more or less complete; at 90 degrees, glare is not affected at all; at intermediate angles, glare is partly eliminated. However, only glare and reflections that consist of polarized light are affected by polarizing filters. Most reflecting surfaces polarize light as they reflect it—water, glass, glossy

paper, paint, varnish, polished wood, and so on. Metallic surfaces, however, do not polarize light as they reflect it, and consequently, highlights and reflections from metallic surfaces are generally not affected by polarizers. Exceptions: the reflected image may consist of polarized light, for example, an area of blue sky.

In color photography, use of a polarizing filter is the only method by which a pale blue sky can be darkened. Maximum effect is evident in that part of the sky which is at right angles to the rays of the sun.

To produce the desired effect, a polarizing filter must be used in the correct position. Hold the polarizer to your eye and look through it at the subject (if you use an SLR camera, place the polarizer in front of the lens and observe the image on the groundglass), slowly rotate the polarizer and notice its effects on highlights, reflections, and glare. When the desired degree of extinction is reached, place the polarizer in front of the lens *in exactly the same position as you held it*. Do not accidentally rotate the polarizer while transferring it to the lens; if you do, the effect will be changed.

It is neither necessary nor advisable to always use a polarizer in its position of maximum efficiency. Sometimes it is better to reduce glare to a moderate level because complete extinction of glare often produces a dull, lifeless effect.

Polarizers and color filters can be used together. This makes it possible to control color rendition and reflection simultaneously, and very often one will act as an aid to the other. Thus, elimination of glare will bring out colors that were obscured by reflections, while a color filter will translate them into shades of gray of desired brightness.

The filter factor for most polarizers is 2.5. If a polarizer is used with a color filter, the factor of one must be *multiplied* by the factor of the other to determine their combined factor. The exposure as indicated by the exposure meter must then be increased in accordance with this factor.

Neutral density filters. The purpose of this kind of filter is to reduce brightness without affecting the color rendition of the subject. Such filters are commonly used in motion picture photography but they are equally useful in still photography when high-speed film is in the camera and a bright scene must be photographed with a large diaphragm aperture to limit extension of sharpness in depth. Under such conditions, when the fastest available shutter speed is not fast enough to prevent overexposure, a neutral density filter will.

Kodak Wratten ND Filters No. 96, available in thirteen standard densities, are neutral gray in tone which make them suitable to color photography. A difference in neutral density of 0.30 is equivalent to one full stop.

GADGET BAG

To be able to carry your photographic equipment conveniently and safely, you need a gadget bag. Choice of type, size, material, and such is, of course, dependent on your taste and needs, whether you wish to carry much equipment or little, the size of your camera, and so forth. However, for the beginner, I wish to add these suggestions: Don't buy a gadget bag that is too small; invariably, as time goes by, you will acquire more pieces of equipment, another lens or two, a set of extension tubes, or what have you. By all means get a bag with one or two outside pockets to hold your light meter and film; this will eliminate the need for constant "digging" in the main compartment of the bag. Adjustable partitions are a valuable aid in keeping things orderly within the bag; excellent also are loose pices cut from a sheet of foam rubber that can be used in many ways to separate the various items and prevent them from scratching one another, and to provide cushioning against shock.

THE FILM

Modern films are produced in a great variety of different types, each designed for a specific purpose. However, different types of film can be classified as variations of the following basic qualities:

> **Type and base**
> **Size**
> **Speed**
> **Definition**
> **Gradation**
> **Color sensitivity**

Once a photographer is familiar with these qualities, he will be able to evaluate any type of film and determine which is best for his kind of work.

Type and base

Film is available in four different types which have the following characteristics:

Rollfilm and 35-mm film. Long strips of film wound on a spool containing material for eight to thirty-six or more exposures, depending on the size of the individual negative, the type of camera, and the capacity of the film magazine.

Rollfilm and 35-mm film is the most practical type of film. It is easily loaded in daylight and easier to use and process than any other type. Disadvantages: individual shots cannot be processed individually (which makes it inadvisable to photograph very different subjects together on the same roll); impossibility of changing from one film type to another (for example, from black and white to color) in the middle of a roll without sacrificing the remaining film (unless the camera provides for interchangeability of backs, or an accessory rollfilm adapter can be used).

Sheet film. Individual sheets of film on a relatively heavy base. Available in sizes ranging from 2¼ x 3¼ inches to 8 x 10 and larger. Individual shots may be processed individually.

Sheet film is less expensive per exposure than filmpack and usually stays flatter in the holder. This makes it preferable for use with lenses of great focal length or high speed when flatness of film is most critical. Disadvantages: film must be loaded in the darkroom one sheet at a time; each holder takes only two sheets, one on each side (the Grafmatic rapid-change film magazine holds six sheets of film); weight and bulk—film and holders for only a dozen shots take almost as much space as the camera.

Filmpack. Sixteen individual sheets of film (Kodak) on a thin base packed flat in a container called a "cassette." Available only in a few black-and-white emulsions but not in color. Most common sizes are 4 x 5 and 3¼ x 4¼ inches. Filmpack combines the ease of handling of rollfilm with the advantage that individual shots may be processed individually and exposed sheets may be taken from the pack without sacrificing the remainder. It can be loaded and unloaded in daylight, and change to another type of black-and-white or a change to color sheet film is possible without sacrificing unexposed film. Disadvantages: filmpack is the most expensive form of negative material; dampness may cause the film to buckle out of the plane of focus and produce partly unsharp negatives.

71

Glass plates. Now only used for diapositives (positive transparencies for projection), color separation negatives (where dimensional stability is important), photo-engraving, and scientific purposes.

Size

Different sizes of film have different advantages and disadvantages. For those photographers who still have not decided whether to buy a large, medium, or small camera, the following summary may be of aid in making a choice:

Large film sizes have the following advantages over smaller sizes:

Sharper pictures because large negatives need proportionally less magnification during enlarging than small negatives.

Better tone values, smoother transitions, and less danger of film grain, because degree of enlargement is usually low.

Higher effective film speed because standard developers can be used. In comparison with many fine-grain developers, these developers do not demand increases in exposure.

Compositional advantages. Because film size is large, relatively small sections of a negative can be enlarged to become effective pictures—a simple substitute for a telephoto lens. Cutting off superfluous subject matter strengthens the composition and increases the impact of a picture.

Processing and printing are easier. Specks of dust and small scratches do not show nearly as much as in enlargements made from smaller negatives, where magnification is much higher. This facilitates "spotting" and retouching.

The sales appeal of large color transparencies is higher than that of small ones.

Against these advantages, the following disadvantages must be weighed:

Higher cost per exposure.

Bulk and weight. Two sheets of 4 x 5-inch film in a holder take about as much space, and weigh as much, as material for one hundred shots on 35-mm film.

Larger, heavier, and more conspicuous cameras are, of course, needed for larger film sizes. Slower operation restricts the photographer's choice of subject.

Small film sizes have the following advantages over larger sizes:

Lower cost per exposure.

More pictures can be taken of each subject since film cost is relatively low. This ensures more complete coverage and reduces the danger of missing important shots.

Cameras are compact and light and therefore permit inconspicuous and fast shooting.

Lenses of much higher speed are available for small cameras than for large cameras.

Superior sharpness in depth at any given diaphragm stop because lenses of shorter focal lengths cover the smaller film sizes.

35-mm film for a hundred exposures takes less space than a package of cigarettes.

Against these advantages, the following disadvantages must be weighed:

Inferior definition of the picture.

Inferior tonal gradation caused by the necessity for higher negative magnification, which makes the film grain apparent.

Lower effective film speed because slow fine-grain films or speed-reducing fine-grain developers must be used if grainless prints are desired.

More critical processing because higher magnification emphasizes specks of dust and small scratches, etc.

The sales appeal of small color transparencies is lower than that of larger ones.

A large film size (4 x 5-inch) is recommended for those who specialize in static subjects, the deliberate worker, the perfectionist who insists on highest technical quality and has great feeling for sharpness, texture, and detail.

A small film size (35-mm) is recommended for the fast, impulsive worker, the reporter who looks for action rather than technical quality, and the traveler who wishes to travel light.

A medium film size (no. 120 rollfilm) is recommended for those who want to combine high technical image quality with reasonable camera size, and for beginners.

Speed

To make accurate calculations of exposure possible, all films have specific speed numbers which provide the basis for setting the dial of the light meter. These speed numbers express the film's sensitivity to light: the higher the number, the more sensitive (the *faster*) the film. Other factors being equal, the faster the film, the shorter the exposure and, consequently, the less danger of blur due to accidental camera movement; the smaller the diaphragm stop that can be used, and the greater the extent of sharpness in depth. For these reasons it may seem that fast films are preferable to slow films. However, in comparison with slow films, fast films, both color and black-and-white, have certain less desirable qualities which become more pronounced as film speed increases: their grain structure is coarser (most objectionable in enlargements made from small negatives) and their gradation is softer (most objectionable if subject contrast is low). For this reason, the "best" film is frequently *the slowest film* that is fast enough to do a perfect job.

Unfortunately, no speed number system is used internationally; several different film rating speeds are in use of which the American ASA (American Standard Association), the British B.S. (British Standard) numbers, and the German DIN (Deutsche Industrie Normen) are the most important. Because more and more foreign films become available in this country, the following table provides equivalent speed ratings for the three different systems:

American ASA and British B.S. film speed numbers

800	640	500	400	320	250	200	160	125	100	80	64	50	40	32	25	20
30°	29°	28°	27°	26°	25°	24°	23°	22°	21°	20°	19°	18°	17°	16°	15°	14°

Equivalent German DIN film speed numbers

(*NOTE:* Different systems use different methods by which to rate the "speed" of a film, as a result of which it seems doubtful that any reliable conversion table can be compiled. The above values must, therefore, be considered only as approximations which have to be confirmed or corrected by individual tests.)

Not long ago, panchromatic films had two different speed numbers, one for daylight and one for tungsten illumination. However, experience has shown that the response of photo-electric exposure meters to these two types of light is, as a rule, so similar to the response of panchromatic films that the same

speed number can safely be used for both types of light. With blue-sensitized and orthochromatic films it is, of course, still necessary to use lower speed ratings for tungsten illumination than for daylight because these films are primarily sensitive to blue, and tungsten light contains less blue than daylight.

Film speed ratings are not absolute. They are intended primarily as guides which may have to be modified to suit a photographer's preferences and way of working. In addition, the *effective* speed of a film (as compared to its *rated* speed) is subject to two factors that must be considered when the exposure is computed:

Type of developer. Some fine-grain developers used in black-and-white photography demand increases in exposure, the exact factor depending on the type of developer used. A few developers actually boost effective film speed. p. 144

Duration of development. Prolongation of development beyond normal ("pushing" or "forcing" a film) is in effect equivalent to increasing the speed of a film and also, of course, its contrast. Color film which can be processed by the photographer can, if demands are not too critical, yield good results when exposed at twice its rated speed *if subject contrast is relatively low.* In black-and-white photography, if a photographer is willing to accept some loss in print quality, even higher gains in effective film speed can be attained by forcing the negative during development, particularly if subject contrast is low.

(NOTE: A table of rated speeds of specific brands of film is not given here because such ratings are always subject to revision. The currently recommended speed number of a film is always given with the film.)

Definition

The higher the definition of a film, the more fine detail can be distinguished in the photograph. Definition is, as a rule, higher in slow, contrasty films than in fast, less contrasty films. Definition is the result of two film qualities:

Grain. The light-sensitive component of photographic emulsions consists of innumerable tiny particles of metallic silver which form the negative; the denser the layer of silver grains, the darker the image. The individual grains are so small that they can be seen only with a microscope. However, under certain conditions, the grains clump together in the negative and become visible in the

enlargement. When this happens, the picture appears "grainy." Grain is always most apparent in the medium shades, which lose their smoothness and in black-and-white photography acquire a sandpaper-like texture.

Acutance. This is a measure of sharpness. But whereas "sharpness" is a subjective impression almost impossible to define (where, actually, does sharpness end and unsharpness begin?), acutance is based upon exact measurements: a knife edge is laid on the film, the film is exposed to light, developed, and the silhouette of the knife edge is examined under a microscope. Because light is scattered within the film emulsion, the transition from light to dark is not clearly defined but somewhat gradual. It is the zone between pure white and pure black which, microdensitometrically evaluated, is the measure of the acutance of a film: the narrower it is, the higher the acutance. Acutance is highest in thin and lower in thick emulsions. It is also affected by exposure: overexposure, which promotes light-scattering within the emulsion, lowers the acutance.

Sharpness. In practice, the impression of sharpness is influenced by the following factors:

Thickness of the film emulsion: the thinner, the sharper.

Film grain: the finer the grain, the more detail can be distinguished. However, *grainy* negatives often produce pictures that *appear* sharper than pictures made from fine-grain negatives that actually show more detail but offer the eye nothing definite to focus on because outlines of their images seem less distinct than the hard specks of grain in a grainy print.

Exposure: the denser the negative, the less sharp the print. Overexposure is a very common cause of unsatisfactory sharpness. It is most harmful in small negatives.

Development: overdevelopment, which promotes film grain clumping and excessive density, is another common cause of unsharpness.

The gradation of the paper: printed on contrasty paper, a negative always produces a print which makes a sharper impression than a print made from the same negative on paper of softer gradation, particularly if grain is apparent in the contrasty print.

p. 112 *Other factors* that affect the sharpness of a picture will be discussed later.

Gradation

The gradation of a film determines its tonal range. There are films of normal, soft, and hard gradation (normal, long, and short tonal range).

If we photograph a gray-scale—a strip of monochromatic shades in regularly spaced steps of increasing depth of tone from white to black—and used a film of *normal* gradation, we would get a picture that faithfully reproduces every tone of this scale: contrast would be *the same* as in the original. If we used a film of *soft* gradation (low-contrast gradient), we would get a picture in which the dark tones are rendered lighter and the light tones darker than they were in the gray-scale, and white and black are rendered as shades of light and dark gray: contrast would be *lower* than in the original. And if we used a film of *hard* gradation (high-contrast gradient), we would get a picture in which the entire gray-scale would appear compressed because differentiation at the light and dark ends of the gray-scale would be lost, the light steps merging into white and the dark steps merging into black: contrast would be *higher* than in the original.

Generally (exceptions exist), the higher the speed of a film (color or black and white), the softer its gradation; and vice versa. Differences in gradation are much greater among black-and-white than among color films. Films that have the hardest gradation (highest-contrast gradient) are found among ortho- chromatic and panchromatic process films designed for line-copy work, fol- lowed by thin-emulsion and fine-grain films of low to moderate speed. Films designed for general photography have normal gradation. Films that have the softest gradation (lowest-contrast gradient) are found among the fast pan- chromatic films.

Gradation, however, is not an unalterable characteristic of black-and-white films (gradation of color films cannot be changed without changing the color rendition). Regardless of the contrast group to which a black-and-white film belongs, its gradation is subject to these influences:

Exposure: overexposure decreases, and underexposure increases, the con- trast of the negative in comparison to a normally exposed negative, other factors being equal.

Development: prolongation of development beyond the normal time increases, and shortening the time of development decreases, the contrast of the negative in comparison with a normally developed negative, other factors being equal.

Color sensitivity

p. 225

In black-and-white photography, subject colors are, of course, translated into shades of gray. To obtain pictures that look as natural as possible, the brightness values of these gray shades must normally (though not always, as we will see later) correspond as nearly as possible to the brightness values of the colors they represent. For example, yellow, a light color, must be rendered as a lighter shade of gray than blue, which to the eye appears darker. To translate colors into specific shades of gray, black-and-white films are color-sensitized. Response to color, however, varies considerably, depending on the sensitizing of the film. In this respect, one must distinguish between four main groups of black-and-white films with the following characteristics:

Blue-sensitive films which contain no color-sensitizing dyes, are sensitive only to the blue and ultraviolet components of "white" light and are "blind" to all other colors. They render blue (or any color containing blue) too light, and they render red, orange, and yellow as black. For ordinary photographic purposes these films are, of course, completely unsuitable.

Orthochromatic films are sensitive to green and yellow in addition to blue and ultraviolet, but insensitive to red. As a result, they can be developed by red light. In the form of sheet films, they are primarily used in certain types of industrial photography (particularly if the subject contains large masses of dark or black areas, machinery, etc.), and in portraiture for photographing men.

Panchromatic films are sensitive to all colors and ultra-violet, although they differ somewhat in their response; those that have a relatively high sensitivity to green are sometimes referred to as Type B, and those that are especially sensitive to red, as Type C, panchromatic films.

p. 141
pp. 151–
152

Because panchromatic films are sensitive to all colors, they must be developed in what amounts to total darkness (a very weak, dark green, overall darkroom illumination is permissible) by the time-and-temperature method. Since sensitivity to all colors is a most desirable quality, panchromatic films are the best general-purpose films.

Infrared films have panchromatic emulsions whose sensitivity to red has been extended beyond the visible spectrum into the infrared. Since infrared has extraordinary haze-penetrating power, infrared films are primarily used in aerial and telephotography. Other common uses include law-enforcement, criminology, detection of forgeries, and fake moonlight scenes shot in day-

light. Infrared film is not suitable for general purposes because of the unnatural way in which color may be rendered. For example, it renders blue water and blue sky dead-black, while green foliage and grass appear snow-white. These strange forms of rendition, however, are determined not by actual subject color but by whether the subject reflects or absorbs infrared radiation. Since infrared radiation is invisible, there is no way to predict how light or how dark a color will appear when photographed on infrared film. Blue water and blue sky appear black in infrared pictures, *not* because they are blue, but because they strongly absorb infrared; and foliage and grass appear white, *not* because they are green, but because chlorophyll strongly reflects infrared radiation.

Because infrared emulsions are also sensitive to visible light, it is necessary to use special filters to get the typical infrared effect, as discussed earlier. Used p. 66 without filters in daylight, infrared sensitized films produce pictures very similar to pictures taken on contrasty panchromatic film. If infrared film is used in darkness in conjunction with infrared flashbulbs a filter is not needed.

Because the wavelength of infrared radiation is longer than that of visible light, the image produced by it lies at a greater distance from the lens than that produced by visible light. Therefore, to ensure sharpness of the infrared image, ordinary photographic lenses must be moved forward slightly after focusing. The average increase in distance between lens and film is one-quarter of 1 percent of the focal length of the lens, although this varies somewhat, depending on the lens design. Some lenses intended for use with 35-mm and 2¼ x 2¼-inch cameras have special infrared markers (usually, a red line marked by an "R" or a red dot). To make a photograph by infrared radiation using an infrared filter (either in front of the lens or in front of the lamp), focus visually, note the subject distance that the regular footage scale indicates, then turn the focusing ring until this point is opposite the infrared marker on the lens mount.

How to choose black-and-white film

For practical reasons, it is advisable to classify black-and-white films in four groups:

Thin-emulsion films
General-purpose films
High-speed films
Special-purpose films

Thin-emulsion films have very low speeds (16 to 64 ASA), extraordinary sharpness, unsurpassed definition, and no visible grain. As a result, they are ideal for 35-mm photography provided that their speeds are not too slow for the job at hand, and that great care is taken in their exposure and development. Because their emulsions are so thin, their exposure latitude is slight and exposures must be correct within less than one stop. For the same reason, they need special development with "compensating" developers which are free from silver solvents. If they are overdeveloped, they become so contrasty that in the print highlights are completely blocked, medium gray tones are virtually absent, and what is left are areas of almost pure black and white. In capable hands these films will yield beautiful 16 x 20-inch grainless enlargements from 35-mm negatives.

With the exception of Kodak Panatomic X, all films belonging to this group are of foreign origin and may not easily (or not at all) be obtainable in this counrty: Adox KB-17, Agfa Isopan F, Ilford Pan F, and Perutz Perpantic 17.

General-purpose films have medium to high speeds (125 to 400 ASA), reasonably fine grain, and unsurpassed exposure latitude which provides a high margin of safety against incorrect exposure. They are ideal for photography with 2¼ x 2¼-inch cameras and larger, and 35-mm cameras in cases in which thin-emulsion films cannot be used because of insufficient speed. They are equally suited to outdoor and indoor photography under all light conditions, and give particularly good results with speedlight and flash. Unless an extreme fine-grain or an ultra-high-speed film must be used, a photographer should select his black-and-white films from this group.

Typical representatives are Kodak Plus-X, Tri-X, and Verichrome Pan; Ansco All-weather Pan; and Ilford FP 4 (ASA 125) and HP 4 (ASA 400).

High-speed films have very high speeds (500 to 1600 ASA), coarse grain, poor definition, soft gradation, and extreme sensitivity to overexposure which produces negatives so lacking in contrast that not even printing on extra hard paper will produce acceptable prints. They are totally unsuited to general photography and especially to outdoor photography in bright light. Their one redeeming feature is that under marginal light conditions, when other films fail, they are capable of producing very beautiful results. Unless their high speed is actually needed, or a grainy effect is deliberately sought, these films should not be used.

Typical representatives are Kodak Royal-X Pan (available only in 120 size rollfilm); Ilford 37, 47, and 57; and Polaroid 3000 speed film.

Special-purpose films. A whole group of films exist which are little known to the average photographer because they are unsuited to general photography. Here are a few examples:

Infrared sensitized films are intended primarily for serial and telephotography. Their ability to penetrate atmospheric haze improves the clarity and definition of such pictures. In addition, these films are widely used for scientific, technological, and military purposes. p. 78

Fluoroscope recording films are ultra-sensitive to blue. They record images from television and cathode-ray tubes, oscilloscopes, and fluorescent screens.

Document copy films are used to copy line material that has no middle tones. They have very high contrast, unsurpassed definition, and extremely fine grain. They are available in both orthochromatic and panchromatic emulsions.

Kodak Fine Grain Positive Film produces from black-and-white negatives positive transparencies used mainly for display in transmitted light and as slides for projection.

Kodak Direct Positive Pan Film is a reversal film which yields positive transparencies in black and white instead of negatives. It is suitable for making slides and "negative prints."

Photographers interested in these films, which also offer tempting opportunities for experimentation, are advised to obtain special literature through their photo dealer.

COLOR FILMS

In color photography, the problems of selecting the most suitable film are different from those that confront a photographer who works in black-and-white. There, graininess, speed, and contrast range are foremost considerations; here, the big questions are:

Positive or negative color film?
Small film size or larger film size?
Daylight-type, Type A, or Type B film?

Positive or negative color film?

Two basically different types of color film exist: positive or reversal films, and negative or nonreversal films. Kodak facilitates distinction between the two groups by ending the brand name with a codelike suffix: the suffix "chrome" designates a *positive* color film (Koda*chrome*, Ekta*chrome*); the suffix "color" designates a *negative* color film (Koda*color*, Ekta*color*). As far as the amateur is concerned, if his primary interest is slides for projection, he must use a positive color film; if color paper prints for album or wall display, a negative color film.

Positive or reversal color film ("reversal," because the image produced by the exposure is a color negative which during development is "reversed" into a positive) yields positive color transparencies primarily intended for viewing or projection by transmitted light, and for reproduction by photo-mechanical methods. Although color prints and enlargements on paper can also be made from positive color transparencies, negative color films are preferable for this purpose. Compared with negative color films, positive color films have the following advantages:

Because the developed film represents the final, finished, salable product and no further time, money, or effort has to be spent on printing, cost per picture is relatively low. For the same reason, positive color films are usually preferable in cases in which time is of the essence as, for instance, in news reporting and many fields of magazine and commercial photography: the minimum time between shooting a picture and seeing the final result is much less than if a negative color film had been used. Furthermore, positive color transparencies can be edited, and final selection be made, without the need for contact prints or proofs, another saving in cost and time. Finally, in comparison with prints and enlargements made from negative color films, positive color transparencies are sharper, their colors more brilliant, and their contrast range considerably greater, factors which tend to make color transparencies more effective and give them greater sales appeal than color paper prints.

The main disadvantage of all positive color films is that, once the exposure has been made it is virtually impossible to correct a mistake; unless the type of light in which the shot was made corresponded precisely to that for which the respective color film was balanced or, if the light was "off," the correct light-balancing filter had been used, and unless the exposure was perfect, the result will be disappointing and often useless. Furthermore, each color trans-

parency is an original and therefore unique and, if damaged or lost, not replaceable (unless, of course, it has been duplicated). But color duplication is a time-consuming and expensive process which, unless done by a first-class color lab, yields transparencies that in regard to photo-technical quality are inferior to the original.

Negative or nonreversal color film ("nonreversal" because the light-induced image does not have to be reversed into a positive during developing) yields color negatives in the complementary colors and tone values of the subject. Like ordinary black-and-white film, such film must be printed before it yields finished positive prints. In comparison with positive color film, negative color film has the following advantages:

Because printmaking includes the intermediary step of the negative, a color photographer has just as much control over the final appearance of his color prints as a photographer who works in black-and-white. Not only can a very considerable degree of overexposure and, to a lesser extent, underexposure of the color negative be corrected during the printing process, but far-reaching color changes can also be made in the overall tone and even within specific areas of the print. This fact alone is of the highest practical value because it virtually eliminates the need for time- and film-consuming "bracketing" (mak- p. 130 ing a series of pictures of the same subject from the same point of view with different diaphragm settings or shutter speeds and, if desirable, different light-balancing filters to ensure that at least one shot will turn out to be perfect), an advantage that is particularly appreciated by photographers involved in fast-breaking action photography, which leaves no time to make a second, let alone a third or fourth, exposure with different camera settings. Other advantages of negative color films are that cropping and sectional enlarging of the negative is possible; that irreplaceable negatives can be kept by the photographer, who only sends out relatively expendable prints; that any number of identical prints can be made from the same color negative and sent out simultaneously to different places (which in effect means the end of the annoying "holding" of valuable transparencies by a client who thus monopolizes a color shot that in the meantime might have been submitted elsewhere); and that small-format cameras can be used to make large-size color prints.

Disadvantages of negative color film are that it is impossible to edit from color negatives (which means that time and money has to be spent on the making of proof prints); that good color prints, particularly in the larger sizes, are very expensive; and that even the best color print is still inferior to a positive

transparency in regard to sharpness, brilliance of color, and contrast range, which adversely affects its sales appeal, although this may be partly offset by larger size.

Small film size or large?

Since different film sizes have specific advantages and drawbacks, those photographers who are still undecided about whether to buy a small, medium, or large camera may find the following summary useful:

In a nutshell: Photographers primarily interested in making slides for projection, no matter whether amateurs, travelers, lecturers, or professionals out to produce color slides for sale, unless special considerations make it necessary to use a larger format, should use 35-mm color film. Likewise, photographers with quick temperaments, action people, fast and impulsive workers, reporters photographing fast-breaking news, anyone interested more in life than in photo-technical quality, and all who wish to travel light, should make 35-mm color film their choice.

Photographers primarily interested in static subjects—landscapes, architecture, objects, art—no matter whether amateur or professional, as well as those who are perfectionists at heart—the slow and deliberate workers who insist on highest photo-technical quality and are obsessed by sharpness, texture, precisions of detail—will only be satisfied and able to do their best if they use a larger film size, 4 x 5-inch and up.

And finally, photographers who prefer the inexpensive type of color paper prints to color slides; those who are equally interested in static and dynamic subjects, in people as well as in things; professionals working in the fields of fashion and advertising photography who specialize in photographing models and action; and, strange as it may sound, inexperienced beginners will probably be most satisfied if they work with a medium-size film: 2 ¼ x 2 ¼-, 2 ¼ x 2 ¾-, or 2 ¼ x 3 ¼-inch.

Daylight-type, Type A, or Type B film?

Unlike different types of black-and-white film, all of which can be used in any kind of light, color films come in three specific types, each designed for use in one specific kind of light. If used in a different kind of light, the colors of the transparency will not correspond to those of the subject.

Daylight-type color films are designed for use with "standard daylight," which is defined as a *combination of direct sunlight and light reflected from a clear blue sky with a few white clouds during the hours when the sun is more than 20 degrees above the horizon,* and are also suitable to shooting pictures with electronic flash or *blue* flashbulb illumination. If a daylight-type is to be used in a different kind of light, the correct color-conversion filter must be used if a natural-appearing color rendition is expected. Without appropriate filtration, color transparencies shot on daylight-type film by photoflood, tungsten lamp, or clear flashbulb illumination will appear too yellow.

Type A color films are designed for use with 3400 K amateur photoflood p. 264 lamps. If used in daylight, color transparencies shot on Type A color film will appear too blue unless a Kodak Filter No. 85 is used and the meter-indicated exposure multiplied by the filter factor.

Type B color films are designed for use with 3200 K professional tungsten lamps. If used in daylight, color tranparencies shot on Type B color film will appear too blue unless a Kodak Filter No. 85B is used and the meter-indicated exposure multiplied by the filter factor.

Only after a photographer has decided whether to use a positive or a negative color film; a small, medium, or large film size; and familiarized himself with the differences between daylight-type, Type A, and Type B color films, should he go on and consider the following factors, all of which play an important although perhaps less critical role in the outcome of his color pictures:

> **Mode of processing**
> **Make of film**
> **The variables**
> **Testing**

Mode of processing

In terms of processing, photographers should distinguish between three categories of color film: those that can be processed by either the user, the manufacturer, or a commercial color lab; those that *cannot* be processed by the user but *must* be processed by *either* the manufacturer or a commercial color lab; and those that *can* be processed by the user or a commerical color lab but are *not* processed by the manufacturer. Information of this kind is of interest to photographers who either wish to have their color films processed by the manufacturer because, normally, this is the best guarantee for top-quality service, or to those who wish to do their own processing. If necessary, ask your

dealer to which one of these three groups the film you would like to use belongs.

Color-film development is a highly critical process. Unless done precisely in conformance with the manufacturer's specifications, the result will be unsatisfactory. Normally, the more highly standardized the procedure and the more fully automated the processing equipment, the better the result. For this reason, selection of a reliable color lab is as important to a color photographer as selection of the right type of film. As a matter of fact, carefully controlled tests have shown that color variations due to variations in processing (by different color labs) are usually greater than variations resulting from all other causes together—a reminder to any photographer to choose his color processor with care.

Make of film

No color film exists as yet which, even under ideal conditions, yields transparencies which in every respect match the colors of the subject. Furthermore, if the same subject is photographed under identical conditions on different makes of color film, the colors of the resulting transparencies will differ. Part of this difference, as we shall see, may be due to certain variables; the main reason, however, is that color films made by different manufacturers have inherent differences which may cause them to respond somewhat differently to a given color. Some brands, for example, are known for their brilliant colors, which at times may even appear "exaggerated"; others again will render color muted and "soft." Certain brands of color films produce renditions that are generally "warmer" (more toward yellow and red) than others, which respond with tones that are "colder" (more toward blue and purplish shades). But differences in the reaction to specific colors are common too: one brand of color film may be famous for its particularly pleasant rendition of skin-tones and therefore preferred for close-ups of people; another for its ability to render clear blue skies or green foliage in more natural shades than other films, which reproduce these colors too harshly, evoking viewer responses that range from "artificial-looking" to "poisonous." Still others may be weak in the reds, which come out looking like stale tomato sauce, or the greens, which have overtones of brown. And so on. Comparative illustrated surveys of the different brands of color films are periodically published in photo magazines in up-to-date form and should be studied by any serious color photographer. To discuss here the characteristics of specific brands would be futile because film

manufacturers, constantly striving to improve the quality of their product, may alter the color response of an emulsion without changing the designation of the film. A better way to learn something about the characteristics of a color film is to make test shots of a flatly lighted chart consisting of swatches of differently colored matte papers, *black, white, and a Kodak Neutral Test Card of 18%* *reflectance (or a Kodak Gray Scale) to represent gray*—the toughest test for any color film. If black comes out as jet-black, white a *clean* white, and gray a *neutral* gray without overtones of color, you need not look further—you can be sure to have found a good color film.

Other factors that make one brand of color film preferable to another are contrast range and exposure latitude. As a rule, the more contrasty a film,—that is, the narrower its contrast range and the more brilliant its colors, the narrower its exposure latitude,—that is, the more limited its ability to absorb a certain amount of over- or underexposure and still produce acceptable results. In this respect, some color film will still yield acceptable (although never first-class) transparencies if overexposed up to two and one-half and underexposed one and one-half f-stops; others will hardly tolerate over- or underexposure by half a stop. The more contrasty the subject is and the less experienced the photographer, the greater the exposure latitude of the film should be. Negative color films, as mentioned earlier, have considerably more exposure latitude than positive color films.

The variables

Color film is a highly complex and perishable commodity easily affected by outside influences. Already during manufacture, despite elaborate controls, minor variations in speed, contrast, and color balance among color films of the same type are unavoidable. Kodak manufacturing tolerances hold these disparities to within plus or minus one-half stop in speed while color balance is not allowed to vary in any direction by more than the equivalent of a 10 CC filter. In addition to these unavoidable variables, other avoidable and usually more serious deviations from standard may be caused by unsuitable storage conditions before or after exposure, and by variations in the processing of color films. Together, these variables may cause greater changes in color rendition than those caused by relatively large fluctuations in the quality of the light for which the film is balanced. This fact, of course, would make the use of corrective filters illusory unless the photographer (1) eliminates the avoidable variables by correctly storing, handling, and processing his film, and (2)

p. 90 precisely establishes by test the extent of the unavoidable variables so that he can correct them by suitable means.

Variations due to manufacture. These are generally greater among emulsions from different batches than among films with the same emulsion number. Film emulsion numbers are stamped on film boxes and embossed on the margin of sheet films. Whenever a series of related pictures must be taken, to minimize variations in color rendition it is strongly recommended to shoot all photographs on film carrying the same emulsion number.

p. 90 The only accurate way to find out if color film conforms to standard and, if not, the extent to which it deviates, is by means of actual tests as described below. True, the supplementary data sheets packed by the manufacturer with color sheet film contain specific information pertaining to the particular film emulsion. However, it has been my experience that this information, valuable as it is as a guide, is not infallible, probably because of subsequent changes in the emulsion due to adverse conditions during shipping and storing. Reliance on such data is therefore no substitute for actual tests.

To guard against variations in color rendition, I make it a practice to buy color film in quantity whenever possible, making sure that all the rolls or packages carry the same emulsion number. However, before I take home my supply, I have the dealer put it aside while I take out one roll or package of sheet film for testing. If the test is satisfactory, I collect the rest and store it in my freezer. If unsatisfactory, I try film with a different emulsion number. Photographers who don't use enough film to justify buying in bulk might do well to get together with others and do their buying and testing collectively.

Variations subsequent to manufacture. Color film is more susceptible than black-and-white film, to damage by heat, humidity, moisture, and certain vapors and gases, notably the fumes given off by ammonia, formaldehyde, carbon tetrachloride and other solvents, and internal combustion engines. These agents, by affecting the three emulsion layers differently, upset the color balance of the film and may also cause overall changes in contrast and speed. To minimize these and other dangers, photographers should do the following:

Watch the expiration date. Color film ages, deteriorates, and eventually becomes useless, no matter how suitable storage conditions may be. Consequently, the longer the time between manufacture and developing, the greater the danger of changes in the characteristics of the film. For this reason, manufacturers stamp an expiration date on every film box, indicating the date

beyond which the film should not be used. Check this date when buying your film and refuse film that is either outdated, or unreasonably close to the expiration date. However, it has been my experience that color film that was very "fresh" when bought (that is, with a long period ahead of it before expiration) and stored continuously in a freezer until it was used, kept its characteristics at least a full year beyond the manufacturer's expiration date, still producing beautiful results.

Protect against heat. The destructive influence of heat upon color film emulsions is best illustrated by Kodak's comments regarding the storage of Kodachrome and Kodacolor films; these will keep for two months at temperatures up to 75° F, for six months at temperatures up to 60° F, and for twelve months at temperatures up to 50° F.

The best way to keep color film fresh for any length of time is to store it in a freezer at temperatures between 0 and −10° F. However, a difference must be made between factory-sealed and opened packages of color film. Factory-sealed film is packed in airtight, moisture-proof wrapping and thus protected from humidity (but not from heat); opened packages are not. Therefore, once the moisture-proof barrier has been broken, film that is to be refrozen, must first be desiccated by placing it together with an adequate supply of a desiccating agent like silica gel in a vapor-proof container for anywhere from two days to a week, the exact time depending on the amount of drying agent used and the relative humidity of the air to which the film had been exposed. Subsequently, the dried film is packed in a waterproof container or wrapping material, sealed with waterproof surgical tape, and refrozen.

Film that has been frozen must be given several hours to thaw and warm up to air temperature before the moisture barrier is broken. Otherwise, moisture from the air would condense on the cold surface of the film and penetrate the emulsion, causing streaks and spots. Frozen film is also extremely brittle, and 35-mm film in particular might tear or break if used in ice-cold condition.

Color film that cannot be stored in a freezer (or at least a refrigerator) must be kept in the coolest practicable place. Beware of attics or lofts (which get too hot) and basements (which get too damp), the glove compartment and rear decks of automobiles, shelves near radiators or hot water or steam pipes, and all places exposed even temporarily to the sun. Kodak advises traveling photographers to carry their film supply in a suitcase tightly packed with dry clothes, which provides good heat insulation and absorbs humidity before it gets to the film. Needless to say, equipment cases and containers with film

should never be left standing in the sun. Remember, as well, that a portable icebox makes an excellent storage place for color film on automobile trips in hot countries; a heat-reflecting aluminum equipment case is better than a nonmetallic one, and the worst possible color for a film storage container is black.

Guard against moisture. Factory-sealed film is adequately protected against dampness by its moisture-proof wrapping. Exposed film, however, unless it can be developed without much delay, may have to be desiccated with the aid of a silica gel and subsequently kept in a moisture-proof sealed container if more or less serious deterioration is to be avoided. Excellent containers for desiccating 35-mm and rollfilm are stainless-steel developing tanks with tight lids sealed with waterproof surgical tape.

Beware of X rays. In hospitals, doctors' offices, laboratories, and other places where X-ray equipment or radioactive material is used, damage from radiation must be considered. If film must be stored in or near such localities, it is advisable first to test the safety of the contemplated storage place: leave one of the safety badges containing a piece of photographic film which X-ray personnel carry pinned to their clothing at the selected spot, for several days; then develop it. If the film is unaffected, the place should be safe for storing color film.

General precautions. Do not break the moisture-proof seal of film packages until the film is needed. Do not leave sheet film in holders longer than absolutely necessary. As far as possible, protect your film holders and film carrying case from the sun and bright light in general. Do not expose 35-mm or rollfilm cameras loaded with color film to the sun longer than absolutely necessary; keep them in the shade between shots (if there is no shade, use the shade cast by your body). Have your exposed color film developed as soon as possible. When traveling, ship exposed color film home by air as soon as you can instead of carrying it with you for the rest of the trip.

Testing

Clearly, before a photographer who takes his color seriously spends money on film and effort on shooting pictures, he should demand accurate information in regard to two vitally important factors: the precise way in which his particular color film emulsion reproduces color, and its *actual* speed. For no matter what manufacturers of color film may say in their advertisements, there is no

"perfect" color film; different brands of color film vary widely in their response to color; even within the same brand and type of color film, considerable fluctuations in regard to color rendition and film speed may occur. For these reasons, it is wise to conduct a test each time you buy a new batch of film.

To have any value at all, a color-film test must be performed under strictly standardized conditions. This means that the test object, the light, the camera, the lens, the respective diaphragam stops and shutter speeds used, and the distance between test object and camera as well as between test object and photolamps must be the same in every test because, otherwise, the resulting data would be useless and valid comparisons between the results of different tests impossible. And *before* a photographer makes his first test, I suggest that he have a competent camera repairman check his shutter in regard to accuracy at all speeds and consistency at each setting. He probably will learn that few, if any, of his shutter speeds are what they are supposed to be—a common occurrence that is not serious as long as deviations from the listed speed are not too great and the photographer knows the *actual* value of each speed (the repairman will prepare a little shutter-speed card for him). Guard against shutter speeds that vary from one shot to the next, usually as the result of accumulations of dirt and gummed oil within the mechanism. Such shutters must be cleaned before they can be adjusted and used.

Each type of color film must be tested in the light for which it is balanced—that is, daylight-type color film in "standard daylight," Type A film in 3400 K photoflood-lamp illumination, and Type B film in 3200 K tungsten-lamp illumination. To conduct a valid test, proceed as follows:

Prepare a setup consisting of swatches of different colored matte papers plus a good-sized swatch of dead-black material, one that is pure white, and a Kodak Neutral Test Card of 18 percent reflectance (or a large Kodak Gray Scale) to represent gray, and a live model (to represent skin tones). Evenly illuminate this setup with the appropriate type of light and make a series of test shots around the exposure indicated as correct by your exposure meter, using the same shutter speed for all the pictures but varying the diaphragm aperture by one-half f-stop between exposures. In this way, make a sequence of five or seven photographs ranging from severe underexposure through correct exposure to severe overexposure. For permanent foolproof identification of each shot (without which the entire test would be a waste), write the following data on a piece of paper which you include in your setup: brand name and type of color film; emulsion number; date of test; type of illumination; identification of camera and lens. Also, prepare a set of smaller cards on which you write the

pertinent data for each shot: f-stop number, shutter speed and, if necessary, type and density of the color-correction filter used. Place these cards so that they appear prominently in the pictures (don't forget to change them after each shot). Conspicuously mark the card which contains the data that according to exposure meter ought to be correct. If this particular test shot turns out to be the one with the best exposure, the *actual* speed of the tested emulsion is the same as its *listed* speed; if not, you know right away whether this particular film is slow or fast.

Use a tripod to ensure that all shots are made at the same distance and to avoid accidental camera movement, which might blur the rendition just enough to make reading the data cards impossible. To minimize the danger of color distortion due to processing variations, have the test film developed by the same color lab that does your regular work.

A test of this kind provides priceless information in three respects: film speed, exposure latitude, and color rendition. Evaluation in regard to speed and exposure latitude is obvious. Evaluation of color rendition should mainly be based upon rendition of the gray and white areas of the test chart: the "cleaner" and more neutral the steps of gray, and the "whiter" the white (that is, the less degraded by overtones of color—a greenish, bluish, or pinkish tinge), the better the color balance of the film.

For accurate evaluation of the test, the individual transparencies should be masked, mounted side by side in a black cardboard frame, and viewed in a dim room on a light-box or a light-table illuminated by light with a color temperature of 4000 to 4500 K and a brightness of at least 100 (better 150) candles per square foot. If the grays have a color cast, view the test shots through a
p. 68 Kodak Color Compensating Filter in the complementary color until you find a filter through which the gray appears neutral. Then run another test, using a filter in the same color but of *half the density* as the viewing filter. A second test is necessary because eye and color film often react differently, and a visual match does not necessarily guarantee a similar result on film.

TEN DO'S AND DON'TS FOR FILM CARE

1. Do not touch the film emulsion with your fingers or hands; if you do, indelible marks may appear.

2. Hold films or negatives by the edges only, for the reasons stated above.

3. Dampness and heat quickly destroy unexposed film and slowly deteriorate negatives and color transparencies. To avoid these consequences, both unexposed and developed films must be stored in a cool and dry place (dryness is more important than coolness). In summer, don't keep film in the glove compartment or trunk of a car.

4. Always load your camera in the shade. No "daylight-loading" film is so light-proof that it can stand direct exposure to the sun without fogging along the edges. If there is no shade, turn your back toward the sun and load the camera in the shade cast by your body.

5. When buying film, check the expiration date stamped on the package; it is your guarantee of freshness. Outdated film has lost some of its speed, is less contrasty, may be partly or wholly fogged, and, in the case of color film, it may produce unsatisfactory color.

6. Be sure that rollfilm is always wound tight (but never "cinch" a roll by holding the spool tight and pulling the paper leader—this will cause marks on the emulsion). Don't allow the film to loosen in loading a camera—if it does, it may become light-struck. Thread the end of the paper leader or film carefully into the slot of the take-up spool, fold it over sharply so that is does not form a bulge—if it does, the film may later become light-struck.

7. Filmpacks are delicate; hold them only by their edges. Don't squeeze their flat sides—if you do, light may get into the pack and fog the film.

8. Pull film tabs s-l-o-w-l-y. If you don't, friction may generate static electricity, which causes marks on the film. Such marks may also be caused by excessively fast operation of rapid winders and motor drives. Static marks appear in the negative as small black wiggles, star shapes, or rows of dots. They are most likely to occur when the air is cold and dry.

9. When loading sheet-film holders, be sure that the emulsion side faces the slide. All sheet film has identification notches in one corner. These differ with each make and emulsion type and can be distinguished in the dark by feeling. *The emulsion side faces you if the film is held vertically and the notches are in the upper right-hand corner.*

10. When shooting pictures in bright light, don't leave the camera uncovered longer than necessary. If you use filmpack or sheet film, to prevent light from fogging the film, shade the slot of the holder with the slide or cover it with the focusing cloth when the slide is pulled.

EQUIPMENT TO WIDEN THE SCOPE OF YOUR WORK

Additional camera for a different purpose
Additional interchangeable lenses
Extension tubes and auxiliary bellows
Lighting equipment
Tripod

Additional camera

As we have already stated, no "universal" camera exists that is equally suitable to every kind of photographic work. Therefore, if a photographer is interested in two or more different fields of photography, it may become necessary for him to acquire a second camera. For example, for candid photography of people, the 35-mm rangefinder or single-lens reflex cameras are unsurpassed; however, although they will also take pictures of buildings, they are basically unsuited to architectural photography because their film size is too small to render fine detail with satisfactory precision, and they lack the required adjustments for perspective control: in most pictures of buildings taken with 35-mm cameras, the vertical lines converge, creating the impression of houses about to collapse. Hence, if a photographer seriously intends to photograph *both* people *and* architectural subjects, for satisfactory results in both fields he would need two different cameras: a 35-mm rangefinder or single-lens reflex camera, and a 4 x 5-inch view camera. The ten basic camera designs from which a photographer can choose are listed on p. 26.

Additional lenses

No lens exists that is equally suitable to all photographic tasks. It is for this reason that so many cameras feature interchangeability of lenses: if the regular or "standard" lens is unable to do a particular job, perhaps a
p. 52 "wide-angle" lens, one that includes a larger angle of view, will be able to do
p. 54 it; or a "telephoto" lens, a lens which, from the same camera position, renders
p. 51 the subject in larger scale than a standard lens; or a "high-speed" lens, a lens which is "faster" than a standard lens and therefore permits a photographer to get a picture even in light that is too dim for his "normal" lens; and so on. Acquisition of one or more lenses with specific characteristics therefore enables a photographer to broaden the scope of his work by branching out into heretofore inaccessible fields. The twelve basic lens types from which a photographer can choose are listed on p. 51.

Extension tubes and auxiliary bellows

Design and mechanical restrictions limit the focusing range—the maximum distance between lens and film—of any camera, thereby limiting a photographer's approach to his subject. For it is one of the laws of optics that the shorter the distance between lens and subject is, the longer the distance between lens and film must be if the picture is to be sharp. Now, if the subject is very small—for example, a flower or an insect—photographing it from the shortest distance which the focusing range of the camera permits would result in an impossibly small rendition. To overcome this handicap, most cameras with interchangeable lenses can be fitted with special extension tubes or auxiliary bellows which increase their focusing range and enable a photographer to approach small subjects much more closely than would have been possible without the aid of these devices, permitting him to produce pictures in sufficiently large scale. If you are interested in close-up photography, make sure that the camera of your choice permits the use of extension tubes or auxiliary bellows.

Lighting equipment

Photographic lighting equipment can be classified as follows:

Lamps producing continuous light

Floodlamps
Spotlights
Fluorescent lamps

Lamps producing discontinuous light

Flashbulbs
Speedlights

Lamps producing continuous light have the great advantage over lamps producing discontinuous light in that the photographer can see exactly what he is doing: he can avoid overlighted areas; he can use a reflected-light exposure meter to check the contrast range of his subject and thereby produce well-balanced color transparencies and slides; he can see which part of the subject will catch the light and which will be in shade; and he can control the form and position of shadows. The disadvantages of this type of light are its relatively

low intensity, which prohibits the use of action-stopping high shutter speeds, and the large amount of heat generated by floodlamps and spotlights which, if placed too close, can scorch paper and wood and blister paint.

Floodlamps have high light output and relatively short life. They produce continuous and rather evenly distributed light suitable for both black-and-white and, if used at rated voltage, color photography with Type A and B color films. Floodlamps are equally suitable as main lights and as fill-in lights and are available in five different types:

Photoflood lamps (3400K) look like ordinary frosted household bulbs, but they produce considerably more light per watt. Because they are overloaded, they burn out in a few hours. They are the least expensive source of high-intensity photo-illumination. For maximum efficiency, they must be used in suitable metal reflectors. They are designed for use with Type A color films.

Professional tungsten lamps (3200K). In appearance and use, these lamps are similar to photoflood lamps, but since they are less overloaded, their light is slightly more yellow and their light-output is somewhat more constant in color and brightness throughout the lamp's life, which is longer than that of a photoflood. They must be used in suitable metal reflectors and are designed for use with Type B color films.

Blue photoflood lamps (4800K). These are ordinary photoflood lamps which have blue instead of colorless glass bulbs. They are intended mainly as fill-in and supplementary lamps for use with daylight color film in daylight color shots of interiors in which the main illumination is provided by daylight coming through windows. They must be used in metal reflectors. If they provide the sole source of illumination, because their light is slightly more yellow than standard daylight, photographs taken with blue photofloods on daylight color film have warmer, more yellow tones than photographs taken in daylight, an effect which can be very pleasing. Used with panchromatic films, blue photoflood lamps render red and reddish tones somewhat darker than regular photofloods, an effect which makes these lamps particularly suitable for taking portraits of men.

Reflector floods and reflector spots. Lamps of this type have their own reflector built into the bulb. This, of course, makes them very convenient when one is traveling because it eliminates the need for space-consuming reflectors. They come in a number of different makes and models that give a photographer a choice of floodlight and spotlight effects, and larger and smaller lamps with

96

higher or lower light output. Lamps of this type are available with color temperatures of either 3400K or 3200K for use with Type A and B color films, respectively.

Quartz-iodine lamps (also called "Iodine-quartz" or "halogen" lamps). These lamps have a tungsten filament mounted inside a Vycor or quartz tube filled with iodine gas. A tungsten filament glowing at high temperatures in an atmosphere of nitrogen gas evaporates a continuous stream of microscopic particles which are deposited on the inside of the glass bulb, darkening it with age. Iodine gas prevents this darkening and the light output of the lamp remains constant during its twenty-five to thirty-hour life. Quartz-iodine lamps produce an intensely bright light. They are powered either by A.C. house current or by a battery pack which makes it possible to use such lamps outdoors as fill-in lights. Quartz-iodine lamps are available in two types: those that produce light of 3400K for use with Type A color films, and those that burn at 3200K for use with Type B color films.

Spotlights concentrate the light of a projection-type filament lamp by means of a spherical mirror behind, and a condenser or Fresnel lens in front of, the bulb. All better spotlights can be focused—that is, the light can be varied from a narrow beam to a broad cone by adjusting the lamp and reflector in relation to the condenser. Spotlights give a sharper and more intense illumination than floodlamps and their light makes harsher and more sharply defined shadows. They are good main lights and accent lights; they cannot be used as shadow fill-in lights. Most spotlights are suitable for color photography with Type B films if they are equipped with a 3200K lamp. A spotlight with a greenish condenser lens may cause a slightly greenish color cast; this can be prevented if a suitable CC filter is used (the right filter must be determined by test). Spotlights come in many sizes from tiny baby spots of 150 watts for table-top photography to the huge 5000-watt lights used in commercial studios for lighting sets.

pp. 282, 283

p. 68

Fluorescent lamps emit light that differs from ordinary types of light (daylight, tungsten light) in that it has a line spectrum superimposed upon a continuous spectrum. This is of no consequence in black-and-white photography, but must be reckoned with in color photography. The same colors seen in daylight and in fluorescent light may appear identical to the eye, but differences in the spectral compositon of these two types of light would make these colors appear different if photographed on color film. For this reason, fluorescent lamps are basically unsuited to color photography.

On the other hand, since fluorescent light is becoming more and more widely used, taking color photographs in fluorescent light is often unavoidable. Recognizing this, Kodak has suggested the following light and filter combinations and accompanying exposure increases for use with Kodak color films which, however, are only intended as a starting point for test series to be made by the individual photographer. In mixed daylight and fluorescent light illumination, suitable filtration is very difficult and may be impossible to achieve.

| Kodak color film type | Daylight | Type of fluorescent lamp | | |
		White	Warm white	Cool White
Daylight Type	20M + 20Y + ⅔ stop	Not recommended	Not recommended	Not recommended
Type B and Type L	85B + 30M + 30Y + 1 stop	20M + 20Y + ⅔ stop	20M + 20Y + ⅔ stop	40M + 50Y + 1⅔ stop
Type A	Not recommended	30M + 10Y + 1 stop	30M + 1 stop	30M + 40Y + 1⅓ stop
Type S and Kodacolor	Not recommended	20M + 10Y + ⅔ stop	20M + 10Y + ⅔ stop	30M + 20Y + 1 stop

NOTE: This table does not apply to deluxe fluorescent lamps.

Fluorescent light has a softly diffused quality and is, particularly if a number of fluorescent tubes are mounted together in a bank, virtually shadowless. In black-and-white photography this makes fluorescent lamps unsurpassed for shadow fill-in and for subjects which require shadowless illumination.

Lamps producing discontinuous light have, of course, the great advantage that they enable a photographer to render motion sharp. In this respect, although electronic flash is superior for stopping action, flashbulbs have the edge over speedlights in that they are much more efficient when high-intensity illumination is needed: flashbulbs provide it at a fraction of the cost, weight, and bulk that an equally effective speedlight setup would entail. On the other hand, a speedlight has the advantage of being a repetitive light source—no time is wasted as it is in changing flashbulbs. The main disadvantage of all lamps that produce discontinuous light is, of course that the photographer cannot know precisely how light and shadow will be distributed in the picture (although some electronic flash lamps contain small incandescent modeling lights to facilitate setting up the lights correctly), nor can he measure the subject's contrast range.

Flashbulbs, despite certain advantages over speedlights mentioned above, are all but obsolete today, at least as far as the serious amateur is concerned. However, there are exceptions: snapshooters and weekend photographers still consume large quantities of Flashcubes and FlipFlash bars which, in conjunction with inexpensive cameras, are very practical for making unpretentious color photographs. And professional photographers use flashbulbs as an inexpensive and practical means for illuminating large industrial and other interiors, often in conjunction with so-called slave units, which permit firing a flashbulb away from the camera by remote control, without the nuisance of trailing wires.

Flashbulbs are available in different sizes, types, and colors. When buying, keep the following in mind:

Size and light-output are directly related: the larger the bulb, the brighter the light. Light-output ranges from about half a million to five million lumens, as a result of which there is a flashbulb for just about any kind of job.

In regard to type, distinguish between two types of flashbulbs: ordinary bulbs suitable for use in conjunction with cameras featuring between-the-lens shutters; and special Class FP flashbulbs, which are the only ones that will work satisfactorily if the camera is equipped with a focal-plane shutter.

In regard to color, distinguish between clear-glass flashbulbs intended for use with black-and-white films, and blue-coated flashbulbs designed for use with daylight color films.

Time to peak is the length of time a flashbulb requires to reach its full intensity from the moment of ignition. It varies with different classes of flashbulbs and must be considered in the interest of satisfactory synchronization between peak brightness and the moment the shutter is wide open.

Exposure with flashbulbs is determined on the basis of guide numbers furnished by the manufacturer. These, like all other pertinent data, are listed in the data sheets which are available at photo stores at no extra cost.

Electronic flash or speedlight has two great advantages over incandescent or fluorescent light: it eliminates worry in regard to unsharpness caused by subject motion or accidental camera movement during the exposure; since flash duration is measured in thousands of a second, all normally encountered motion will be "frozen" and, provided the lens was focused correctly, the picture will be razor sharp. Second, because its light-output is constant and predictable in regard to brightness and color, provided the exposure is made

on daylight color film either automatically or in accordance with the flash unit's true guide number (see below), color rendition should be excellent. Because of these characteristics, day in and day out, hordes of photographers all over the world who know nothing about photography except how to load a camera with film and where to press the button, crank out millions of pictures of surprisingly high technical quality. And electronic flash is not only the snapshooter's best friend; it also serves as an indispensable tool for the pro who makes his living in photography: almost every professional studio today relies mainly on electronic flash. Not to mention wedding photographers, ships' photographers, passport and ID photographers, photographers of babies and children, in-plant photographers and police photographers—none of whom would know how to stay in business were it not for electronic flash. Flash at the camera may not produce great photographs, but it has one advantage which endears it to millions: it works.

Before proceeding further, I want to clear up a common misunderstanding: popularly, speedlights or electronic flash are often referred to as "strobes." This is technically incorrect. To use an analogy: a speedlight can be compared to a single-shot rifle, a strobelight to a machine gun. The first yields individual flashes, whereas the second produces a continuous series of flashes spaced at certain adjustable, but usually very short intervals. In other words, while all the popular electronic flash units are speedlights, they are not "strobes."

All speedlights consist of five main parts: a power supply (batteries or AC house currect), a condenser (capacitor) in which a high-voltage electric charge is stored until it is needed, circuitry for triggering the flash at the moment the camera's shutter is open, a flash tube filled with pressurized gas which lights up while under the influence of a surge of high-voltage current, and a reflector which directs and concentrates the light on the subject.

Speedlights are available in a wide variety of models that differ in size and weight, light-output, constructions, refinements, and price. They range all the way from bantam-sized units light enough to be mounted on top of a 35-mm camera to large professional models costing thousands of dollars and powerful enough to light up entire convention halls. But regardless of such differences, all speedlights share the following characteristics:

1. A flash duration short enough to "freeze" on the film any normally encountered subject motion. As a result, the photographer can stop worrying about pictures that are blurred due to movement of either the subject or the camera during the exposure.

2. Uniformity of light-output. As long as the unit is given enough time to fully charge its capacitor, each flash will be as powerful as the one before or after, a fact which enables a photographer to calculate his exposure precisely on the basis of the guide number that applies to his unit—unless, of course, the unit is automatic and times its own exposures.

3. Illumination approximate in color to that of standard daylight. As a result, color photographs taken on daylight color film exposed by speedlight illumination usually show excellent color.

4. Synchronization of film exposure and flash is possible at any shutter speed if the camera is equipped with a between-the-lens shutter. However, if the camera features a focal-plane shutter, synchronization is possible only at relatively low speeds because, at higher speeds, the shutter curtains don't open fully, with the result that only part of the film would be exposed.

5. Illumination impossible to evaluate precisely in terms of light and shadow. With big studio speedlights, however, this problem is solved (after a fashion) thanks to small incandescent guide or modeling lights built into the flashlamp heads.

6. Light intensity at the subject plane impossible to measure with ordinary light meters (or the light meter built into the camera). As a result, unless the speedlight unit is of the automatic kind, the photographer must either use an electronic flash meter or calculate his exposure on the basis of guide numbers p. 62 (see below).

7. High initial cost, but relatively low cost of operation.

Mode of operation. Speedlights are powered either by batteries (all amateur units) or by AC house current (all large professional models). Many, however, can be operated alternatively with either form of current.

Light-output and exposure calculation. The light-output of a speedlight unit, knowledge of which is indispensable for reliable exposure calcuation, can be measured in different ways. At the present time, most amateur speedlights are rated by their manufacturers on the basis of a system which uses guide numbers that relate to the speed of Kodachrome 25 daylight film in accordance with the following formula:

$$\text{f-stop} = \frac{\text{guide number}}{\text{distance in feet between subject and speedlight}}$$

101

This would be perfectly adequate provided the ratings are accurate and the photographer works with Kodachrome 25 film. Unfortunately, however, such ratings are sometimes inflated and, if films other than Kodachrome 25 Day are used, the then applying guide number must be established by recalculation or conversion in accordance with the ASA speed of the respective film.

In view of these uncertainties and complications this author suggests that the reader establish *by test* the guide number which precisely applies to his own speedlight in conjunction with his favorite film. This is easily done. Simply take a series of exposures with different f-stops bracketed at half-stop intervals around a value that ought to be correct on the basis of a calculation which uses the speedlight manufacturer's "official" guide number, modified, if necessary, in accordance with the speed of the film you use (if it is faster than Kodachrome 25). To simplify the subsequent calculation, place your model exactly ten feet from the flash-equipped camera and make notes on the f-stop with which each shot of the series was made. The best way to do this is to write each f-stop number on a card which the model holds up to the camera so that it appears on the film and thereby becomes a permanent part of the record. Subsequently, the developed transparencies should be examined and the best exposure picked out. Since the f-stop number with which it was made is known, the *accurate* guide number for the speedlight used in conjunction with this particular film can easily be calculated on the basis of the following formula:

$$\text{Guide number} = \text{f-stop number multiplied by subject-to-flash distance in feet}$$

For example, if the manufacturer's guide number for the speedlight was 56 and the subject-to-flash distance ten feet, the best exposure should be the one made at f/5.6. However, let's assume that, on the basis of this test, the best exposure was the one made at f/4.5 (half-way between f/4 andf/5.6). In that case, the light-output or "speed" of the unit was obviously overstated by the manufacturer because its actual or effective guide number is not 56, but 45.

Exposure calculation or automation. Each time a photographer varies the distance between subject and flash, he has to recalculate the required f-stop. This is not only a nuisance but also a potential source of failure because misjudging the subject-to-flash distance by only two feet—say, guessing at 5 instead of 7 feet—already makes a difference of one f-stop. Furthermore, guide numbers are based on "average" shooting conditions, which means indoors in rooms with light (but not white) walls and white ceiling, and if a shot

has to be made outdoors at night with no reflecting surfaces nearby, an exposure based upon the same guide number would obviously be way off and the film underexposed. And this despite the fact that in both cases the photographer conscientiously calculated his exposure in accordance with the guide number established as "correct."

To avoid such pitfalls, free the photographer from tiresome and not always reliable calculations, and improve the reliablity of their products in regard to correctness of exposure under any conditions, speedlight designers invented the automatic flash exposure by making use of the principle of feedback: light reflected from the flash-illuminated subject falls upon a photo-conductive cell which, via a special electronic circuit, the moment the required exposure has been reached, shunts the surplus of the charge released by the capacitor into a "black" (non-light-emitting) tube where it is dissipated. Alternatively, other, still more sophisticated speedlights simply stop the flow of power as soon as the required exposure level has been reached with no waste of current. As a result, of course, their batteries last longer. There even are speedlights on the market which permit automatic exposure with bounce-light. As a matter of fact, p. 274 developments in the field of speedlight design are in such a flux that it would be pointless to go into more detail here since today's marvel may well be superseded by a still more fantastic innovation tomorrow. My aim here is to present a summary of what is available today, permitting the informed reader to decide what he needs. His final selection should be made at the photo shop on the basis of an actual demonstration.

Reflectors. A reflector's design has a considerable influence upon the quality of the light. Equipped with the same kind of lamp, a reflector that is small in diameter produces a harsher, more concentrated light than a reflector that is large in diameter, producing a softer illumination with less sharply defined shadows. Equipped with the same kind of bulb, a smooth or highly polished reflector produces a harsher, more concentrated illumination than a satin-finish reflector or one that has pressed-in ridges which produce a more diffused illumination. If incorrect exposures are to be avoided, one must remember that guide numbers for flashbulbs always relate to specific types of reflectors. Reflectors that "stack" take considerably less space than those that do not.

Light stands. Points to consider when buying light stands are the weight and solidity of the stand, the height to which it can be extended, and the width of its base, which is a measure of its stability. Inexpensive collapsible light stands are often so badly made that they are all but useless. A counter-balanced boom-extension arm that fits on a light stand is invaluable because it enables a

photographer to get the lamp into any position without the stand ever appearing in the picture or otherwise getting in the way.

Tripod

Almost without exception, other factors being equal, photographs taken with the camera mounted on a good tripod or steadied by another rigid support will be sharper than others that were made with the camera hand-held, no matter how high the shutter speed. In many cases the difference will be so slight as to be practically negligible and probably not worth the trouble of mounting the camera on a tripod, always provided that the nature of the subject and the circumstances surrounding the shot permit this. Still, if a tripod can be used—that is, if the subject is sufficiently static and the extra time available—I strongly urge the reader to make his pictures with the camera mounted on a tripod instead of shooting them "hand-held," even if he works with a 35-mm camera. The reward will be negatives that are uncompromisingly sharp and slides that can be projected wall-size without getting fuzzy around the edges.

There are instances where a tripod is a prerequisite for getting usable pictures at all. To mention only the most important examples: time exposures at night; close-ups in which differences measured in fractions of an inch in the distance between the subject and the lens make the difference between a sharp and an unsharp picture; interior shots made in relatively dim light with small diaphragm stops (for sufficient depth) and correspondingly long exposure time; architectural photographs in which perspective is controlled with the aid of camera "swings"; telephotographs with extreme long-focus lenses that demand an especially firm support; copy work of any kind.

The best tripod is the strongest, most rigid one; unfortunately, it is also the heaviest and the most expensive model. Unless the tripod is used only in the studio or at home, weight is a problem. Consideration should also be given to the height to which a tripod can be extended. Height in a tripod is normally proportional to its weight and bulk. I like a center post (elevator) which can be raised or lowered either manually or by a crank. It makes precise adjustments in height much easier, which is particularly appreciated in close-up photography or when the tripod is set up on uneven or slanting ground. In addition, a center post extends a tripod's useful height. However, care must be taken not to extend the center post unnecessarily high because this promotes instability, negating the purpose of a tripod. Occasionally one sees photographers who

are too lazy to extend the three tripod legs at all and instead mount their camera on the fully extended center post, where it sways like a topheavy flower at the end of a thin long stalk.

Most tripods have what I consider a serious defect: they provide no means for leveling the camera laterally; this must be done by adjusting the tripod legs. For leveling relatively light cameras, a heavy-duty universal joint can be mounted on the tripod. But for large and heavy cameras, only a special leveling adjustment which is part of the tripod will do, like the lateral tilt of the *Tilt-all* tripod.

Certain rugged tabletop tripods which, when equipped with a ball-and-socket head, can be set up on any hard, reasonably level surface, or pressed tightly against any rigid surface, vertical or slanting—a wall, a tree trunk, a telephone pole, a rock—serve as versatile supports for cameras up to 2 ¼ x 2 ¼-inch size. They can also be held against the chest, making hand-held exposures with extreme long-focus lenses or relatively slow shutter speeds less likely to be marred by camera motion.

How to Take a Picture

PHOTOGRAPHY AT THE BASIC LEVEL

Photography can be pursued on many different levels. Without any previous experience, simply by following the instructions that accompany every new camera, exposure meter, or roll of film, anyone can snap pictures that are technically adequate and pleasing to look at. This is photography on the basic level, the level at which to start, the level at which all of us began. You will be able to compete successfully at this level if you observe the following twelve "basic rules":

1. Read—and study—your camera's instruction manual. Familiarize yourself with the different controls and how they work, make a few "dry runs" involving the whole sequence of operations from loading the camera to rewinding the film before you make your first shot.

2. Load the camera with the right type of film—for slides (transparencies) or for color prints, for daylight or for photoflood illumination. Be sure to keep camera and film out of the sun during this operation or extraneous light might fog and ruin your film. If there is no shade, turn away from the sun and load the camera in the shadow of your body.

3. Photograph only subjects in which you are genuinely interested.

4. Avoid unusually contrasty subjects with which neither the film nor the automatic exposure controls of your camera can cope. For the same reason, make sure that your subject is either *completely* in the sun, or *completely* in the shade. Until you are more experienced, avoid photographing a light subject against a very dark background, and a dark subject against something very light.

5. Watch the direction of the light relative to your subject. Until you have more experience, it is best to have the light-source more or less behind your back as you face the subject.

6. Don't pose people so that they have to face the sun while having their portraits taken. This would make them squint and mar their faces with harsh and ugly shadows. Instead, arrange the pose so that the sun shines on your model's back or side, set your exposure controls for bright sunlight, then take the picture either with a blue flashbulb or with electronic flash. The only thing you have to watch out for is that no direct sunlight falls upon your lens. A good lens shade, or the shadow cast by another person placed accordingly, will prevent this.

7. Move in on your subject—whatever it may be—until it fills the entire viewfinder frame. One of the most common mistakes made by beginners is to take pictures from too far away. Such pictures contain too much, and too diversified, subject matter, and everything shown is rendered too small to be effective.

8. Watch the background behind your subject. Make sure it is not too cluttered and distracting. Often, taking a few steps in either direction, by changing the relationship between subject and background, can improve a picture enormously.

9. Set the diaphragm and shutter speed according to the exposure table in the instruction sheet that accompanies your film; or, use your camera's built-in exposure meter, or a separate exposure meter, in accordance with the instructions that accompany it.

10. Focus the lens sharply on your subject (consult your camera's instruction manual).

11. When making the exposure, *hold the camera level and perfectly still.* Spread your feet apart, brace yourself, press the camera firmly against your face and your elbows against your ribs, hold your breath, and *slowly* press the shutter release button without jerking the camera. Otherwise, your picture will be blurred.

12. Immediately following the exposure, wind the film. If the film transport and shutter cocking mechanisms are coupled, this makes you ready for the next shot more quickly; if they are separately operated, you will avoid possible double-exposure.

PHOTOGRAPHY AT THE SECOND LEVEL

Photographers who wish to progress beyond the basic level must not only know *what* to do, but also *why* to do it. For example, in bright sunlight, Kodachrome 25 film will yield correctly exposed transparencies if the lens is stopped down to f/8 and the shutter set at 1/100 sec. However, the exposure would also have been correct if a photographer had made the same picture with a diaphragm opening of f/2.5 and 1/1,000 sec., or f/16 and 1/25 sec. Giving him this information is telling him *what* to do. But in order to select the particular combination of f-stop and shutter speed which is most suitable for a specific occasion—the combination which would give him *the most effective picture*—he must know *why* he is doing what he does. It is the difference between knowing *what* and knowing *why* which makes the difference between photographing at the basic and the second level.

A photographer who works at the second level brings home pictures that are superior to those made by one who is unable to go beyond the basic level. Why? Because he is equipped to choose. After all, any subject can be rendered in an almost limitless number of different ways. But only a photographer familiar with the "Why?" will be able to make an intelligent selection among the many possible ways of rendition.

This brings us to a common misconception: the idea that photography is "easy." It is—and yet it isn't. In this respect, photography is somewhat like reading and writing: any normal person can learn to read and write without much difficulty; but having learned how to read and write does not necessarily make him a good writer. Likewise, in photography, as we have seen, camera and film manufacturers have made it very easy to make rather pleasing snapshots without any knowledge except the limited information given in the instruction sheets or booklets which they provide. But following these instructions doesn't necessarily make one a great photographer. Unfortunately, many beginners, encouraged by initial success, are loath to go beyond this "easy" stage and dig deeper into what seems like a complex and difficult subject. They want results without "going back to school." They may remember periods of learning which required hard work and entailed frustration, and view photography as a hobby, a means of fun and relaxation. But it is neither amusing nor relaxing if inadequate photo-technique makes pictures disappointing. To avoid this, students of photography must start with fundamentals and systematically learn the elements of their craft. These are presented in the following sections.

THIS IS WHAT HAPPENS WHEN YOU MAKE A PHOTOGRAPH

Light strikes the subject, is reflected by it, and makes it visible to the eye as well as to the lens.

The lens refracts the light reflected by the subject, forms an image of the subject, and projects it onto the light-sensitive film.

The film, within certain limits, responds to the light to which it is exposed in proportion to the intensity of the light. A latent—that is, invisible—image is formed by chemical interaction of the light with the molecules of the sensitized emulsion.

Development transforms the latent image into a visible image. Depending on the type of film, this image is either negative or positive: negative in ordinary black-and-white photography and if negative color film is used; positive if reversal color film is used. In a negative image the values of light and dark are reversed; in a color negative subject color is represented by complementary color. The developed film must be made impervious to further exposure by fixing in a chemical solution. To make it permanent, it must then be freed from all processing chemicals by washing or other stabilizing process before it can be dried.

Printing reverses the tone values of the image—the negative becomes a positive image. Printing—contact-printing or enlarging—of black-and-white and negative color film is essentially a repetition of the process of exposing and developing a film: the image contained in the negative is projected onto the light-sensitive emulsion of the paper, where interaction between light and emulsion produces a latent image which, after being developed, fixed, and washed, becomes the final picture.

The technically perfect negative or color transparency, besides being absolutely clean—free from spots, streaks, scratches, and fingermarks—combines sharpness (or a deliberately chosen degree of unsharpness or blur) with proper color balance, contrast, and the right degree of lightness or darkness. To make it a perfect *picture,* it must also be well composed. Four major operations contribute to first class results. They are:

Viewing
Focusing
Exposing
Processing

How these operations, their controls, and the results they produce, are interrelated, is shown in the following diagram.

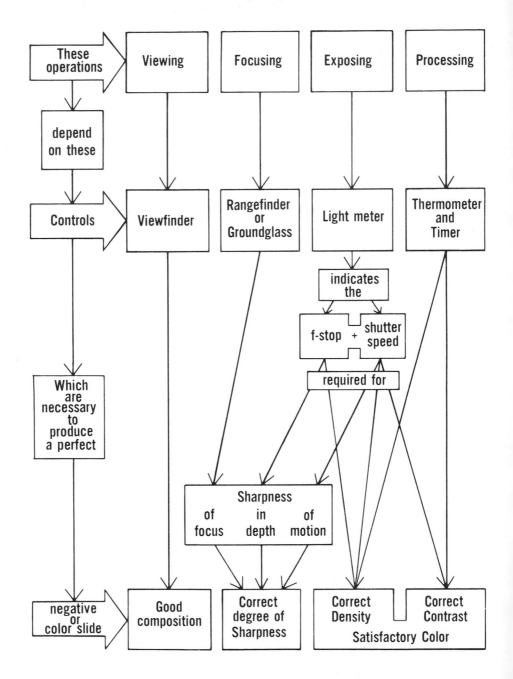

VIEWING

At the basic level, viewing is equivalent to aiming, and aiming a camera is very much like aiming a gun: the photographer lines up his subject squarely in his "sights"—the viewfinder—and "shoots," satisfied if he gets his victims on the film without cutting off their heads.

At the second level, however, viewing is what the term implies: a deliberate contemplation and examination of the subject within the confinements of the viewfinder with the aim not only to "get the subject on the film," but also to get it on the film in a form that shows it to best advantage and will make the future picture a graphically satisfactory, self-contained unit. In other words an operation which, at the basic level, amounted to nothing more than mechanically pointing the lens at the subject now becomes *composing*. Since this is a large and important topic, I have devoted an entire chapter to its discussion; see pp. 372–379.

FOCUSING

Focusing means adjusting the distance between lens and film in accordance with the distance between lens and subject to produce a sharp image. Sharpness is relative. Most negatives have areas that are sharp and areas that are less sharp but not really unsharp. Where does sharpness actually end and unsharpness begin?

Definition of sharpness

Sharpness is a psychophysiological phenomenon. Actually, one should only speak of "apparent sharpness" because sharpness is always relative. If a negative, print, or transparency appears sharp it *is* sharp as far as the observer is concerned, even though when further enlarged it would eventually become "unsharp." For if sufficiently magnified, even the sharpest negative, transparency, or print becomes unsharp. "Absolute" sharpness does not exist.

Theoretically, sharpness is when a point-source of light (for example, a star) is rendered in the transparency as a point. Practically, of course, this is impossible because even the most perfect image of a star is not a point (which has a diameter of zero) but a circle. Similarly, the image of a subject is not composed of an infinite number of points, but of tiny, overlapping circles called "circles of confusion." The smaller these circles of confusion are, the sharper the image appears.

For practical purposes, the definition of "sharpness" has been related to negative size for the simple reason that small negatives must be sharper than large negatives because they must be able to stand higher degrees of magnification during enlarging. Generally, depth-of-field scales and tables (that give the extension of the sharply covered zone in depth at different diaphragm stops in conjunction with different subject-to-camera distances for lenses of different focal lengths) are computed on the basis that negatives 2 ¼ x 2 ¼ inches and larger are "sharp" if the diameter of the circle of confusion is no more than 1/1000 of the focal length of a standard lens for the respective film size. And a 35-mm negative or transparency is considered "sharp" if the diameter of the circle of confusion is not more than 1/1500 of the focal length of the standard lens, which corresponds to a diameter of 1/750 inch.

Three kinds of sharpness. The observant reader will have noticed that three kinds of sharpness were listed in the diagram on p. 110. This is how they differ:

Sharpness of focus is essentially two-dimensional sharpness theoretically limited to the plane on which the lens is focused. It is a function of focusing.

Sharpness in depth is three-dimensional sharpness which, in the photograph, extends the zone of sharpness in two directions at right angles from the plane of focus: toward and away from the camera. It is the combined result of focusing (which places the plane of focus at the desired distance from the camera) and stopping down the lens (which extends the depth of the sharply rendered zone from the plane of focus both toward and away from the camera). It is a function of the diaphragm.

Sharpness of motion means that a subject in motion has been rendered sharp instead of blurred. This is done by accurately focusing—by placing the plane of focus at the distance from the camera where the moving subject is located—and using a shutter speed high enough, or electronic flash, to "freeze" or "stop" the subject's motion in the rendition. Sharpness of motion is a function of the exposure time.

Causes of Unsharpness

Whether or not the desired degree of sharpness is achieved depends upon the following factors:

The sharpness of the lens, see p. 45.

The sharpness of the film, see p. 76.

Camera movement during exposure. I have already mentioned that inadvertent camera movement is the most common cause of unsharp pictures, and recommended certain precautions. An additional note: the lighter and smaller p. 107 a camera, the more difficult to hold it still during exposure. To overcome this disadvantage, some professional photographers attach a quarter-inch lead plate to the bottom of their 35-mm camera to increase its weight without unduly increasing its volume; others leave a small electronic flash unit attached at all times, even when they don't intend to use it. A good way of steadying any camera is to wrap the strap around one's hand or wrist and tense it against the shoulder or neck so that its other end pulls against the camera, which in turn is pressed firmly against the face or, if a waist-level finder is used, the chest. When preparing to push the shutter release button, rest your finger on the collar that encircles it, then roll your fingertip onto the button itself; this method results in a softer release than a straight downward jab with a finger. If you add a release-extension button to your 35-mm or 2¼ x 2¼-inch camera—a small device that looks like an oversized thumbtack, screws into the release button, and considerably enlarges its surface—you will have still greater control over the exact moment of release. And unless other considerations prevail, use the highest possible shutter speed. Even though your lens may perform better at a smaller stop. What this gains you in sharpness is likely to be more than offset by a loss of sharpness due to inadvertent camera motion caused by the then-required slower shutter speed.

Subject movement. When a subject in motion is photographed, its image moves across the film during the exposure, with the result that it will be rendered more or less blurred. To reduce this unavoidable blur to a degree where it becomes unnoticeable, the picture must be taken with a shutter speed high enough so that, during the time the shutter is open, the image of the moving subject moves only an imperceptibly small distance across the film. Whether or not a shutter speed is high enough to avoid blur depends on the motion of the subject relative to the film: a higher shutter speed is needed to "stop" a fast-moving subject than one that moves slowly; or a subject that moves across the field of view than one that moves toward or away from the camera; or a subject that moves close to the camera than one that is farther away. For specific information, consult the table on p. 361.

Rangefinder out of synchronization. Check out your rangefinder as follows: take a printed page from a magazine. At approximately the center of the page, draw a black line above, another line below, the same line of print. Tape this page to a wall so that its lines run *vertically* and use it as a test object.

Mount your camera on a tripod, the lens axis horizontal and its height that of the center of the page. Place your tripod to one side of the magazine page 3 to 4 feet from it *at an angle of approximately 45 degrees* (this is not critical). Sharply focus on the type between the two lines you drew and take a picture with the lens wide open. Examine the processed transparency with a good magnifier or project it. If the type between the lines is sharpest and the rest more or less fuzzy, the rangefinder and the lens are correctly synchronized. But if a line of type other than the one you had focused on—the one between the black lines—seems sharpest, the rangefinder and the lens are out of "sync" and they must be synchronized by a competent repairman before the camera can produce sharp pictures.

Dirty lens. Fingermarks on the glass, or a filmy deposit of grease and dust particles, act as diffusers and produce overall softness of the image. To clean a dirty lens correctly, use a soft camel's-hair brush to remove all traces of dust and grit from both surfaces; breathe on the glass and, with a piece of lens-cleaning tissue, gently wipe it clean. To avoid scratching the antireflection coating, don't press too hard. Make it a habit never to touch the glass with your fingers—the everpresent acid sweat might leave indelible marks.

A dirty filter has the same effect as a dirty lens.

Unsuitable filters. Acetate filters, because of their optically poor quality, are unsuitable for taking photographs. However, they are perfectly adequate for balancing the light of an enlarger used for making color prints (as long as they are used between light-source and film and NOT between the enlarging lens and the paper) or changing the overall color of a photo lamp.

Focus shift of the lens. Some high-speed lenses shift the plane of focus with a change in f-stop. If such a lens is focused with the diaphragm wide open (as is the case in many 35-mm cameras with automatic diaphragm and built-in exposure meter) and then stopped down to shooting aperture *without refocusing,* the transparency will be slightly unsharp. To produce sharp pictures, such a lens must be focused with the same diaphragm stop with which the photograph will be made.

Turbulent air. This phenomenon can easily be seen when sighting across the steel top of an automobile that has been standing for a while in the sun: the heat rising from the hot metal in waves causes the background to wobble and appear now sharp, now blurred. Normally, this effect is too slight to cause unsharpness. But it can become serious under certain conditions: if pictures are

taken out of a window set in a sun-heated wall, waves of hot air rising past the window may blur the picture, and the same effect will often be observed when a shot is made across a hot radiator, chimney, or roof. And the magnifying power of long-focus and telephoto lenses will also magnify the effects of heat waves and turbulent air until it may become impossible to get sharp photographs. Turbulence strong enough to cause unsharpness is visible on the groundglass of an SLR, TLR, or view camera: parts of the image wobble, or the image appears partly or uniformly unsharp, only to snap suddenly (and temporarily) into sharp focus; this is the moment to release the shutter quickly before the mad dance starts again.

Buckling film. Film does not always stay flat in a camera or film holder. Under humid conditions, film, which is very hygroscopic, absorbs moisture and may buckle out of the plane of focus, the tendency to buckle increasing with film size. To minimize the danger of partial unsharpness, particularly when working with 8 x 10-inch film and a long-focus lens, it is advisable to stop down the diaphragm an additional stop or two to create a "safety zone" of extended depth of focus.

How to create sharpness in depth

Most photographic subjects are three-dimensional: in addition to height and width they have depth. This fact immediately raises two questions: which depth zone of the subject should the photographer focus on? and: how can sharpness be extended beyond the *plane* of focus to cover a subject *in depth*?

The most instructive way of finding the answers to these questions is to mount an SLR or groundglass-equipped camera on a tripod and focus it obliquely on a subject that has great extension in depth—for example, a picket fence.

Step 1: With the diaphragm wide open, focus on a fence stake 3 to 4 feet from the camera. Notice that the fence stake on which you focused appears perfectly sharp; that the fence stake in front of it and two or three behind it appears perfectly sharp; that the fence stake in front of it and two or three behind it appear reasonably sharp; and that all others are increasingly unsharp, the farther they are from the plane of focus—the fence stake you focused on.

Step 2: With the diaphragm wide open, focus on a fence stake about 30 feet from the camera. Notice that now a larger number of fence stakes than in your first experiment, both in front and behind the one you focused on, appear sharp.

Step 3: Focus on a fence stake about 15 feet from the camera and, while gradually stopping down the diaphragm, watch the image on the groundglass. Notice that, as the diaphragm aperture is decreased (and the image darkens), more and more fence stakes are brought into sharp focus.

Evaluation of this test reveals the "secret" of creating sharpness in depth:

1. A certain amount of sharpness in depth is inherent in any lens. It is the greater, the slower the respective lens and the farther the plane of focus from the camera.

2. Normally, the "inherent depth" of a lens is insufficient to cover the entire depth of the subject. It then becomes necessary to increase the zone of sharpness in depth. The means for this is the diaphragm.

3. The more the diaphragm is stopped down, the more extensive the zone of sharpness in depth; also, the darker the image and consequently the longer the exposure.

4. Stopping down the diaphragm creates a zone of sharpness in depth in front of and behind the plane of focus. Therefore, it is wasteful to focus on either the beginning or the end of the depth zone that must be rendered sharply and then stop down the lens accordingly. For example, focusing on infinity and stopping down the lens is wasteful because depth beyond infinity is useless.

5. Stopping down the diaphragm creates proportionally *more sharpness in depth behind the plane of focus* than in front of the plane of focus. This being the case, the best way to cover a three-dimensional subject in depth is to

> focus the lens on a plane situated approximately one-third within the subject's depth

and stop down the diaphragm until the entire subject is covered sharply.

How much to stop down. Selecting the most advantageous diaphragm stop usually amounts to making a compromise between two conflicting interests:

Large diaphragm apertures have the advantage that they permit a photographer to use the relatively high shutter speeds which are required to minimize the chances of getting unsharp pictures due to inadvertent camera movement and to "stop" subject motion. They have the disadvantage that the sharply covered zone in depth is relatively small.

116

Small-diaphragm apertures have the advantage that they create a relatively extensive zone of sharpness in depth. They have the disadvantage that they require proportionally long exposure times, which may result in unsharpness due to inadvertent camera movement, necessitate the use of a tripod or other firm camera support, and may be insufficient to "stop" subject motion, causing the picture to be blurred.

To determine the diaphragm stop necessary to cover a given zone in depth, observe the image on the groundglass or use the camera's depth-of-field indicator: first, focus on the nearest, then on the farthest part of the subject which must be rendered sharply, to determine their distances from the camera. Note each distance as registered on the foot scale. Refocus the lens until identical diaphragm stop numbers appear on the depth-of-field indicator scale opposite the foot numbers that correspond to the beginning and end of the zone that must be sharply covered. Leave the lens as focused and stop down the diaphragm to the f-number that appears opposite the foot-numbers that correspond to the distances at the beginning and the end of the subject-depth. In this way a maximum of sharpness in depth is created with a minimum of stopping-down.

The hyperfocal distance. When a lens is focused on infinity, sharpness in depth extends from infinity to a certain distance toward the camera. Precisely at which distance from the camera sharpness begins depends on the focal length of the lens, the diaphragm aperture, and the diameter of the circle of confusion: the shorter the focal length, the smaller the diaphragm aperture, p. 111 and the larger the diameter of the circle of confusion, the nearer the camera the beginning of the sharply covered zone. The distance from the camera to the beginning of this sharply covered zone is called the *hyperfocal distance*.

> If a lens is focused on the hyperfocal distance, sharpness in the picture extends from half the hyperfocal distance to infinity.

A photographer can easily determine the hyperfocal distance for any of his lenses at any diaphragm stop with the aid of the following formula (this could be a worthwhile job for a rainy afternoon):

$$\text{Hyperfocal distance equals } \frac{F^2}{f \times d} \text{ inches}$$

In this formula, F is the focal length of the lens in inches; f is the diaphragm-stop

117

number; d is the accepted diameter of the circle of confusion in fractions of an inch.

For example, a landscape photographer wishes to make a picture with his 4 x 5-inch view camera in which sharpness in depth should extend from infinity to as close to the camera as possible, using a lens with a focal length of 5 inches stopped down to f/22. Sharpness of the transparency should be governed by the requirements stated previously, according to which the diameter of the circle of confusion must not exceed 1/1000 of the focal length of the lens. In this case it would be 5/1000, or 1/200 of an inch. To produce the maximum extent of sharpness with a minimum of stopping down, the lens must be focused at hyperfocal distance. Then everything from half that distance to infinity will be sharp in the picture. The hyperfocal distance can be found by the formula given above which leads to the following equation:.

p. 112

$$\frac{F^2}{f \times d} = \frac{5^2}{22 \times 1/200} = \frac{25}{22} \times 200 = 227 \text{ inches} = \text{about 19 feet.}$$

Accordingly, by focusing his lens at 19 feet and stopping it down to f/22, the photographer can create a sharply rendered zone which begins at 9½ feet from his camera (half the hyperfocal distance) and extends to infinity.

And here is another useful formula:

If you want to find the f-stop that is required to create a sharply covered depth-zone that begins at a given distance from the camera and extends to infinity, the following formula will provide the answer:

$$\text{f-stop number equals } \frac{F^2}{H \times d}$$

In this formula, F is the focal length of the lens in inches; H is the hyperfocal length in inches; d is the diameter of the permissible circle of confusion in fractions of an inch.

For example, you wish to shoot a picture with your 35-mm camera in which sharpness extends from infinity to 10 feet from the camera. You use a 2-inch lens and accept a circle of confusion with a diameter of 1/1500 of the focal length of the lens, or 1/750 inch. You know by now that to get a maximum of depth with a minimum of stopping down you must focus your lens at twice the distance at which sharpness in the picture should begin or, in this case, at 20 feet (240 inches) from the camera. But how far do you have to stop down the

118

diaphragm to create a zone of sharpness in depth sufficient to cover the distance from 10 feet to infinity? Here is your answer:

$$f = \frac{F^2}{H \times d} = \frac{2^2}{240 \times 1/750} = \frac{4}{240} \times 750 = \frac{750}{60} = 12.5$$

Accordingly, by focusing your lens at a distance of 20 feet and stopping down to f/12.5, you can create a sharply covered depth-zone which begins at 10 feet (half the hyperfocal distance) and extends to infinity.

Depth of field. The sharply covered depth-zone in a photograph is called the *depth of field*. Its extent depends upon the two following factors:

The distance between subject and lens. The farther away the subject, the greater the extent of the sharply covered zone in depth created by any given diaphragm stop. For this reason, close-ups require smaller diaphragm stops than long shots; at short subject distances, stopping down is "less effective."

The focal length of the lens. At equal subject-to-lens distances, short-focus (wide-angle) lenses have greater depth of field than long-focus (telephoto) lenses, all other factors being equal. However, if the size of the image on the film (the scale of rendition) and the f-stop are the same, the depth of field will also be the same *regardless of the focal length of the lens*. For example, if a portrait is taken with a lens of 50-mm focal length from a distance of 3 feet, and another shot is made with a lens of 200-mm focal length from a distance of 12 feet, the scale of both images will, of course, be the same. And if both pictures are made with identical diaphragm stops, depth of field will also be the same in both, although one was made with a short-focus and the other with a long-focus lens. However, as we will see later, the perspective of the two p. 344 pictures would be different.

EXPOSING

One of the requirements for a technically perfect negative or color transparency is correct exposure.

A correct exposure results when the exact amount of light necessary to produce negatives with the right density and color transparencies with pleasing colors is admitted to the film.

Overexposure (caused by too much light) produces negatives that are too

black and too dense and transparencies in which color is too light or completely washed out. Highlights (the darkest areas in a negative and the lightest areas in a color transparency) are frequently surrounded by haloes which will spill over into adjacent parts of the image. In black-and-white photography, overexposure also decreases sharpness through light-diffusion within the film emulson, promotes graininess, and produces negatives in which over-all contrast is abnormally low.

Underexposure (caused by too little light) produces negatives that are too thin and transparencies in which color is too dark. Shadows lack detail and overall contrast is abnormally high.

The two devices which control exposure are the diaphragm and the shutter, each of which has a double function:

The diaphragm controls $\Big\langle$ The amount of light admitted to the film
the extension of sharpness in depth

The shutter controls $\Big\langle$ The time light is admitted to the film
the sharpness of subjects in motion

The interrelationship between diaphragm and shutter

A larger or smaller diaphragm aperture admits a wider or narrower beam of light to the film, while a higher or lower shutter speed permits this beam of light to affect the film for a shorter or longer time. Through this dual control, we can produce a correct exposure in many different ways because, as far as the exposure itself is concerned, the effect is the same if we combine a large diaphragm aperture and a high shutter speed (and admit a large amount of light for a short time), or a small diaphragm aperture and a low shutter speed (and admit a small amount of light for a long time).

To produce photographs that are not only *technically* perfect, but also *pictorially* and *graphically* pleasing, the most suitable combination of diaphragm aperture and shutter speed must be found. The basis for its determination is the data furnished by an exposure meter whose dials, correctly adjusted, simultaneously show all the possible combinations of diaphragm aperture and shutter speed which, under the prevailing light conditions, will produce a correctly exposed negative or color transparency. The combination chosen depends upon three factors:

120

Hand-held or tripod-mounted camera. Few people can hold a camera perfectly still for more than 1/60 sec. Accordingly, to avoid accidental unsharpness through camera movement, if a picture must be taken with the camera hand-held, a shutter speed of 1/60 sec. or higher should be used and the diaphragm aperture adjusted accordingly. If the camera is mounted on a tripod, accidental camera movement is not a consideration and which shutter speed should be used will be determined by other factors.

Subject motion. If a subject in motion must be rendered sharp, a shutter speed high enough to "stop" its motion must be used and the diaphragm aperture adjusted accordingly. A table relating subject motion and shutter speed is given on p. 361.

Sharpness in depth. If this is important, a correspondingly small diaphragm aperture must be used and the shutter speed adjusted accordingly. How small the diaphragm aperture should be can be determined with the aid of the depth-of-field scale engraved on the lens mount or the focusing knob of the camera or, lacking these, by direct groundglass observation or by consulting the depth-of-field table that applies to the respective lens.

How to use a light meter correctly

Exposure tables and guides may be sufficiently accurate for average demands under average working conditions, but only a photo-electric light meter enables a photographer to do precise work. Correctly used, it not only permits him to measure the overall illumination of a scene and detect minor fluctuations in brightness, but it alone allows him to establish the contrast range of a subject through measurements of its lightest and darkest areas and, if photographs are taken indoors, to correctly adjust his lights. Shadows and backgrounds that are too dark can thus be detected and lightened with fill-in illumination, and over-lighted areas that otherwise would appear burned-out in the negative or transparency can be toned down. But although a light meter is a marvelous instrument, it cannot think. No matter how expensive and reliable your meter, unless you correctly interpret its readings in the light of present circumstances, it may lead you astray. Here are some of the facts which must be kept in mind:

Light meters "think average." If you prepare a test object consisting of three large cards—one white, one black, and one medium gray (like a Kodak Neutral Test Card)—take *an overall brightness reading* with a reflected-light integrating light meter, and expose your color film accordingly, you will get a transparency in which the three different tone values are correctly rendered.

However, should you take an individual brightness reading of each card and make a shot of each exposed in accordance with the respective meter reading, I'm sure the result would surprise you: the tone values of the resulting three transparencies would be more or less the same. In other words, the white card would be rendered as a medium gray (that is, too dark); the gray card would also be rendered as a medium gray (in this case, correctly); and the black card too would be rendered as a medium gray (that is, too light).

p. 126

The lesson which a photographer can learn from such a test is this: in combination, the three cards represented "a subject of average brightness" since the above-average brightness of the white card was compensated for by the below-average brightness of the black card. Consequently, an exposure based upon data furnished by an integrating reflected-light light meter produced a transparency in which the tone values appeared natural. And the same applied to the close-up of the gray card: representing a subject of average brightness, it too was rendered in its "natural" tone when exposed in accordance with the data furnished by the light meter.

The white card, however, represented something abnormal, a subject of above-average brightness. Now, as I mentioned above, light meters cannot "think,"—that is, they cannot distinguish between subjects of average, above-average, and below-average brightness. And since they cannot make such distinctions, they treat *all* subjects as if they were of average brightness (since this is the way they are designed)—that is, they furnish data which will make such subjects look in the transparency as if they actually were of average brightness. If you compare the individual brightness measurements that apply to the gray card and the white card, respectively, you will find that the white card gave a reading that was approximately *five times as high* as that of the gray card. However, an exposure based upon an integrated reading of all three cards (or a spot reading of the gray card alone by itself, which yielded the same result), lead to a transparency in which the white card appeared white. Therefore, it stands to reason that a shot of the white card made with an exposure only one-fifth as long as that which produced a correctly exposed transparency, must render the white card severely underexposed—that is, too dark—as a medium gray. It is for this reason that subjects of *uniformly* higher-than-average brightness, like snow or beach scenes, require more exposure than scenes of average brightness (although common sense would assume exactly the opposite) if they are to appear as light and bright in the transparency as they were in reality.

And the same apparent paradox—this time in reverse—is found in regard to

122

subjects of below-average brightness. Because they are abnormally dark, such subjects produce abnormally low readings on the light meter dial, with the result that exposure will be too long—the dark subject will be overexposed and consequently appear too light in the transparency. It is for this reason that abnormally dark scenes require less exposure than the meter indicates (here, too, common sense would lead us to assume the opposite) if they are to appear as dark in the transparency as they did in reality.

How to use a reflected-light meter

Begin by setting the film speed dial at the rated speed of the film to be exposed. p. 74
Orthochromatic films have different speeds in daylight and tungsten light; be sure you use the right speed rating. Also be sure that the film speed rating and the light meter calibration conform to the same system. Foreign films may not use the ASA system, in which case their ratings must be converted to ASA ratings before the exposure for a foreign film can be established with an ASA-calibrated exposure meter; see table comparing ASA, B.S., and DIN ratings given on p. 74.

Overall readings. To take an overall reading, the photographer must *aim the meter at the subject from the camera position*. However, he must keep in mind that any abnormally bright area or light source within the acceptance angle of the meter will raise the reading and cause underexposure of the dark subject areas. Accordingly, outdoors, overall light measurements must be made with the meter aimed at a point halfway between the horizon (or subject) and the foreground to prevent excessive sky light from inflating the reading. This is particularly important on overcast days when brightness of the sky is abnormally high in relation to the landscape. Views that include white sand, large patches of snow, brilliant reflections on water, a strong source of light (backlighted scenes and city views at night), or unusually bright foreground matter such as a sunlit cement walk, if incorrectly measured, will inflate the meter reading.

Selective readings. The great advantage a reflected-light meter has over an incident-light meter is that it permits a photographer to measure the brightness of specific subject areas. This is particularly important when subject contrast is so high that it exceeds the contrast range of the film and accurate rendition of both the lightest and the darkest parts of the subject is impossible. Under such conditions, by selectively measuring the brightness of the most important part

123

of the subject and adjusting the exposure accordingly, a photographer can at least be sure that the most important area of his subject will be exposed correctly.

To take a selective brightness reading, hold the meter 6 to 8 inches from the subject but be sure that neither the meter nor your hand casts a shadow upon the area measured, for this would falsify the reading and cause overexposure.

By taking selective brightness readings of the lightest and darkest areas of the subject, a photographer can establish its contrast range. However, in doing this, *he must disregard white and black and measure only those areas which must show detail in the picture*. For reversal color film, the maximum contrast range should not exceed 8:1 (corresponding to a three-stop difference); for negative color film, 16:1 (four stops); for black-and-white film, 64:1 (six stops).

If subject contrast exceeds the contrast range of the film, a photographer has several alternatives:

If he has control over the illumination, he can rearrange the lights, use fill-in illumination to lighten shadows, add extra lamps to lighten the background, or increase the distance between lamp and subject to tone down overlighted subject areas. Outdoors, if subject distance is not too great, he can use daylight fill-in flash or speedlight illumination, or reflectors consisting of boards covered with crinkled aluminum foil, to lighten shadows that are too dark and thus make the contrast range of the subject compatible with the contrast range of the film.

If the photographer cannot control the illumination and subject contrast exceeds the contrast range of the film, he can do one of three things:

If he uses reversal color film, he can set the arrow of the meter dial one and one-half diaphragm stops *below the value that corresponds to the highest brightness reading* (two diaphragm stops if he uses negative color film; three diaphragm stops if he uses black-and-white film). This will give good rendition in contrast and color from the brightest subject areas on down, but dark subject areas and dark colors will be rendered too dark and will show little or no detail. This method, called "exposing for the highlights," is usually *the best compromise if reversal color film is used*.

Conversely, if he uses reversal color film, he can set the arrow of the meter dial one and one-half diaphragm stops *above the value that corresponds to the*

lowest brightness reading (two diaphragm stops if he uses negative color film; three diaphragm stops if he uses black-and-white film). This will give good shadow detail, and color from the darkest color on up will be rendered correctly; but highlights will be overexposed or burned out entirely, light subject colors will appear too light or white, and in the negative, light subject areas will be rendered excessively dense. This alternative, called "exposing for the shadows," is usually the *best compromise if negative color or black-and-white film is used.*

And finally, he can settle for an intermediate exposure which will render all the intermediate tones and colors correctly but will render dark subject areas and colors too dark and undetailed, and light subject areas and colors too light or burned out. Unless excessively light and dark subject areas are small and unimportant, this method gives the least satisfactory results.

Gray card reading. By measuring the brightness of a gray card instead of that of the subject, a photographer can in effect make incident-light measurements with a reflectance-type (reflected-light) meter. To do this, he must hold a Kodak Neutral Test Card (which has the required reflectance of 18 percent) close to the subject and facing the camera* and take a brightness reading from it from a distance of 6 to 8 inches. Thus, by indirectly measuring the light that falls on the subject (instead of measuring the light reflected by it), if he takes card readings in both lighted and shaded subject areas, a photographer can establish the *lighting contrast ratio* of a scene. With reversal-type color film, p. 326 the lighting contrast ratio should not exceed 3:1. However, if subject *color contrast* is below normal—that is, if all subject colors are either light, medium, or dark—a lighting contrast ratio as high as 6:1 is permissible. For negative color film, the lighting contrast ratio can vary from 4:1 to 8:1, and for black-and-white film, from 8:1 to 16:1, the higher figure applying when subject contrast is low. For an explanation of the terms "subject contrast," "lighting-contrast ratio," and "reflectance (reflected-light) ratio" see p. 325.

White card reading. In dim light it may be impossible to get a reading with any of the methods so far described. It may, however, be possible to get a reading if a white card (having a reflectance of about 90 percent) is used; the reverse side of the gray Kodak Neutral Test Card can be used, or any card or piece of white paper with a similar reflectance such as the back of white enlarging paper.

*Strictly speaking, this position of the card applies only to front light—that is, to light coming more or less from the camera position. If the subject is illuminated by sidelight, the card must be held so that it faces halfway between the camera and the light source.

Since such a card reflects approximately five times as much light as an 18 percent gray card, *the reading taken from it must be divided by 5*. The most practical way to do this is to divide the film speed by 5 and set the film speed dial of the light meter accordingly, or to expose the film five times as long as indicated by the normally set meter (for example, 1/20 sec. instead of 1/100 sec.). If the subject is relatively dark, exposure must be further increased half a stop for reversal color, and one full stop for negative color and black-and-white film.

Hand reading. When it is impossible, impractical, or undesirable to take a close-up brightness reading of the subject, one can take a meter reading of the palm of one's hand at the camera position *if the illumination is the same for both subject and hand*. This method gives fairly accurate results if light and middle tones and colors dominate the scene, or in portraiture where the brightness of a face closely matches the brightness of the hand. If darker colors dominate, if shadow detail is important or if subject contrast is high, exposure must be increased by one-half stop for reversal color film and one full stop for negative color and black-and-white film.

How to use an incident-light meter

Set the film speed dial as described before, then, from a position immediately in front of the subject, measure the light that falls upon the subject *aiming the light collector of the light meter at the camera*. Outdoors, if the illumination is the same at both the subject and the camera positions, the reading can be taken from the camera position *with the meter held in front of the camera in line with the subject, its light collector facing the lens*. The incident-light-measuring method is especially suitable for indoor photography, particularly if more than one photo lamp is used, and outdoors for backlighted scenes.

Here is a summary of the most important requirements for correct exposure:

Set the film speed dial of the light meter correctly. If exposure determination is made with the aid of a white card, the ASA speed of the film must be divided by 5.

Shield the cell of the light meter from extraneous light and excessive skylight. Color film has considerably less exposure latitude than black-and-white film and must be exposed with great accuracy.

Exposure latitude varies with subject contrast: latitude increases as subject contrast decreases—the smaller the difference in brightness between the

lightest and darkest areas of a scene, the greater the exposure latitude. The exposure of low-contrast subjects may vary up to two stops in either direction from "correct" before the negative or transparency appears over- or underexposed, respectively.

As subject contrast increases, exposure latitude decreases and eventually becomes nil. Consequently, relatively contrasty subjects must be exposed "on the nose."

If subject contrast exceeds the contrast range of the film, correct simultaneous rendition of both the lightest and the darkest subject areas becomes impossible. If this is the case, transparencies in which the light colors (and highlights) are correctly exposed, while the dark areas (and shadows) are underexposed and appear too dark, invariably look better than transparencies in which the dark are correctly exposed while the light are overexposed and "burned out."

In color photography, overexposure is the worst mistake you can make.

How to adjust the exposure

As already indicated, numerous occasions exist which require that the exposure data established with the aid of a light meter are modified if the result is to be a correctly exposed negative or transparency. In particular, the following must be considered:

The exposure must be increased by one-half to one and one-half f-stops (use a larger diaphragm aperture or a slower shutter speed) when photographing subjects that combine *low contrast* with *above-average brightness*—for example, many snow and beach scenes, and hazy aerial views.

Exposure must be increased by $\frac{1}{2}$ to $\frac{2}{3}$ f-stops if lighting contrast is low and the illumination flat, diffused, and uniform—for example, when taking pictures on a misty day or in the rain.

Exposure must be increased by one to one and one-half f-stops if lighting contrast is still lower as, for example, when taking pictures during a snowfall or in heavy fog.

Exposure must be increased by about one-half f-stop if the scene contains an abundance of dark green foliage.

The exposure must be decreased by one to two f-stops (use a smaller diaphragm aperture or a higher shutter speed) in sunset shots of the sky; when photographing a rainbow against a background of dark gray clouds while the

foreground is illuminated by sunlight; when shooting across sun-sparkling water; and when attempting to capture the somber mood of pre-dawn and dusk.

Exposure must be decreased by one-half to one full f-stop if the subject is uniformly dark, and when taking pictures under abnormally dark outdoor-lighting conditions (but NOT at night).

The filter factor. If a color-conversion, light-balancing, color-compensating, or other kind of filter is used, the exposure must be multiplied by the respective filter factor (which is listed in the instruction sheet that accompanies the filter or in the manufacturer's promotional brochure). If two or more filters are used simultaneously, *their factors must be multiplied* by one another (NOT added), and the exposure must be *multiplied* by the common factor.

p. 68 **The polarizer factor.** If a polarizer is used, exposure must be multiplied by the polarizer factor, which is normally 2.5x. In this respect, it does not make any difference whether the polarizer is used in a position of maximum, moderate, or minimum efficiency—the exposure factor remains the same.

The distance factor. If *positive* (reversal) color film is used and the subject-to-lens distance is equivalent to or shorter than *eight times the focal length of the respective lens;* or if *black-and-white* or negative color film is used and the subject-to-lens distance is shorter than *five times the focal length of the respective lens,* the exposure must be multiplied by the corresponding distance factor, which can be determined by the following formula:

$$\frac{\text{lens-to-film distance x lens-to-film distance}}{\text{focal length of lens x focal length of lens}} \quad \text{or} \quad \left(\frac{D}{F}\right)^2$$

For example: a photographer wishes to make a close-up of an insect using a lens with a focal length of 2 inches. After focusing, the distance between lens center and film measures 4 inches. He can find the corresponding exposure factor by using the following equation:

$$\frac{4 \times 4}{2 \times 2} = \frac{16}{4} = 4$$

This means that he must expose his subject four times as long as his light meter indicated in order to get a correctly exposed negative or transparency. If the meter indicated an exposure of, say 1/40 sec. at f/11, he must multiply this by a factor of 4 and expose either 1/10 sec. at f/11, or 1/40 sec. at f/5.6.

A very practical aid for immediate determination of the exposure factor for close-ups is the Effective Aperture Kodaguide published by Kodak. This is a card with an attached dial, which after proper setting gives the *effective* aperture (that is, the value of the f-stop that applies in the respective case), the distance factor by which the exposure must be multiplied, and the scale of magnification (or reduction) of the image on the film.

The reciprocity factor. Theoretically, according to the law of reciprocity, the effect upon a photographic emulsion should be the same whether the film is exposed for one second at 100 foot-candles, or for one hundred seconds at one foot-candle. Actually, however, this holds true only if exposure times and light intensities are more or less normal. If exposure times are either abnormally long or short and if light intensities are either abnormally high or low, the law of reciprocity fails.

Reciprocity failure manifests itself as follows: if light intensity is very low, doubling the exposure time does not double the density of the film but produces less than twice that density. Nor in very short exposure times do 1000 exposures of 1/1000 sec. produce the same density as one exposure of one full second, but instead produce somewhat less. Since different films react differently to reciprocity failure, tests alone can reveal how much exposure must be increased if exposure times are abnormally long (minutes) or short (electronic flash).

In color photography, additional complications arise because reciprocity failure usually affects the differently sensitized layers of color film in different degrees. As a result, the color balance of the film will be changed and the film will have an overall color cast. To help photographers correct as far as possible the effects of reciprocity failure, Ansco and Kodak include supplementary data slips with their positive (reversal) color sheet films. These data slips show the factors by which abnormally long or short exposures must be increased and, if necessary, recommend the corrective filters that must be used for best results.

High-key and low-key renditions. If the photographer wishes to produce a high-key effect in pale pastel shades (possible only with low-contrast subjects; shadowless illumination and light colors are best suited to this form of rendition, which has been used with great success in fashion photography and portraiture of women), exposure must be increased by one to two full f-stops. Conversely, exposure must be decreased by one-half to one full stop if the photographer wishes to produce a low-key effect with rich blacks or fully

saturated colors (best results are achieved if subject colors are relatively pure, and subject contrast is low; when shooting color transparencies for reproduction, a slight degree of underexposure is always preferable to overexposure).

Bracketing

The observant reader will have noticed that in previous sections instructions for supposedly "correct" exposure were somewhat less than precise. Phrases such as "increase exposure by one-half to one and one-half f-stop," and "subjects of more-than-average contrast" (how much more?) indicate the large uncertainty factor inherent in all methods of black-and-white or color-film exposure. Add to this the fact that a photograph that pleases one photographer may be judged too light or too dark by another and you get an idea of how complex a subject film exposure is. The surest way out of this muddle, whenever possible, is to make a series of different exposures of the same subject under otherwise identical conditions grouped around an exposure which, according to exposure meter and experience, is most likely to be correct. As noted earlier, this method is called "bracketing."

p. 83

Bracketing has several advantages: it is the best guarantee for correct exposure. It gives a photographer a choice of several negatives or transparencies of the same subject which differ slightly in regard to brightness—some lighter, some darker—small differences in tone which, nevertheless, can make the difference between an acceptable and a perfect negative or transparency. Bracketing also provides one or several "spares" as insurance against accidental damage or loss of a potentially valuable transparency plus the always appreciated advantage of having several "originals" instead of only one. It is for these reasons that, wherever practicable, "bracketing" is a technique used by all successful photographers; it is part of the "secret" of their success.

Under normal conditions in regard to lighting and subject contrast, in addition to the supposedly correct exposure, a second shot should be taken with a smaller, and a third shot with a larger, diaphragm opening. Under difficult conditions—if subject contrast exceeds the contrast range of the film or if backlight provides the main source of illumination—a larger number of exposures should be made with different diaphragm stops. If positive (reversal) color film is used, the number of shorter-than-normal exposures should exceed the number of longer-than-normal exposures. However if negative color or black-and-white film is used, more longer-than-normal than shorter-than-normal exposures should be made. If positive (reversal) color film is used, the

130

individual exposures of the bracket should be spaced one-half f-stop apart; if negative color or black-and-white film is used, they should be spaced one full stop apart. Smaller intervals are wasteful; larger intervals may cause a photographer to miss the best exposure. The shutter speed of all the exposures must, of course, remain the same.

Inexperienced photographers often complain that "bracketing" is too wasteful for their means. This is a fallacy. What is wasteful is spoiling good color film through bad exposure and ending up with nothing. A photographer who brackets his shots may waste one or two exposures but is sure to come up with one perfect and very likely two or three acceptable negatives or transparencies. And—at least in my opinion—if a subject is worth photographing at all, it is worth photographing well. Photographers who really want to save on film should do this through greater selectivity—shooting *fewer* subjects but doing them *right*.

Subjects that cannot be "measured" by an exposure meter

Neon lights and city streets at night, fireworks, campfire scenes, the wheeling stars, and certain other subjects cannot be exposed according to exposure meter because no meter can "read" them correctly. Instead, a photographer must rely on published exposure tables, experience, and tests. The following data are intended only as guides.

	ASA 25	ASA 64	ASA 160
Downtown city streets at night, bright neon lights	1/10 sec. at f/2.5	1/25 sec. at f/2.5	1/30 sec. at f/2.8
Fireworks. Set the shutter at B, include several rocket bursts	f/4.5	f/7	f/11
Campfire scenes, burning houses	1/25 sec. at f/2	1/30 sec. at f/2.8	1/30 sec. at f/3.5
Star tracks at night, no moon or haze, very black sky	3 hours f/3.5	3 hours f/5.6	3 hours f/6.3

Different shutters may be differently calibrated, and none has all the different speeds commonly found in exposure tables. However, for all practical purposes, the differences between, say, 1/25 and 1/30 sec. 1/50 and 1/60 sec., 1/100 and 1/125 sec. can be disregarded.

131

THE IMPORTANCE OF INTELLIGENT COMPROMISE

It is of the utmost importance for the student of photography to realize how closely the three operations, FOCUSING, setting the DIAPHRAGM, and setting the SHUTTER SPEED, are interrelated. A change in one almost invariably demands a change in the others if the result is to be a technically perfect negative or color transparency. For example, when shooting candid pictures of people, a photographer does not always have the time to focus as accurately as desirable if he wishes to capture the fleeting moment. To guard against out-of-focus pictures, he uses a smaller diaphragm aperture, which gives him a more extensive "safety-zone" of sharpness in depth. A small diaphragm aperture, however, must be compensated by a correspondingly slow shutter speed, which in turn might lead to unsharpness due to movement of the subject or the camera. To reduce this danger, a film of higher speed can be used which permits the use of higher shutter speeds but, on the other hand, yields negative that are more grainy and somewhat less detailed than if a slower film had been used. And so on.

In practice, perfect solutions to the problem of making a photo-technically perfect negative or color transparency are rare. Usually, the best a photographer can do is to find the most *advantageous compromise* between conflicting demands. The basis for this is the data furnished by a light meter whose dials, correctly adjusted, simultaneously show all the possible combinations of diaphragm aperture and shutter speed which, in conjunction with a film of a given speed, under the prevailing lighting conditions, will produce a technically perfect negative or transparency. In particular, the following aspects must be considered:

Focusing. If the lens is accurately focused, there is no problem. In "grab-shooting," however, there is usually no time to focus carefully, and insurance against out-of-focus pictures must be taken out in the form of a relatively small diaphragm aperture, which creates a correspondingly extensive "safety-zone" of sharpness in depth.

Diaphragm. If sharpness in depth is important, a correspondingly small diaphragm aperture must be used and the shutter speed adjusted accordingly. This in turn may rule out a hand-held exposure because of insufficiently high shutter speed. How small the diaphragm aperture must be can be determined with the aid of the depth-of-field scale of the camera or by groundglass observation.

132

Shutter speed. As noted earlier, since few people can hold a camera perfectly still at shutter speeds slower than about 1/60 sec. a shutter speed not slower than 1/60 sec. must be used when the camera is hand held. The diaphragm aperture should be adjusted accordingly. Also, if subject motion must be "stopped," shutter speed must be considered first and the diaphragm adjusted accordingly; see the table on p. 361.

Realization of the interdependence of the three operations—focusing, diaphragm setting, and shutter-speed setting—and their effects upon the picture should make it obvious that they must never be considered separately; instead, they must be treated as a unit. The following graph shows the relationship of the main factors that determine the outcome of an exposure.

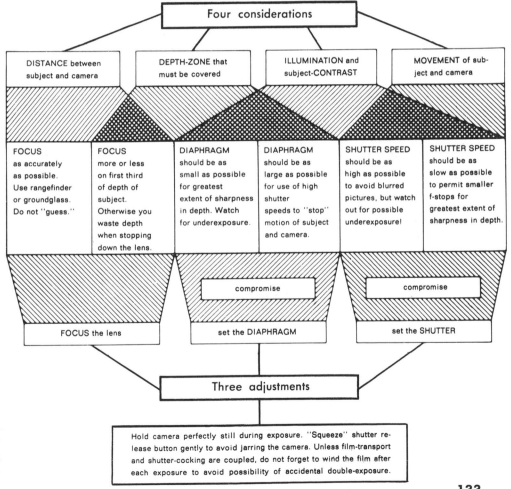

USEFUL TIPS

Unless other more important considerations prevail, always use the highest practicable shutter speed. Even though your lens may be somewhat sharper at a smaller f-stop, the corresponding slower shutter speed may more than offset this gain through blur due to inadvertent camera movement caused by a shutter speed too slow to be hand-held safely.

Remember to take the cap off the lens when working with an RF camera. The alternative: use a transparent lens cap—a colorless UV filter that can stay on the lens indefinitely without causing any undesirable color effects; it protects the lens against fingermarks, raindrops, ocean spray, dirt, and the like.

After loading the camera, do not forget to set the film counter back to zero unless the counter sets itself automatically.

Make sure the film is advancing properly by watching the rewind knob: if it turns as you wind the film, all is well; if it doesn't the film is not moving.

If you work with sheet film, don't forget to pull the slide of the holder prior to exposure. Outdoors in bright light, cover the back of a view camera with the focusing cloth to guard against light-struck negatives or transparencies.

A good way to remember what type of film is in your camera is to tear the square top off the end of a rollfilm cardboard box and tape it to the camera. Don't forget to change this tag when loading a different type of film.

When using flash in conjunction with a variable synchronizer, do not forget to set the delay-dial in accordance with the type of flash you use.

Inch-wide white surgical tape is great for making labels on which to jot notations. I use it on the backs of cameras and rollfilm holders, camera and lens cases, boxes, and the like, and wouldn't want to go on any job without a roll of it. Black photographic (masking) tape is another invaluable aid in hundreds of situations.

IV

How to Develop and Print

Once his film is exposed, a photographer can do one of three things:

First, he can give the film to a commercial or custom photo-finisher for developing and printing. This solution should be considered primarily by those who work exclusively in color, and by professional photographers whose time is too valuable to be spent in the darkroom, particularly if they have a good custom photo-lab nearby which specializes in individually customized work and provides personal contact with those who do the actual work.

His second choice is to let a commercial lab develop the film and do his own printing. This, in my opinion, is the best solution for the average photographer who uses both reversal color film (which does not need printing) and black and white. This way he can skip the "dirty work" and enjoy clean, evenly developed negatives, and still have the fun and excitement which comes from watching one's own pictures take shape in the creative atmosphere of the darkroom.

As a third alternative, he can develop and print his own films. If he works exclusively in black-and-white, this presents no problems. But if color work is involved, an investment in temperature- and voltage-control devices and in instruments for analyzing and controlling color may have to be made to produce consistently good results. This third solution should appeal particularly to the creative photographer who does not trust anyone but himself with any part of his work. True, it involves greater time, skill, and devotion, but the results can be extraordinarily rewarding.

In deciding whether or not it is worthwhile to set up one's own darkroom, the following pros and cons should be considered:

Yes—a darkroom is worth the effort. To begin, one doesn't need a permanent darkroom because first-class work can be done in improvised quarters. The main argument in favor of having a darkroom is that only by printing one's own

135

negatives can one get *exactly* the effect one had in mind. A negative can be

p. 171 printed in literally hundreds of different ways, as we shall see, and *only* the photographer can know what look he is striving for. In addition, in the long run despite the expense involved, including amortization of darkroom equipment, doing one's own developing and printing costs less than having a photo-finisher do it. Also the work itself can be immensely stimulating, because, in a sense, each print is an experiment which provides new experience, the opportunity to enrich the scope of one's work.

No—a darkroom isn't worth the effort, particularly to a photographer who works primarily in color. Color-film developing and, if negative color film is used, color printing, involves some rather critical operations that are best done in an air-conditioned, temperature- and voltage-controlled laboratory equipped with instruments that are so expensive that only a large establishment can afford them and without which precision work is difficult if not impossible. Black-and-white films, too, profit from being developed in deep tanks equipped with nitrogen-burst agitation devices rather than in small reel-type tanks, where the danger of uneven development is always present. If a photographer has a good commercial photolab nearby and can have the same printer do all his work and learn how he likes his negatives printed, then he may even get prints that are better than those he could make himself. So why set aside space for a darkroom, invest in equipment, and keep a stockpile of chemicals and sensitized paper which, unless used within the proper time, would spoil?

> A tip to those who have 35-mm film developed: to avoid loss through mix-ups or loss of address, photograph your name and address on one frame of each roll.

THE DARKROOM

To most beginners a darkroom seems formidable and expensive. But a workable darkroom is literally nothing but a dark room. It does NOT have to have running water, a built-in sink, and a waterproof floor. It does not even have to be permanent. It can be improvised in the corner of an ordinary room. Lack of a real darkroom is not an excuse for sloppy work or for doing no darkroom work at all. Many of our best photographers began their careers in improvised darkrooms.

Minimum Requirements

A workable darkroom must be dark. If there are windows, they must be made light-tight by using opaque blinds. Black roller shades that run in channels, of the type used in lecture halls and auditoriums, are most practical but expensive. A convenient substitute is black twill fastened with thumbtacks to the top of the window frame in lengths long enough to spill over the window sill or onto the floor. When I worked for *Life*, I unloaded and reloaded filmholders at night in hotel and motel rooms, making the windows light-tight with blankets fastened to the top of the window casing with two icepicks that I carried for this purpose. If space permits their storage, home-made blinds made of Masonite on wooden frames provide another simple means for darkening windows.

However, if all this seems too complicated or expensive, film can be loaded into the developing tank at night in a clothes closet (if the lights are turned off in the next room, cracks around the door do not have to be light-proofed); a daylight-loading 35-mm-film developing tank can be used which permits one to load and process film by ordinary room light; or films can be given to a laboratory for development.

Prints can be made at night. Heavy curtains are sufficient to keep out the feeble light of street lamps and sky. Small amounts of stray light are usually harmless. To be sure the space is dark enough, make the following test: darken the room; do NOT use the safelight. Place a few coins on a sheet of sensitized paper and leave it on the working table for four to five minutes. Develop and fix this test sheet in darkness with the safelight turned off. Then examine the test sheet: if the paper is uniformly white, the room is safe for printing. If the paper is gray except where the coins were placed, the room is too light and the darkening arrangement must be improved.

An electric outlet is needed for the safelight and the enlarger.

The room temperature should not be lower than 65 and not higher than 75 degrees F. If the room is colder or warmer, maintaining solutions at the correct temperature becomes too difficult. In winter an electric heater can be used to raise the temperature. In summer an exhaust fan in conjunction with light-proof louvers in the door, or better still, a room air-conditioner, permits air circulation and prevents a darkroom from getting too hot.

The water supply should be nearby. In the darkroom itself, a pail and a tray

full of water are all that is needed. Negatives and prints can be washed later under a faucet outside the darkroom.

The work table should be covered with a piece of oilcloth or Formica, which is impervious to water and photographic solutions. Several thicknesses of newspaper beneath the trays prevent accidentally spilled liquid from flooding the table or running down to the floor. However, a careful worker rarely spills solutions, mainly because he does not fill his trays too high.

The color of walls and ceiling should be white or very light green to reflect a maximum of (safe) light and thus improve visibility.

Which darkroom space is best?

A photographer who has the run of an entire house should have no trouble finding a place to install a permanent darkroom of modest scale. The apartment dweller, and especially one who lives in a furnished room, has to use much more ingenuity to arrange a darkroom for his work. Listed in order of their suitability are the following suggestions for the location of improvised and permanent darkrooms:

The basement. A corner of a dry, finished basement that can be partitioned off is an excellent place for a darkroom. Advantages: fairly even temperature the year round; electricity and running water are usually nearby; permanency of the setup permits the gradual development of a first-class darkroom.

A large closet of the type found only in old houses can easily be made into an excellent darkroom if the problem of ventilation is solved with light-proof fan and louvers installed in or above the door. Negatives and prints can be washed in the bathroom.

The kitchen, when not in use, makes an excellent improvised darkroom. It provides water, electricity, and suitable working space. Developer and wash trays go right into the sink. And if a photographer is lucky, he can appropriate a kitchen cabinet for storage of all his darkroom equipment.

The attic. Advantages are privacy and seclusion, which permit a permanent setup. However, there are often serious drawbacks. Attics tend to be brutally hot in summer and frigid in winter, and running water may not be available on the same floor.

A bed or sitting room. Advantages are plenty of space and even temperature the year round. Drawbacks: before he can start work, a photographer must darken the windows, clear a table, set up his equipment, get water from the

bathroom, switch from desk lamp to safelight, and so on. But once this extra work is done, operations should proceed as smoothly and efficiently as in any permanent darkroom.

The bathroom. Despite the advantages of running water and waterproof floor, this is the least suitable place for an improvised darkroom. Drawbacks: steam and moisture ruin equipment, chemicals, and sensitized material in a very short time; interruptions make concentrated work impossible.

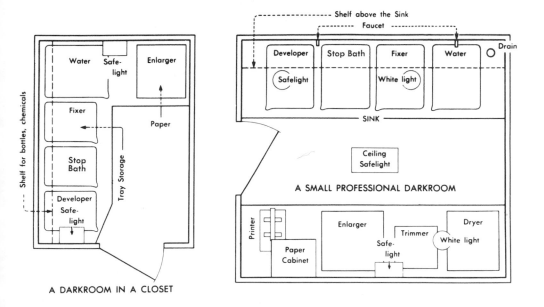

A DARKROOM IN A CLOSET

A SMALL PROFESSIONAL DARKROOM

Efficiency and comfort of any darkroom depend upon its organization. Strict separation of dry and wet operations is essential. The best layout places the dry bench along one wall and the processing sink along the opposite wall, with a 3-foot aisle between. On the dry bench, which, for a worker of average height, should be 36 inches high, 24 inches wide, and covered with Formica (next best: linoleum), will stand the dryer, trimmer, printer, storage cabinet for sensitized paper, and enlarger—in that order (working direction from left to right if the worker is right-handed, in reverse order if he is left-handed). The processing sink will contain the trays for developer, short-stop bath, fixer (hypo), and wash water. Above the sink, a shelf running the entire length of the wall provides storage space for bottles containing processing solutions. Trays, when not in use, are stored upright in racks below the sink.

139

The processing sink should be equipped with a drain and it should provide space for a minimum of four trays of the largest size to be used. Stainless steel (A.I.S.I. Type 316, 18-8) is best. Fiberglass bonded to marine plywood ranks next. For proper drainage, at least ¼ inch of pitch per running foot should be provided. Processing trays should be supported by wooden slats with triangular cross-section running the entire length of the sink. Hot and cold water faucets should be at a height above the sink that provides a minimum clearance of 15 inches to allow for the filling of regular 1-gallon jugs and 3½-gallon tanks. Installation of two faucets—one combination hot- and cold-water swing spout and a cold-water faucet equipped with a piece of rubber hose for rinsing trays and sink—makes for greater efficiency. For additional convenience—and almost a necessity in developing color film—a thermostatically controlled mixing valve is recommended to keep the water temperature constant.

Electric installation. General illumination is provided by indirect light from a large safelight suspended in the center of the darkroom that throws its light against the white ceiling. Local illumination comes from individual safelights equipped with 15-watt bulbs; one should hang from a drop cord above the developer tray; another should be mounted near the enlarger, preferably interconnected with the enlarger lamp via a foot switch in such a way that when the enlarger lamp is on, the safelight is off, and vice versa. A well-shielded white light (small spotlight equipped with snoot) operated by a foot switch belongs above the right-hand end of the sink for inspection of prints in the fixer and washer. Another white light, which also serves as general room illumination for darkroom cleaning purposes, should be installed above the trimmer.

Because of the proximity of electric wiring to metal and water, a darkroom can be a dangerous place unless the following precautions are taken: all noncurrent-carrying metal parts of both fixed and portable electric equipment must be grounded; this applies to the contact printer, enlarger, dryer, foot switches, electric timer, safelights, and so on. Furthermore, the "one-hand rule" should be strictly observed. This means that when handling any electrical equipment or operating any switch, the other hand must not touch any object or must not be in touch with any solution at all to exclude the possibility of making a direct ground connection. And an electric switch must NEVER be touched with wet hands. Electric outlets should be located above the dry bench and as close to the respective appliances as possible to eliminate the potential hazard of dangling wires.

Dust can be a source of endless annoyance in a darkroom. It settles on negatives and causes spotty prints, its effect more marked the smaller the

negative. The best way to fight dust is to periodically vacuum the entire darkroom, including walls, ceiling, and the inside of the enlarger. In addition, the following precautions help to minimize dust accumulation:

Whenever possible, the darkroom should be ventilated by filtered air forced in under pressure rather than by an exhaust system. Use of dust-producing building material such as fiber board or fabrics should be avoided. Empty containers and waste should not be permitted to accumulate. A cement floor should be painted and waxed. Accidentally spilled solutions must be wiped up before they dry and chemicals crystallize into powder, contaminating the entire darkroom. And to keep them dust-free, the enlarger and printer should be covered with plastic covers when not in use. One final suggestion:

Do not smoke in your darkroom!

How much or how little to spend on darkroom equipment is almost entirely up to the photographer. Except for the enlarger, the *essential* equipment is relatively cheap. What runs up bills are those accessories which mainly increase the comfort and ease of operations without materially adding to the quality of the print—for example, electric timers and dryers, motor-operated print washers, printing exposure meters, dry-mounting presses, and so on. Let us now examine in detail those items which, in my opinion, are essential for the successful operation of a darkroom:

BASIC DARKROOM EQUIPMENT

The safelight. Only special photographic darkroom lamps with interchangeable filters should be used. Colored-glass incandescent bulbs are not "safe." The color of the safelight filter is determined by the type of work in progress:

Dark green (Kodak Wratten Filter Series 3) for panchromatic film development. However, since panchromatic film is sensitive to *all* colors, the recommended dark green filters are safe only if the lamp is at least 4 feet from the film. Its light is intended *only* for general darkroom illumination and *not* for close visual inspection of the negatives during development.

Dark red (Kodak Wratten Filter Series 2) for orthochromatic film development.

Green (Kodak Wratten Filter Series 7) for the development of infrared sensitized films.

Light amber (Kodak Wratten Filter Series OC) for enlarging papers.

Dark amber (Kodak Wratten Filter Series 10) for Ektacolor and Ektachrome Paper, Ektacolor Print Film, and Panalure Paper.

Timer. A spring-driven timer with a range from one second to sixty minutes that rings at the time set is sufficient for most purposes. An electric timer that times exposures automatically to fractions of a second can be hooked up to the enlarger.

Thermometer. It must be accurate to half a degree. A mercury-in-glass thermometer is usually more accurate than a dial thermometer. It is best to have one of each, check one against the other, and use the dial thermometer because it is more convenient.

Graduates are used for measuring liquids (mainly developer stock solutions which must be diluted with water in prescribed proportions) and for dissolving chemicals. Glass graduates are the best. Two are needed, a small cylindrical one and a larger one with tapered sides.

Funnel for pouring solutions back into the bottle and for filtering solutions. Glass is the best material.

Stirring rods to stir dissolving chemicals; again, glass is the best material.

Polyethylene bottles. Select brown quart bottles for developers, white bottles for hypo and other solutions. Bellows-type squeeze bottles permit the exclusion of harmful air from only partly filled bottles. The hypo bottle should hold one gallon.

Plastic bucket for dissolving chemicals and preparing solutions.

Filter paper or absorbent cotton to filter out emulsion particles and other impurities from used developer solutions before re-use. The glass top of a vacuum coffee maker with a layer of absorbent cotton in its bottom, placed in a laboratory ring-stand, makes an excellent filtering device.

Paper toweling in holder mounted to the underside of the shelf above the sink.

Sponge for cleaning the sink and wiping up accidentally spilled solution.

Apron to protect one's clothing—developer spots are indelible. A nonabsorbent plastic apron is the best.

Waste basket or garbage can. A large plastic can is the best.

A roll of wide, white, surgical adhesive tape. Cut it into label-sizes, write

on it, and use it to identify bottles and cans, to keep track of the age of solutions, and to record the number of rolls developed in a developer and the amount of replenisher added.

Pad and pencil to record paper exposure times, including dodging data; to list supplies needed; to jot down ideas that occur during work.

A stool is very welcome for long darkroom sessions.

Floor mats with ribbed vinyl tops and nonabsorbent cushion vinyl bottoms placed in front of the enlarger and the developer tray are a boon for tired feet.

EQUIPMENT AND MATERIAL FOR NEGATIVE PROCESSING

Film developing tank. Its size must fit the size of the film. Capacity varies; 35-mm and rollfilm developing tanks that will accommodate one, two, or more reels simultaneously are available. Some tanks have adjustable reels that can alternatingly accommodate 35-mm and size 120 films; others permit daylight loading and processing of 35-mm films. Sheet film is best developed on stainless-steel hangers in an open tank. Plastic sheet-film hangers are not recommended.

Film clips with which to fasten drying film on a wire stretched wall to wall above the sink. Stainless-steel clips are the best. Each roll of film requires two clips, one at the top, the other at the bottom to prevent the film from curling.

Negative developer. Ready-mixed developers in powder form or in highly concentrated stock solutions are more practical than developers which the photographer mixes by combining the individual components of formulas. They are generally more uniform and dependable, they can be stored (in unopened containers) almost indefinitely, and they need only to be diluted or dissolved in water to be ready for use. They eliminate the need for a scale and for storing a number of different and sometimes highly perishable chemicals in space-consuming glass jars. They also eliminate worry about purity of chemicals, omission of an ingredient, inaccuracy of measuring and weighing, faulty compounding, and waste due to deterioration, contamination, and incorrect storage.

Developers for black-and-white films can be divided into five groups, from which a photographer must choose the one most suitable for his particular work:

Standard developers act fast and thoroughly, utilizing the full inherent speed of a film. They are the best developers for processing negatives 2¼ x 2¼ inches and larger. In my opinion, they are also best for developing 35-mm Tri-X film.

Rapid developers, widely used by press photographers and commercial photofinishers, act more quickly than standard developers and produce negatives of somewhat higher contrast.

Fine-grain developers produce negatives with a relatively fine grain and are mainly intended for the development of certain 35-mm films. Some fine-grain developers boost film speeds, whereas others require increases in the exposure of the film, the factor depending on the type of the developer (consult the manufacturer's instructions). Not all fine-grain developers are equally suitable for the development of all 35-mm films. Thin-emulsion films must be developed in special compensating fine-grain developers. High-speed 35-mm films should never be developed in fine-grain developers but in standard developers.

Tropical developers permit development at temperatures up to 90 degrees F., at which point the gelatine of the emulsion ordinarily begins to dissolve and float off the film base.

High-contrast developers produce negatives of more than ordinary contrast and are primarily intended for the development of reproductions of line drawings, printed pages, and other subjects that are purely black and white.

Stop bath. This serves to terminate development by neutralizing the alkalinity of the developer retained by the emulsion, and protects the acidity of the fixing solution, thus preventing its premature exhaustion. In conjunction with a hardening agent, the stop bath also hardens the gelatine of the film to prevent it from curling, reticulating, and peeling along the edges during washing.

Fixing bath, or "hypo." This is used to clear the negative by dissolving the unexposed silver halides (the light-sensitive particles of the emulsion) which otherwise would in time darken and obscure the image.

Hypo neutralizer (for example, *Kodak Hypo Clearing Agent*).

Barber shears—narrow-bladed scissors—are particularly good for accurately cutting developed film into strips even when individual frames are very closely spaced, for cutting negative masks, adhesive labels from strips of surgical tape, and such.

Negative file or glassine envelopes for storing negatives.

EQUIPMENT AND MATERIAL FOR PRINT PROCESSING

The enlarger—construction and special features

An enlarger is a camera in reverse. Like a camera, it has a lens that must be focused to produce a sharp print (enlargement) and a diaphragm that permits regulation of the brightness of the projected image and thus the exposure time of the paper. Two different lighting systems are most commonly used:

Semi-diffused illumination. The light source is a special tungsten filament opal-glass lamp; the light collector is either a double or a single plan-convex condenser. This system produces images of excellent quality, without unduly emphasizing negative grain. It is best suited to negatives up to and including 4 x 5 inches.

Cold-light illumination. The light source is a mercury vapor, fluorescent, or cold-cathode tube, usually bent to form a square grid. These enlargers produce scarcely any heat. They are used primarily for negatives larger than 4 x 5 inches. However, the peculiar quality of their light makes it difficult to focus critically without a focusing magnifier, and many, though not all, cold-light installations are unsuitable for use with variable-contrast paper and for making color prints.

Manual or automatic focusing. Manual focusing involves racking the lens in and out while visually checking the sharpness of the projected image on the paper. In automatic focusing, the projected image is supposedly always sharp, regardless of the scale of the enlargement, because lens-focusing is mechanically coupled with the vertical movement of the enlarger head. Each system has advantages and disadvantages. If done with proper care, manual focusing is the more accurate of the two but takes more time. Automatic focusing is much faster but requires constant checking to detect and correct unavoidable inaccuracies of focus primarily caused by negatives that are not held perfectly flat in the plane of focus. There is also a considerable difference in price.

The lens. Enlarging lenses are specially computed for optimum performance at short distances. Sharpness of definition and flatness of field are all-important. Speed is not a factor here because, in the interest of manageable exposure times, most enlargements are made with the diaphragm stopped down to somewhere between f/5.6 and f/11.

The diaphragm. To facilitate accurate stopping-down in the dimness of the darkroom, the diaphragm should be equipped with click stops.

The negative carrier. There are two types: glass plates and glassless carriers. Glass plates ensure perfect flatness of the film by preventing the negative from buckling out of the plane of focus under the influence of heat. But they also have *four* surfaces to which dust can cling, and they may cause "Newton's rings": concentric bands of colored light that occur when glass and film are not in perfect contact. Newton's rings show clearly in the print and they are very difficult to avoid once the conditions for their appearance are present. Special glass is available that avoids the danger of Newton's rings. Glassless negative carriers eliminate the danger of Newton's rings but they do not hold the film as flat as glass plates; the consequence may be partially unsharp prints. In general, for negative sizes up to 2¼ x 2¼ inches (where dust is a greater problem than buckling), glassless carriers are most practical. Glass plates, despite their disadvantages, are preferable for use with enlargers with automatic focusing, and generally for larger negatives, which are more apt to buckle and in which, because of normally lower image magnification in the print, dust does not show up as badly as in smaller negatives.

Special features. No enlarger can take negatives larger than the largest size for which it is designed, but many enlargers are so constructed that they can also accommodate smaller negatives. This should be considered by the photographer who owns two or more cameras that take different film sizes or who intends to get another camera of a different size. Enlargers that take different negative sizes provide for interchangeability of lenses and feature condensers that are either interchangeable or condensers that can be moved from one position to another, or they have an adjustable negative stage.

If the enlarger is to be used for color printing, it must be equipped with a heat-absorbing glass and facilities for the use of color-balancing filters. The ideal is a dichroic color head since dichroic filtration eliminates the need for filter packs and, in conjunction with a color print meter, enables a photographer to get the correct color balance by simple dial adjustments. Lacking this feature, an enlarger used for color printing should have a filter drawer between the lamp and the color negative where filters cannot affect the sharpness of the image. The least desirable filter location is below the lens. Illumination must be provided by tungsten light because "cold light" illumination is unsuitable for color printing. The condenser lenses must consist of colorless (not greenish) glass.

If "converging verticals" in negatives of architectural subjects should be

parallel in the print, the enlarger must be equipped with a tilting negative stage p. 203 (this is the better solution) or a tilting lens stage. If the enlarging paper is then tilted accordingly, perspective distortion can be corrected and prints that are uniformly sharp produced, without stopping down the lens beyond normal.

The scale of the projected image increases as the distance between paper and lens increases (image magnification equals lens-to-paper distance divided by lens-to-negative distance). Normally, the highest degree of magnification an enlarger can produce is determined by the height to which its lens can be raised above the enlarger's baseboard. But much greater degrees of magnification can be achieved with enlargers that either permit rotating the head on the column or the entire column by 180 degrees, so that the image can be projected onto a chair or onto the floor, or which permit tilting the head into a horizontal position and projecting the image onto a wall. Enlargers that lack such features can be converted to horizontal projection by mounting a 45-degree front-surface mirror below the lens.

OTHER RECOMMENDED EQUIPMENT AND MATERIAL FOR PRINT PROCESSING

Contact printer or printing frame. The size depends upon the paper size it must accommodate. It is used primarily for making contact prints to facilitate identifying, cataloguing, and filing negatives. The usual practice is gang-printing—that is, printing all the negatives from one roll of film side by side in strips of six (35-mm) or four (size-120 film) on one sheet of 8 x 10 inch paper. Similarly, four sheets of 4 x 5-inch film, or eight sheets of 2¼ x 3¼-inch film, can be contact-printed on one sheet of 8 x 10-inch paper. An inexpensive contact printer can be made by hinging with inch-wide adhesive surgical tape a sheet of glass 10 x 12 inches to a 9½ x 12-inch piece of ¾-inch plywood. Sandpaper the edges of the glass to avoid cutting yourself.

A paper easel is necessary to hold the enlarging paper flat and in focus.

Developer trays in different sizes. The most practical size is one size larger than the paper that is to be developed; for example, use a 10 x 12-inch tray for an 8 x 10-inch print. Trays smaller than 8 x 10 inches are impractical even for the development of much smaller prints. The best material is stainless steel, the next best is high-impact plastic. Enameled trays chip and rust, hard rubber trays break.

Stop bath tray and **tray for hypo neutralizer.** Select the same sizes and materials as above.

Fixing bath tray. It should be larger and deeper than the largest developer tray. Stainless steel or high-impact plastic are the best materials.

Water tray and syphon (attached by rubber hose to faucet). For washing prints. To provide clearance for the exhaust spout, place the water tray on bricks in the processing or kitchen sink.

Focusing magnifier to ensure sharp prints. Best are those high-magnification devices that focus on the grain structure of the negative instead of on the subject detail.

Two or three print tongs to handle and agitate prints and transfer them from one solution to the next. Tongs used for developing must not come in contact with fixing solution because hypo contaminates the developer. If accidentally contaminated with hypo, the developer print tongs must be rinsed clean before reuse in the developer.

Camel's-hair brush or anti-static brush, and anti-static negative cleaner or cloth, to remove dust from negatives before they are placed in the enlarger.

White petroleum jelly (Vaseline). Rubbed in minute amounts on a negative it fills abrasion marks and small scratches so that they do not show in the print.

Paper punch. A particular negative (called a "frame") on a strip of six (35-mm) or four (size-120) frames can be marked for printing by punching a semi-circular piece out of the clear edge of the film. These punch marks can easily be felt in the dark. Another way to mark negatives for printing is to apply a dash of ink to the clear edge of the respective frame with a felt-tipped ink marker.

pp. 173–175 **Dodging aids.** Two circular pieces of cardboard, one approximately 1½ and the other ¾ inches in diameter, attached to one end of a stiff wire approximately 10 inches long, make a good dodger for "holding back" thin negative areas during exposure to prevent them from becoming too dark. Bend both ends of the wire into circular loops the size of the respective cardboard disks and tape the disks to the loops with black photographic tape. Pieces of cardboard approximately 8 x 10 inches, each with a hole of a different diameter near its center, make dodgers for "burning in" negative areas which are so dense that they need more exposure than the rest of the negative. The dense negative area receives extra exposure through the hole, while the

148

cardboard shields the rest of the picture from becoming too dark.

Blotter roll or **electric print dryer** for drying prints. To give prints made on glossy paper a high glossy finish, an electric print dryer in conjunction with **ferrotype plates** and a **squeegee** are required.

Trimming board (cutter) for trimming the white edges from prints before drymounting.

Drymounting tissue for mounting prints to cardboard with a flatiron or an electric **drymounting press.**

Spotting colors and a **fine watercolor brush** for spotting (retouching) prints.

Paper developer. For best results, use one of the developers which the paper manufacturer recommends.

Stop bath. Used as a short rinse between developer and fixer, it prevents prints from staining in the fixing bath through insufficient agitation.

Fixing bath (hypo). Acid-hardening fixing baths are best for prints.

Hypo neutralizer (for example, *Kodak Hypo Clearing Agent*).

PHOTOGRAPHIC PAPER

Regardless of type or make, photographic papers can be classified according to four different characteristics:

Speed

There are *slow* chloride and *fast* bromide papers, and between these are medium-fast chloro-bromide papers. Chloride papers are used for contact printing because they are slow; fast emulsions would require impractically short exposures. Bromide papers are used for enlarging (projection printing) because they are fast; chloride papers would require impractically long exposures. Chloro-bromide papers can be used for either contact printing or enlarging.

Gradation (contrast capacity)

Photographic papers are made with different contrast gradients, ranging from "soft" (low contrast) through "normal" (average contrast) to "hard" (high

contrast). If a negative of normal contrast range were printed on a paper of normal gradation, the print would have a normal contrast range. Printed on paper of soft gradation, contrast in the print would be lower, and printed on paper of hard gradation, contrast in the print would be higher than in the print made on paper of normal gradation. Accordingly, by selecting a paper with the appropriate gradation, a photographer can make prints that have a satisfactory contrast range from negatives in which contrast is unsatisfactory because it is either too high or too low.

The gradation of photographic papers is designated by numbers: no. 1 designates a paper of soft gradation (low contrast range); no. 2 is normal; nos. 3, 4, and 5 designate increasingly harder (more contrasty) gradations. In addition, there are variable-contrast papers which enable a photographer to produce a wide range of contrasts from the same kind of paper. This is done by using filters of different colors between the light source and the paper. The advantage of variable-contrast paper is that it makes it unnecessary to stock seldom-used grades of paper, since all the normally needed gradations are included within a single box except the equivalent of no. 5 paper (extra hard.)

Surface

Photographic papers are made in a great variety of different surface textures: glossy, semi-matte, matte, and textures that imitate the appearance of fabrics, tapestry, and so on. Personally, I find such imitation textures in poor taste and prefer to use only glossy, semi-matte, and matte. Of these, glossy is richest in graphic qualities: it gives brighter whites and more lustrous blacks than any other surface; prints for reproduction should normally be made on glossy paper. To bring out the full inherent beauty of a glossy surface, the print must be ferrotyped (dried with its emulsion in close contact with a highly polished ferrotype plate); dried with their paper side facing the ferrotype plate glossy prints are not quite as shiny and sparkling but they are less sensitive to fingermarks and can thus withstand more handling. Semi-matte and matte surfaces are best for exhibition prints and photo-murals because they mitigate or eliminate, respectively, surface reflections.

Base

Photographic papers are made in two standard thicknesses: single-weight (abbreviated: SW), which is relatively thin, and double-weight (DW), which is approximately twice as thick, corresponding in thickness to a postcard. Single-weight papers are best for prints up to and including 8 x 10 inches and

for larger prints that are to be mounted. Double-weight papers are preferable for unmounted prints in sizes larger than 8 x 10 inches. Single-weight paper is less expensive, washes and dries more rapidly, is easier to mount, and takes less filing space than double-weight stock. Double-weight paper does not curl as easily, stands up better under rough treatment, and is preferable for prints exposed to frequent handling.

A different type of photographic material are the RC (resin-coated) papers, which have a plastic base. Since this base is virtually impervious to liquids, it permits greater utilization of the developer and fixer solutions and, because it doesn't absorb chemicals, makes for shorter washing times and greater print permanence. On the other hand, it cannot be ferrotyped.

For selection of anything but glossy papers (which all look alike), consult the manufacturer's sample book at your photo shop. To order a specific paper, you must provide the name of the manufacturer, the trade name of the paper, the gradation of the emulsion, the type and color of the surface, the weight of the stock, and the size of the paper. Here is an example: Kodak Kodabromide, normal (no. 2), glossy, white, double-weight, 11 x 14 inches.

HOW TO DEVELOP A BLACK-AND-WHITE FILM

Anyone who can read a watch and a thermometer can successfully develop a black-and-white film, for development time is determined by the temperature of the developer. If the developer is warm, development time must be shorter than if the developer is cold (the terms "warm" and "cold" cover a temperature range from 65 to 75 degrees F.; standard temperature is always 68 degrees F.). Naturally, different types of film, as well as different types of developer, require different times of development. These are given in the tables that film manufacturers pack with their films. The following table applies to Tri-X Pan roll and 35-mm film.

Developing times (min.)

Kodak packaged developer	Small tank, agitation at 30-sec. intervals					Large tank, agitation at 1-min. intervals				
	65°F.	68°F.	70°F.	72°F.	75°F.	65°F.	68°F.	70°F.	72°F.	75°F.
D-76	9	8	7½	6½	5½	10	9	8	7	6
D-76 (1:1)	11	10	9½	9	8	13	12	11	10	9
Microdol-X	11	10	9½	9	8	13	12	11	10	9
DK-50 (1:1)	7	6	5½	5	4½	7½	6½	6	5½	5

The advantage of this method, which is called "development by time-and-temperature," is its simplicity, permitting even a beginner to produce consistently good results. All he needs to do is to use the developer the film manufacturer recommends, and the instruction sheet that comes with the film, to find the recommended time of development for the temperature of his developer solution. The only control instruments needed are a thermometer and a timer.

Normal (correct) development produces negatives in which the densest parts (called the "highlights") are not blocked but show differentiation, and in which the thinnest parts (the shadows) are not glass-clear but show detail. If such a negative is placed on a printed page, one should barely be able to see the type through its dark parts, while its thinnest parts should have a distinct gray tone.

Overdevelopment—caused by leaving the film too long in the developer, using a developer that was too warm, or both—produces negatives that are too dense and too contrasty. They are difficult to focus in the enlarger because the projected image is very dark, and they demand exposure times so long that heat from the enlarger lamp may cause the negative to buckle out of the plane of focus during the exposure. If such negatives are printed on paper of normal gradation, they produce prints that are, as a rule, too contrasty, too grainy, and not critically sharp.

Underdevelopment—caused by taking the film out of the developer too soon, using a developer that was too cold, using exhausted bath—produces negatives that are too thin and lacking in contrast. They appear gray and "weak." If such a negative is placed on a page of type, one can easily read the type even through the darkest parts of the negative. If underdeveloped negatives are printed on paper of normal gradation, they produce "flat" grayish prints devoid of white and black.

THE HOW-TO'S OF SUCCESSFUL FILM DEVELOPMENT

Habits are easy to form and hard to break. It is important, therefore, that the student of photography learn at the outset correct methods of film processing. Specific instructions are given in the following sections. A few general but equally important pointers are given below.

Do not try to "save" on material, least of all on developer, fixer, and chemicals, most of which are comparatively cheap. Replace the developer and fixer *before* they are exhausted. "Saving" on chemicals inevitably leads to waste of more valuable things such as irreplaceable negatives and time. This results in work having to be done twice—provided that there is a second chance.

Buy only products of reputable manufacturers. "Nameless" films, developers, and chemicals sold by certain chain stores or discount houses are admittedly cheaper. Unfortunately, often they are outdated stock bought in bulk for quick resale, or they are so inferior in quality that they are worthless.

Always perform the same operation in the same way. Standardize whatever you can. Develop a system of processing films and prints, then stick to it. Do not change one developer or process for another because someone else had success with it. There is individual taste and preference in photography as in any other art or craft. Methods perfectly suited to another's temperament and ways of working may be entirely wrong for you.

Best results are invariably obtained if exposure and development of films are standardized through intelligent use of an *exposure meter, timer, and thermometer*. Negatives so produced are technically far superior to those obtained by subjective methods. In my opinion, the method of exposing films "by experience" and developing them by "visual inspection" is obsolete and inferior to the "time-and-temperature method" of negative development discussed in the following pages.

Preparations

The preliminary steps are the same for all films and developers. Consult the following chart as you go along.

Prepare the developer. Decide what type of developer to use by consulting the survey on p. 144. If possible, follow the film manufacturer's recommendations. Before using a fine-grain developer, see that the film was exposed accordingly, otherwise negatives may turn out too thin. Developer solutions that have been used must be filtered before reuse to eliminate particles of emulsion and sludge. Pour the solution through a funnel that is loosely stopped with a wad of absorbent cotton. Do not filter solutions that are too cold, because some of their components might have crystallized and filtering would remove them from the solution, spoiling it.

HOW TO DEVELOP A FILM

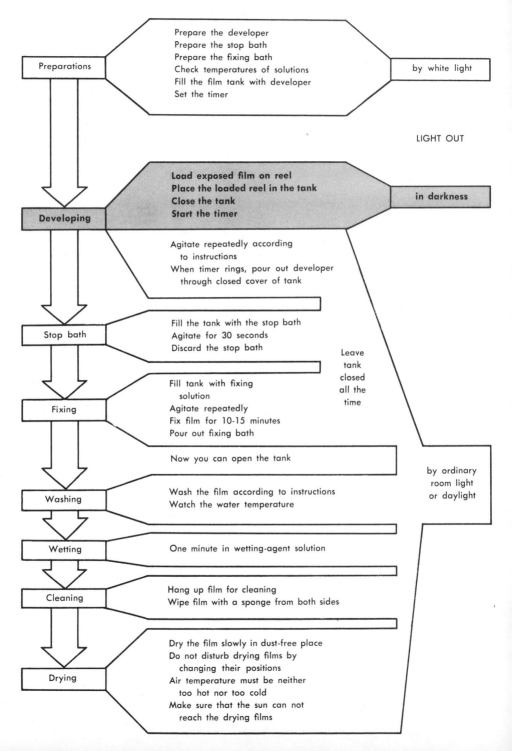

Preparations

Prepare the developer
Prepare the stop bath
Prepare the fixing bath
Check temperatures of solutions
Fill the film tank with developer
Set the timer

by white light

LIGHT OUT

Developing

Load exposed film on reel
Place the loaded reel in the tank
Close the tank
Start the timer

in darkness

Agitate repeatedly according
to instructions
When timer rings, pour out developer
through closed cover of tank

Stop bath

Fill the tank with the stop bath
Agitate for 30 seconds
Discard the stop bath

Leave
tank
closed
all the
time

Fixing

Fill tank with fixing
solution
Agitate repeatedly
Fix film for 10-15 minutes
Pour out fixing bath

Now you can open the tank

Washing

Wash the film according to instructions
Watch the water temperature

by ordinary
room light
or daylight

Wetting

One minute in wetting-agent solution

Cleaning

Hang up film for cleaning
Wipe film with a sponge from both sides

Drying

Dry the film slowly in dust-free place
Do not disturb drying films by
changing their positions
Air temperature must be neither
too hot nor too cold
Make sure that the sun can not
reach the drying films

Prepare the stop bath. A stop bath for negatives that has a greater hardening effect than ordinary hardening solutions can be prepared by dissolving 30 grams of granulated potassium chrome alum in 30 cc of a 5 percent sulfuric acid solution and adding water to make 1 liter.

Prepare the fixing bath. In using a prepared fixer, instructions for dissolving its components should be strictly followed; if not, the bath may spoil immediately. If you wish to prepare your own fixing bath in accordance with a published formula (which is very simple and much cheaper), observe the following rules:

Dissolve the sodium sulfite first, then the acetic acid. Add the hardener (alum) to the sulfite-acid solution. Do not mix sulfite and alum directly with each other because they would form aluminum sulfite which precipitates as white sludge. Dissolve the hypo in hot water, then let it cool. Do not mix hypo and acetic acid directly with each other. Acetic acid is sensitive to heat; do not add it to solutions that are warmer than 85 degrees F. Mixed with hypo in solution above 85 degrees F., it decomposes the hypo and the bath would become milky. A fixing bath that is milky is spoiled and must be discarded. After they have cooled below 85 degrees F., mix the sulfite-acid-alum solution with the hypo solution.

Check the temperature of all solutions. The normal temperature is 68 degrees F. Temperatures within a range of 7 degrees higher or lower may be used, provided that all solutions, including the wash water, have the same temperature. Differences in the temperature of the solutions can cause reticulation (wrinkling of the emulsion). Solutions that are too warm may melt the film emulsion and cause it to flow off its base. Solutions that are too cold act sluggishly and erratically, or do not act at all. If temperatures of solutions are higher than 75 degrees F. or lower than 65 degrees F., cool or heat by immersing the solution bottles in a pot filled either with cracked ice or very hot water. Metal developing tanks are good heat conductors and respond quickly to temperature changes; handle them as little as possible in hot weather because your body heat will raise the temperature of the developer. Plastic developing tanks conduct heat poorly and respond slowly to temperature changes. They keep solution temperatures more stable, but changing temperatures by placing the tank in a hot or ice-cold water bath is more time-consuming with plastic tanks than with metal tanks.

Fill the developing tank with film developer. Be sure it is filled neither too high (or it will overflow when you immerse the film reel) nor too low (or a strip

along the edge of the film will remain underdeveloped and become streaky).

Set the timer. The time of development depends on the type of film, the type of developer, and the temperature of the solution. Consult the manufacturer's chart.

Load the developing tank. If you use a daylight-loading tank, loading can be done either in daylight or by ordinary room illumination. *Other tanks must be loaded in total darkness.* If you use a photographic darkroom, turn off the safelight, too. If you do not have a darkroom, load the developing tank in a light-tight closet or windowless space in the basement, or some other appropriate area, but be sure the place is *really* dark or you may fog and spoil your film. Arrange the developer-filled tank, tank cover, film reel, and film so that you can find them easily in the dark. Then turn off the light and start loading in accordance with the instructions that accompanied the tank.

ROLLFILM DEVELOPMENT

Load the film on the reel. Before you risk spoiling your first exposed film, sacrifice a roll of *unexposed* film and practice loading the reel—first in daylight, then in the dark. At first, it may seem difficult, but once you have the knack, loading a reel is easy. Above all, *be sure that the film reel is completely dry.* The film will stick if it hits a wet spot, and it will have water spots or kink and pleat in the tank and you will have what is called in movie-production jargon a "film salad."

Place the loaded reel in the tank. Tap it sharply a few times against the tank bottom to dislodge air bubbles trapped between the coils of the film. Place the cover on the tank.

Start the timer immediately.

Now the white light can be turned on and left on for the rest of the operations, or the tank can be taken to an ordinary lighted room.

Agitate repeatedly. Correct agitation is necessary to produce uniformly developed negatives. Mechanical uniformity of agitation causes streaky development. After the film has been in the developer for a few seconds, take the tank in both hands and move it gently back and forth while tilting and rotating it simultaneously. Continue agitation for approximately five seconds; repeat

at half-minute intervals during the entire development. If you use a tank that has a reel that can be turned by a rod or a crank inserted through the cover, rotate the reel gently but *unevenly* back and forth for the first minute, and for approximately five seconds every two minutes thereafter until development is completed.

When the timer rings, without removing the cover of the tank pour the developer back into its bottle or, if a one-shot developer is used, discard it and fill the tank with the stop bath.

Stop bath. Agitate for about thirty seconds, then pour the stop bath out through the tank cover and discard it. It can be used only once.

Fixing. Pour in the fixing solution. Agitate immediately for half a minute, repeat several times until fixation is complete. Leave negatives in the fixing bath approximately twice as long as is required to clear the emulsion. A fixing bath is exhausted when the time required to clear a negative is twice that required when the bath was fresh. Although an exhausted fixing bath will clear a negative, the negatives are not permanent and they will fade within a relatively short time.

The safest way to fix negatives and prints is to use two fixing baths: use the first for the prescribed time, then transfer the negatives or prints to the second bath and fix them for five minutes. When the first bath begins to show signs of exhaustion, discard it, replace it with the second bath, and prepare a new bath for the second fixing.

Negatives and prints are not damaged if left in the fixer more than twice the time required to clear them. However, if they are left more than ten minutes in the fixer, excessive swelling and softening of the negative emulsion may result, particularly if the bath does not contain a sufficient amount of hardener, and the image of prints will begin to bleach and fade.

Now the cover can be taken off the tank.

Rinse the film on the reel under running water for a couple of minutes, then fill the tank with a hypo neutralizer solution, replace the reel for two to three minutes, and agitate constantly.

Wash the film. Correct washing is required for permanency of the negative. Even minute traces of chemicals left in the emulsion will in time produce discoloration or fading of the image. Rollfilm can be washed on the reel in the developing tank. First, put a piece of cork beneath the reel to make the center

core opening slightly higher than the edge of the tank. Place the tank under a faucet and let a thin stream of water run directly into the center core of the reel. Another equally effective method is to connect a piece of rubber hose to the faucet and put the other end into the center of the reel. In both cases, water is forced through the core of the reel and up through the coils of the film, flushing out all the chemicals that must be removed. Most other methods of washing are less effective. Washing film in a tray by running water into it and out over its edge is ineffective since hypo is heavier than water and sinks to the bottom, where it is more slowly removed. The temperature of the wash water must be within a few degrees of the temperature of the other solutions; if it is not, negatives may reticulate. Occasional temperature checks are recommended during washing. As a rule, negatives should wash for half an hour under water running fast enough to change the water in the washing vessel every five minutes. Use of a hypo neutralizer shortens the required washing time considerably (see the manufacturer's instructions).

Cleaning. Remove the film from the water, place a film clip on one end, and hang the film up. Pull the film slowly between two well-soaked and wrung viscose sponges to wipe both sides simultaneously and remove all water drops and loose gelatin particles. After ten minutes, check the film. If any drops have formed, remove them, not by wiping, but by absorbing them with the corner of a moist viscose sponge.

Drying. Films must be dried slowly and evenly in clean air. Rapid drying seems to increase the size of the negative grain. If unfiltered air is used, drying under a fan is certain to spoil a film because the forced draft propels particles of dust and dirt, like tiny projectiles, into the emulsion. Films moved during the drying may dry streaky, for changes in position usually cause changes in temperature and air currents that affect the rate of drying. The part of the negative that dried faster will have a different density from the part that dried more slowly. To prevent rolls of film from sticking together when drying, space them well apart and weigh their lower ends with film clips. *Films must never be dried in the sun.*

As soon as films are dry, cut them apart in lengths of six frames (35-mm) or four frames (size-120) and place them in suitable film preservers for safekeeping.

SHEET FILM TANK DEVELOPMENT

In total darkness, load the developing hangers. Lower them smoothly into the developer-filled tank and start the preset timer. Strike the hangers down hard three times to dislodge air bubbles, then agitate vertically for about five seconds. Turn the safelight on. Leave the hangers undisturbed for one minute, then lift the entire rack out of the solution, tip 90 degrees, let the developer briefly run off, and put the hangers back into the tank. Repeat this operation once every minute for the entire duration of development, draining the hangers very briefly by tipping them in opposite directions.

When the timer rings, lift the whole rack out of the tank, drain, and put the rack into a second tank filled with a stop bath. Lift and drain four or five times, drain, and transfer the hangers to a third tank filled with the fixing solution.

Agitate the negatives vertically in the fixer for half a minute, then lift and drain the hangers once every two minutes until fixation is complete. Turn on the white light.

Immerse the hangers, after a brief rinse, for two or three minutes in a hypo neutralizing solution, agitating constantly.

Wash the negatives in their hangers in a separate tank under running water for half an hour. Immerse them briefly in a wetting-agent solution, take them one by one from their hangers, wipe both sides of each negative carefully, and hang them to dry following instructions given above.

FILMPACK AND SHEET FILM TRAY DEVELOPMENT

If up to six filmpack or sheet film negatives must be developed quickly, the following method can be used if one is careful, has short fingernails, and if the temperature of the developer is not higher than 72 degrees F—otherwise the gelatin softens and becomes too vulnerable.

In total darkness immerse the film sheets, emulsion-side up, one after the other in a tray of water not warmer than 72 degrees F. Be sure the first film is completely immersed before you place the next on top of it, otherwise they will adhere permanently. After the last film is immersed, carefully draw the bottom film out and place it on top of the pile, touching it only at its extreme edges. Be careful that its corners do not scratch the other films. Take one film after

another from the bottom and place it on top until the whole stack has been leafed through twice.

Start the preset timer and transfer the films to the developer, removing one at a time from the bottom of the water tray. When all the films have been transferred, repeat the operation of slowly leafing through the films from bottom to top for the entire duration of development, occasionally turning the negatives sideways, but always keeping the emulsion-side up. After the negatives have been in the developer for a minute or so, the safelight can be turned on.

When the timer rings, transfer the negatives one by one to the stop bath. Leaf through them twice as described above.

Finally, remove the negatives one by one to the fixer and, immediately after all are immersed, leaf through the pile twice. Repeat this every two minutes until fixation is complete.

Treat the negatives in a hypo-neutralizing solution as described above. Wash in a tray equipped with a syphon for a minimum of half an hour, briefly immerse the negatives in a wetting-agent solution, and dry as described above.

HOW TO DEVELOP A COLOR FILM

I have deliberately omitted instructions for color-film development from this book because any information I could provide would be too short-lived to be of any practical value. Only recently, Kodak started a revolution by replacing its E-4 process for Ektachrome film development with the new E-6 process, making all previous rules obsolete. Furthermore, Kodachrome, the "work-horse" of so many 35 mm photographers, can only be developed by complex machinery, never by the photographer himself. Add to this the fact that most photographers send their Kodacolor films to a commercial photo-finisher for processing and printing; that Ektachrome film development is a rather critical process, during which temperatures must be held stable to within one-half degree F; and that authoritative and always up-to-date instructions pertaining to color-film development are available in practically any photo store in the form of the excellent, inexpensive Kodak data booklets, and the reader will, I hope, understand and approve my decision, which is based on the conviction that no information is preferable to obsolete, misleading advice.

HOW TO MAKE A BLACK-AND-WHITE PRINT

A contact print is identical in size to the negative from which it is made. It is a positive replica of the negative, containing most of its merits and faults. Contact prints are made in a printing frame or contact printer on slow chloride paper.

p. 147

An enlargement is, of course, larger than the negative from which it is made. It is possible to control enlargements to a very high degree, and to extensively correct undesirable qualities of the negative. Enlargements are made with an enlarger on fast bromide or medium-fast chloro-bromide paper.

p. 145

Aside from these differences, the processing of contact prints and enlargements is identical.

The two accompanying graphs show the steps involved in making contact prints and enlargements. Most of the operations are so simple that further explanation is unnecessary. Additional instructions are given in the pages that follow to clarify those operations that are more complicated.

pp. 164, 166

The negative

A good print starts with a good negative. A "good" print is one that is correctly exposed and developed, and also *clean*. Before a negative is put into the printing frame or the enlarger, remove particles of dust with a camel's-hair brush. In cold and dry weather, this is difficult, for brushing causes the negative to become increasingly charged with static electricity which tenaciously holds the particles of dust. Under such conditions touch the negative carrier to the grounded enlarger to dissipate static electricity, brush the negative *once very slowly*, then use a small rubber syringe to blow off the remaining particles with short, sharp puffs. To determine whether a negative is clean, hold it under the light-beam of the enlarger at a steep angle, and even minute specks of dust will stand out startlingly bright against the dark background of the film. Fresh fingerprints can sometimes be removed by wiping the negative with a tuft of cotton dampened in a good film cleaner. Old fingermarks that have eaten into the film cannot be eliminated. Minor scratches and abrasion marks can be minimized or prevented from showing in the print by gently rubbing a thin film of white petroleum jelly (Vaseline) into them. However, this is feasible only if the negative is to be enlarged and a glassless carrier is used; otherwise, the petroleum jelly would smudge the glass or stain the contact paper. After the print has been made, the petroleum jelly should be removed with Carbona.

161

In contact printing it does not much matter whether a negative is dense or thin, but if an unusually dense negative is to be *enlarged,* it must first be "reduced" (made more transparent by treating it in a reducer solution). Otherwise, exposure times would be so long that accumulated heat from the enlarger lamp would buckle the film and accumulated stray light and reflected light would fog the paper. A negative is too dense if the required exposure exceeds one minute. Before you reduce an overly dense negative, examine its gradation: if it is too contrasty (usually as a result of overdevelopment), use potassium persulfate reducer; if it is too contrastless (usually as a result of overexposure), use Kodak Farmer's Reducer (single solution). If a negative is so thin that it requires an unworkably short exposure time, stop down the diaphragm of the enlarger lens completely; if this is not adequate, enlarge the negative on slow contact printing paper. Weak contrast and faint detail can also be strengthened by treating the negative in an intensifier bath. However, glass-clear areas are beyond improvement—no intensifier can produce detail where none exists.

> The first prerequisite for successful printing and enlarging is a clean negative of correct density and contrast.

The paper

Unfortunately, not every negative is satisfactory in regard to gradation (contrast range). There may be many reasons for this: either the exposure was too long or too short, the developer too warm or too cold, the development too lengthy or too quick, or the subject contrast was abnormally high and the photographer failed to take corrective measures. Luckily, such faults can usually be corrected in the print by selecting a paper of appropriate gradation in accordance with the following table:

Character of the negative	Extremely contrasty	Contrasty	Normal	Soft	Extremely contrastless
Recommended paper gradation	Extra soft (No. 1)	Soft (No. 2)	Normal (Nos. 2, 3)	Hard (No. 4)	Extra hard (Nos. 5, 6)

In analyzing a negative to determine the most suitable paper gradation, do not confuse gradation and density. One has nothing to do with the other. A very

thin negative can be very *contrasty* (as a result of underexposure and over-development), or extremely *lacking in contrast* (overexposed and underdeveloped). And a very *dense* negative that appears almost uniformly black can be very *contrasty* (if considerably overdeveloped) or extremely *lacking in contrast* (if considerably overexposed). When in doubt, make a test print on paper of normal gradation. If the print is too contrasty, make the final print on softer paper. If it lacks sufficient contrast, choose a paper of harder gradation.

> The second prerequisite for successful printing and enlarging is the selection of a paper with a gradation appropriate to the contrast range of the negative.

Focusing

An unsharp negative will, of course, not yield a sharp print, but unsharp prints from perfectly sharp negatives are common. The best way to get sharp prints is to use a focusing magnifier and focus on the negative grain (disregarding fine subject detail). This is easy if the negative is held flat between glass in the negative carrier of the enlarger. But if a glassless negative carrier is used, heat from the enlarger lamp may cause the negative to warp and buckle out of the plane of focus between the time of focusing and exposing, with the result that the "sharply focused" negative yields an out-of-focus print. To avoid this, give the negative half a minute or so to warm up before you focus, and if you make several prints from the same negative, check the focus before you make each print.

> The third prerequisite for successful enlarging is correct focusing.

The exposure

The operation most likely to cause trouble in making prints is the exposure. Unlike most films, which have a relatively wide exposure latitude—that is, can stand a good deal of overexposure and even some underexposure and still produce usable negatives—sensitized paper must be accurately exposed to yield good prints. A negative is an intermediary step in picture-making, and mistakes in the negative can largely be corrected in making the print. But a print is the final step, and mistakes made in printing can rarely be corrected; normally, a new print must be made.

HOW TO MAKE A CONTACT PRINT

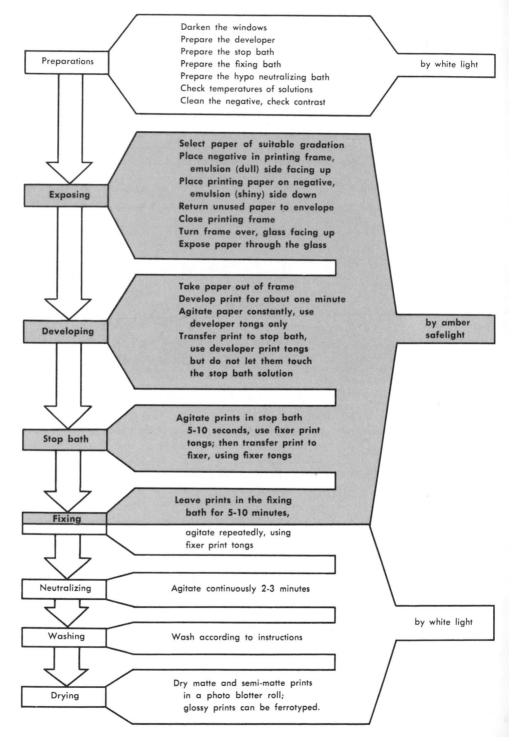

Preparations

Darken the windows
Prepare the developer
Prepare the stop bath
Prepare the fixing bath
Prepare the hypo neutralizing bath
Check temperatures of solutions
Clean the negative, check contrast

by white light

Exposing

Select paper of suitable gradation
Place negative in printing frame, emulsion (dull) side facing up
Place printing paper on negative, emulsion (shiny) side down
Return unused paper to envelope
Close printing frame
Turn frame over, glass facing up
Expose paper through the glass

Developing

Take paper out of frame
Develop print for about one minute
Agitate paper constantly, use developer tongs only
Transfer print to stop bath, use developer print tongs but do not let them touch the stop bath solution

by amber safelight

Stop bath

Agitate prints in stop bath 5-10 seconds, use fixer print tongs; then transfer print to fixer, using fixer tongs

Fixing

Leave prints in the fixing bath for 5-10 minutes, agitate repeatedly, using fixer print tongs

Neutralizing

Agitate continuously 2-3 minutes

Washing

Wash according to instructions

by white light

Drying

Dry matte and semi-matte prints in a photo blotter roll; glossy prints can be ferrotyped.

Contact print exposure determination. Duration of exposure depends on: intensity of the light source, distance between the light and the paper, sensitivity of the printing paper, density of the negative. The first three factors can be standardized by using the same type of paper with the same light at the same distance. The only variable then is the density of the negative. If the negative is small, make a few test exposures until you get the right one. Use a 60-watt bulb at a distance of 20 inches from the printing frame and expose a sheet of, for example, Kodak Azo or Velox Paper for twenty seconds. If the negative is large, to save paper use a strip about 1 inch wide the length of the negative for the test exposure. Develop the strip for the time recommended by the paper manufacturer, fix, and examine it by white light. If the image is too dark, exposure was too long; if it is too light, exposure was too short.

Enlargement exposure determination. In principle, exposure is determined by the same factors that apply in contact printing. In practice, however, two additional variables must be considered: the degree of magnification of the projected image and the diaphragm stop of the enlarger lens. The higher the magnification and the more the lens is stopped down, the longer the exposure time required. If the negative has average density, the lens should normally be stopped down to around f/8 or f/11 to produce exposure times of ten to twenty seconds—long enough to be timed precisely and to allow time for "dodging," yet short enough to prevent the negative from overheating and buckling. p. 173

The simplest way to determine the exposure time for an enlargement is to make a test strip as follows: cut a sheet of paper of appropriate gradation in strips about 1½ inches wide. Place a strip on the easel. Cover four-fifths of it with a piece of cardboard, and expose the uncovered part for thirty-two seconds. Uncover one-fifth more, and expose for sixteen seconds. Repeat this operation, exposing the remaining three-fifths of the strip for eight, four, and four seconds, respectively. Thus, the five sections of the strip receive exposures of sixty-four, thirty-two, sixteen, eight, and four seconds, respectively. Develop the strip for the time recommended by the paper manufacturer, fix, and examine it by white light. Decide which exposure is correct and use it as the basis for making the final print. Of course, the best exposure may be between two steps. If so, that time should be used in exposing the final print. After exposing a few prints successfully, a beginner will quickly get enough experience to judge the density of most negatives correctly.

The crucial test for the correctness of exposure is the reaction of the sensitized

HOW TO MAKE AN ENLARGEMENT

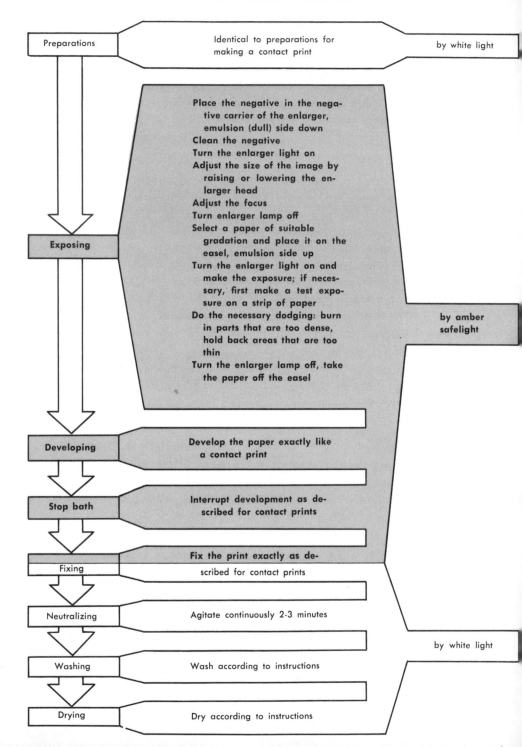

Preparations — Identical to preparations for making a contact print — by white light

Exposing
- Place the negative in the negative carrier of the enlarger, emulsion (dull) side down
- Clean the negative
- Turn the enlarger light on
- Adjust the size of the image by raising or lowering the enlarger head
- Adjust the focus
- Turn enlarger lamp off
- Select a paper of suitable gradation and place it on the easel, emulsion side up
- Turn the enlarger light on and make the exposure; if necessary, first make a test exposure on a strip of paper
- Do the necessary dodging: burn in parts that are too dense, hold back areas that are too thin
- Turn the enlarger lamp off, take the paper off the easel

— by amber safelight

Developing — Develop the paper exactly like a contact print

Stop bath — Interrupt development as described for contact prints

Fixing — Fix the print exactly as described for contact prints

Neutralizing — Agitate continuously 2-3 minutes

Washing — Wash according to instructions — by white light

Drying — Dry according to instructions

paper in the developer. The print must appear satisfactory at the end of the development time recommended by the paper manufacturer. If, beyond this time, the print is too light—if highlights are chalky and shadows are grayish instead of black—the exposure was too short. Conversely, if the image appears within a few seconds after immersion and rapidly turns too dark, exposure was too long. In both instances the print is worthless. In the first instance longer development would produce over-all grayishness from fog and yellow stain from oxidizing developer. In the second instance, if the paper were prematurely taken from the developer, the result would be a brownish print with mottled and streaky tones.

> The fourth prerequisite for successful printing and enlarging is correct exposure of the paper.

The development

Exposure of the sensitized paper produces a latent image which must be developed like the latent image in a negative, except that a paper developer must be used. Best results are usually achieved with one of the developers recommended by the paper manufacturer.

The temperature of the developer. This factor influences not only the duration of development but also the tone of the print. When paper developers are relatively cold, they act sluggishly and produce prints that appear under-exposed, with chalky highlights and grayish shadows. When developers are too warm, prints appear brownish in tone like a print that is overexposed.

> The fifth prerequisite for successful printing and enlarging is a developer temperature between 68 and 75 degrees F.

The time of development. To reach their full inherent richness of tone, prints must be fully developed within a certain time, usually from one to two minutes. Prints that apppear fully developed before this time, and those that have not yet acquired their full strength within this period, are incorrectly exposed and will appear so. The only way to regulate the developing time is to adjust the time of exposure accordingly.

> The sixth prerequisite for successful printing and enlarging is maintenance of a developing time of one to two minutes.

Practical print processing

Developing. Do not touch the emulsion side of the paper with your hands. Slide the paper edgewise into the developer, emulsion-side up. Be sure to immerse the paper smoothly without interruption to prevent streaks. Agitate continuously. If the developer tray is small, agitate by gently rocking it alternately from side to side and from front to back. If the tray is large, use tongs to agitate the print, moving it around in the developer. Do not dip your hands into the developer, because it may become contaminated by the residue of another solution which could quickly spoil it, causing brown and yellow spots or streaks in the print. Always use different print tongs for the developer and the fixer. Stop bath and fixing solutions spoil developers, so be careful to keep developing tongs uncontaminated.

Stop bath. When the print is fully developed, transfer it to the stop bath for five to ten seconds. Use the developer tongs, but be sure that they do not touch the stop bath solution. Let the print slide edgewise into the stop bath, then dunk it with the fixer tongs. Agitate continuously. The stop bath not only stops development almost instantly, but also prevents the print from staining in the fixing bath. Staining occurs frequently when prints are transferred directly from the developer to the fixer and when they are not sufficiently agitated in the fixing bath.

Fixing. Remove the print from the stop bath to the fixing bath, using the fixer tongs. Agitate thoroughly for about ten seconds. Fixing takes from five to ten minutes (depending on the freshness of the hypo), during which time any accumulating prints must be separated and agitated occasionally. Prolonged immersion in the fixer causes the image to bleach and may also cause the phenomenon known as "water soak," a condition which shows as a mottle on the back of the print and which in time may turn into a yellow stain. For maximum print permanency, use the two-bath fixing method described before; leave prints from three to five minutes in each bath. After a print has been in the fixer for about one minute, it is safe to inspect it in white light.

p. 157

Hypo neutralizing. Although not absolutely necessary, this step is recommended for maximum print permanency. Take the print from the fixer, rinse it briefly, and transfer it to the hypo-neutralizing bath. Treat single-weight prints for a minimum of two and double-weight prints for a minimum of three minutes, agitating continuously. Prints that have been thus treated require much shorter washing times.

168

Washing. Adequate washing is vitally important to print permanency because residual chemicals left in the emulsion and entrapped in paper fibers will, with time, cause stains and fading of the image. This is most likely to happen if prints have been treated in strong stop baths, in exhausted fixing baths, or if they have been left overly long in the stop bath or the fixing solution. Wash double-weight prints for a minimum of one hour (if treated with a hypo neutralizer, wash half an hour) under running water 70 to 75 degrees F. in a deep tray equipped with a tray-syphon. Do not overload the tray or the prints will stick together and they will not be properly washed. From time to time move the prints around by hand, transfer prints from the bottom of the stack to the top, and see to it that each print gets a proper wash. If running water is not available, soak the prints in a large, deep tray for five minutes, then change the water; repeat this process twelve times. Agitate and separate the prints during washing.

Drying. To remove excess water, place the print on a clean, smooth, inclined surface (in the processing sink lean a sheet of Plexiglas against a wall or use the bottom of a large tray turned upside-down and braced at an angle). Let the print drain, then swab it off with a viscose sponge or a squeegee before you place it on an electric dryer or in a photo blotter roll. To ferrotype glossy prints, use a soft cloth to clean the ferrotype plate under a stream of water before rolling on the print with a print roller. Let the print dry thoroughly, either at room temperature or in an electric dryer. Do not remove prints from ferrotype plates prematurely or the emulsion will crack. Prints that are perfectly dry strip off easily. Lift one corner and draw the print diagonally off the plate. If sticking occurs, the plate was not clean. Yellow stains are a sign of insufficient agitation during fixing, exhaustion of the fixing bath, or insufficient washing. Matte spots in the glossy finish are caused by air trapped between the ferrotype plate and the paper. They can be avoided as follows: place the print dripping wet above the ferrotype plate; stand the print on its short edge, lower it gradually onto the plate in such a way that the water running down from the print forms a cushion between print and plate, driving all air ahead of it and preventing the formation of bubbles. Then roll the print down with a print roller.

Finishing. The effect of a print depends to a surprising degree on the way in which it is presented. If it is perfectly flat or faultlessly mounted, evenly trimmed, clean, and free from dust specks and spots, the observer is much more likely to overlook or excuse minor faults of composition, definition, or contrast. However, if a photograph is good in other respects but is poorly

dried, bumpy and curling, spotty from dust specks on the negative, sloppily trimmed, with corners that are worn from careless handling, its faults would probably obscure all its good features.

Flattening. Papers that have a tendency to curl can be flattened by treating them in a commercial flattener solution or by dampening the back with a moist cloth or sponge and placing them overnight between blotters under a weight.

Trimming. To get a perfectly straight, clean edge, use a cutting board (paper trimmer) or place the print on a sheet of plate glass and trim it with a single-edge safety razor blade and a steel straight-edge. The glass, of course, dulls the blade within relatively short time, but no other support produces an equally crisp cut. If the blade gets dull, keep it sharp by breaking off worn corners. If a narrow white edge is left around the print, be sure it is even. I prefer to trim off the white edge because I feel that it makes the near-white tones of a photograph appear grayish by comparison. On the other hand, a white edge protects prints that must be handled frequently. If the white edge gets ragged, trim off a bit, and the photograph will look new.

Spotting. To spot a print, first remove dark spots with a knife—an etching knife or a safety razor blade which can be kept sharp by breaking off worn corners. Work very lightly. Carefully shave off the emulsion layer by layer until the spot blends with the surrounding tone. Be careful not to dig through to the paper base—a common mistake of the beginner. Practice on inferior prints before you start on a good one. If you have overdone the shaving and the spot is too light, darken it with a no. 4 pencil or watercolor when you retouch the light spots on the print.

Light spots must be darkened with a hard pencil, watercolor, or dye. For glossy prints, special retouching colors are available at photo stores. Apply a shade of watercolor somewhat lighter than the area surrounding the spot because as the watercolor dries, it darkens. Mix the proper shade from black and white and apply it with the tip of a fine watercolor brush. Use the color as dry as possible and apply it in very thin layers, gradually blending the spot with the surrounding area. If necessary, apply a slightly darker coat of paint after the first has dried, or use a no. 4 pencil. If a spot appears too dark after drying, shave it off before you apply a lighter tone to avoid raising a spot of paint on the print.

Mounting. Prints can be mounted on exhibition boards (standard size is 16 x 20 inches) in several different ways. However, the "professional" and permanent way to mount a print is with dry-mounting tissue that has a chemically inert

resin base which is not affected by humidity and water and does not warp the print or mount. The mounting process is simple. It is best done with a dry-mounting press, but it can also be done with an ordinary flatiron; instructions accompany the tissue. Rubber wax-base mounting tissues are subject to early decomposition of the organic rubber component. Rubber cement is temptingly easy to use but in time will discolor and stain the print. Water-soluble pastes and glues distort the paper and cause the print and mount to buckle—only a professional bookbinder or paperhanger can do a competent job with glue.

Creative enlarging

Important as a good—that is, technically perfect—negative is for the production of a good photograph, it is only an intermediary step in the making of the print. A good photo-technician can use the same negative to make many enlargements, each so different that the uninitiated would never believe they were made from the same negative. Instructions have already been given for the customary processing of prints. The following are offered to the reader whose interest goes beyond technical perfection.

Cropping. Instead of enlarging an entire negative, a single section can be enlarged. To select an area for enlarging, study your contact prints and decide which parts of the picture are important. Use two L-shaped pieces of cardboard to mask off the margins of each contact print, gradually decreasing the size and changing the proportions of the area within the L-masks until you find the most effective section of the photograph. Mark it with a grease-pencil (such marks can easily be removed with a cloth dampened in cleaning fluid). Eliminate unsharp foreground, untidy background, wires cutting across the sky, and other superfluous subject matter and marginal detail until the subject proper appears in its most concentrated form. Then enlarge it to the most effective size.

Masking. When a section of a negative is to be enlarged, the rest must be masked with black paper. Otherwise, stray light passing through the marginal parts of the negative might fog the sensitized paper, highlights would appear grayish instead of white, and the contrast range of the print would be lower than expected.

Proportions. The size and proportions of a photograph should be determined by the nature of the subject rather than the proportions of the negative or the paper. Although the standard proportions of the most common sizes of printing paper are four-to-five, many subjects can be presented with greater

effectiveness in more horizontally elongated or vertically narrow shapes, or as squares. If enlarging paper is cut down to such sizes, the part removed makes

p. 165 excellent test strips for determining the correct exposure of prints.

Perspective control. "Converging verticals" in negatives of architectural subjects can be restored to parallelity during enlarging: adjust the paper in such a way that the side of the projected image toward which the verticals converge is farther from the lens than the opposite side of the image. This is done by tilting the paper easel until the verticals appear parallel. Such a tilted image is sharp only within a very narrow zone. If the degree of tilt is very slight, the entire image can be brought into focus by stopping down the lens.

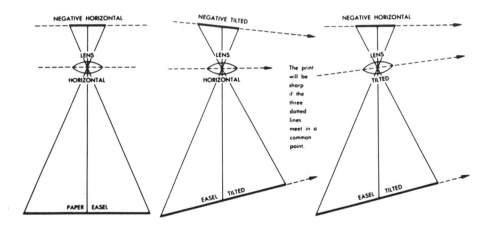

Otherwise, over-all sharpness must be restored either by slightly tilting the negative in the opposite direction from which the paper is tilted (for this purpose, some enlargers have a tilting negative carrier; if yours does not, support the negative carrier in a tilted position by blocking up one of its sides as best you can), or by *slightly* tilting the lens in the same direction the paper is tilted (for this purpose, some enlargers are equipped with a tilting-lens stage). The principle according to which such tilts must be adjusted demands that imaginary lines drawn through the planes of the negative, the lens (diaphragm), and the sensitizer paper, if sufficiently extended, would meet in a common point. If this condition is fulfilled, the entire print will be sharp without the need for stopping down the lens beyond normal. If the tilt of the easel is considerable, to produce an evenly exposed print, additional exposure must be given to that part of the image which is farthest from the lens.

172

Over-all contrast control. As noted above, the best results are generally p. 167 achieved if paper exposure is timed so that the print is fully developed in not less than one and not more than two minutes. However, the exposure latitude of photographic papers varies, and some papers allow more leeway in this respect than others. As a result, it is sometimes possible to influence the contrast of a print by appropriate manipulation of the times of exposure and development: prolonging the exposure and shortening the time of development decreases contrast; conversely, shortening the exposure and prolonging the time of development increases contrast. Since different papers react differently, the permissible latitude of such deviations from the normal times must be determined by test.

Local contrast control. A common fault of many negatives is that they are both too contrasty (hard) and too contrastless (soft). For example, in a portrait taken in bright sunlight, if shadow fill-in illumination is not used, contrast between the sunlit and the shaded parts of the face is very high; at the same time, contrast *within* the shadows, and contrast *within* the sunlit areas, is very low. If such a negative were printed on paper of soft gradation, contrast between light and shadow would be reduced to a pleasing level; but *within* the shaded and sunlit areas, contrast would be much too low and the effect would be one of flatness. The simplest way to make a satisfactory print from such a negative is to use relatively contrasty paper to produce sufficient contrast within the areas of highlights and shadows and reduce over-all contrast through "dodging."

Dodging involves giving the dense parts of a negative more exposure than the thin parts. This is done by techniques known as "burning in" and "holding back." Dense areas of the negative that normally would be too light in the print can be darkened by "burning in." This is done by cutting a hole of the appropriate shape in a piece of cardboard through which the light is allowed to fall for an additional period on the area to be darkened, while the rest of the picture is shielded from overexposure by the cardboard. Conversely, thin negative areas that normally would appear too dark in the print can be kept lighter by "holding back." This is done by using a "dodger," a small circular piece of cardboard attached to a wire handle, to shade the thin area from the enlarger light while the rest of the picture is exposed. In both cases, to avoid unsightly "holes" surrounding the treated areas, the dodging device must be kept in constant motion to blend the tone of the treated and untreated areas of the picture. Experienced printers generally use their hands for burning in and holding back, forming the appropriate shapes with their fingers.

Local darkening of the print. Despite care, it sometimes happens that toward the end of development an area of a print appears too light. If the print is small, it is usually simpler to make a new print than to try to improve a defective one. But in the case of a large print, and particularly one that was difficult to make because it required extensive dodging, there are two means by which it may be improved:

Hold the print, emulsion-side down, under the hot water faucet. Let the hot water run only over the area that is too light. Move the print back and forth slightly while it is under the stream of hot water to avoid streaks and to blend the tone of the treated and the untreated areas. Then put the print back into the developer for additional development. If necessary, repeat this once or twice.

Or darken areas that are too light by swabbing them with concentrated developer solution. For this purpose keep a small jar of developer-concentrate. Apply it to the print with a tuft of absorbent cotton. If the area to be treated is very small (for example, a small face in a crowd), apply the concentrated developer with a Q-Tip. Extreme care must be taken to avoid streaks and spots caused by developer drops, runs, and inappropriate application which fails to blend the treated area with surrounding areas. To avoid runs and streaking, place the print in horizontal position on the back of a processing tray set in the sink, touch the developer-dampened cotton to the area to be treated for a few seconds, then put the print back into the developer tray for additional development. Since these techniques require a considerable degree of skill to produce satisfactory results, a photographer should practice with test prints before he works on an important print.

Local lightening of prints. Areas of a print that appear somewhat too dark after development can be made lighter by treating them with a potassium ferricyanide solution (Farmer's reducer). This solution is highly poisonous, does not keep, and must be freshly prepared before use: shake half a teaspoon of the red crystals into a small tray half-filled with water and dissolve them completely. The strength of the solution is not highly critical, but if it is too concentrated it works so fast that it cannot be controlled and it may also stain the print. A properly prepared solution of potassium ferricyanide is yellow; if it is orange or red, it is too strong and must be diluted with water; if it turns green, it is exhausted. Prints to be treated must be *completely* fixed; if not, they will stain. Take the print from the fixer and apply the reducing solution with a cotton swab to the area that is to be lightened (for very small areas, use a Q-Tip). This must be done quickly, and immediately thereafter the print

must be immersed in the fixing bath and agitated vigorously to prevent staining (fixer neutralizes the reducer). Areas that demand considerable lightening should be reduced in stages. Once overdone, the print is spoiled. Furthermore, great care is needed to prevent streaks and spots which result if the reducer runs across, or falls in drops on, print areas that should not be reduced. Correct use of ferricyanide requires a high degree of skill and a great deal of experience. But since it offers the only means for achieving certain effects, it seems to me important that a photographer who does his own printing train himself in its use by practicing on test prints made especially for this purpose.

Test strip data. When making tests for exposure determination and dodging, experienced photographers often pencil the exposure times on the back of the paper before developing the strip. If this is not done, the exposure times may be forgotten and the whole procedure may need to be repeated.

Check for pure white. The best way to determine whether highlights and white in a print are truly white or slightly gray is to curl back a corner of the sensitized paper while it is in the developer and hold it against the image. Since the back of the paper is pure white (unless, of course, a tinted paper is used), even the slightest degree of grayishness in a seemingly white highlight can be detected. Otherwise, even surprisingly dark shades of gray can seem white under the safelight if not subjected to such comparison.

Check on darkness. Prints always appear lighter in the fixer or water than when they are dry. If a wet print appears just right under the safelight, one can almost be sure that it will be too dark after it has dried. Allow for this change by developing prints slightly lighter than you wish them ultimately to be.

Hand protection. During long darkroom sessions, it is unavoidable that the hands come into repeated contact with processing solutions. Since some people are allergic to certain chemicals used in photography (Metol poisoning is not uncommon), to avoid the danger of skin irritations and rashes some darkroom workers use thin rubber gloves. I prefer using Kerodex protective hand cream which, if applied according to instructions, offers complete protection against skin irritation and chapping.

HOW TO MAKE A COLOR PRINT

Like color-film development, color-film printing involves processes which I consider outside the scope of this text for the following reasons: the overwhelming majority of color photographers work with positive color films which don't require printing; manufacturers of color-printing materials are likely to change their products and processes at any time, as they have done in the past, and information given here might be obsolete before this book is off the press; authoritative instructions are already included with all materials needed for printing color films; the techniques involved in color printing are complex and critical, as a result of which photographers who work with negative color films largely let commercial color labs make their prints; excellent instructions for making color prints on Kodak materials are already available in the form of the inexpensive, authoritative Kodak Color Data Book *Printing Color Negatives,* which is available at most camera stores—a "must" for anyone intending to make his own color prints. I therefore present here only that basic information which will give the reader who is interested in color printing an idea of what is involved. Should he later decide to make his own color prints, he will find the necessary up-to-date instructions in the sources listed above.

Photographers used to seeing positive color transparencies on a light-box or projected on a screen are often disappointed to find that, by comparison, even the finest color print seems dull and flat. The explanation of this difference lies in the fact that color in a transparency is experienced in transmitted light; in a print, in reflected light. In the first case the effect is comparable to that of, say, a traffic light—disks of colored glass seen in transmitted light. In the second case, the effect is comparable to that of a painted warning sign—what we see is reflected light. Obviously, the traffic-light signal must appear brighter and more luminous than the opaque warning sign that is merely painted.

The difference between a transparency and a print is basically the difference between transmitted and reflected light—the same difference that exists between "light" and "white." When a color transparency is viewed on a light-box in transmitted light, only the light which has passed through the transparency reaches the eye of the observer. This means that even in the deepest shadows, where the light may be transmitted only to the extent of perhaps one-tenth of 1 percent, the light is still controlled by the dyes of the transparency. As a result, the full range of tones of the transparency is seen by the observer.

However, although a color print is similar in structure to a color transparency insofar as it consists of three layers of dye images, light which reaches the eye of an observer derives from two sources: the first, as in the transparency, is that which passes through the dye layers and is reflected back to the observer's eye by the underlying white print base. The second (and note that this does not occur when one contemplates a color transparency on a light-box) consists of the light which is reflected directly from the surface of the print without ever having passed through the dye images. Since this second component of the light amounts to approximately 2½ percent of the total light reflected from the print, the maximum ratio between the brightest highlights and deepest shadows in a color print can never amount to more than about 40 to 1. For no matter how much one increases the intensity of the light by which one views a print, its lightest and darkest parts always receive the same amount of illumination, thus its contrast range remains constant. For this reason, a color print on an opaque base can never appear as vivid and natural as a color transparency viewed in transmitted light.

Another problem in direct color printing is created by the imperfect absorption characteristics of the dyes which must be used. Although there are inevitable losses in any color reproduction because the dyes are not perfect, in positive color transparencies made directly from the original subject these losses are minor and generally pass unnoticed except when the transparency is compared critically with the original. But when a color print is made from a transparency, no matter whether positive or negative, the result becomes a reproduction of a reproduction. Losses in faithfulness of color rendition become cumulative, distortion is multiplied by distortion, and color degradation can assume proportions which make the subject appear decidedly unnatural in terms of color.

How to select color negatives for printing

Although it is possible, within reasonable limits, to correct certain faults of color negatives during printing, the fact remains that color negatives which are already as nearly perfect as possible invariably yield the most beautiful prints. To be specific, the following points require attention:

Contrast. As explained above, the tone scale of a paper print is relatively short. If a color negative contains simultaneously very dense and very thin areas, either one or the other, but not both, can be rendered satisfactorily with ordinary printing techniques in the same print. Consequently, color negatives in which contrast is relatively low, always yield the most pleasing prints.

If excessively contrasty color negatives are expected to yield good prints, masking is required. A "mask" is a positive contact print made from the color negative, usually on low-contrast panchromatic black-and-white film, which is "dense" where the color negative is "thin," and "thin" where the color negative is "dense." During printing, the mask is bound in register with the color negative, the contrast of which is thereby reduced to a printable level.

Color. The production of a color print always involves a certain loss of color saturation. In addition, as explained above, some color degradation is unavoidable. Therefore, color negatives of subjects in clean and highly saturated colors usually yield better prints than negatives of subjects in dull colors or pastel shades, which not only will appear even drabber in the print, but also reveal inaccuracies in color rendition more prominently than vivid colors, in which even relatively large departures from the actual color shade may pass unnoticed.

Overall inaccuracy of color rendition in the negative due, for example, to excessively bluish or yellowish light, fluorescent illumination, or tinted window glass through which a photograph was taken, can usually be corrected without much difficulty during printing by an appropriate adjustment in filtration, as p. 182 will be explained later.

Exposure. Since printing inevitably involves some loss of color saturation, underexposed color negatives, in which color is already desaturated to a higher or lesser degree, invariably yield disappointing prints. On the other hand, color negatives which are somewhat denser than normal owing to a slight degree of overexposure, generally make excellent prints. Therefore when working with positive color films and shooting negative color film, erring on the side of overexposure is, contrary to usual practice, preferable to exposing too little.

The printing process

In essence, making a print from a color negative is identical with making a print from a black-and-white negative except that, in color printing, the enlarger light must be color-balanced in accordance with the color characteristics of the negative and the desired overall color of the print. For this purpose, unless the enlarger is already equipped with a special color head containing a set of dichroic filters, special color filters are used which come in two types: Kodak CP (acetate Color-Printing) filters for use in enlargers which accommodate filters between the lamp and the negative (this is the best filter location; filters

178

so placed cannot interfere with the sharpness of the print); and Kodak CC (gelatin Color-Compensating) filters for use between the enlarger lens and the sensitized paper. Minimum requirements: a red, a magenta, and a yellow set of filters, each set having four filters in different densities if acetate, and six filters in different densities if gelatin. In addition, no matter what type of filter is used, the enlarger must be equipped with a constantly used ultraviolet-absorbing filter (Kodak Wratten Filter No. 2B or Color Printing Filter CP2B) and a heat-absorbing glass (Pittsburgh No. 2043).

The first step in color printing is determining the correct *basic filter pack*—that is, that combination of filters which, used with a "normal" color negative, will produce a print of satisfactory color balance. Unfortunately, the combination of color filters will vary with the voltage applied to the enlarger lamp, the color of the enlarger's condensor and heat-absorbing glass, the specific color paper emulsion (which usually varies from batch to batch) and, of course, what the photographer prefers. Consequently, it is not possible to predict in advance which combination of color filters will give the best result, and the only way to establish the basic filter pack is by trial and error.

Photographers who work with Kodak negative color films (Kodacolor or Ektacolor) should begin by making an exposure determination test using a basic filter pack consisting of a 2B and a 50R filter and the combination of diaphragm aperture and image magnification with which the final color print will be made. The test paper should be exposed in strips as follows: cut a sheet of Ektacolor paper into strips approximately 2 inches wide. Place a strip on the easel. Cover four-fifths of it with a piece of cardboard, and expose the uncovered part for 32 seconds. Uncover one-fifth more, and expose for 16 seconds. Repeat this operation, exposing the remaining three-fifths of the strip for 8, 4, and 4 seconds, respectively. Thus the five sections of the strip receive exposures of 64, 32, 16, 8 and 4 seconds, respectively. Develop and dry the strip. In bright light (but *not* in fluorescent illumination), examine the print for exposure and color balance. If the darkest section of the strip is still too light, the longest exposure was still not long enough and a new test with longer exposures must be made. If the lightest section of the strip is still not light enough, the shortest exposure was still not short enough and a new test with shorter exposures must be made. If one of the sections of the strip contains the correct exposure, judge its color; if you like what you see, you are all set to make the final color print.

However, it is much more likely that your first test will be unsatisfactory in terms of overall color. If this is the case, determine the exact shade of the

179

excess color. This is most easily done by analyzing the neutral shades, particularly gray and white if present; otherwise, skin tones and pastel shades. If they are too red, too yellow, too blue—whatever the color problem—add to your basic filter pack a filter in the same color as the color cast of your test print and make a second test. The density of this additional filter depends on the degree of the color cast: if the cast is very mild, use your palest filter (CC05); if the cast is moderate, use a moderately dense filter (CC10, CC20); if the cast is very pronounced, use a still denser filter (CC40, CC50). And if the color cast seems to be a combination of two colors, for example red and yellow (that is, orange), add one red and one yellow filter to your basic filter pack.

But what should one do if the print happens to turn out with, for example, a blue-green (cyan) color cast? Then, instead of *adding* a cyan filter in the proper density (which, of course, would correct the color cast), it is more practical (because it requires the use of a smaller number of filters) to take away excess red filtration (which achieves the same result because red is the complementary color of cyan as was explained before) and, instead of the originally used 50R filter, use a weaker red filter, perhaps 30R, 20R, 10R, 05R or, if this is not sufficient, omit the red filter altogether.

As this example shows, the overall color cast of a color print can be corrected in two different ways:

> by *adding* a filter in the same color as the color cast;
> by *taking* away a filter in the complementary color of the cast.

Additive primary colors		Subtractive primary colors
red	is complementary to	cyan
green	is complementary to	magenta
blue	is complementary to	yellow
red	is equivalent to	yellow + magenta
green	is equivalent to	cyan + yellow
blue	is equivalent to	magenta + cyan

In practice, such corrections can usually be accomplished by combining color filters in different ways, and the best way is always that which requires the smallest number of filters.

For more about complementary, additive, and subtractive colors see Par VI. In order to select the best possible filter combination, a photographer must draw

from the information regarding the nature of color that section contains. For our present purpose, however, the principles of additive and subtractive color mixture can be summed up as follows:

The relationships between the above colors should make it clear why any desired color correction can be made with filters in only three different colors: cyan, magenta, and yellow. For example, if the overall tone of the test print is too blue, you can remove the excess blue either by adding blue to your basic filter pack (which means increasing the number of filters, although this is always disadvantageous); or you can get the same effect by subtracting yellow (since blue and yellow are complementary colors).

Now, if you started your test series with a 50R filter as recommended, you can NOT, of course, take away a yellow filter because there is no yellow filter in your filter pack. However, as is evident from the above table, in effect, a 50R filter is the equivalent of a 50Y (yellow) plus a 50M (magenta) filter. Hence, if you substitute these two filters for your 50R filter, you would get the same effect. But now you have a yellow filter in your basic filter pack, and if you chose instead to combine a 30Y (instead of 50Y) and a 50M filter, you would in effect have subtracted yellow in the amount of a 20Y filter. The following table, which shows the interrelationship between color cast and color correction filters, should make it easy to select the appropriate correction filters.

If your test print contains too much	Either subtract filters in these colors	Or add filters in these colors
red	cyan	red (or yellow + magenta)
green	magenta	green (or cyan + yellow)
blue	yellow	blue (or magenta + cyan)
yellow	magenta + cyan (or blue)	yellow
cyan	yellow + magenta (or red)	cyan
magenta	cyan + yellow (or green)	magenta

Changes in the filter pack, of course, influence the exposure, which must be corrected accordingly. The new exposure can be determined either by making a new test strip with the changed filter pack, or by using the Kodak Color-Printing Computer. It is included in the *Kodak Color Dataguide* which, in my opinion, is indispensable to any photographer who wishes to develop and print his own Kodak color films.

Once the principle of corrective color filtration is understood, the mechanics are simple and can be summed up as follows:

To correct a color cast (that is, to eliminate excess overall color), subtract a filter in the complementary color from your filter pack. This method usually gives the best results because it normally involves the smallest number of filters. Alternatively, you can add to your filter pack a filter in the same color as that of the color cast.

To give the print a specific overall color shade (for example, yellow to make it "warmer," or blue to "cool it off"), subtract a filter in the same color from your filter pack. Alternatively, you can add to your filter pack a filter in the complementary color.

The greater the amount of color you wish to remove or add, the greater the density (and the higher the number) of your CP or CC filter. If a filter with the highest number is not dense enough to produce the desired effect, two or more filters of the same color can be combined. For example, a combination of a CC40R and a CC50R filter is equivalent to a CC90R filter (which does not exist in the form of a single filter).

The color relationship between Kodak color correction filters is such that the additive filters red, green, and blue each contain approximately the same amount of the same dye as the two corresponding subtractive filters yellow + magenta, cyan + yellow, and magenta + cyan. For example, a 10R (red) filter produces the same effect as a 10Y (yellow) + a 10M (magenta) filter, and a filter pack consisting of a 10R + 20Y + 10M filter is equivalent to one consisting of a 30Y + 20M filter (because 10R is equivalent to 10Y + 10M). Accordingly, a specific color can usually be produced by different combinations of filters, and the best combination is always that which requires the smallest number of filters and which also has the least density and requires the shortest exposure.

Local contrast control. Areas which in a "straight" or uncontrolled color print would appear either too light or too dark, can be darkened or lightened, respectively, through "dodging." The process is similar to the one described earlier for black and white film.

p. 173

182

The eye sees this: The lens "sees" this:

The eye adjusts automatically to different levels of illumination; the lens does not. As a result, dark subject areas and shadows which appear to us transparent and full of detail are rendered as more or less undifferentiated black areas in an uncontrolled photograph.

Differences in "seeing" between the eye and the lens

When looking up at a building, the eye automatically compensates for the apparent converging of vertical lines; the lens does not. As a result, while we perceive the sides of buildings as parallel, the uncontrolled camera shows them leaning, as if about to collapse.

Focusing and "selective focus"

The eye automatically adjusts to differences in subject distance; the camera does not. As a result, while all the objects that surround us appear sharp simultaneously, no matter whether nearby or far away, the lens can be focused sharply on only one specific plane in depth at a time. Although this characteristic may at first seem a weakness of the photographic process, actually it is an advantage: by focusing his lens selectively upon a specific, preselected object in depth, the photographer can single it out, emphasize it, and render it sharply while allowing objects at other distances to appear increasingly unsharp the

farther they are from the plane of focus. In comparison with pictures that are sharp throughout, such "selectively focused" photographs evoke a much stronger impression of "depth."

To familiarize himself with this technique and its effects, I suggest that the reader create a test situation similar to the one shown in the first picture on this spread, then photograph it three times with the lens focused first on the background, next on the middle-ground, and finally on the foreground, as illustrated above. The larger the diaphragm aperture and the longer the focal length of the lens, the stronger the resulting depth effects will be, and vice versa.

Creation of sharpness in depth

The means for extending the sharply rendered zone in depth is the diaphragm. The more it is stopped down, the greater the extent of sharpness in depth. Maximum sharpness in depth with minimum stopping down is achieved if the lens is focused on a plane situated approximately one-third within the depth of the zone which must be covered sharply; subsequently, the diaphragm is stopped down in accordance with the depth-of-field scale engraved on the lens. To make the pictures on this page, the lens was focused on the statue and stopped down to f/1.8, f/11, and f/22, respectively.

The four kinds of unsharpness

Overall, nondirectional unsharpness (top left) is the result of incorrect focusing or forgetting to focus at all.

Partial, nondirectional unsharpness (top right) is the result either of incorrect focusing, diaphragm aperture too large to produce sufficient "depth," or both.

Overall sharpness (right) is the result of correct focusing, appropriate diaphragm stop, suitable shutter speed.

Partial, directional unsharpness (bottom left) is the result of a shutter speed too slow to "stop" subject motion.

Overall, directional unsharpness (bottom right) is the result of camera movement during exposure.

Reflected-light meters "think average"

In the picture series to the left, the girl's blouse was white, the rectangle (a Kodak Neutral Test Card) gray, the drape black. The numbers indicate the brightness values established with a Weston light meter. The first picture was exposed for the white blouse, the second for the gray card, the third for the black drape. Consequently, these three items appear in the pictures cited in approximately the same shade of medium gray—a reminder to photographers that brightness values established with the aid of light meters require careful interpretation. For more specific information, see the discussion on pp. 121-122.

The light-accumulating ability of film

The effect of light on any photographic emulsion is cumulative within certain limits—the longer we expose, the denser the negative (but the paler and more "washed out" a color transparency). This phenomenon is particularly useful in night photography: the longer the exposure, the more detailed the picture. The photographs at the left were exposed 1, 60, and 300 seconds, respectively. The one furthest to the left corresponds approximately to what the eye saw in reality. The furthest to the right is as detailed as if it had been made in daylight.

189

Exposure too short

Development too short

Exposure too long

Normal negative

Development too long

Knowing how to "read" a negative in regard to correctness (or incorrectness) of exposure and development is an indispensable prerequisite for successful photographic work. The pictures above show how a perfect negative (center) looks in regard to density and contrast in comparison with four unsatisfactory negatives, the characteristics of which are summarized below.

Appearance of the negative			Cause of the defect	
Too thin	and too contrasty	=	Exposure	too short
	and too contrastless	=	Development	
Too dense	and too contrastless	=	Exposure	too long
	and too contrasty	=	Development	

Density is equivalent to the lightness or darkness of a negative or a specific negative area. Negatives that have too little density (left) are deficient in detail of rendition; those that are too dense (right) are unnecessarily grainy, unsatisfactory in regard to sharpness due to halation within the emulsion, and difficult to print.

Distinguish between density and contrast

Contrast is equivalent to the difference between the lightest and darkest areas of a negative. "Soft" negatives have too little contrast (left), yield prints that appear too gray, and never contain areas of black and white simultaneously. "Hard" negatives have too much contrast (right), yield prints that appear harsh, are deficient in intermediary gray shades.

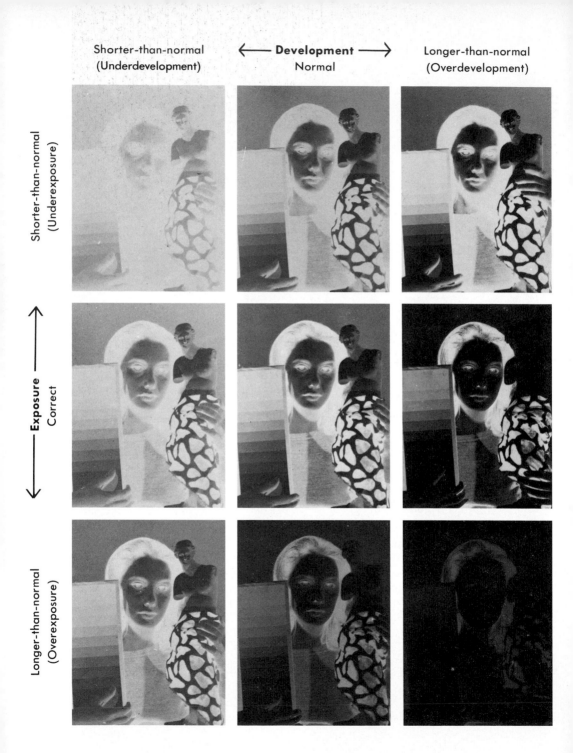

Shorter-than-normal (Underdevelopment) ← **Development** → Longer-than-normal (Overdevelopment)
Normal

Shorter-than-normal (Underexposure)

Exposure Correct

Longer-than-normal (Overexposure)

The nine negatives

From left to right and top to bottom, these are the nine possible combinations of exposure and development and their results in terms of density and contrast of the negative. Intermediate and more extreme effects can be achieved as well.

1. *Underexposed and underdeveloped*. Overall contrast and density are extremely low, shadow detail is lacking, highlights are too weak. Remedy: None. This kind of negative is a total loss.

2. *Underexposed but normally developed*. Overall density is too low, contrast is slightly higher than normal, shadow detail is inadequate, highlights are still printable. Remedy: If shadow detail is present, print on paper of hard gradation and burn in highlights.

3. *Underexposed and overdeveloped*. Overall density is about normal, contrast is relatively high, thin areas are often fogged, highlights are barely printable. Remedy: Print on paper of relatively soft gradation.

4. *Correctly exposed but underdeveloped*. Overall density is somewhat low, contrast is low, shadow detail is present but very thin, highlights are too weak. Remedy: Print on paper of hard gradation.

5. *Correctly exposed and developed*. Overall density, contrast, and shadow detail are normal, highlights strong but still transparent. Such negatives print well on no. 2 or 3 paper.

6. *Correctly exposed but overdeveloped*. Overall density is too high, contrast exaggerated, shadow detail very strong, highlights too dense and partly blocked, graininess pronounced. Remedy: Print on paper of medium-soft gradation; if possible, reduce negative in a potassium persulfate reducer (Kodak R-15).

7. *Overexposed and underdeveloped*. Overall density is about normal, contrast slightly low, shadow detail good, highlights easily printable. Negative should print well on no. 3 or 4 paper.

8. *Overexposed but normally developed*. Overall density is too high, contrast low, shadow detail very strong, highlights much too dense; sharpness is diminished due to halation within the emulsion and excessive graininess. Remedy: Reduce in ferricyanide reducer (Kodak R-4a).

9. *Overexposed and overdeveloped*. Overall density is extremely high, the negative appears almost uniformly black. Contrast is about normal; highlights unprintable; halation and graininess extreme. Remedy: Reduce in a proportional reducer (Kodak R-4b or R-5), then print on paper of normal gradation.

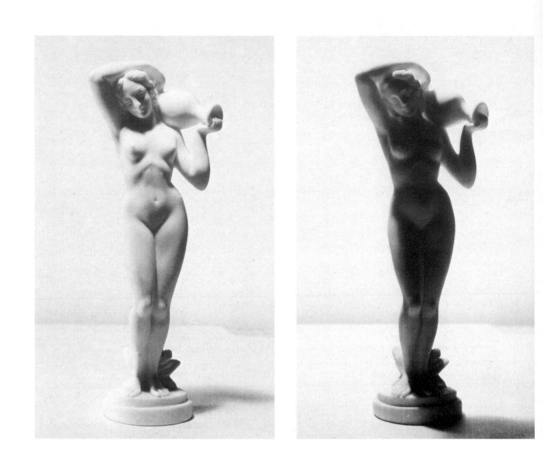

Working with light

If circumstances permit, the simplest method of controlling subject contrast is with the aid of light in accordance with the principle that a brightly illuminated subject or area will be rendered lighter in the picture than one that receives less light or is kept in the shade.

To explore lighting as a means of contrast control, I suggest that the reader repeat the "photographic finger exercise" shown on this spread (from left to right): Place a white object in front of a white background and illuminate it with a single photo-lamp so that, first, both subject and background are fully illuminated; second, background receives full illumination, the object is in the shade; and third, the object is fully illuminated, the background is in the shade. Then, print the negatives but, in addition to these "normal" prints, make two additional prints from the first negative: one, longer exposed (top right), in which object and background appear in a medium gray;

and another one (lower right), still longer
exposed, in which object and background
are nearly black.

As this experiment proves, through light
alone, a white object in front of a white
background can be rendered either as
white against white, gray against gray,
black against black, black against white,
or white against black, plus in any number
of intermediary forms not pictured here
—convincing proof of the creative poten-
tial of light.

Blue filter No filter

Control of a single color, in this case: blue

Color contrast is an important means of visual object differentiation. In black-and-white photography, however, colors of different hues (for example: red and green) but equal brightness are transformed into more or less identical shades of gray. As a result, color contrast and with it subject differentiation is weakened or even lost in the black-and-white rendition unless the photographer is aware of this danger and counters it with the aid of filters.

In practice, color separation in terms of black and white by means of filters is based on the fact that a filter transforms its own color into a lighter shade of gray, and its complementary color into a darker shade of gray, in the black-and-white rendition, than these colors would have appeared if no filter had been used.

Yellow filter

The photographs in this series were taken only minutes apart. They show how the rendition of sky and clouds can be controlled with the aid of filters. Although clouds are usually emphasized rather than suppressed in pictures, the latter may be desirable if complex subject matter must be photographed against the sky, necessitating a neutral background for clarity's sake.

Red filter + polarizer

Control of two colors, in this case: red and green

By means of judicious filtration, a photographer can exert a very high degree of control over the translation of subject color into shades of gray. To familiarize himself with the effect of different filters on different colors, I suggest the reader repeat the "finger exercise" depicted on this spread: arrange a still life consisting of an object and a background in complementary colors and, with the aid of the appropriate filters, make a set of pictures in which subject and background appear as white on white, gray on gray, black on black, white on black, and black on white. That this is possible is proven by the accompanying photographs, which show a bright red pepper against a bright green cabbage leaf. Although, as indicated by the shadow, all pictures are positives, the differences between them are such that photographs which face one another diagonally in the layout seem like positive and negative—proof of the inherent potential of filtration as a means of creative picture control.

Control of space

The pictures on this page were made with a wide-angle, a standard, and a telephoto lens, respectively. Since subject-to-camera distance was the same in all three, *perspective*—the relationship between the different picture components—is the same, although the *scale* of rendition varies.

The pictures on the opposite page were made with the same lenses as the photographs above but from different subject-to-camera distances (to ensure that the speed sign always appeared in the same scale). As a result, *perspective* is different in each, even though the *scale* of the speed sign is the same.

As these two picture sets prove, by using a lens with the right focal length in conjunction with the appropriate subject-to-camera distance, a photographer can control the rendition of space in terms of perspective and scale in his pictures; choosing either perspective, or scale, or both to fit his purpose precisely. For more specific information, see pp. 257, 343-346.

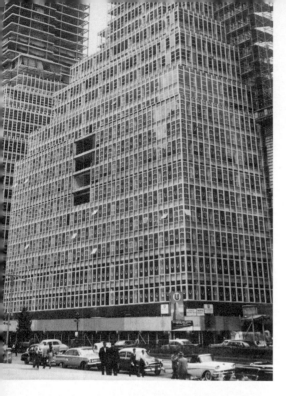

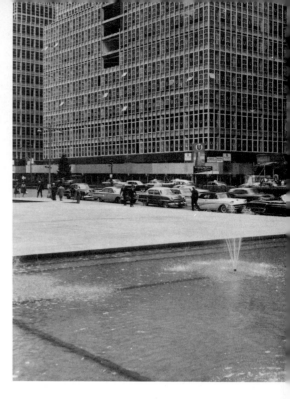

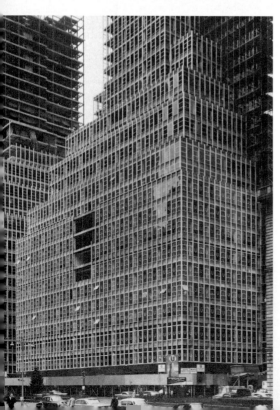

Space control with a view camera

To render a tall building ''distortion-free' proceed as follows:

1. Aim and focus the camera as usual. The walls of the building will converge on the groundglass as in the picture above, left.

2. Level the camera. This will restore the parallelity of vertical lines, but the upper part of the building will be cut off as in the picture above, right.

3. Raise the lens until the building appears on the groundglass as desired; see the picture at left.

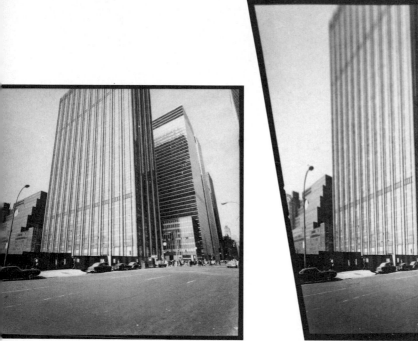

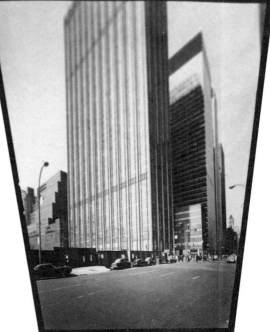

Space control with an enlarger

Even if "distorted," a negative can yield an "undistorted" print if the photographer proceeds as follows:

1. Place the negative in the enlarger and project it upon the easel. The image will appear distorted; see picture above, left.

2. Tilt the easel until vertical lines are parallel in the image and support it in this position. The trapezoid-shaped image will be partly blurred; see picture above, right.

3. Tilt the negative in the opposite direction from the easel until, after refocusing the lens accordingly, the entire image appears sharp; see the picture at right.

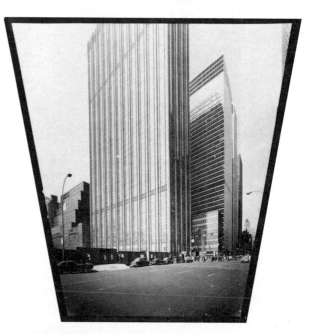

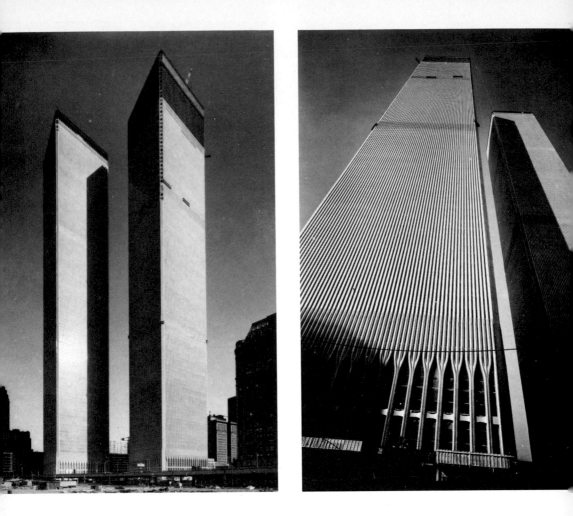

Space control: the four kinds of perspective

As photographers, we can choose among the four different kinds of perspective illustrated on this spread. Each has its own characteristics and usages.

1. **Academic rectilinear perspective.** Straight lines are rendered straight in the picture. Verticals are always rendered parallel. With the exception of verticals, parallel lines not parallel to the plane of the film converge toward vanishing points.

2. **True rectilinear perspective.** Straight lines are rendered straight in the picture. All parallel lines that are not parallel to the plane of the film, verticals included (for example: in oblique views), converge toward vanishing points.

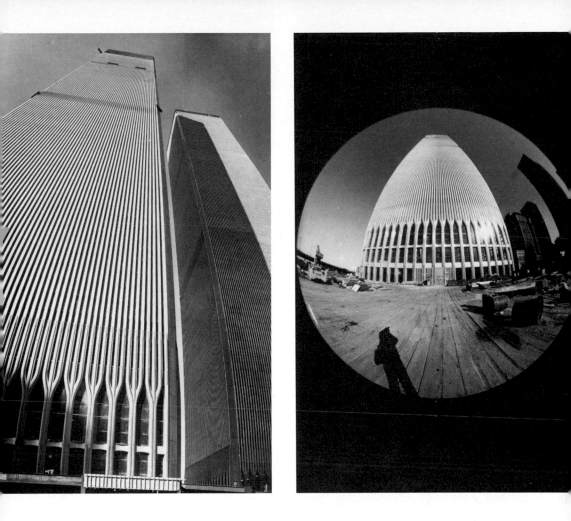

3. **Cylindrical perspective.** This form of perspective is produced by all "panoramic" cameras, the lenses of which swing through an arc during the exposure, "scanning" the film. Any straight lines not parallel to the axis of the swing appear as curves—the more curved, the closer they are to the long edges of the picture. The angle of view is usually 140 degrees.

4. **Spherical perspective.** This form of perspective is produced by all fish-eye lenses. All actually straight lines appear as curves except those that are parallel to the optical axes which, appearing as radii in the picture, are rendered straight. Rendition, which usually includes an angle of 180 degrees, is identical to the image of the same view reflected in a mirrored sphere.

Synthesis of a cylindrical perspective

The composite picture at the left demonstrates why straight lines must appear curved in renditions that encompass abnormally large angles of view. Each of its three components was made with a Rolleiflex equipped with a lens of standard focal length. Considering the direction of view of each individual picture, its perspective is "normal": in the center picture—camera held level—verticals are rendered parallel because they were parallel to the plane of the film. When the camera is tilted (top and bottom pictures), verticals converge toward common vanishing points. Considered alone, each segment is rendered in "normal" perspective, each encompassing an angle of view of some 45 degrees. But when we join them to include the entire height of the skyscraper in one view—a view of some 140 degrees!—the impression is that of a building bulging at the middle, similar to that of the picture on the opposite page which was taken with a panoramic camera in cylindrical perspective encompassing an angle of 140 degrees. Similar—but not identical: instead of "unnatural" angles where the composite pictures meet, we now have smooth and elegant curves—precisely what we can see with our own eyes if we let our gaze sweep the actual building from top to bottom. The reason we don't normally see this effect is because the angle of sharp human vision is less than five degrees while the angle encompassed by this picture is thirty times as large.

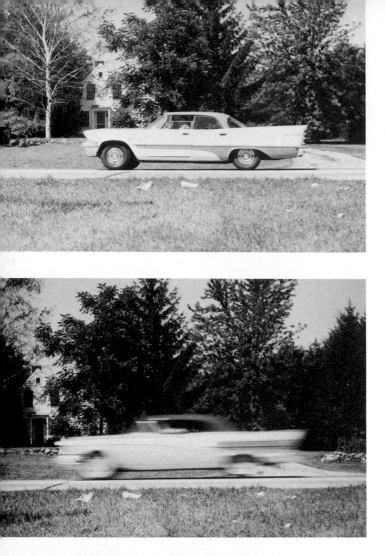

Exposure 1/1000 sec. Motion is "frozen." The car, although moving, appears to be standing still.

Exposure 1/25 sec. Blur is proof that the car was in motion. The degree of blur suggests the rate of speed.

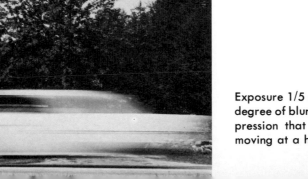

Exposure 1/5 sec. A higher degree of blur gives the impression that the car was moving at a higher speed.

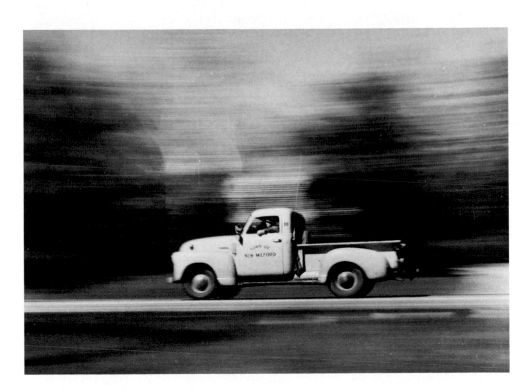

Motion symbolization

In a still photograph, motion can be expressed only in symbolic form. The graphic symbol of motion is blur. Normally, to indicate motion, the moving subject is rendered blurred against a sharply defined background, and the higher the degree of blur, the stronger the feeling of motion. Sometimes, however, the moving subject must be rendered sharply (to be recognizable in detail); in that case, the background can be made to appear blurred by means of a technique called *panning*: the photographer centers and holds the image of the moving subject stationary in the viewfinder by swinging the camera like a gun trained on flying game, and releases the shutter while the camera is in motion. This makes the background move relative to the subject with the result that, in the picture, the subject will appear sharp and the background blurred, as in the photograph above. For more information, see pp. 359-363.

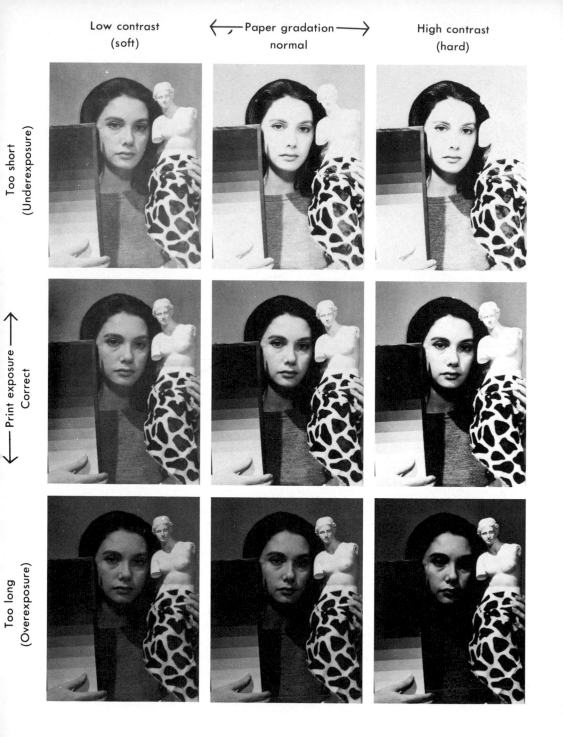

Low contrast (soft) ⟵ Paper gradation normal ⟶ High contrast (hard)

Too short (Underexposure)

Print exposure · Correct

Too long (Overexposure)

The nine positives

From left to right and top to bottom, these are the nine possible combinations of paper gradation and print exposure and what they produce in terms of contrast and lightness or darkness of the picture. Results obtained can also fall some place between the examples presented here or be more extreme.

1. *Paper too soft, print underexposed.* Overall impression: one of weakness. Gray shades appear "muddy," and black and white never occur together in the same print.

2. *Paper gradation normal, print underexposed.* Overall impression: the print appears too light, "washed-out," gray shades are inadequately represented.

3. *Paper too hard, print underexposed.* Overall impression: harsh and "chalky," too contrasty, the image consists almost exclusively of black and white.

4. *Paper too soft, print correctly exposed.* Overall impression: contrast is too low, the print looks "muddy" and "flat."

5. *Paper gradation normal, print correctly exposed.* Overall impression: natural and pleasant, the print is satisfactory in regard to contrast and tonal differentiation.

6. *Paper too hard, print correctly exposed.* Overall impression: too contrasty, somewhat harsh, intermediate gray shades inadequately represented.

7. *Paper too soft, print overexposed.* Overall impression: too dark, too soft, too contrastless.

8. *Paper gradation normal, print overexposed.* Overall impression: slightly dark, but not really unpleasant.

9. *Paper too hard, print overexposed.* Overall impression: too contrasty and too dark, intermediary gray shades inadequately represented.

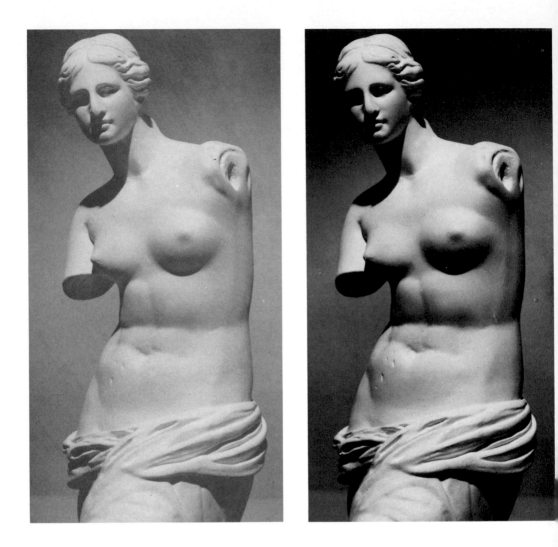

Contrast control through paper gradation

The easiest, though not necessarily the best, method of controlling the contrast gradient of a photograph is to print the negative on a paper of appropriate gradation. Most photographic papers are available in four, some in five, and very few in six different gradations ranging from very soft and contrastless to ultra-hard and contrasty. For most normal purposes, four different

gradations—soft, normal, hard, extra-hard—are sufficient. The range of these papers is demonstrated by the pictures on this spread, all of which were printed from the same negative. Additional techniques are available to produce even softer or harder prints if required, the ultimate in contrast control being prints from normal negatives which consist exclusively of black and white. For more detailed information, see the discussions on pp. 324-331.

Lighter or darker print? The choice is yours. By simply varying the time of exposure during enlarging, you can produce lighter or darker prints, thus controlling your picture's mood. A light overall tone creates a gay, inviting impression; a darker overall tone evokes a serious, somber, even ominous mood.

Exposure equivalents

Correct exposure is the result of correct choice of f-stop (diaphragm aperture) relative to the shutter speed in accordance with the brightness of the incident light. The instrument which provides the necessary data is the light meter.

A light meter, however, provides more than one set of data for any specific occasion. This is due to the fact that, as far as correctness of exposure is concerned, the same result can be produced by combining a relatively large diaphragm aperture with a relatively high shutter speed, or a relatively small diaphragm aperture with a relatively low shutter speed. But although, in both cases, the density of the negative or the colors of the transparency will be the same, as far as subject rendition is concerned the results would be very different.

In the first case, the depth of the sharply rendered zone would be rather limited but a subject in motion would appear sharp, while in the second case the opposite would be true: the depth of the sharply rendered zone would be rather extensive but a subject in motion would appear more or less blurred.

Consequently, in deciding which one of the possible combinations of f-stop and shutter speed he should use, a photographer must take into consideration the depth of the subject which must be covered sharply and, if subject movement is involved, whether he wants to "freeze" this motion in his photograph or symbolize it by a more or less pronounced degree of blur.

Study these differences in the pictures at the right. Proceeding from top to bottom, they were shot with 1/1000 sec. at f/2.8, 1/125 sec. at f/8, and 1/15 sec. at f/22.

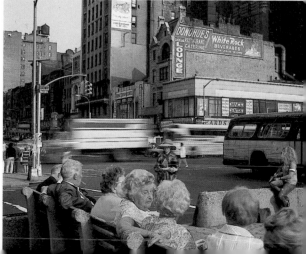

"White" (colorless) standard daylight.

The golden light of late afternoon.

The varying colors of daylight

Daylight color film is designed to give faithful color rendition in standard daylight—a combination of direct sunlight and light reflected from a clear blue sky with a few white clouds during the hours when the sun is more than 20 degrees above the horizon. If pictures are made on daylight color film in any light that does not conform to these specifications, the transparency will have a more or less pronounced color cast and the colors of the subject may appear unnatural.

At sunset, light is more or less red. Daylight in the open shade is blue.

The pictures on this spread show the same white plaster figurine photographed on daylight color film in different types of daylight. The statue appears white—or "natural"—only in the shot that was made in standard daylight. In all others it has a color cast in the color of the light in which it was photographed. If such a color cast is not too pronounced (the pictures above show extremes), it can usually be avoided with the aid of the appropriate filter. In my opinion, however, a more interesting effect will usually result if the photographer deliberately uses the "abnormal" color of the illumination to produce pictures which effectively reflect the special character of such "unusual" forms of light.

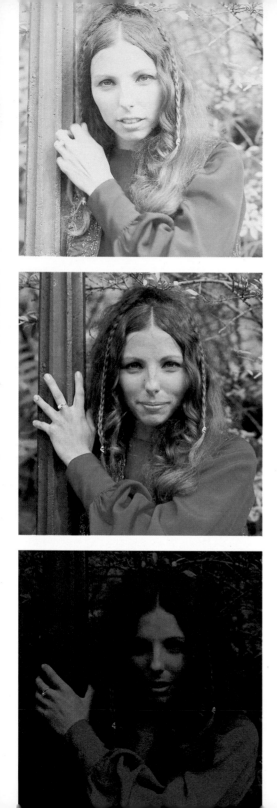

In color photography, exposure latitude is much narrower than in black-and-white. Overexposure—the consequence of a shutter speed that was too low or a diaphragm aperture that was too large—manifests itself in the form of colors that are too light (left, top). Underexposure—the result of a shutter speed that was too high or a diaphragm aperture that was too small—produces colors that are too dark (left, bottom). For comparison, a correctly exposed transparency is shown at the left, center.

If conditions permit, the best way to correct exposure is by *bracketing*—that is, making several exposures of the same subject with slightly different f-stops or shutter speeds, grouped around a value which, according to light meter, should have been correct. Normally, a bracket of three exposures is sufficient—one shot exposed according to light meter, another slightly shorter, and a third slightly longer. Under difficult circumstances, a series or "bracket" of four or more exposures might be necessary. To be effective, exposures must be spaced at half f-stop intervals if reversal (positive) color film is used, at full f-stop intervals if negative color or black-and-white film is used. Smaller intervals would be wasteful, larger ones might cause the photographer to miss the best exposure. The illustrations on the opposite page show a bracket of six shots, at least two of which would be usable, depending on whether the photographer prefers a lighter or darker picture.

Portrait shot outdoors in the open shade on daylight color film. The only illumination came from light reflected from a deep-blue sky. Left: No filter used, the transparency appears unnaturally blue. Right: Shot through an 81G "warm-up" filter, skin tones appear "normal" despite the strongly blue-colored light.

Color control through filtration

Portrait shot outdoors in "golden" afternoon light on daylight color film. Left: No filter used, the actually white sweater appears yellow, the face too red. Right: Shot through an 82C filter, both sweater and face appear in their "natural" colors as we remember them from seeing them in colorless "white" light.

Sunlight streaming through windows was complemented in the photos above by incandescent light for shadow fill-in. The left picture was made on daylight color film, the right one on Type B. As always in such cases, the daylight film produces the "warmer," more yellowish rendition and the Type B film the "cooler," more bluish one. Here, the left rendition, although somewhat exaggerated in color toward red, produces an effect that is more appropriate to the nature of the subject than the right one, which appears too "cold."

Daylight color film, Type A or Type B?

The two pictures below were made one immediately after the other, the left one on daylight color film, the right one on Type B. Since no "correct" type of color film exists for this kind of illumination, which consists of a mixture of daylight and artificial light, the colors of neither transparency are "true." In such cases, the decision whether to use one type of color film or the other depends on which kind of result the photographer prefers.

Left: A "straight" shot of a shop window, its contents overlaid and partly obscured by reflections. Right: Use of a polarizer enabled the photographer to eliminate the reflections and bring out the underlying colors of the window display.

Control of reflections by means of a polarizer

Right: Picture made without a polarizer. Left: A polarizer was used to make this shot. Note the difference between the two pictures in regard to the sky reflection in the water and the glitter (glare) on the foliage.

V

Seeing in Terms of Photography

Seeing in terms of photography means realizing potentialities: visualizing things not as they are, but as they could be made to appear in picture form. This kind of seeing depends as much on the mind's eye as on the eyes themselves. It is based upon imagination—imagining what could be made out of a subject or event, how it might be isolated from its surroundings, characterized, condensed, and finally presented in the most graphically effective form. Seeing in terms of photography is potentially the most powerful control a photographer has over the impression his pictures make.

WHY IT IS IMPORTANT TO PERCEIVE REALITY IN PHOTOGRAPHIC TERMS

As I have already suggested, perhaps the greatest misconception about pp. 7–10 photography is expressed in the saying "the camera does not lie." If anything, the opposite is true. The great majority of photographs are "lies" in the sense that they don't fully conform to fact: they are two-dimensional representations of three-dimensional subjects; black-and-white pictures of colorful reality; "frozen" stills of moving subjects. Every photograph that "didn't come off," every picture that disappointed the photographer because it did not express what he wanted to say, is an example. Yet every photograph is in a very real sense a truthful and authentic rendition of a subject or event at the moment the picture was made.

An explanation of this apparent paradox is that a photograph is an authentic rendition of *everything* visible within the field of view of the lens, whether interesting or dull, graphically effective or weak, but does *not* automatically contain perhaps important intangible qualities of the subject. It is primarily the abundance of dull subject matter, the absence of graphically effective qualities, and the lack of emotionally important intangibles which make so many photographs appear to "lie."

223

POSITIVE CAMERA LIES

Once a photographer is convinced that the camera can lie and that, strictly speaking, the vast majority of photographs are "camera lies," inasmuch as they tell only part of a story or tell it in distorted form, half the battle is won. Once he has conceded that photography is not a "naturalistic" medium of rendition and that striving for "naturalism" in a photograph is futile, he can turn his attention to using a camera to make more effective pictures. For "photographic lying" is not necessarily a negative quality. It implies only that a difference exists between a photograph and the subject it depicts. If left to luck and chance, such differences between subject and picture tend to make a photograph inferior to the experience that triggered it. On the other hand, because the vision of the camera is more penetrating than that of the human eye, virtually independent of subject distance, highly variable in regard to angle of view, and capable of "stopping" any kind of motion, the camera permits us to produce pictures which show more than what we could have seen in reality at the moment of exposure. Therefore, the camera's ability to "lie" can also be used to produce positive results, the photograph being more effective than the actual experience. Here are a few examples of such use: any telephotograph that clearly shows us something too far away to be distinctly seen by the eye, any close-up that shows us interesting detail which the eye had failed to notice in reality, any picture in which insipid natural color has been transformed into powerful, graphic black and white, any high-speed photograph in which a rapidly moving subject has been "frozen" into tack-sharp rendition, any photograph in which unsharpness, blur, film grain, or halation have been creatively used to symbolize some intangible qualities of a subject or the photographer's response to it and to convey them effectively to others.

In such photographs the subject is shown in a form *different* from that in which it would have appeared to the eye—in a form *superior* to that in which it would have appeared to the eye because the presentation is more *informative*. As a result of this difference, such photographs must be called "unnatural." And yet—probably no one would deny that such photographs are more interesting and hence *better* than many photographs which, strictly speaking, are more "natural" because they conform more closely to the images perceived by the eye.

Arnold Newman once said that "a camera is a mirror with a memory, but it cannot think." This expresses a basic truth about photography. It implies that every photograph is a "true" image, but not necessarily one that is effective or

224

"good." In many cases a photograph will *appear* "true" only if it actually *"lies,"* as in the following examples:

A black-and-white fashion photograph of a green dress trimmed with red is to be made. A "true" rendition would translate these two colors, which are approximately equal in brightness, into more or less identical shades of gray. The effect of the dress—the contrast between the fabric and the trim—would be destroyed through the technical correctness of such a black-and-white translation true to the characteristics of the medium. To *appear* true, the photograph must *"lie"*: to show the contrast between the dress and its trim in a black-and-white rendition, the photographer must translate one of the colors into a lighter shade of gray than the other. He can do this by using either a red filter to make the red trim appear light and the green fabric dark, or a green filter to make the red trim appear dark and the green fabric light. In either case the contrast upon which the effect of the dress depended would have been preserved in the black-and-white rendition and the photograph made effective despite its being, or rather because it was, a "camera lie."

Another example: a tall building has to be photographed. To get its entire height on the film, the camera must be tilted upward, and in this position the vertical lines of the building converge toward the top of the picture. Such convergence of vertical lines is a natural manifestation of perspective which we find perfectly natural when it occurs in the horizontal plane (such as the apparent convergence of railroad tracks toward depth) but which most people object to as "unnatural" when manifested in the vertical plane. To make a photograph of a tall building which appears natural, we must make the camera "lie" by rendering vertical lines as parallels, even though this is contrary to the laws of perspective.

A third example: a racing car has to be photographed during a race. Most pictures of cars racing are sharp. They show every detail of the car and the course. This kind of photograph may show the form in which the eye perceived the event, but it does *not* convey the feeling of a race—speed. From looking at such a uniformly sharp picture, one cannot tell whether the car was photographed while racing or while standing still. To express the feeling of speed, a photographer must indicate motion in his picture. Motion, however, is an intangible that in a photograph can be expressed only in symbolic form, perhaps through blur, although the eye saw the car sharp. But in picture form matters are different, and to produce an impression that conveys the feeling of racing, the camera must be made to "lie." We will discuss methods of conveying motion in Part VI.

225

DIFFERENCES IN SEEING BETWEEN CAMERA AND EYE

The habit of comparing the eye and the camera with one another and stressing only the *similarities* in their construction has confused the understanding of photography as a medium of expression and communication because it disregards the enormous *differences* in their function. These differences make the eye superior to the camera in some respects and the camera superior to the eye in others. The following is a summary of these differences in seeing.

1. Human vision is binocular and stereoscopic, that of the camera is monocular. This explains why so many photographs lack "depth"—the photographer, through his stereoscopic vision, saw his subject as three-dimensional and forgot that, with only one "eye," his camera "saw" his subject without depth. Unless depth is expressed in a photograph in symbolic form, the picture must appear "flat."

2. The eye, guided by the brain, is selective. It sees subjectively, generally noticing only what the mind is interested in, wishes to see, or has been forced to see. In contrast, the camera "sees" objectively, recording *everything* within its field of view. This is why so many photographs are cluttered with pointless subject matter. Photographers who know how to see in photographic terms *edit* their pictures *before* they take them by eliminating superfluous subject matter through an appropriate angle of view, subject-to-camera distance, choice of lens, or other means.

3. The eye is sensitive to color; black-and-white photography "sees" color as shades of gray. However, these gray shades can be changed to a great degree through the use of color filters. To produce pictures that are effective, a photographer who works in black and white must not only know the corresponding shades of gray for different colors, but he must also know how to change these normal shades into lighter or darker tones.

4. The eye does not normally notice minor changes in the color of light. Color film is very sensitive to such small changes. Since we generally do not notice small changes in the color of the light which, however, cause corresponding changes in the color of objects, we are astonished when we see such changes recorded on color film. It is the failure to notice such changes in the color of the incident light which accounts for the majority of color transparencies in which color appears "unnatural." However, if we could compare such transparencies with the subject seen under the same conditions in which the picture was made, we would most likely find that the color film was right and our judgment wrong.

Later I'll have more to say about this phenomenon of *color adaptation,* which is p. 310 the most common cause of apparently "unnatural" color transparencies.

5. The eye cannot store and add up light impressions—the dimmer the light, the less we see, no matter how long and hard we stare. Photographic emulsions, however, can do this and, within certain limits, produce images whose strength and clarity increase with increases in the duration of the exposure. pp. 188–189 This capacity to accumulate light impressions makes it possible to take detailed photographs under light conditions of a level so low that little or nothing can be seen by the eye.

6. The eye is sensitive only to that part of the electromagnetic spectrum which we know as light. Photographic emulsions, sensitive also to other types of radiation, such as infrared, ultraviolet, and X rays, make it possible to produce pictures which show familiar objects in new and more informative forms as well as to show many things otherwise invisible.

7. The focal length of the lens of the eye is fixed, but a camera can be equipped with lenses of almost any focal length. As a result, the scale of the photographic image is virtually unlimited.

8. The angle of view of the eye is fixed, but lenses range in angle of view from very narrow to 180 degrees. Unlike our own vision, a photographic angle of view can be chosen to give a desired effect.

9. Our vision functions so that we see three-dimensional things in the form of rectilinear perspective. Although most photographic lenses are designed to produce this type of perspective, other lenses produce perspective that is p. 346 cyclindrical or spherical. The remarkable properties of these types of perspective make it possible to create impressions and show relationships between a subject and its surroundings which are beyond the scope of other graphic means.

10. The focusing range of the eye is severely restricted in regard to near distances; anything closer than approximately 10 inches can be seen only indistinctly—increasingly so, the shorter the distance between the subject and the eye. And small objects can be perceived less and less clearly the smaller they are, until a limit is reached beyond which they become invisible to the unaided eye. The camera, however, equipped with a lens of suitable focal length or in conjunction with a microscope, has none of these restrictions.

11. To the normal eye, all things appear sharp at the same time (this is actually an illusion caused by the ability of the eye to constantly adjust focus as it scans

a scene in depth). The camera produces not only pictures in any desired degree of unsharpness, but can also make pictures in which a predetermined zone in depth is rendered sharp while everything else is unsharp.

12. The eye adjusts almost instantly to changes in brightness, its pupil contracting and expanding as it scans the light and dark parts of a scene. The "pupil" of the camera, the diaphragm, can be adjusted only for overall brightness. The contrast range of our vision is thus much wider than that of a photograph (exception: photographs taken on XR Film, which has a contrast range of 100,000,000:1); we can see detail in the brightest and darkest parts of a scene, whereas in a corresponding photograph, if contrast was high enough, such areas would be shown as overexposed, detailless white, and under-exposed, detailless black. To compensate for the limited contrast range, a photographer must check the brightness range of his subject with an exposure meter (since his eye is untrustworthy in this respect) and, if contrast is excessive, he must take appropriate counteraction.

13. The eye cannot function virtually instantaneously, cannot retain an image, and cannot combine a number of successive images in one impression. The camera can do all three. As a result, a photographer can not only superimpose different images in one picture, but can also express movement graphically, either by instantaneously "freezing" the image of the moving subject or by symbolizing motion through blur and multiple images and thus expressing movement in heretofore unknown beauty and fluidity of form.

14. The eye notices and accepts as normal the apparent converging of receding parallel lines in the horizontal plane. However, as a rule, it does not notice in reality, and generally rejects as "unnatural" in picture form, the apparent convergence of receding parallel lines in the vertical plane. The camera does not make a distinction between horizontal and vertical parallels but treats them alike. The result is well known in photographs of buildings and is generally considered a fault. How this fault can be avoided is explained later.

p. 335

15. The eye sees everything it focuses on in the context of its surroundings, relating part to the whole. We do not see sharp boundaries between the things we see sharply and the things we see vaguely or not at all because they are near the periphery or outside of our field of vision. As a result we are generally not conscious of any particular overall design because we focus successively upon different parts of a much larger whole which we never take in all at once. In contrast, a photograph shows the subject out of context, cut off from related subject matter so that attention is centered upon it alone and the picture must

stand on its own merit. Because it is a small, limited view it can be seen at a glance. Each component of the picture is seen in relation to the others in the form of a design, and if the design is weak, the picture "falls apart." As a result, a subject that was appealing in reality because it was contributed to by surrounding subject matter that had a special atmosphere or mood is dull in picture form when divorced from those elements. Photographers who know how to see in terms of photography are aware of this and, if possible, choose subjects that are inherently photogenic.

p. 237

HOW TO SEE IN TERMS OF PHOTOGRAPHY

To be able successfully to bridge the gap between ordinary and photographic seeing, a photographer must train himself to see as the camera sees. He must remember that human vision is reinforced by other sense impressions: sound, smell, taste, and tactile sensations combine to inform him about the various aspects of his surroundings. If he stands by the ocean, he sees water, sand, and sky; he *hears* wind and waves; he *smells* the kelp, *tastes* the salty spray, and *feels* the pounding of the surf. But if he takes a photograph trying to record these impressions, he probably will be dismayed that it lacks the feeling of that experience.

To see as the camera sees, a photographer must mute all his senses except sight. To the camera, a person is a shape consisting of various lighter and darker areas, each characterized by its own texture; a dinner plate is an oval form of a specific color and brightness, or a circle if the lens looks straight down at it; a house is a pattern consisting of rectangular or trapezoid forms which differ in brightness and texture; and so on. There is no feeling, meaning, implication, or value involved except the graphic values of form and texture, color, light and dark; no depth and perspective, only monocular projection of reality onto the surface of film and paper where two-dimensional shapes lie side by side; no motion or life, only sharpness, unsharpness, or blur; no radiant light, only the white of the paper.

A good way to learn to see a subject in terms of photography is to analyze it in regard to its different visual qualities and to study these qualities in terms of design, light, color, and perspective. To do this, one must be able temporarily to forget the purpose and meaning of the subject and see it as an abstract design consisting of lines and forms, color, light, and darkness. This might be done as follows:

Design

Begin by studying the subject's design (often called "composition"), the arrangement of its components in terms of masses, light, and color. Ask yourself where the focal point of your composition should be within the framework of your picture (the focal point is also known as the "center of interest"). Should it be high or low, to one side or the other, in the middle? Each placement will produce a different impression: the more centered, the more static the composition; and the more off center, the more dynamic the design. Which placement would best express the nature of the subject?

Forget, for the moment, that your subject has "depth." Try to see it "flat," as it will appear on paper, where all its components are in one plane. The simplest way to do this is to look at it with one eye. This will change your normal stereoscopic vision to monocular vision and you will see as the camera sees. Relationships between picture components that you probably had not noticed before will become apparent: a tree that seemed safely behind your model may now seem to grow out of her head. Or another part of the background, unnoticed before, will suddenly relate to the subject and will weaken—or strengthen—the impression of the picture. Lines that previously appeared parallel, such as verticals of a building when one looks up at it, will now seem to converge.

Analyze the subject's design in terms of shapes and masses. Does it consist primarily of a few large forms or a multitude of smaller shapes? Are these shapes arranged in an overall organization, a "pattern" which can be used advantageously to lend order and graphic interest to your composition, perhaps in the form of a repetition of similar picture elements?

What are the dominant forms? Vertical shapes? Horizontal shapes? Irregular shapes? Is there a form that can be used as the "backbone" of the overall design around which other picture elements can be arranged to make a self-contained design? How will such considerations influence the proportions of your picture? Regardless of the proportions of your negative, should the photograph be oblong or square, perhaps very narrow and wide, or very narrow and high? Such decisions should *not* be made in the darkroom when enlarging the negative but *before* one makes the exposure, while choice of methods and means is still unlimited and radical changes can be made.

Analyzing a concrete subject in such abstract terms may seem difficult at first but it eventually becomes routine. Begin such exercises in photographic seeing by studying simple forms—for example, a leafless tree seen against an empty

sky. Try to see *not* the tree but its linear design—the pattern that is characteristic of it alone. Whether it be an elm, a maple, or an oak, each kind of tree has its own characteristics, its own particular "design," the pattern typical for its particular species. From there, go to more complicated subjects: a face, a room, a street. See them in terms of lines, outlines, and forms, angles and curves, each related to, and part of, the whole. It is this relationship that forms the design which a photographer must discover. More often than not he will find that the design is not clear, but obscured by extraneous subject matter. He'll sense this rather than see it and such sensitivity to design, plus the ability to reveal it in his picture, is the mark of a *good* photographer. To find out what he needs to know he may have to eliminate disturbing subject matter, select a different angle of view, a different type of perspective, or go farther away from the subject and use a lens of greater focal length, rearrange the lights and change the placement of the shadows, or wait for more suitable illumination, or employ other photographic controls. I cannot emphasize strongly enough that he can do such things *only before* he makes the exposure, because only before that moment can he radically influence and change the concept, design, and effect of his picture.

Light

Most photographers see light *quantitatively*: if there is enough light to make a hand-held exposure at a shutter speed short enough to keep the camera from shaking and blurring the picture, they are satisfied. In contrast, photographers who know how to see in terms of photography perceive light *qualitatively*; to them, it makes a great difference whether the light is directional or diffused; whether it is front, side, back, or top light; whether its "color" is white or tinted; whether there is one source of light or several. They are also aware of contrast: they know that high-contrast illumination and low-contrast illumination produce entirely different impressions. As a result, unlike the amateur, who, seeing a subject that appeals to him, shoots it without considering that it might be more effective in a different kind of light—and with different shadows—the photographer who knows how to see in terms of photography is aware of these different aspects of light, and if the light is not to his liking, he waits for the light to alter, changes the illumination if he can, or does not take the picture.

To learn to see light in terms of photography, a photographer must constantly consider such questions as these: Is the intensity of the illumination high, medium, or low? Does the light strike the subject from the front, the side, the

back, or from above? Is the source of illumination point-like or an area-type? Is it direct or reflected light? What is the color of the light, and how will it affect my color film?

pp. 260–291 If the light is unsatisfactory, a resourceful photographer has a number of means by which he can alter its quality. These will be discussed later. What is important here is that the reader become aware of the fact that differences in the quality of light are as consequential as the quantity of the available light. The *quantity* of light influences the *exposure* of the film; the *quality* of the light influences a picture's mood. And if the mood of a picture is wrong for the depicted subject, not even a perfect exposure can make such a picture "good."

Color

Similar considerations apply, of course, to color. Color is part of the overall design of a photograph, and a photographer must learn to see and appreciate color apart from its subject association. He must learn to see and think in terms of color harmonies and clashing color, related and complementary color, colors that are "warm" or "cold," aggressive or receding, saturated or soft. He must train himself to see color, *not* with the eye of the calendar photographer, who evaluates color only in relation to its "naturalness," but with the eye of the painter, who if he finds it necessary paints a face green, a horse blue, or a shadow pink. Shocking? Unnatural? Modernistic nonsense? Not at all—as any color photographer can easily prove: if he photographs a person beneath a big tree with the light filtering through its leaves, the face will appear green in the color photograph; if he photographs a white horse in the shade of a barn when the sky is blue, the horse will appear blue in the color photograph; and if he photographs the shadow of a building cast on freshly fallen snow at sunset when the sky is red, it will appear pink in the color photograph. Unnatural? Distorted color? Inherent weakness of the color film? Not at all. Under such conditions, this is the way things actually look, and the reason that most people don't notice such "abnormal" color is that they tend to see color as they remember seeing it in average "white" daylight and *not* as it

p. 310 is. I'll have more to say about this later.

The first result of a newly acquired ability to see color as an independent quality, disassociated from the subject, will be the realization that there is no such thing as "true" color. Skin color is *not* necessarily pink or tan in a "white" person, nor is freshly fallen snow necessarily white. All colors change with changes in the color of the incident light. As a result, since the color of the light is almost constantly changing, even though changes are small, what at one

232

moment looked white at another will have pink, blue, yellow, or green overtones. Color may be *unusual* but it is rarely "unnatural." If I see a picture in which a face is blue, I say the color is true because the photograph was made either in blue light or through a blue filter, and under such conditions a face must appear blue. And had I seen it in blue light or through a blue filter, my eyes would have received exactly the same impression.

Another change of a photographer's attitude toward color that will result from an awareness of color as a dimension in itself will be the realization that color does not have to be bright and loud to be effective. If anything, the opposite is true. Loud color has been used so much in our brash society that we are quite immune to it. On the other hand, soft, muted colors are rarely used and they thus automatically attact attention. Besides, their subtlety can express feelings and moods which loud color cannot. In these delicate shades a color photographer will find a scarcely touched world of sophisticated color. Fog and mist, the subtle tints of rainy days and overcast skies, of dawn and dusk, and indoors the use of bounce-flash and shadowless light arrangements, offer limitless opportunities for discovery and invention to anyone who has learned to see color in photographic terms.

Through seeing color in photographic terms, a photographer will become aware of color to a degree he would not have thought possible. He will not only become *consciously* aware of color, but he will become aware of its subtle shades and changes. Where he had seen color quantitatively, he will now see and appreciate it qualitatively. The world will look marvelously rich and beautiful, everchanging. The photographer will feel his imagination stir in this discovery. He will now wonder whether color could be made better, more interesting and more significant by waiting for changes in the color of the light—toward sunset or dusk, very early in the morning, or under a different sky—or by using special filters: to "warm up" a scene or to "cool it off," to give it a pink glow, or to soften it and create a sense of mystery by giving it a purplish tint. Who is to say this should not be done? Who should suggest how one should create?

Perspective

Unfortunately, the habit of seeing their surroundings always in the same "perspective" makes most people believe that only one type of perspective exists and that any perspective that does not conform to that concept is "distorted." But photography proves this a fallacy. Actually, although our eyes function like a camera's lens, our brain corrects our visual images in the

light of knowledge and previous experience, and as a result, we often "see" things as we think they ought to be, not as they really are. For example, looking up at a building, we still see its verticals as parallels, although according to the laws of perspective, they should appear to converge as they recede. The camera, of course, registers this convergence. Actually, this type of perspective is entirely true to reality. To prove this, cut a rectangular hole 2 x 2½ inches in the center of a piece of cardboard. Hold this frame in front of one eye, and close the other. Look through the cutout at the building. If you tilt both your head and the frame as you tilted your camera, the vertical lines will appear to converge. And if you had set up a groundglass-equipped camera and were to compare the groundglass image with the image you see through the cardboard frame, you would find that the angle of convergence in the two would be the same. Similarly, you can prove that the apparent "compression of space" in telephotographs is real. To do this, hold the frame at arm's length and center in its opening a subject such as the far end of a street. You must look carefully because the image is so small. You will see, perhaps to your surprise, that the highly foreshortened buildings give exactly the same kind of compressed effect that you have seen in telephotographs in which, of course, this phenomenon was more obvious because the image was larger.

Seeing in terms of photography means training one's eye to see consciously, and training one's mind to accept as true, these and other phenomena of perspective. The phenomenon known as "wide-angle distortion," for instance, p. 344 is *not* true distortion (as will be explained later), but the natural effect of a relatively short distance between subject and camera in conjunction with a lens that has a wide angle of view. Whether such perspective should be considered a fault depends upon the intent of the photographer and the purpose of the picture. What matters here is that the photographer should be aware of it and learn how to recognize it in reality *before* he takes a picture, so that he can either use it to good advantage or avoid it.

Another phenomenon that should be noted here is scale. Time and again people take pictures of landscapes or other very large subjects and are dismayed that in the photograph the subject looks so small. This effect results from the photographer's inability to see space in photographic terms. Such photographers forget that in reality they experience the landscape in relation to themselves—as small human beings surrounded by its immensity. As a result, their experience has scale. But in their pictures the landscape is without an indicator of scale. If a human figure were included and placed for enough from the camera so that it appeared small, in contrast to the figure's smallness

234

the landscape would appear large. Without such an indicator of scale, the landscape, or any other large subject, appears, of course, no larger than the paper it is printed on. More about scale in Part VI.

THE PRACTICE OF SEEING AS A CAMERA SEES

A great aid in learning to see as a camera sees is the cardboard frame described above. A similar but even more versatile frame can be made from two L-shaped pieces of cardboard. Its advantage is that the frame can be varied both in size and in the proportions of the opening. Lacking such frames, of course, a frame can always be improvised by using the hands to form an opening through which to study the subject.

Studying a subject through a frame has several advantages. The frame isolates the subject from its surroundings. It thus makes it possible to see a subject "out of context" and to more or less tell how the finished picture will look: whether it will stand up on its own merit, whether it will be a self-contained unit in regard to editorial content and graphic design.

By gradually and progressively scanning the subject through a frame, holding the frame close to one eye while keeping the other shut, then farther away, and then at arm's length, a photographer can locate the best possible view. To duplicate this view on film, a lens is selected that has a focal length that will make the view that was seen through the frame exactly fill the camera's viewfinder or groundglass. If the subject looked best when the frame was held very close to the eye, a lens of relatively short focal length—a wide-angle lens—must be used; on the other hand, the farther the frame was held from the eye to isolate the most effective view, the longer the focal length of the lens must be.

Another advantage of studying a subject through a frame is that the perspective of the future picture can be evaluated more easily. I have already mentioned that, seen through the rectangular opening of the frame with its parallel sides used as guides, "converging verticals" can be recognized with ease. Similarly, other manifestations of what is popularly known as "perspective distortion" show more clearly when seen through a right-angle frame than when seen without it. Objects which, because of their nearness to the camera, would be rendered unproportionally large in the picture (most familiar examples: hands or feet extended toward the photographer), will clearly reveal

themselves in their exaggerated size when studied through a frame but may not when seen without it.

Two other valuable aids in learning to see as a camera sees are viewfinders and groundglass-equipped cameras (twin-lens reflex cameras, because their viewing lenses cannot be stopped down, are less suitable). The most suitable types of viewfinder are multiple-focus and zoom finders because they enable a photographer to isolate his subject from its surroundings and to study it in different degrees of image size. Incidentally, studying reality from close range through a 100-degree wide-angle viewfinder can be traumatic but is very worthwhile because it can lead to a more thorough understanding of perspective and space. I recommend that a serious student of photography always carry a viewfinder and use it whenever possible.

pp. 115–116 Studying a subject on the groundglass of a camera has the advantage that it enables a photographer to observe directly the extension of sharpness in depth. This phenomenon is difficult to visualize without such direct visual aid; it cannot be seen through a viewfinder or a frame. As has been explained before, extension of the sharply rendered zone in depth is one of the functions of the diaphragm and can be studied by gradually changing the diaphragm aperture while observing the image on the groundglass.

Another advantage that the groundglass-equipped camera provides in learning to see in photographic terms is that it permits a photographer to study and evaluate a subject in terms of masses, color, and distribution of light and dark. To see a subject in these terms, all he has to do is throw the image out of focus. In so doing, he destroys sharpness of rendition and eliminates detail. What is left is a blurred picture which, removed from reality, reduces the subject to an arrangement of masses, daubs of color, and areas of light and dark. The underlying design emerges much more clearly than it does in an ordinary view, in which it is always more difficult to see beyond the realistic qualities and find the underlying graphic-abstract design.

To further increase his experience and his understanding of photographic phenomena, a photographer should look at things through as many suitable devices as possible. For example: study landscapes, street scenes, buildings, ships, and so forth through *binoculars* and you will see things in telephoto perspective—space "compressed" and objects in more nearly true proportions to one another. In such views, perspective and distortion will be virtually eliminated and *you will be able to see things as they are*, not as you *think* they are. This is the first step in learning to see space in photographic terms.

236

Study your nearest surroundings through a *magnifier*. Discover the structural and textural beauty of that indescribably rich world which is not otherwise clearly seen because of small size or closeness.

Look at reflections in *shiny curved surfaces*. Observe the images of familiar objects which are, through distortion, turned into caricatures whose grotesque shapes are often extraordinarily expressive. Study reflections in a *mirrored sphere* (a Christmas tree decoration or a garden ornament). You will see your surroundings in spherical perspective, exactly as a 180-degree fisheye lens would render them. You may have seen pictures with such perspective reproduced in magazines or books. Looking at images reflected in a mirrored sphere, you can study such perspective, learn to translate the images, and observe for yourself what is represented.

Study objects through *filters* of different colors. See how a subject looks in a rose light, or in a cool blue light. Remember that there are no "true" colors, because the color of all things changes with the color of the incident light. In rosy light, a face appears rosy, in blue light, blue. Although you may not be able to change the color of the light, you can get the desired effect by using a filter of the right color.

A creative photographer looks at things through rippled and pebbled glass, through the bottom of a beer bottle, the stem of a wine glass, or other likely material to find new effects. Instead of using a photographic lens, he puts a magnifying glass, a condensor, a positive spectacle lens, or a pinhole in front of his camera and studies the images they produce on the groundglass. He experiments with diffusion screens of various kinds to find new ways to express concepts of radiance and light. He can then draw on such images to show in symbolic form subject qualities he could not render directly.

THOUGHTS ABOUT THE PHOTOGENIC

In their quest for "good" photographs, it has been the experience of all perceptive photographers that certain subjects are effective in picture form while others are not. Those subjects that make "good" photographs have attributes popularly known as photogenic qualities, qualities that unphotogenic subjects lack. Therefore, whenever they have a choice, experienced photographers avoid unphotogenic subjects because they have found that it is more rewarding to pass them up and find something better than it is to try to make a good photograph of a subject deficient in photogenic qualities.

A definition of what constitutes photogenic qualities depends, of course, to a large degree upon the taste and preference of the person asked. Blue eyes, blond hair, or a configuration that makes it possible to "compose" the picture in the form of a triangle or an S-curve may be photogenic qualities in the eyes of a beginner, but a more experienced and in matters of taste more mature photographer has considerably more sophisticated ideas. Personally, I find it difficult to list *specific* subject qualities which I consider photogenic, although I have learned from experience that certain *combinations* of subject quality, condition at the moment the picture was made, and photo-technique, produce better results than others. In particular, I'd like the reader to consider the following:

Simplicity, clarity, and order head, in my view, the list of photogenic subject qualities. Since the camera shows *everything* within its field of view but people, as a rule, are interested only in certain *specific* aspects of a subject or scene, it is always advisable to "clean up," both literally and figuratively speaking, before making the exposure. Such a cleanup should include the physical removal of as much superfluous subject matter as possible, and the exclusion of extraneous picture material through selection of a more advantageous angle of view, changes in distance between subject and camera, choice of a lens with longer focal length, and other photographic controls.

If the subject in question is very complex, it is usually advantageous to show it once in an overall view and again in a number of close-ups, each showing one specific aspect or detail of the subject in a clear and well-organized form that effectively supplements the overall view. If only a single photograph can be used, it is often possible to convey the essence of the subject through a part.

Maximum clarity and graphic impact are found in subjects that have "poster effect"—subjects that are so simple and at the same time so bold in design that they are effective even at a distance that obscures detail. The ultimate in this respect is the silhouette.

Spontaneity and authenticity are qualities difficult to define but easy to recognize in a picture. Spontaneity is revealed in a natural expression or gesture, movement, arrangement of forms, and many other ways. Authenticity is the quality that gives a photograph the stamp of honesty, believability, and conviction. Overdirection of a subject weakens these most important picture qualities, posing destroys them.

The unusual is *ipso facto* more interesting and informative than the banal and

familiar. This applies to the subject itself, its coloration, the circumstances surrounding the making of the picture, and the form of rendition selected by the photographer. In an unusual light, for example, even an ordinary landscape can become attractive, and seen in a new and unusual way the most commonplace subject will arouse the interest of the beholder. However, unusualness used merely for its own sake—that is, without contributing anything positive to the content of the picture—is valueless and becomes a gimmick. Photographers who are aware of this avoid, whenever possible, not only commonplace subjects and situations, but also tricky techniques.

Subject coloration. In color photography, color, of course, is a very important, and certainly the most obvious, quality of a subject or picture. As far as photogenic considerations are concerned, experience has shown that ordinary everyday colors, no matter how accurately rendered in a photograph, are less interesting than colors that are unusual. Particularly effective are: colors that are exceptionally strong and saturated; the aforementioned very pale soft colors, pastel shades, and subjects that are virtually colorless; subjects that are mainly black, gray, and white but also possess one or two very strong colors of limited extent; unexpected and "unnatural" color—like the "green face" p. 232 mentioned earlier. But again, in his quest for "unusual" color, a photographer p. 320 must not lose sight of the fact that color must relate to the nature of the subject and the purpose and meaning of the photograph; otherwise, color becomes a gimmick and the picture a farce.

Telephoto and long-focus lenses are, in my opinion, preferable to standard and wide-angle lenses because they preserve to a higher degree the true proportions of the subject by forcing the photographer to keep a greater distance from it. Information on the advantages, uses, and effects of telephoto lenses will be given later.

Close-ups, as a rule, make more interesting pictures than overall shots because the subject is more tightly seen and shown in larger scale.

Backlight is, to me, the most dramatic (and the most difficult) form of illumination, superior in beauty and strength to front or side light. For specific information concerning its use see Part VI.

Unphotogenic Qualities and Techniques
Sometimes, advising a student what *not* to do can be more helpful than telling

him how to proceed. This is the case in regard to photogenic qualities where it is often easier to recognize a subject, situation, or technique that lacks photogenic qualities than to define unequivocally those which possess these desirable properties. The following is a summary of subjects, practices, and techniques which, to my mind, are unphotogenic, almost invariably lead to unsatisfactory pictures, and should be avoided.

Insipidity and lack of subject interest are probably the two most common causes of unsuccessful pictures. They can be overcome only through discrimination and self-discipline on the part of the photographer.

Disorder and complexity rank high among unphotogenic subject qualities. Again, don't forget that the camera shows *everything* within its field of view, whereas normally a photographer is *interested only in some specific aspect or part of a subject or scene* and regards everything else as superfluous and therefore distracting. Photographs that are overloaded with pointless subject matter are confusing and ineffective.

Unsuitable backgrounds have ruined more potentially successful pictures than any other single factor. In particular, avoid telephone wires and powerlines that cross the sky; utility poles; trees and branches that conflict with the subject; bright patches of sky surrounded by dark foliage; strongly colored objects which are rendered out-of-focus and, because they are not easily recognizable, catch the eye and detract from the subject proper of the picture; shades and colors so similar to those of the subject that they blend with the subject and cause it to "fade into the background"; backgrounds that are unnecessarily contrasty, "busy," and "loud."

Stridently bright backgrounds should also be avoided, particularly if they are used in conjunction with subtly colored subjects, such as jewelry, pottery, chinaware, sea shells, or female nudes. It almost seems as if photographers were trying to make up for such subjects' delicate color by setting the background on fire, a practice which, of course, eclipses the subject itself.

Another frequently made mistake is to let the subject's shadow fall on the background. This error is particularly unslightly if several lamps are used and crisscrossing shadows result. An attempt to correct this fault by using additional lamps to "burn out the shadows" merely makes matters worse by adding new sets of shadows. The only way to avoid such shadows is to place the subject at a sufficiently great distance from the background.

Meaningless empty foreground is a fault of many otherwise acceptable

pictures. It is easily avoided by decreasing the distance between subject and camera or, better still, by making the shot with a lens of longer focal length.

Awkward shadows in a picture unmistakably spell "beginner at work." In particular, avoid: getting your own shadow into the picture; casting the subject's shadow on the background unless this shadow contributes to the effect of the picture; harsh shadows in a face, particularly around the eyes and underneath the nose and chin; sets of shadows that crisscross one another in indoor shots lighted with more than one lamp.

Multiple lighting. As a rule, *not counting fill-in lights*, one light source is preferable to two, and two are preferable to three or more because the greater the number of lights, the greater the danger of overlighting, shadows within shadows, and shadows pointing in different directions—some of the most unsightly photographic faults.

Overlighting and indiscriminate shadow fill-in. Outdoors on sunny days, contrast is often so great that shadows would appear too dark in close-up photographs if not lighted by fill-in illumination. However, unless correctly used, fill-in illumination will create a shadow within a shadow or make shadows appear too light. Both of the above-mentioned mistakes are common, perhaps because overlighted pictures are commonly used by flashbulb and speedlight manufacturers in their promotion. "Filling-in" has also been so publicized that many photographers seem to have forgotten how to take outdoor pictures without flash. If not well used, flash destroys the mood of a subject.

Flash at the camera. This method of illuminating a subject makes areas close to the camera appear disproportionally light in relation to areas farther away, which appear disproportionally dark. Furthermore, it destroys the feeling of depth because, like all front light, it produces virtually shadowless illumination—and shadows are the strongest means for creating the illusion of depth in a photograph.

Flash at the camera as the sole source of illumination, however, must not be confused with flash at the camera for purposes of shadow fill-in—that is, as provider of supplementary illumination, or bounce-flash at the camera for overall illumination in depth. These two latter uses of flash at the camera are, of course, highly commendable photographic techniques which, in the hands of competent photographers, produce excellent results.

Shooting from too far away and thereby including too much extraneous subject matter are typical faults of the beginner. In this connection it is

interesting that when a beginner acquires a second lens, it is usually a wide-angle lens (which includes even more subject matter than a standard lens), whereas the second lens of a more experienced photographer is usually a telephoto lens (which takes in a narrower angle of view and thus improves the picture).

Posing. Highly photogenic subjects are not enough to save a photograph taken by a photographer who confuses posing with directing. Directing is often vitally important. Posing, with its commands, destroys naturalness, as we can see in advertisements in which beautiful girls have frozen smirks instead of smiles. And the results of posing are equally unfortunate in most academic studies of the nude.

The gimmick. In our fast-changing society, "newness" is an almost indispensable quality. Anything goes—as long as it is "new": in art, in merchandising, in photography. . . . As a result, photographers often try to be "original" at any price, even if the price is a trivial picture. Shots taken through prisms or the grid of an exposure meter; photographs in which perspective distortion does not contribute anything to a better understanding of the subject but is employed as a means for being "different"; the indiscriminate use of colored gelatins in front of photo-lamps, and other "novel" approaches motivated solely by a desire for "newness" are, in my opinion, gimmicky and in bad taste.

THE CONCEPT OF TOTAL SEEING

One of the reasons that a good photographer is good is that he is capable of what I call "total seeing," vital to perceiving one's subjects in photographic terms. This visualization is made up of the following stages:

1. The conceptual stage. At this stage the picture exists only in the photographer's mind—it is what he wishes to express. Although he sees his future picture clearly with "the eye of the mind," he often does not yet know exactly how he will express it in concrete form, since this will depend to a large degree on the particular subject and the conditions surrounding it.

2. Through the viewfinder. The photographer, looking at the subject, analyzes it in photographic terms. He selects the combination of specific photographic means and techniques that will produce the picture that will most closely correspond to the one he saw in his mind. And he will not make the exposure until he is satisfied with what he sees in the viewfinder or on the groundglass.

3. On the contact sheet. If possible, an experienced photographer makes a number of different shots of the same subject. Most photographers contact-print all the frames of a roll of film on one sheet of 8 x 10-inch paper and use these proof prints as a basis for selecting specific negatives for final printing. However, smallness and technical inequalities of individual negatives often make their correct evaluation difficult because some of the little contact prints may be too light, others too dark, some may be too contrasty and others too soft, since all are printed together under identical conditions. Proper evaluation thus requires experience and imagination. What a photographer must learn to see is *not* the often badly printed picture in the contact sheet, but how it could be made to appear in the final, expertly controlled print.

4. In the darkroom. Differences in printing—in cropping, lightness, contrast, and so on—will result in prints that look so different that an untrained person could not believe they were made from the same negative. A good photographer "sees" his final print before it is made.

SUMMARY AND CONCLUSION

We have learned that the eye and the camera "see" things differently; that the eye is superior to the camera in some respects and the camera superior to the eye in others; that any subject can be photographed in many different forms; that some of these forms are more effective than others; and that the photographer must train himself in the art of total seeing. If we now consider each of these statements in relation to the others and draw the logical conclusions, it becomes obvious that (1) a badly seen subject *must* result in a photograph which is *inferior* to the impression received by the eye at the moment the picture was made, while (2) a well-seen subject—a subject "seen in photographic terms"—can result in a picture that is potentially *stronger* than the impression which the eye received at the time the photograph was made. In other words, it depends on the photographer whether the photograph will be good or bad—HE HAS A CHOICE.

In order to make the right choice a photographer must know three things: what to do, how to do it, and why it should be done. This in turn presupposes that he knows how to "see in terms of photography"; knows how to control the graphic components of his rendition; and is familiar with the meaning of the photographic symbols. This discussion has concerned itself with the first of these premises; the second and third are the subject of Part VI.

VI

How to Control the Picture

Every photograph is a translation of reality into picture form. And like translation from one language into another, the visual translation of reality into the "picture language" of photography can be accomplished in two different ways: literally or freely.

As in translating from one language into another, in photography too the *literal* approach, concerned primarily with preserving the *superficial form,* is often clumsy and inadequate. In contrast, the *free* approach, concerned above all with the content of the original or subject, concentrates on meaning and feeling. As a result, whereas the literal approach is likely to produce a "translation" or photograph which is inferior to the original, a free translation can not only match but may even surpass the original in terms of beauty, impact, and clarity of expression. The literal approach is typical of the beginner—and the snapshooter; the free approach is that of the accomplished photographer—and the artist.

That there are two approaches to the problem of rendering a subject with photographic means is due to the fact that, contrary to popular belief, photography is not a purely mechanical medium of reproduction, nor is a photograph a "reproduction" of reality. That photography is not a "purely mechanical" process should be obvious to anyone who has ever watched an expert photographer at work and realized the high degree to which the physical part of picture-making is dominated and controlled by the mind and imagination of the photographer. And that a photograph is not a "reproduction" of reality is obvious because a reproduction is a replica which in every respect is identical with the original. Indeed, except perhaps for the photographic reproduction of a page of print, few photographs can truthfully be called reproductions because, as we have noted, most photographic subjects have three dimensions, whereas a photograph has only two—depth is lost. Furthermore, the majority of photographic subjects move or change, but a photograph is a "still"—motion and change are lost. A still photograph reveals only a single instant in time—continuity is lost. Some of the most

exciting photographic subjects are alive, but a photograph is an object—life is lost. Most subjects evoke other sensations besides visual ones: sensations of touch—hot, cold, wet, dry, soft, hard, smooth, rough, sound, smell, or taste—but a photograph involves only the sense of sight. No wonder so many photographs seem "incomplete," disappointing, ineffective, even dull.

To overcome the deficiencies inherent in the photographic medium, photographers express in symbolic form subject qualities which cannot be rendered directly. Color, for example, can be rendered directly, but motion cannot. A sharp picture of, say, an automobile in motion, is in no way different from a sharp picture of the same car standing still. If feeling of motion, perhaps the most important aspect of the moving subject, is missing, the camera *did* indeed "lie." However, all is not yet lost because motion can be indicated in symbolic form: by taking the picture with a shutter speed just a little slower than required to "stop" motion, a photographer can render the automobile just a bit blurred—enough to create the illusion of motion. Blur is one of the photographic symbols of motion.

Likewise, depth is a subject quality which cannot be rendered directly within the two-dimensional flatness of a photograph. But with the aid of "perspective"—the apparent converging of actually parallel lines—foreshortening, diminution, overlapping, light and shadow, and other "depth symbols," a photographer can create the *illusion* of depth in his picture—or fail to create this feeling if he does not know how to handle his symbols as proved by all those pictures that look "flat."

True enough, you may say, but why elaborate upon the obvious? After all, when I take the photograph of a street, for example, the buildings are automatically shown "in perspective," will automatically diminish in size toward depth, and people and cars will automatically overlap and thereby strengthen the feeling of depth—whether this is my aim or not.

Quite right—but don't forget the extremely important conclusion we reached at the end of Part V, the fact that YOU HAVE A CHOICE!

You have the choice of making your picture with a lens of standard focal length, a wide-angle, or a telephoto lens; you have the choice of innumerable different camera positions and angles of view; you have the choice of various types of daylight, or can wait for the sun to hit the buildings "just right" to give you the best effect of light, shadow, and texture; you have the choice of different diaphragm stops for different degrees of sharpness in depth; you have the

choice of different shutter speeds which will give you different degrees of blur to symbolize motion (or can "stop" motion if this is your wish); you have the choice of waiting for different traffic patterns, or specific groupings of people . . . and so on. And each of these different ways of seeing and rendering things will result in a different picture of what basically remains the same subject. Just as each effect will be different—be it ever so slightly—*some will be more significant than others*. This is the reason why I make such ado about "the obvious"—because YOU HAVE A CHOICE!

This choice is yours no matter what the subject, whether a landscape or the close-up of a flower, an industrial shot or the picture of a face. . . . Just for argument's sake, let's see how many different choices are involved in the making of a portrait: You have the choice of different types of light—daylight or artificial light—in particular the sun, open shade on a sunny day, light from an overcast sky, daylight in the home or studio, electronic flash, flashbulbs, photo lamp. . . . Choice of camera: 35-mm or 2¼ x 2¼-inch for rapid shooting, for capturing the fleeting expression, the genuine spontaneous smile . . . or a larger size for a more formal study. . . . Choice of lens: focal length, speed—for different types of perspective, sharpness in depth, or "selective focusing," which concentrates sharpness on the eyes while leaving the rest softly blurred . . . or perhaps a soft-focus lens for a more idealized view. Choice of pose: standing, leaning, sitting, reclining, at rest or in action, smoking a cigarette, discussing the latest play. . . . Choice of view: front, semiprofile, profile, close-up of only part of the face, head shot, head-and-shoulders, level view or looking slightly up or down. Choice of horizontal, vertical, or square picture. Choice of diaphragm aperture: smaller or larger, for overall sharpness or for sharpness limited to only a specific zone. Choice of color: the clothing, the accessories, the background, the "props." Choice of timing: determination of the "decisive moment"—the moment when a gesture is significant, an expression meaningful, the face "alive."

It is a sign of a novice—of insecurity—to put on a show of confidence by approaching your subject authoritatively, and after a casual glance, setting up your equipment, firing away—once—and departing with a casual "got it," leaving your audience gaping. An experienced photographer acts very differently. Aware of the enormous range of possibilities and choices, he studies his subject from many angles and sides, from nearby and farther away, is not afraid of climbing a vantage point or lying flat on the ground to obtain a better angle, unmindful whether he looks dashing or silly to other people because his only concern is how to make the best of his privilege of CHOICE. For the same

reason he is not content with making a single photograph but keeps on shooting while the shooting is good, aware of the fact that the first shot rarely, if ever, is the one that yields the best picture. And the longer he works with his subject, the more he gets involved, the more he sees, the greater the stimulation. Aspects overlooked at first become apparent, new concepts suggest themselves, a different angle, a different perspective, a different lighting effect, a different "twist" (which is a far cry from a gimmick). Only when he feels he has exhausted all the possibilities of his subject does he stop, satisfied that he has made the best possible choice.

THE CONCEPT OF THE PHOTOGRAPHIC SYMBOL

Photography is picture language and, like all communication, based upon symbols. I have already mentioned, for example, that depth can only be *symbolized* in a photograph—by the apparent converging of actually parallel lines, diminution, foreshortening, overlapping, light and shadow, and other graphic devices that create the *illusion* of the real thing. Unfortunately, most photographers are so used to this kind of pictorial symbolism that they are no longer aware of it, particularly since the camera "automatically" produces all the necessary symbols with every click of the shutter.

Nevertheless, I believe that an understanding of the symbolic nature of photography benefits every photographer, mainly because thinking in terms of symbols necessitates thinking of the subject and *its* specific qualities in terms of the photograph and *its* specific qualities—light and shadow, color, contrast, perspective, sharpness, blur, and so on—thereby forcing the photographer to see in photographic terms.

p. 223

An analogy between photography and language might be helpful here. Letters, for example, are symbols which stand for sounds, and combinations of sounds or letters—words—are symbols that stand for concepts, objects, actions, events. . . . Anyone familiar with the English language and able to read understands the meaning of the symbols g-i-r-l, although he first has to translate them in his mind into the concept which they represent. This process is, of course, completely automatic and most people are not even aware of it.

But professional speakers and writers—experts in the use of words—are very much aware of the importance which the right kind of expression, the right kind of *symbol*, has upon the effect of their speeches and writings, and they take

great care to choose the most expressive words. Writing about a girl, for example, any writer is aware that there are other terms from which to choose, ranging from miss to ms., from damsel to tomboy . . . each in essence meaning "girl," yet with a different connotation.

Similarly, a good photographer realizes not only that he has a large number of different symbols at his disposal, but also that each of these symbols appears in many different forms. Light in conjunction with shadow, for example, is one of the symbols for depth. A face illuminated by flat front light—shadowless light—appears "flat"; but move the lamp to one side, or turn the head so the sun illuminates the face more or less from the side, and the face acquires "depth" through shadows. This is elementary, as any draftsman knows who in his drawing creates the illusion of depth through "shading." Light-plus-shadow is, in effect, a "symbol" of depth. Obviously there are innumerable different ways of arranging the illumination, each way producing different proportions between the areas of light and shadow and also making shadows fall differently, thereby producing different depth effects. Furthermore, there are degrees of contrast: softer, more transparent and "filled-in" shadows, or harsher, deeper, blacker shadows. . . . Such variations are the equivalent of synonyms for the writer. *In addition* to creating the illusion of depth, predominance of light over shadow, for example, creates a brighter, more youthful, joyous, and festive impression, while, predominance of shadow over light produces a darker, more somber and even tragic mood. For a photographer to pay attention to such subtleties—that is, using the right kind of symbol, and in *the right degree*—is equivalent to the writer choosing the most effective synonym: a means to sharpen the impact of his work.

This "choice of synonyms" pervades all photography. A photographer wishing to symbolize depth through the apparent converging of actually parallel lines, for example, can, through appropriate choice of camera position in conjunction with a lens of wider or narrower angle of view, create any number of "synonymous" perspectives—that is, any number of variations of perspective in which actually parallel lines converge *more or less abruptly*, thereby producing *different* depth-effects. Or, a photographer wishing to indicate in his picture the "speed" of a moving subject through blur can, through appropriate choice of shutter speed, create any desired *degree of blur*. Total picture control is yours if you know your "symbols" and "synonyms"—and know how to choose and control them.

Whether or not he likes it—or is aware of it—a photographer cannot avoid working with symbols. It is because of this symbolic nature of photography

that, as noted above, a photograph can never be considered a "reproduction" of the subject it depicts; nor is it an inferior "substitute." If anything, it is a work in its own right created with graphic-symbolic means. Therefore, "naturalism" in photography is a fallacy, and anyone trying to limit his photographic activities to "naturalistic" renditions would soon find himself frustrated indeed, because he would quickly run out of subjects that can be rendered "naturalistically."

As a matter of fact, if "naturalism" were the criterion of a "good" photo- p. 7–9 graph, we should have to reject all wide-angle and telephotographs because they show the world to be different from the way it appears to our eyes; likewise, we should have to repudiate all high-speed photographs and time-exposures of subjects in motion, and most photographs that make use of blur and unsharpness, because they show things in a form in which the eye cannot see them. And we would have to reject as "unnaturalistic" all black-and-white photographs because they lack color, and most color photographs because they have no real depth. This shows the absurdity of such an approach.

Now, since a photograph is *ipso facto* unnaturalistic, a photographer might as well cease to strive for a "naturalism" that can never be more than superficial—a pseudorealism based upon antiquated academic standards that can only lead to standardized photographs. Instead of accepting stifling restrictions, he should use to the best of his ability the fabulous potentialities of the photographic medium and exploit it to "break the vision barrier" imposed upon us by the shortcomings of our eyes. He should think of the camera as a means of exploring the world and extending his horizon, as an instrument for making life richer and more meaningful by acquiring insight into many of its aspects which otherwise would remain unknown, as a powerful tool of research, and ultimately as a disseminator of knowledge and truth.

To be able to do this he must be in command of his symbols and know how to exert control.

THE CONCEPT OF PHOTOGRAPHIC CONTROL

The means and techniques of photography have been refined to such a degree that even a rank beginner will find it difficult *not* to render almost any subject in the form of a recognizable photograph. However, there is a vast difference between a recognizable and a significant depiction of a subject. The picture in which the subject is merely recognizable may be adequate for many purposes,

249

but it will rarely leave a lasting impression, nor will it greatly stimulate the mind. The difference between such a photograph and one that is truly memorable, largely depends on the extent of control the photographer was able to exert over his medium.

Unfortunately when applied to photography, the term "control" is sometimes misunderstood—assumed to imply either falsification through use of retouch or other extraneous means, or certain antiquated "pictorial" printing processes. Needless to say, I have neither definition in mind. When I speak of control I literally mean what the word implies: power and ability to choose from the different means and techniques of photographic rendition those that are most suitable to perform a required task.

Photographic control is in no way different from the kind of control other craftsmen or artists exercise in their work. Any sculptor has dozens of chisels and any painter dozens of brushes, all slightly different, from which he chooses the one most suitable to create a certain effect. True, a differently shaped chisel or a brush of different size and form could probably do the job, *but not quite as well*. In other words, these experts use control, which is merely a shorter way of saying that they do their work in the best and most efficient way.

p. 51 Similarly, in photography, any lens will project an image of the subject on the film. But since there are many different types of lenses with widely differing characteristics, some lenses will do a specific job better than others, and often only one type of lens will do it to perfection. The photographer who realizes this and selects the best-qualified type of lens uses control.

I know that photographic purists frown upon the concept of symbols and the use of control, although they themselves unknowingly use, for example, perspective that symbolizes space and depth. The only apparent difference is that they accept the chance appearance of these symbols and make no effort to control (and thus to decide) their final form, and that they regard control as equivalent to faking. Their ideal is the "straight" photograph. But what actually does the purist mean when he speaks of straight photography as opposed to controlled photography? Unquestionably, Mathew Brady's Civil War photographs are examples of straight photography, as are Atget's pictures of Paris. But is this definition equally applicable to Edward Weston's work, which is dodged (that is, contrast-controlled) during contact printing? And what about "converging verticals" in photographs of buildings? This form of perspective, accurate and natural as it may be, is universally frowned upon by conservative photographers who maintain that this is not the way in which a building appears to

250

the eye—looking as if it were about to collapse. Yet this effect can be avoided only through perspective control with the aid of the front and back adjustments of a view-type camera. Is such tinkering acceptable to the purist, or does he regard it as "faking"? And should the image of a racing car streaking down the track be sharp or blurred—appear to be standing still or in motion? If the practice of dodging is acceptable to the purist, why not perspective control or the use of blur? Where should one draw the line between reporting and faking? p. 336

The futility of such squabbles becomes apparent in considering the following situation: Two photographers record a boxing match. One shoots by available light, the other uses synchronized electric flash. The pictures of the first are partly blurred and suggest action. Those of the second are sharply defined, the motion "stopped." Let us suppose that the pictures of both, each set in its own way, report the event dramatically. Now, of the two sets of pictures so different from each other, can we say that only one is "straight" photography? And which of the two?

To me, both approaches provide an honest and effective representation of the event, different though they may be. Each has its merits. The first, through blur, suggests the violence of action and dramatically illustrates the concept "fight." The second, through precision of rendition, shows that which could not have been seen in reality because it happened too fast: the impact of fist on chin and its effect upon the face. Either approach is legitimate. This example merely indicates the need for planning and control if one is to present in his pictures those aspects of a subject or event which he considers most important for effective characterization. To my mind, theorizing about straight versus controlled photography, experimental versus pictorial approach, artistic dramatization versus falsifying interference, is a waste of time—indulged in by those who prefer talk to the more exacting task of making pictures. There are only *two* kinds of photographs and photographers: good and poor. The poor photographers, unimaginative and timid in their work, imitative rather than inventive, are enslaved by antiquated rules. In contrast, good photographers continuously search for new means of graphic expression, improving their craft through imaginative use of any means at hand.

THE RANGE OF PHOTOGRAPHIC CONTROL

Control in photography can be exercised on three interconnected levels. These include:

251

Subject selection
Subject approach
Subject rendition

Although these levels may at first appear in no way related to one another, nothing could be less true. Each one is an important link in a chain that ends with the picture, whose success depends to a large degree upon the skill with which the photographer had been able to utilize and integrate the various controls into one overall plan. Any mistake on one of these levels is invariably transferred to the next, and no effort can ever completely correct it. This interrelationship of the different levels of photographic control cannot be overemphasized; an awareness of its importance on the part of the photographer is one of the prerequisites for success.

Subject selection

The reader will remember our discussion of photographic qualities where I noted that, given the choice, experienced photographers concentrate on photogenic subjects and avoid unphotogenic ones because they have found it simpler and more rewarding to pass up an unsuitable subject than to try to photograph it effectively. I hope he will draw the proper conclusion: to yield good photographs, a subject must be *photogenic in every respect*. The most beautiful girl, if photographed in an unphotogenic pose, in an unphotogenic setting, in unphotogenic light, will look disastrous on film. One of the most common mistakes made by inexperienced photographers is that they don't see the whole picture, they see only part of it—the part they are interested in. If the girl is beautiful, the natives colorful, or if the Acropolis or the Taj Mahal beckon, they take pictures, no matter how unphotogenic the surrounding, the background, or the light. A good photographer, realizing the impossibility of turning unpromising subject material into effective photographs, either shifts his camera position to change the background, waits for better light, comes back some other time—or abstains from making the picture, saving his film for a more worthy cause.

Practicing control on the first level—the level of subject selection—enormously increases a photographer's chances for success because it gives him the invaluable advantage of a good start. In this respect, a photographer who is discriminating in regard to subject selection—who chooses his subjects on the basis of photogenic qualities—can be likened to a craftsman who makes certain that his raw material is flawless as well as suitable for the work intended before he spends (and possibly wastes) time and effort on it. Any fashion

p. 237

p. 238

editor, art director, or commercial photographer who critically screens a number of models before he selects one as right for a specific job is concerned with control on the first level—subject selection. This kind of critical approach to the problem of subject selection is almost always possible in other fields of photography as well. It is, of course, easiest when the choice of subjects is large, as in travel or landscape photography, where the photographer can select from hundreds of different possibilities. It becomes more complicated when the subject is more clearly defined, as in architectural or industrial photography. And it is most difficult when a photographic assignment is very specific, although even under such restrictions a resourceful and experienced photographer can, as a rule, avoid those hopeless shots which a less experienced and less discriminating photographer might take—and regret when he sees the outcome.

Subject approach

Having made up his mind *which one* of a number of potential subjects to choose for rendition, a photographer must next decide *how* to render it. This decision involves two phases: subject approach, and subject rendition. The first takes place in the photographer's mind; the second involves the physical act of making the picture.

Subject approach is strategy—devising a plan for making the picture which takes into consideration all the factors involved: the nature of the subject with particular attention to its characteristics, the purpose of the picture, and the available photo-technical means. Once more, the photographer has a choice—the choice between a literal and a free translation—that is, between an illustrative-documentary and an interpretive-creative approach. The difference between these two approaches is essentially the difference between fact and feeling. If one were to draw a parallel between picture language and word language, one might say that illustrative-documentary photographers could be compared to journalists, and interpretive-creative photographers to writers of fiction or poetry.

The illustrative approach is impersonal and factual—basically a documentarian's or scientist's approach to a pictorial problem. It is immediate and objective inasmuch as the photographer tries to refrain from injecting his own opinion of the subject into the photograph, which should be as factually accurate and informative as possible, enabling the viewer to provide his own interpretation and draw his own conclusions.

253

The interpretive approach is personal, opinionated, emotional—basically an artist's or poet's approach to a pictorial problem. It is imaginative and often prejudiced, a frank attempt at expressing a point of view. This approach is less concerned with facts and surface appearances than with feelings and implications. Instead of limiting himself to a physically accurate rendition of the subject, an interpretive photographer tries to include in his picture, and convey to the viewer, something of what he felt and thought in response to it. This is a more difficult approach—but potentially more rewarding because the picture, if successful, instead of being merely informative will show the subject to the viewer in a new light, providing a new insight and an unexpected visual experience.

Since they serve different purposes, neither approach is "best." Which should be chosen depends upon the purpose of the picture and the "audience" for which it is intended. Because a fact is incontrovertible, either "true" or "false," the factual photographer's subject approach is much more restricted in regard to the number of available forms of expression than is the approach of the interpretive photographer, whose range of expression is limited only by the scope of his imagination. Each approach, of course, can borrow elements of the other. A strictly factual photo-report can be made pictorially attractive through the incorporation of certain imaginative touches without loss of accuracy; and an interpretive subject approach need not be so "far out"—so "experimental"—that the subject or idea behind the photograph become unrecognizable, since inclusion of factual aspects does not necessarily destroy its subjective, interpretive-creative character. At its best, an illustrative photograph is interesting and informative; but a first-class interpretive photograph is not only interesting but stimulates the mind.

The physical aspects of subject approach

The overwhelming majority of photographs involve three-dimensional subjects located in three-dimensional space. This brings up the question: Where should the camera be located in relation to the subject? Which one of a theoretically infinite number of different camera positions should the photographer select?

Once again, control must be exerted, a choice must be made, and the basis for this choice is the same as everywhere else in creative control: reject the obviously unsuitable, impractical, and impossible camera positions, and from the remaining possibilities select the best. But how? The choice becomes easier if it is explored in terms of two separate factors:

Subject distance
Direction of view

Subject distance

Choice of the best distance between subject and camera demands careful attention because this factor determines two important picture qualities:

The scale in which the subject is rendered
The proportions of the picture components

The scale in which the subject is rendered. The shorter the subject-to-camera distance (and/or the longer the focal length of the lens), the larger will be the image of the subject on the film but the smaller the included subject area, and vice versa. In this respect, distinguish between three basically different types of photographs:

The overall shot
The medium-long shot
The close-up view

The overall shot (or long shot) shows the subject in its entirety together with its surroundings and background. Its purpose is to provide a general impression of the total subject complex—to orient a magazine reader, for example, and prepare him for the more specific views that will follow as the picture story unfolds. Since photographs of this kind are usually made with a lens of standard focal length at a comparatively great distance between subject and camera or, when enough distance is not available, with a wide-angle lens, the scale of the subject is always relatively small and detail often too insignificant to be effective. Furthermore, because of the large angle of view involved, there is always the danger that too much extraneous subject matter might clutter up the scene and "dilute" the impression of the picture. Beginners in particular commonly make the mistake of taking an overall view where a medium-long shot (or a shot with a lens of longer focal length) would have been more effective, apparently in an attempt at matching the impression received by the eye and the picture produced by the lens. However, because of differences in "seeing" between the eye and the camera, such photographs are usually disappointing—the sweeping grandeur of the panoramic view is reduced to insignificance, detail is much too small to be effective, and the feeling of boundless space is lost.

The medium-long shot—the most common type of view—is generally made with a lens of standard focal length from an average distance—"average" meaning a distance great enough to show the subject in its entirety but not too great to make recognizing detail impossible. This is the approach most often used to photograph people, objects, events. The effect of a medium-long shot is comparable to the average view of the eye—like seeing a flower patch from a distance of 3 to 6 feet, a person from 10 to 15 feet, or a building from 50 to 100 feet. Although the medium-long shot is the generally most useful and therefore most common type of photograph, it rarely produces exciting photographs since, normally, it does not show us anything we have not seen before.

The close-up represents a form of intensified seeing—a dramatic and intimate view which is usually more effective than a picture of the entire subject. Close-ups are made from relatively short subject-to-camera distances with any kind of lens from wide-angle to telephoto, and render the subject in larger scale and with more detail than it appears in reality to the unaided eye. As far as viewer impact is concerned, close-ups generally score higher than the two other types of photographs for three reasons:

As a highly concentrated and more critically "edited" version of the subject, close-ups contain less superfluous and distracting subject matter than medium-long and overall shots. They are therefore a particularly clear form of pictorial statement and, as noted earlier, simplicity, clarity, and order head the list of photogenic qualities.

p. 238

Close-ups depict the subject in larger scale than it appears in the average picture, with correspondingly improved rendition of surface texture and essential detail. Because of this, they often show features and phenomena the viewer had not noticed before and, as opposed to the ordinary picture in which such subject matter appears too small to be effective, they give a stronger and more significant impression of the subject, thereby deepening the viewer's experience.

Since the majority of photographs are medium-long shots or overall views—that is, taken at average or greater-than-average distances between subject and camera—close-ups are comparatively rare, and rare types of pictures automatically arouse more interest than common ones.

The proportions of the picture components. If a picture contains a subject in front of a background, a photographer can control the scale of one relative

to the other, and the apparent extent of the intervening space, without changing the distance between the two, by

choosing the appropriate distance between subject and camera
choosing a lens with an appropriate focal length for making the shot

Suppose, for example, you wish to photograph a monument in the center of a plaza with historical buildings forming the background. The monument, being the subject proper of the picture, should fill the entire frame, while the buildings provide "atmosphere" and background. Set up your camera equipped with a lens of standard focal length, choose your distance so that the monument fills the entire picture, and check the groundglass image: the buildings in the background will appear in a certain scale. If you don't like this scale, this size-relationship between subject and background, you can change it without changing the scale of the monument by making appropriate changes in subject distance and focal length of the lens. If you want the background to appear *larger* relative to the monument, exchange your standard lens for a lens of *longer* focal length and *increase* the distance between subject and camera until the entire monument is again included in the picture, then make the shot: the buildings in the background will now appear *larger* than before. Conversely, if you want the buildings in the background to appear *smaller* relative to the monument, use a lens of *shorter* focal length and *decrease* the distance between monument and camera until the monument again fills the entire picture, then make the shot: the buildings in the background will now appear *smaller* than before. You can proceed similarly if, instead of a monument in front of buildings, you wish to photograph a figure in front of a castle, or any specific subject in front of any kind of background. You can control their relative scales and make the intervening space appear larger or smaller in your photograph, simply by taking the picture from the appropriate distance with a lens of appropriate focal length.

Direction of view

A photographer working in three-dimensional space has two basically different possibilities of physically approaching his subject: he can approach it in a straight line—that is, change the distance between subject and camera and thereby *control in the picture the subject's scale;* and he can encircle the subject laterally and vertically—that is, look at it more from the left or right, look up to it or down on it, and thereby *control the direction of view.* We have already

discussed control of scale; when contemplating the direction of view, a photographer must base his choice on the following factors:

The characteristics of the subject
The purpose of the photograph
The relationship of subject to background
The direction of the incident light

The characteristics of the subject. Some subjects (a person, an automobile, a house) have definite front, side, rear, and top views. Others (a tree, a landscape) lack such clear distinctions but may still look quite different from different directions. And a few subjects look more or less the same regardless of the direction from which they are seen. If the subject is complex, its components will probably appear in more satisfactory relationships to one another if seen from a certain direction, overlapping of the various elements in depth may make for a clearer rendition and foreshortening look better from one direction than another. Such reasons make it advisable to study, as far as circumstances permit, a subject from all possible angles and viewpoints, including views from above and below eye level.

The purpose of the photograph. The more conventional the angle of view, the more literal the translation of reality into picture form. Conversely, when a free translation is sought, a more unusual and fantastic angle of view may be chosen. Certain purposes require that perspective distortion be avoided as much as possible; in such cases, a "head-on view"—making the shot from a direction which places the principal plane of the subject (for example, the front of a building or the side of an automobile) parallel with the plane of the film—will yield the picture with the least degree of perspective distortion.

The relationship of subject to background. The camera position which affords the best view of the subject may show it against an unsuitable background. If the subject is movable or the background can be changed (for example, when photographing a person, or a sculpture in a museum), the remedy is simple, *provided the photographer notices the necessity for such a change before it is too late*. On the other hand, if change is impossible, an unsuitable background can often be made less offensive by rendering it unsharp through selectively focusing on the subject proper and making the shot with a relatively large diaphragm aperture, stopping down only as far as required to bring the entire depth of the subject into focus. In other cases, it may be possible to tone down the background by keeping it in the shade—

258

either by waiting until the sun has moved into a more suitable position, or by placing shadow-casting panels or such between the background and the source or sources of light. An "impossible" background that cannot be changed or modified is, of course, a valid reason for abstaining from making the picture.

The direction of the incident light. If the photographer can control his illumination (indoors, by shifting the lights; outdoors, by changing the position of the subject), he has no problem. However, if an immovable outdoor subject is badly illuminated (like a building or landscape in flat light), a photographer has very few choices: he can wait for the light to change (clouds to pass; the sun to move to a more suitable position); come back another time (when atmospheric conditions have improved); or look for another subject.

Subject rendition

Having decided upon a specific subject, and having made his choice of approach, a photographer is at last ready to choose his means of rendition. Here, on the third level of control, the choice of possibilities—of "symbols" and "synonyms"—is virtually unlimited. In particular, he must distinguish between four groups of controls, the components of which, through differential use, enable him to create almost any imaginable effect in his picture.

Mechanical devices

Camera	Shutter	Polarizer	Photo lamp
Lens	Swings and tilts	Film type	Speedlight
Diaphragm	Filter	Film size	Flashbulb

Photographic techniques

Subject selection	Focusing	Timing	Developing
Subject approach	Composing	Exposing	Printing

Picture aspects

Illumination	Motion symbolization	Sharpness
Color rendition	Light symbolization	Unsharpness
Contrast range	Glare rendition	Graininess
Space symbolization	Texture rendition	Mood rendition

Means of photographic rendition

Light	Contrast	Symbols of motion
Color	Space and depth	Timing the moment of
	symbols	exposure

Each of these devices, techniques, and aspects can be modified to various degrees, each modification having a corresponding effect upon the appearance of the picture. Since any one of these modifications can be used in combination with any modification of any of the other controls, the number of possible variations in the rendition of any given subject is truly astronomical, permitting a resourceful and imaginative photographer almost unlimited control over the final appearance of his picture. We will discuss key areas, based on the above list, in the following sections.

LIGHT

Light is a form of radiant energy produced by atomic interaction in the physical structure of matter. In terms of the photographer, light has four main qualities:

Brightness
Direction
Color
Contrast

In addition, he must differentiate between three main forms of light:

Direct light
Reflected light
Filtered light

For practical reasons, he must also distinguish between two main types of light:

Natural light
Artificial light

In photographic terms, light has four main functions:

It illuminates the subject
It symbolizes volume and depth
It sets the mood of the picture
It creates designs of light and dark

Brightness

Brightness is the measure of the intensity of light. It can be measured with an exposure meter, determines exposure time, decides whether the camera can be hand-held or must be mounted on a tripod, and influences the color and mood of the picture.

Brightness runs the gamut from the almost unbearably intense illumination found on snowfields and glaciers to the darkness of a starless night. Bright light is crisp, often harsh, and always brutally matter-of-fact; dim light is vague, restful, and mysterious. High-intensity illumination makes subjects appear not only lighter, but also more contrasty and their color more brilliant than low-intensity illumination. Accordingly, through choice of the intensity of the light, a photographer can control the feeling and mood of his picture.

Outdoors, if the illumination is too bright, intensity can be reduced with the aid of a neutral density filter (available in different densities), which cuts down the brightness without affecting the color rendition. This may become necessary if a shot is to be made with a large diaphragm aperture for deliberate restriction of the extent of sharpness in depth (selective focus) and the light is so bright that use of the optimum shutter speed would cause overexposure. Waiting for different atmosphereic conditions is an alternative.

p. 69

Indoors, brightness at the subject plane is determined by the distance between subject and photo lamp and, at least theoretically, controlled by the inverse-square law: the intensity of the illumination is inversely proportional to the square of the distance between the illuminated surface and the illuminating light-source. Expressed in more practical terms, this means that if the distance betweeen subject and lamp is doubled, the intensity of the illumination at the subject plane is reduced to one-quarter; if the distance is tripled, it is reduced to one-ninth; and so on. However, since this "law" applies only to point sources of light in the absence of reflecting surfaces, when used to determine the effect of a photo lamp (an area source of light in combination with a reflecting surface), it gives only approximate values that should be checked with the aid of a light meter and a gray card and, if necessary, refined. The inverse-square law is even less trustworthy when appreciable amounts of reflected light contribute to the illumination—for example, light reflected from walls or a ceiling (bounce-light). And it does not apply at all to line sources of light such as fluorescent tubes, the fall-off of which is directly proportional to the distance between subject and light—that is, doubling the distance between subject and fluorescent tube halves the intensity of the illumination at the

p. 125

261

subject plane, tripling cuts it to one-third, and so on. Incidentally, guide numbers for flashbulb and speedlight exposure are calculated in strict adherence to the inverse-square law—which explains why they should only be regarded as "guides," not absolutes.

Direction

The direction of the incident light determines the position and extent of the shadows. The five main types of light and their characteristic effects upon the picture can be distinguished as follows:

Frontlight. The light-source is more or less behind the camera, illuminating the subject more or less "head-on." Subject contrast is lower than with light from any other direction, a basic advantage in color photography. However, frontlight is also the "flattest" type of light because shadows are partly or entirely hidden behind the subject and thus not visible to the lens. As a result, while frontlight is particularly suitable to accurate color rendition, it makes objects appear less "rounded" and space less "deep" than light that casts more extensive shadows. Incidentally, 100 percent frontlight is extremely rare because even the sun behind the photographer's back or flash at the camera is slightly off-axis light and therefore casts some shadow; the best source of true frontlight is a ring-light—an electronic flash lamp that encircles the lens and produces completely shadowless illumination.

Sidelight. The light-source is more or less to one side of the subject but always more in front than in back. This is the most commonly used type of light and the one most suitable for making photographs in which good color rendition and a feeling of three-dimensionality are equally important. Sidelight is easier to handle than light from any other direction, consistently produces good results, but rarely creates spectacular effects.

Backlight. The light-source is more or less behind the subject, illuminating it from the rear, shadows pointing toward the camera. Subject contrast is higher than with light from any other direction, a fact which makes backlight basically unsuitable to color photography. On the other hand, backlighting creates illusions of space and depth more convincing than those created by any other type of light. As far as the color photographer is concerned, backlight is the most difficult type of light, but also the one which, if handled well, is the most rewarding. Almost invariably, its use either leads to outstandingly beautiful and expressive pictures or to failure. It is the most dramatic form of light and unsurpassed for expressing mood.

262

Toplight. The light-source is more or less above the subject. This is the least photogenic of the five types of light because vertical surfaces are insufficiently illuminated for good color rendition and shadows are too small and poorly placed for good depth symbolization. Outdoors, this is the typical high-noon light, the light beloved by most beginners because it is "nice and bright." In contrast, experienced photographers know that the best times for making outdoor pictures are the early-morning and late-afternoon hours, when the sun is relatively low.

Light from below. The light illuminates the subject more or less from below. Because it almost never occurs in nature, this type of illumination produces unnatural and theatrical effects (the effect of old-fashioned footlights). It is a difficult light to use well because it is conducive to the creation of a spooky atmosphere that can appear forced and gimmicky—novelty for novelty's sake.

Color

Light emitted by a source of radiation—the sun, a gaseous discharge tube, an incandescent filament—is not homogeneous. It is a mixture of different kinds of light—light of all the wave lengths from 380 to 760 millimicrons in nearly equal quantities. It is an "accord," an accord of radiant energy. But unlike an accord in music, in which a trained ear can distinguish between the different components and single out the individual tones that make up the accord, the human eye cannot separate and distinguish individually the different spectral components of white light.

As far as the color photographer is concerned, this is extremely important because differently composed types of light exist which *appear white* to the human eye but *colored* to the color film. Color film is much more sensitive to differences in the spectral energy distribution of light and, if the light does not conform to the standard for which the film is balanced, reacts by yielding transparencies that have a more or less pronounced color cast. To prove this, one has only to photograph a chart containing a number of color samples plus a patch of white in the apparently "white" light of, say, the sun, the light of an overcast sky, a photoflood lamp, and a fluorescent tube. To the eye, the colors and white patch of the chart will appear virtually the same in any of these four types of light. But the differences in rendition between the color chart and the various transparencies will be great enough to make most of the color pictures unacceptable.

Now, since color films are balanced to give satisfactory color rendition in only a few specific types of light, and since our eyes are incapable of distinguishing with sufficient accuracy between the different forms of apparently "white" light, how does one know whether or not the light is "white" as far as the respective type of color film is concerned—that is, whether it conforms to the standard for which the film is balanced? And if the light is "off," how does one know how much?

To answer these questions, color photographers need a gauge by which to measure the color of light. Then, if they find that the incident light does not conform to the standard for which their color film is balanced, they can determine to what degree it does not conform and, by using the appropriate filter, they can in effect convert the light to standard. This measure for the color of the incident light is known as the Kelvin scale.

The Kelvin scale, which derives its name from the British physicist W. T. Kelvin (1824–1907), measures the color of the incident light, in terms of "color temperature" in Kelvins (formerly degrees Kelvin)—that is, in Centigrades starting from absolute zero, which corresponds to $-273°$C. The reddish light emitted by a piece of iron heated to $1000°$ C., for example, would have a color temperature of 1273 K.

The color temperature of any given light source can be found by heating what is called a "black-body radiator" (a hollow sphere with a circular opening cut into one side that absorbs all outside light entering it) until the color of the light which it emits matches the color of the light source under examination. Then the temperature of the black-body radiator is taken and translated into Kelvins. The resulting figure is the color temperature of the light source in question.*

In this connection it is interesting to note that artists distinguish between "warm" (reddish) and "cold" (bluish) light. According to the laws of physics, however, the contrary is true: reddish light is produced by radiation at relatively low temperatures, whereas blue-white light is emitted only by the hottest stars. In terms of color temperature, reddish light rates around 1000 K while blue light (for example, from a blue northern sky) may rate as high as 27,000 on the Kelvin scale.

*Actually, because all substances reflect a certain amount of light which mixes with the light emitted on heating, the spectral composition of all incandescent light-sources except true black-body radiators is not exactly proportional to their temperature; but the discrepancy is usually so small it can safely be disregarded.

And this observation brings us up against one of the most important, and most consistently misunderstood, concepts in color photography: the color temperature of light that has been reflected, scattered, filtered, or otherwise altered in regard to its spectral composition since emission from its radiant source.

True and false color temperatures. The concept of color temperature is based upon the observed uniformity in relationship between the *temperature* of an incandescent body and the *color* of the light it emits. Therefore, only incandescent light-sources can have a color temperature in the true meaning of the term. The so-called color temperature of nonincandescent light-sources —for example, a clear blue northern sky—is not a true color temperature since the sky is obviously not radiating at a temperature of some 25,000° C. above absolute zero, as its "color temperature" would indicate.

Unfortunately, matters are further complicated by the fact that color temperature is only a measure of the color of light and gives no indication of its spectral composition. As noted above, different types of "white" light exist that have the same color (and therefore the same color temperature) but differ in regard to spectral composition (and therefore react differently with color film). For example, a color-temperature meter reading of standard daylight and light p. 85 emitted by a daylight-type fluorescent tube may produce the same result, indicating identical color temperatures. As far as the color of their light is concerned, two such light-sources would appear identical to the eye. But since the spectral composition of one is quite different from that of the other, the same subject photographed first in standard daylight and then in the light of the daylight-type fluorescent lamp would appear very different in the two transparencies.

The spectral composition of light emitted by incandescent lamps conforms very closely to the spectral composition of light emitted by a true black-body radiator, the standard of all color-temperature measurements. Color-temperature meter readings taken of such light therefore provide reliable data on which to base the selection of light-balancing filters. In all other cases, however, that is, as far as light from gaseous discharge tubes (speedlights), fluorescent tubes, the sky, and so on is concerned, color-temperature meter readings may be misleading rather than helpful, unless they are evaluated in the light of previous experience based upon experiments and tests. Instead, selection of corrective filters should be based upon data taken from published tables such as the following, which list true color temperatures of incandescent light-sources and empirically determined equivalent values of light-sources that have no true color temperatures.

Light-source	true or equivalent color temperature in Kelvins	decamired values
Candle flame	1500	66
Standard candle	2000	50
40-watt general-purpose lamp	2750	36
60-watt general-purpose lamp	2800	36
100-watt general-purpose lamp	2850	35
500-watt projection lamp	3190	31
500-watt professional tungsten lamp	3200	31
250-watt amateur photoflood lamp	3400	29
500-watt amateur photoflood lamp	3400	29
clear flashbulbs (press type)	3800	26
daylight photoflood lamps (blue glass)	4800–5400	21–19
white flame carbon arc	5000	20
daylight flashbulbs (blue lacquered)	6000–6300	17–16
electronic flash	6200–6800	16–15
morning and afternoon sunlight	5000–5500	19
sunlight through thin overall haze	5700–5900	18
noon sunlight, blue sky, white clouds	6000	17
sunlight plus light from clear blue sky	6200–6500	16
light from a totally overcast sky	6700–7000	15
light from a hazy or smoky sky	7500–8400	12
blue skylight only (subject in shade)	10,000–12,000	9
blue sky, thin white clouds	12,000–14,000	7
clear blue northern skylight	15,000–27,000	6–4

NOTE: The color temperatures listed above for incandescent lamps apply only if these lamps are operated at the voltage for which they are designed.

How to select the correct light-balancing filter. The task of selecting the correct light-balancing filter—that is, the filter which in effect will convert a given type of incident light into the type of light for which the respective color film is balanced—has been simplified enormously through a filter classification system based upon decamired values. These values are equivalent to color temperature values expressed in the micro-reciprocal or mired scale divided by 10. To arrive at the decamired value, divide the color temperature in Kelvins into 1,000,000 and divide the result by 10. For example, a professional tungsten lamp with a color temperature of 3200 K is equivalent to 1,000,000 divided by 3200, which is 313 mireds; to arrive at the decamired value, divide 313 by 10. The decamired value of a 3200 K photolamp (or light with a color

temperature of 3200 K) is therefore 31, as indicated in the table above.

Now since Type B color film is balanced for light with a color temperature of 3200 K, which has a decamired value of 31, this particular type of color film can also be said to have a decamired value of 31. Likewise, other types of color film can be said to have the same decamired values as the light for which they are balanced (see below):

Decamired values for color films

Daylight-type color films	16
Type A (3400 K photoflood lamps)	29
Type B (3200 K tungsten lamps)	31

In similar fashion, light-balancing filters have been assigned specific deca-mired values: see the following table, which lists the Kodak Wratten Light-balancing Filters Series 81 and 82 together with their decamired values and exposure-increase factors.

reddish filters	Conversion power in decamireds	Exposure increases in f-stops (approx.)
81	1 (1.0)	⅓
81A	2 (1.8)	⅓
81B	3 (2.7)	⅓
81C	4 (3.5)	½
81D	4 (4.2)	⅔
81E	5 (4.9)	⅔
81EF	6 (5.6)	⅔
81G	6 (6.2)	1
blue filters		
82	− 1 (− 1.0)	⅓
82A	− 2 (− 2.0)	⅓
82B	− 3 (− 3.2)	⅔
82C	− 5 (− 4.5)	⅔
82C plus 82	− 6 (− 5.5)	1
82C plus 82A	− 7 (− 6.5)	1
82C plus 82B	− 8 (− 7.6)	1⅓
82C plus 82C	− 9 (− 8.9)	1⅓

To find the correct light-balancing filter, calculate the difference between the decamired values of the film you wish to use and the type of light in which you wish to use it. This figure is the decamired value of the filter you need.

Whereas reddish filters lower the color temperature, raise the mired value, and have a positive-mired shift, blue filters raise the color temperature, lower the mired value, and have a negative-mired shift. Therefore, *if the light has a higher decamired value than the color film, you need a blue filter* (Kodak Wratten Filter No. 82 in the correct density); *if the film has a higher decamired value than the light, you need a reddish filter* (Kodak Wratten Filter No. 81 in the correct density). For utmost ease in selecting the right kind of filter, use the Color Filter Nomograph on the opposite page, which is based upon a chart designed by C. S. McCamy of the National Bureau of Standards in Washington, D.C.

If a decamired filter of relatively high value is needed but not available, it is possible to produce the same effect by combining two or more filters of lower value. For example, instead of a 9 filter, a 2 and a 7 can be used together, or a 5 and a 3 and a 1. However, for optical reasons, it is always desirable to use as few filters as possible.

Contrast

Since the contrast range of color film is relatively narrow, a low-contrast illumination is usually preferable to a high-contrast illumination. In this respect, a photographer must know that the degree of contrast of an illumination is inversely proportional to the *effective* size of the light source (the *effective* size of, for example, the sun, is very small although its *actual* size is, of course, immense): the smaller the effective size of the light-source or the more parallel the beam of light it emits, the more contrasty the light and the more sharply defined and darker the shadows it casts. Conversely, the larger the effective size of the light-source and the more diffused the light it emits, the less contrasty the light and the softer and more transparent the shadows it casts.

Examples of high-contrast illumination are direct sunlight on a cloudless day and light from a spotlight; of low-contrast illumination, light from an evenly overcast sky and from banks of fluorescent tubes. The most contrasty light is produced by a circonium arc lamp, which casts shadows as sharp as if cut with a razorblade, followed closely by the end-on ribbon filament lamps used in point-source enlargers and photoengraving. The softest light is the shadowless illumination produced by a "light-tent." Between these extremes, there is light of intermediate contrast: outdoors, sunlight in conjunction with white clouds of different sizes, and sunlight diffused to different degrees by haze; indoors, light from photoflood lamps, flashbulbs, and speedlights.

p. 270

268

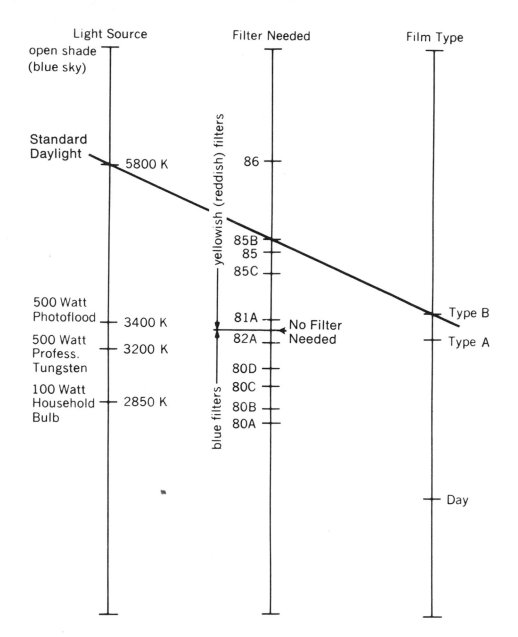

To find the required filter, place a straightedge across the Nomograph connecting the type of light in which the shot will be made (left-hand column). with the type of color film that will be used (right-hand column) The correct filter can then be found at the point where the straightedge crosses the center column. Example: The combination of Type B color film and standard daylight requires an 85B filter.

As far as artificial light is concerned, degree of contrast varies widely with the type of reflector and/or diffuser used. The same bulb can be made to produce a relatively contrasty or diffused illumination. To effectively diffuse a light-source and make it cast softer shadows, its luminous area must be increased. A diffuser of the same size as the reflector placed tightly in front of a lamp does not increase its effective size or diffuse its light but only cuts down its brightness. To be effective, a diffuser must therefore be larger than the reflector, and it must be placed far enough in front of the reflector so that its entire area is illuminated. Kodapak sheeting is excellent. The following combinations of bulb, reflector, and diffuser would produce different illuminations beginning with relatively contrasty light, going through increasingly less contrasty light effects, and ending with practically shadowless illumination: photoflood lamp used without a reflector; with a small, deep and narrow reflector; with a small, shallow reflector; with a medium-size reflector; with a large, shallow reflector; with a large, shallow reflector equipped with a large spun-glass diffuser 6 to 10 inches in front of it; with a large, shallow reflector 2 feet behind a diffuser made of a sheet of translucent paper stapled to a 3 x 3-foot frame.

Completely shadowless illumination can be produced with the aid of a light-tent: white background paper is used to surround the subject, enclosing it within a kind of large, cubical "tent" that has no opening other than an aperture large enough to accommodate the lens. A number of photoflood lamps are placed *outside* the tent—more or less evenly distributed around it, light from these lamps shielded, if necessary, so that direct light cannot accidentally fall upon the lens—and *directed toward the center of the tent* so that the light penetrates the white paper walls and, thoroughly diffused, completely envelops the subject inside the tent.

Direct light

Direct light is light which has not been reflected, filtered, scattered, or otherwise altered since emission from its original source. It is therefore *predictable* light insofar as its spectral composition is constant and identical to that of its source. For example, the direct light emitted by the gaseous discharge tube of a speedlight is compositionwise always the same and, in regard to color rendition, will give predictable results. However, if the same speedlight were directed toward the ceiling and used for "bounce light," its light, before illuminating the subject, would be *reflected* by the ceiling and, if the ceiling is not pure white, altered in regard to its spectral composition, as a

p. 274

result of which the color of the subject would be rendered differently and the transparency acquire a "color cast."

Normally, direct light should not be permitted to strike the lens since this might cause objectionable flare and halation in the transparency. To avoid this, p. 48 make sure that the source of light itself is not within the field of view of the lens, nor close to, though outside, the boundaries of the picture. And, take care to use an effective lens shade, your hand, or other nearby object to cast a shadow over the lens during the exposure.

Occasionally, however, it is desirable (or unavoidable) to include the source or sources of light in the picture. In order to produce the effect of direct or radiant light (instead of reflected light or "white") it may then become necessary to create the impression of radiance through the use of symbols.

The traditional symbols of radiance have always been the halo and the star. Artists wishing to create the impression of radiant light in their paintings invented the four- or many-pointed star—a man-made symbol that has no counterpart in reality because real stars appear to the eye as pinpoints of light. They also depicted candle flames as surrounded by circular halos of light. Such halos are another figment of the imagination.

Photographers wishing to symbolize the radiance of direct light in their pictures in more expressive form than that of a blob of white have several techniques at their disposal:

Flare and halation. According to academic rules, these are "faults" that must be avoided. According to modern creative thinking, however, if used in the right place with daring and imagination, these onetime "faults" can become powerful means for expressing in graphic form the radiance of direct light. Although not present in reality, flare and halation in the picture correspond closely to the sensations we experience when we look at a bright source of light: we become partially blinded temporarily, we see spots in front of our eyes, things get blurred—in short, the image seems dissolved in light. To produce equivalent impressions in picture form, don't hesitate to shoot smack into the light—and accept the outcome. Results will vary with the type and intensity of the light source, its position in the picture, the design of the lens, the size of the diaphragm aperture, and the duration of the exposure. In other words, the effect is unpredictable—a challenge to daring and imaginative photographers willing to gamble the loss of a piece of film against the chances of getting a terrific picture.

Wire screens. Placing a piece of ordinary copper fly-screen in front of a lens will turn dotlike sources of direct light (for example, streetlights at night) into four-pointed stars. If eight-pointed stars are desired, two such screens, one rotated against the other by 45 degrees, must be used. The size of these starlike images increases with exposure. Since the wire screen acts as a diffuser, the image is never perfectly sharp. However, the resulting slight degree of unsharpness and overall halation is usually inconsequential in the kind of picture for which this device is best suited: romantic high-key photographs of women, and night photographs of city scenes in which documentation is subordinated to mood.

Small-diaphragm apertures. In photographs taken with diaphragm apertures as small as f/16 and smaller, the images of bright, dotlike light sources are rendered as many-pointed stars, their size increasing with increases in exposure. In night photographs that include streetlights, in photographs of sun-glittering water, or in pictures in which the sun itself appears, star shapes effectively symbolize the radiance of direct light. This method of light symbolization has the advantage of affecting only the brightest lights within the picture; the rest of the image is crisp and sharp.

Diffusion screens. Placed in front of a lens, a diffusion screen differentially softens the entire image: bright picture areas are more strongly affected than darker areas. For example, in a photograph showing sun glitter on water, each highlight would be surrounded by a tiny halo, whereas the rest of the picture would remain relatively untouched. Likewise, sparkling jewelry, highlighted hair, and the edge-lighted silhouettes of backlighted objects would seem to be edged by softly diffused light. The effect is best in very contrasty scenes containing brilliant highlights; in the absence of highlights, sparkle and direct light, diffusion screens produce disappointing results.

Similar yet even more spectacular and unusual effects are produced by the Rodenstock Imagon lenses which, with the aid of variable sieve-like diaphragm stops, permit the photographer to adjust the degree of diffusion in accordance with the nature of the subject and the purpose of the picture. Dot-like sources of light and small but brilliant highlights, for example, appear in flowerlike shapes—as if surrounded by petals of light. These lenses, which are particularly suited to making romanticized portraits of women but otherwise rather restricted in their use, are available in focal lengths suitable for use with 2 ¼ x 2 ¼-inch SLR and larger cameras.

Out-of-focus rendition. Throwing the image of a dot-like light source out of

focus turns the dot into a circle. The more out of focus the dot, the larger the circle. Occasionally, this technique of deliberately unsharp focusing can be used to symbolize graphically the radiance of direct light. Streetlights at night, for example, if rendered out of focus, no longer appear as rows of small white dots but as strings of great luminous pearls, softly diffused, partly overlapping and semi-transparent, creating the vision of a fairy-tale street. Naturally, since the rest of the picture will appear as much out of focus as the lights, this method is limited in its application. But there are always times when its results, which must be observed on the groundglass, offer a new and stimulating possibility for symbolizing the radiance of light in night photographs of a city, particularly if the intent is to create an unrealistic, dreamlike mood.

Reflected and filtered light

Unlike the spectral composition of direct light, which is always the same as that of its source of emission, the spectral composition—the color—of light that has been reflected, filtered, scattered, or otherwise altered after its emission is different from that of its source of origin. If a reflecting surface is, for example, blue, the light it reflects will also be blue, even if the light which illuminated it, as far as the color film is concerned, was "white." A similar effect results, of course, when white light passes through a colored medium. For example, light in a forest or under a big tree is always more or less green from being reflected and filtered by green leaves. And the color of sunlight changes with the position of the sun in the sky because, in overhead position, the path of the light through the atmosphere is shorter than at sunset. As a result, sunlight is scattered less at noon than at sunset, explaining why the color of sunlight changes with the time of day. Such "accidentally" colored light is a frequent cause of unexpected color cast in a transparency—the photographer thought he was working with a specific type of light but forgot to make allowances for the changes that light had undergone since its emission.

Reflected light is commonly used both indoors and outdoors to lighten shadows which otherwise would be rendered too dark. The usual means for this are plywood panels covered with crinkled aliminum foil placed so that they reflect the principal source of illumination onto the shadow areas of the subject. Indoors, a very effective indirect illumination can be arranged with large frames covered with white muslin or paper, their angle and height precisely positioned in relation to the subject. Floodlamps or speedlight illumination is then directed toward and reflected from these surfaces, which illuminate the

subject with either softly diffused or shadowless light, depending upon whether this illumination is used alone or with direct front or sidelight.

A variant of this method—bounce-light—is used primarily for making candid indoor photographs: the reflector of the flashgun or speedlight is turned up and slightly forward so that the light strikes the ceiling, is reflected or "bounced" by it, and thus illuminates the subject with evenly diffused light. If bounce-light is used with reversal (positive) color film, the ceiling must, of course, be white, otherwise the transparency will have a color cast in the ceiling color. If negative color film is used, such a color cast can be corrected through appropriate filtration during enlarging.

Exposure with bounce-light is usually computed with guide numbers: use the focusing scale of the lens to establish the distance from the light-source (flash at the camera) to the reflecting point on the ceiling and from there to the subject; divide the guide number by the sum of these two distances to find the basic f-stop number, then make the exposure with the diaphragm opened up by two full stops beyond the basic f-stop—three full stops if the room is unusually large.

Natural light

As far as the color photographer is concerned, natural or daylight is the most difficult and troublesome type of light because it is unpredictable and inconsistent, varying frequently not only in brightness (which can be checked with a light meter), but also in color (which is difficult to notice and virtually impossible to check accurately). On a bright and sunny day, when the light is presumably identical with the type of light for which daylight-type color film is balanced, pictures taken in the open shade will be too blue, pictures taken under trees too green, and pictures taken next to a red brick wall too red. In addition, contrast in close-up shots will probably be too high because, contrary to artificial light where several photo lamps can be used simultaneously, outdoors there is only one source of light, the sun. As a result, shadows, illuminated only by blue skylight or hardly at all, may be so dark that subject contrast exceeds the contrast range of the color film, unless shadows are artificially lightened with supplementary fill-in illumination: flash at the camera, or sunlight reflected by means of aluminum-foil-covered panels, sheets of white paper, white cloth, or such.

Off-color daylight leads, of course, to off-color tranparencies. Whether or not

such off-color pictures are objectionable depends on a number of factors. For example, it makes a difference whether the "true" subject colors are familiar or unfamiliar to the viewer of the transparency; in the first case, particularly if skin tones are involved, demands for "natural" color rendition are much higher than in the second case, in which the subject conceivably might be any color, as is true of many man-made objects and structures. Furthermore, subjects characterized by strong and saturated colors will tolerate a much stronger color cast without appearing objectionable than subjects in delicate or pastel shades. Most sensitive in this respect are portraits and close-ups of people, again because skin tones, unless they correspond to what the viewer of the transparency expects, appear easily "unnatural." But here too differences exist insofar as a higher degree of color degradation toward ruddy colors will be accepted than one toward blue and green, which makes the depicted person look sick.

Nevertheless, to reject outright any color photograph which doesn't conform to academic concepts of color rendition is foolish. On the contrary, photographers and nonphotographers alike should learn to "see" subject color in off-color light—and accept it as natural, which it is. In the glow of a golden sunset sky, a face *must* appear more golden than in bluish midday light—why shouldn't we record it in its golden beauty?

"White" daylight. As far as daylight-type color films are concerned, "white" light or *"standard daylight" is a combination of direct sunlight and light reflected from a clear blue sky with a few white clouds during the hours when the sun is more than 20 degrees above the horizon.* This kind of light has an equivalent color temperature of 5800-6000 K and a decamired value of 18-17. When this combination of sunlight and clouds exists, color rendition in a correctly exposed and processed transparency made on daylight-type color film appears natural and corrective filters are not needed.

The only other type of daylight that approximates white as far as daylight-type color film is concerned is light from a uniform low-altitude haze dense enough to completely obscure the sun. However, since even slight changes in the nature of such an overcast can shift the color balance of the illumination toward blue, use of a No. 81 light-balancing, an ultraviolet, or a Kodak Skylight filter is often advisable.

Blue daylight. On a cloudless day, shadows are always blue (unless a strongly colored object adds its color to the shadow area, in which case the

shadow color becomes an additive mixture of both colors) because they receive their illumination from the blue sky. This is easily seen by comparing the color of a shadow on a white surface with the color of the blue sky: hold a mirror against the shadow on the white surface and tilt it so that it reflects the sky; thus seen together, the two blues, the shadow and the sky, will match.

If subjects are photographed in open shade—that is, if they are illuminated exclusively by the blue light of the sky, their color will naturally be distorted toward blue. Likewise, pictures made on cloudy days tend to be bluish in character, particularly if the sun is hidden behind heavy clouds and large areas of the sky are clear, or if the sky is uniformly covered by a high, thin haze. Under such conditions, if a bluish color cast is unacceptable, it can be avoided by using a reddish light-balancing filter in the appropriate density; see the tables on pp. 266 and 267.

Red daylight. Shortly after sunrise and again toward sunset the sun appears yellow or red. This is caused by light-scattering within the lower, heavily dust-laden layers of the atmosphere which only the longer, yellow- and red-producing wave lengths of light can penetrate, giving the early-morning and late-afternoon light its distinctive hue. The colors of subjects photographed in such light appear "warmer" than they would in white light. To avoid such color casts, manufacturers of color film recommend taking color photographs only from two hours after sunrise to two hours before sunset. Otherwise, the color cast can be avoided by using a blue light-balancing filter in the appropriate density. However, once a photographer learns to see color in terms of photography, he will be aware of the inherent beauty of the different kinds of daylight and find that color pictures taken in the early-morning and late-afternoon hours have a mood and beauty of their own.

Artificial light

Unlike natural light, the light emitted by artificial photographic light-sources is predictable and constant in regard to both brightness and color—provided, of course, that incandescent lamps are operated at the proper voltage and that this voltage is constant.

Another basic difference between natural and artificial light is that, if necessary, any number of separate artificial light-sources can be employed. Whereas the outdoor photographer is limited to a single light-source—the sun—and a single rather unsatisfactory type of shadow fill-in illumination—

the sky—the indoor photographer is free to arrange his illumination in any desired way. Not only can he draw upon as many individual lights as he needs to illuminate his subject perfectly, but he is also free to choose exactly the type of lamp which he feels will best meet specific requirements. Spotlights ranging from giant sun spots for sunlike effects down to tiny baby spots for accent lights, open floodlights for general illumination and diffused floodlights for shadow fill-in, are at his disposal for use in accordance with his plan. And, if he so desires, action-stopping electronic flash or flashbulbs permit him to cut exposures down to fractions of a second. Here is a listing of the most commonly used types of artificial light:

3200 K light is produced by professional tungsten lamps which are available in the form of floodlamps, reflector floods, reflector spots, halogen lamps, and projection bulbs for spotlights in different sizes with different wattages. Type B professional color films are balanced for use with this type of light, which has a decamired value of 31.

3400 K light is produced by amateur photoflood lamps which are available in the form of floodlamps, reflector floods, and halogen lamps in different sizes with different wattages. Type A color films are balanced for this type of light, which has a decamired value of 29.

3800 K light is produced by clear press-type flashbulbs which are available in different sizes with different light-outputs. This kind of light is intended mainly for black-and-white photography although satisfactory color photographs can be made on daylight color film in conjunction with an 80C color-conversion filter. The decamired value of this type of light is 26.

4800-5400 K light is produced by blue photoflood bulbs which are available in different sizes with different wattages. This kind of light is primarily intended for shadow fill-in when making indoor photographs in daylight on daylight color film. It is not recommended as the sole illumination in conjunction with daylight color film because the resulting transparencies would have a some-what warmer, more yellow tone than photographs taken in standard day-light. The decamired value of this type of light is 21-19.

6000-6300 K light is produced by blue-lacquered flashbulbs. This kind of light is intended mainly as shadow fill-in when making outdoor photographs on daylight color film. The decamired value of this type of light is 17-16.

6200-6800 K light is produced by electronic flash. Daylight color films are balanced for this type of light, which has a decamired value of 16-15.

Advice on the use of electric power

Ordinary home wiring is dimensioned for average household needs. In comparison, photographic lights take relatively large amounts of power. To know how many lamps can safely be connected to one circuit, multiply the voltage of the powerline by the number of amperes of the fuse. The result is the number of watts that can be safely drawn from the circuit. For example, if the line carries 120 volts and the fuse can take a load of 15 amperes (this is the most common combination), multiply 120 by 15. The result is 1800 watts, the maximum load that may be drawn from the circuit without the danger of blowing a fuse. This means that you can simultaneously use three 500-watt bulbs, or two 500-watt and three 250-watt bulbs, or one 500-watt and five 250-watt bulbs, or seven 250-watt bulbs; in all but the first case, this leaves 50 watts available for other purposes—for example, a weak room or ceiling light for general illumination between shots.

To avoid blowing a fuse, additional lights must be connected to a different circuit. You can determine the different circuits by connecting lamps to different outlets and unscrewing fuses one by one. All the lamps that go out when a certain fuse is unscrewed connect to the same circuit, while the lamps that remain lit are controlled by a different fuse.

The fuse is the safety valve of the powerline. It is an artificial weak link designed to break under overload to protect the line from destruction. If you accidentally blow a fuse, do not replace it with a stronger fuse, a coin, or a wad of aluminum foil. If you do, it will be the powerline itself that melts, and the resulting short-circuit may start a fire that can burn the house down.

The chances of accidentally blowing a fuse can be virtually eliminated by following these suggestions:

When buying electrical equipment or wiring, preference should be given to those items that carry the UL (Underwriters Laboratories) label. It is a guarantee that they meet certain safety standards which merchandise that lacks this label may not meet.

Do not reconnect equipment that caused a fuse to blow without first finding and eliminating the cause of the short-circuit.

Do not use electric wires with cracked, frayed, gummed, or otherwise damaged insulation or broken plugs. When disconnecting an electric cord, do not grab the wire and jerk but grip the plug and pull it out straight.

Be sure to place your temporarily strung wires so that people do not trip over them. Place them along the walls or furniture, or cover them with a rug.

Do not nail or staple ordinary rubber-insulated electric wires to baseboards, walls, or ceilings. This type of wire is not meant for permanent installation. Depending on the local building code, only metal-sheathed cable or Flex should be used for fixed installation, and it should be installed by a qualified electrician.

If you have to splice a wire, first solder both connections, then insulate each of the two strands separately with moisture-proof tape before you tape the entire splice. It is better still to make a plug connection.

Do not overload wires. Be sure your wires are of sufficiently heavy gauge to carry the intended electrical load; ask the clerk at the hardware store for the right gauge. Touch the wire after the equipment has been in use for a while; it may get warm but it should never get uncomfortably hot.

Do not indiscriminately fire flashbulbs with house current (for example, in an attempt to simulate light from a table lamp). Although they may fit a lamp socket, most flashbulbs will blow the fuse. Flashbulbs that can be safely fired with house current up to 125 volts are General Electric's Nos. 22 and 50 and Sylvania's Nos. 2 and 3. If several flashbulbs have to be fired simultaneously, connect a large incandescent bulb in series to absorb shock and avoid blowing a fuse.

Voltage control. The rated color temperature of photo-lamps applies only if the lamp is operated at the voltage specified by the manufacturer. Even changes of a few percent in line voltage are sufficient to alter the effective color temperature of the lamp. For example, a line fluctuation of 5 volts in a 120-volt circuit, applied to a high-efficiency photo-lamp, changes the color temperature by about 50K, the light output by about 12 percent, and the life of the lamp by a factor of 2. In general, within the normal limits of voltage fluctuation, it can be assumed that the color temperature of a photo-lamp intended for operation at 120 volts increases or decreases, respectively, about 10K with each increase or decrease in line voltage of one volt.

Color changes in transparencies due to changes in line voltage are most noticeable in pastel colors of low saturation and in neutral grays. If such colors predominate, a change in color temperature of only 50K may produce noticeable changes in color. If highly saturated colors predominate, color temperature changes up to 100K produce no serious color changes.

Specifically, below-normal voltage causes a color shift toward yellow and red, while a rise in voltage above the specified rate produces transparencies with a cold bluish cast in addition to shortening lamp life.

Fluctuations in line voltage are usually caused by abnormally high or low consumption of electric current (during peak hours, line voltage is most likely to drop to serious lows). Fluctuations which originate in the same building in which the studio is located (caused, for instance, by elevator or refrigerator usage) can be avoided through the installation of a direct line between the studio and the power main in the street. However, voltage fluctuations may also be caused by improperly dimensioned wiring and, on occasion, by temporary overloading with electric equipment.

If the line voltage is *consistently too low,* the simplest way to compensate for voltage deficiency is to measure accurately the color temperature of the lights under actual working conditions (with all lights turned on simultaneously), and to correct the yellowishness of the illumination with the aid of the proper blue light balancing filter. If the voltage *fluctuates constantly,* the only way to get consistently good color rendition is to stabilize the voltage through the installation of special voltage-control equipment.

How to expose by artificial light

p. 121
p. 326
p. 325
If the illumination is provided by lamps that produce continuous light, exposure data are determined on the basis of light-meter readings taken as described earlier. Particular attention should be paid to lighting contrast range (take readings from a gray card), subject-contrast range (take individual readings of the lightest and darkest colors), and, if applicable, the background (make sure it receives sufficient light for satisfactory rendition).

p. 101
If the illumination is provided by lamps which produce discontinuous light—flashbulbs or electronic flash—exposure data are determined with the aid of guide numbers, as previously described.

Gray scale as color guide. If a transparency is intended for reproduction, either in the form of a color print on paper or by a photo-mechanical process, whenever possible a paper gray scale or a Kodak Neutral Test Card should be included in the picture as a color guide for the printer or engraver. If positive (reversal) color film is used, this practice considerably facilitates balancing the color separations; if negative color film is used, it is almost a necessity for accurate color rendition in the print. Such a gray scale or card should be

placed near the edge of the picture, where it can be trimmed off later without affecting the appearance of the photograph. If it is impractical to include such a color guide in the picture, it can be photographed under otherwise identical conditions on a separate film of the same emulsion number, which must be processed together with the film on which the subject is photographed.

To be reliable as a color guide, the gray scale or card must receive the same amount of light as the most important areas of the subject. This should be checked with an exposure meter. Furthermore, the color guide must be placed in such a way that its image on the groundglass is free from glare and is illuminated by light of the same quality as the subject—that is, free from colored light reflected upon it by an adjacent colored surface. Outdoors, for example, the gray scale or card must not be placed directly on the ground since the unavoidable color cast from grass, sand, or such would destroy its value as an aid to the proper color balance of the separations or the print.

The functions of light

Every art form has its specific medium. That of the photographer is light. He literally creates with light, and is helpless without it. Light alone enables him to make photographs, to communicate, to express himself in picture form. To be able to make the fullest use of his own potentialities as well as those of light he must be aware of the four main functions which light fulfills in regard to his pictures:

> **Light illuminates the subject**
> **Light symbolizes volume and depth**
> **Light sets the mood of the picture**
> **Light creates designs of light and dark**

Light illuminates the subject

In the absence of light we cannot see. Hence, in a very real sense, light is synonymous with seeing. "Seeing is believing," says an old proverb. Indeed, seeing is one of the few priceless bridges between reality and the mind.

I want to stress the fact that there are different stages of seeing: the casual glance, the interested look, the curious investigation, the search for knowledge and insight. If you see a subject that interests you, don't be satisfied with the first look. If a subject is worth photographing, it is worth photographing well. Remember, the first view is rarely the best. Study your subject from

different angles, literally as well as figuratively speaking. See it with your eyes as well as with the eye of your mind: see its significance, its implications; bring out important features, concentrate, clarify, and condense, show *more* in your pictures than what the casual eye saw in reality! Light made the subject visible to you and gave you your chance; now it is up to you to make the viewer of your photographs "see."

Light symbolizes volume and depth

Any draftsman knows that "shading" adds "depth" to a drawing. It does the same in photography: a subject illuminated by shadowless frontlight appears "flat"; but if we move it relative to the sun, or move our photo lamp relative to the subject—*if we create shadows*—the impression of flatness disappears and is replaced by one of three-dimensionality. Flooded with shadowless light, the Venus de Milo itself appears flat as a paper doll; on the other hand, properly lighted to create shadows, even a shallow bas-relief acquires depth. It is the interplay of light and shadow which graphically symbolizes depth.

However, in order to create convincing illusions of substantiality, roundness, and depth, light and shadow must organically follow and accentuate the subject's forms. Unfortunately, this is not always the case, and often rampant shadows crisscrossing the subject's important forms destroy its design. To acquire a feeling for the importance of the interplay between light and shadow, I recommend that the reader perform the following experiment in portrait lighting. It will teach him how to arrange an effective illumination step by step.

Preparations. You need four photo-lamps and a model. Pose the model comfortably 6 feet in front of a neutral background. Darken the room until there is just enough light left to see what you are doing, but not enough to interfere with the effect of the photo-lamps.

The main light. This is the lamp that plays the role of the sun, the one dominating light. It has the double purpose of illuminating the subject in such a way that its forms are brought out as clearly and significantly as possible, and creating a graphically effective design in terms of light and shadow. In comparison with the main light, all the other lamps are subordinate auxiliary lights the object of which is to elaborate further the design established by the main light. They must not be brought into play until the position of the main light has been definitively established.

The best main light is a large spotlight approximating the effect of the sun. If not available, a No. 2 photoflood lamp in a reflector, a reflector spot, or a reflector flood can be used. Place this light approximately 30 degrees to one side and just above eye-level of the model. This position automatically produces a good illumination. Watch the distribution of light and shadow—particularly the shadows in the corners of the eyes near the nose, in the angles between nose and mouth, and beneath the chin; and above all, watch the shadow cast by the nose. This is the single most important shadow in any portrait; it must never cross or so much as touch the lips—the effect would be that of an ugly mustache.

As a photographer becomes more experienced, he can try to place the main light in other positions for more unusual effects. But in the beginning it is wise to use a safe arrangement. The total flexibility of artificial illumination makes it only too easy to end up with contrived light-effects—novelty for novelty's sake. But as long as the main light is correctly placed the basic design will be good, and what remains to be done is mainly a matter of contrast control.

The fill-in light. Its purpose is to lighten the shadows cast by the main light—not too much, not too little, just enough so that they will not appear black in the transparency but show some color and detail—without in any way changing the character of the illumination established by the main light. The fill-in light should be a well-diffused photoflood lamp. It should be placed as close to the camera-subject axis as possible and slightly higher than the lens. Such a position reduces as much as possible the danger of producing shadows within shadows—separate crisscrossing sets of shadows cast by the main and the fill-in light. Such disfiguring shadows must be avoided at any price. The exact distance between fill-in light and subject is determined by the desired subject-contrast ratio, as will be explained later.

p. 325

The accent light. Its purpose is to enliven the rendition by adding highlights and sparkle—in this case, to the model's hair. The accent light should be a small spotlight that can be focused on a specific area. It is used as a backlight to highlight the outline of the subject's cheek and hair, to add texture, catch-lights, and glitter. Since it must be placed somewhere in back and to one side of the subject—directed toward, but outside the field of view of the lens—it cannot cast secondary shadows. It must be prevented from shining into the lens because this might produce flare or halation on the film. A piece of cardboard placed between the light and the lens will accomplish this.

The background light. Its purpose is to ensure that the background gets

sufficient light to be rendered in the desired color—even if this "color" should be neutral gray or white. A large photoflood lamp directed toward the background is best. Use an exposure meter in conjunction with a Kodak Neutral Test Card to check that the illumination levels of background and face are the same. Underlighted backgrounds that turn out too dark in the transparency are common mistakes of the beginner.

p. 125

Texture lighting. Texture is surface structure—an aggregate of minute elevations and depressions. To bring out texture photographically the elevations must be illuminated and the depressions filled with shadow. Since the elevations—the grain of stone, the nap of a rug, the weave of cloth—are usually very small, they can be made to cast effective shadows only if they are illuminated by low-skimming light. Up to a point, the more the incidence of the light approaches parallelity with the textured surface, the better the texture rendition will be. Directionally, three-quarter backlight is most effective. For best results, use a point-like light-source or a light-source that emits parallel or near-parallel light, which casts hard shadows; best of all is direct sunlight or light from a spotlight. Next in line are undiffused photoflood or flash illumination. Diffused or reflected light is useless here. Since the components creating texture are usually very small, texture can be rendered satisfactorily only if, in addition to having sufficient contrast, the photograph is also perfectly sharp.

The principles of good lighting. In summary, the lighting scheme described above produces what might be called a "standard illumination." Although never spectacular, it is always successful and can be used equally well to light a girl, a gadget, or a geranium. It can be used with incandescent light, flash, or speedlight illumination. It can be varied in innumerable ways by varying the position, intensity, or spread of the different lights. By changing the ratio of light to dark, one can produce pictures that are either gayer or more somber. By increasing the contrast until the shadows are pure black, one can create the typical Hollywood glamour lighting, guaranteed to produce the most seductive effects. Once a photographer knows the purpose and effect of the different lights he can do anything he likes, and he will succeed as long as he observes the following basic rules that apply to any type of lighting:

> Arrange the illumination step by step. Always start with the main light. Never add an additional light until the previous one is placed to your satisfaction.
>
> Too much light and too many lights will spoil any lighting scheme.

284

Multiple sets of shadows that crisscross one another, and shadows within shadows cast by separate lights, are extremely ugly and must be avoided.

Don't be afraid to use pitch-black shadows if such shadows are expressive in form and placed in such a way that they accentuate the subject's forms and strengthen the graphic design.

In portraiture, the most important shadow is that cast by the nose. It must never touch or cross the lips. If it does, the effect suggests an ugly mustache.

Watch for the "blind spots" in a face and make sure they receive enough light. You find them in the corners of the eyes near the nose, in the angles between nose and mouth, and beneath the chin.

Keep your fill-in light well diffused to avoid shadows (cast by the fill-in light) within shadows (cast by the main light). Because it produces completely shadowless light, the best fill-in lamp is a ringlight—an electronic flash tube that encircles the lens.

Place your fill-in light above the level of the lens so that its shadow will fall low. Placed too low, a fill-in light can cast shadows that can ruin an otherwise clean background.

A fill-in light that is too weak is better than one that is too strong. A fill-in light that is too strong produces the same effect as single flash at the camera.

Concentrate your light toward the background and keep the foreground darker. A dark foreground suggests a frame and takes the eye toward the center of the picture, where interest belongs.

An underlighted background is a common fault of many color photographs. Use a light meter in conjunction with a Kodak Neutral Test Card to check the illumination levels of subject and background and make sure they are the same by arranging the lights accordingly.

Backlight is the most dramatic illumination, and the one most difficult to handle in color.

Low-skimming sidelight or three-quarter backlight brings out surface texture better than any other type of light.

Single flash at the camera is pictorially the worst kind of light.

Light sets the mood of the picture

The mood of a landscape changes with the time of day and atmospheric conditions—it can variously stretch blank and monotonous in glaring noonday light, lie brooding under an overcast sky, or come to life in a burst of color at sunset. A subdued low-level illumination creates a feeling which is totally different from that evoked by brilliant sunshine. The pink light of dawn affects us differently than the cold blue light of dusk. These differences in mood are the result of variations in the brightness and color of light.

Most photographers know this instinctively and prove it by pictures they take primarily for the sake of a mood with the aid of appropriate light. They realize the role of "atmosphere" and know that had they found the subject in a different light—in a different "mood"—they might not have taken the picture; because mood and atmosphere (in the psychological, not the meteorological, sense) are largely created by light.

As an example, consider the atmosphere of the interior of a church. We feel a different mood in a whitewashed New England church with bright sunlight streaming through large clear-glass windows than in a cathedral where mysterious light dimly filters through deeply colored stained glass.

The specific mood induced by a specific light can be preserved in the transparency only if the characteristics of the illumination which created it are preserved too. Photographers who tamper with the special quality of such light—who use corrective filters in an attempt at bringing it back to "standard," who indiscriminately use auxiliary illumination to fill in shadows and reduce contrast in an effort to record details that otherwise would have been lost to darkness—destroy its mood. Every experienced photographer knows that the use of fill-in light is often a necessary requirement for an effective rendition; but he also knows that such auxiliary light must be used in a way that does not destroy the very thing that made him take the picture—its mood.

Today, an increasing number of photographers realize the significant influence that illumination has on the mood of a picture and, as a result, available light is increasingly used. To me, a grainy and slightly fuzzy photograph taken under marginal conditions in available light, *that preserves the mood of the subject,* is far more meaningful than the sharpest and most detailed picture in which the mood is destroyed or falsified by tampering with the light. As a matter of fact, when the illumination level is too low to make detailed photographs at shutter speeds sufficiently fast to prevent blur due to subject motion, the actual subject

when seen creates the same slightly vague impression typical of a photograph taken of it in "available light."

In mood pictures, light is used to make emotional statements. The subject proper of such pictures is not something concrete but an intangible—a feeling. Tangible subjects appearing in the rendition are merely the means by which we convey the specific mood. Occasionally, color and light are the subject proper of such pictures, as in sunset shots and many pictures of the city scene at night—the "neon jungle." Abstract concepts like mood cannot be photographed directly; they can only be suggested. A photographer must direct the viewer's imagination through use of symbols that will lead him to contemplate in his mind the indicated mood. To suggest mood, muted illumination is usually needed, supplemented by color of suitable quality—warm or cold as the case may be, soothing or exciting, clashing or harmonious—and large areas of the picture must be filled, not with detailed factual subject matter, but with intangible color, shadow, and light.

As a means of creating mood, backlight is the most suggestive type of illumination. Backlight tends to subordinate reality by submerging concrete subject matter in darkness or light and to emphasize instead intangibles— atmosphere, mood. Although it is the most difficult type of light to use—often resulting in underexposure and overexposure within the same picture— nevertheless, if used with daring and skill, it enables a photographer to produce photographs that are more suggestive and powerful than those produced by any other type of light. p. 262

The special significance of backlighted pictures lies in the interplay of luminosity and darkness. In addition, shadows extending toward the viewer create particularly effective impressions of depth. This depth effect is often increased by delicate seams of light that outline objects, separate different zones in depth, and further heighten the spatial effect.

To preserve the character of backlight, the photographer must above all preserve the contrast between darkness and light. The worst mistake he can make is to use too much fill-in illumination. Anyone who seriously believes that undifferentiated black shadows are invariably a sign of incompetence on the part of the photographer should avoid using backlight. Although black areas are obviously undesirable in many types of photgraphs, this is not always true. Competently handled, black areas in backlighted shots are NOT "necessary evils" but compositional picture elements which give backlighted photographs their particular strength and character. The fact that this type of rendition is

287

unsuitable for certain purposes and subjects does not negate the value of backlight as a powerful means for symbolizing mood. Whenever definition in shadow areas is important, backlight should normally not be used. In portraiture, for example, backlight is used only as auxiliary illumination to add sparkle and highlights. But in landscape photography, particularly if the scenery contains a body of water or a dramatic sky, backlight is unsurpassed for producing meaningful effects. For satisfactory results, three conditions must be fulfilled:

The subject must be suitable for a rendition that emphasizes outline and silhouette, exaggerates contrast, and minimizes or obliterates detail. Among the subjects that fulfill these demands are: landscapes; bodies of water which, without the glitter and sparkle induced by backlight, often appear characterless and dull; silhouettes of city skylines; nude figure studies; all pictures that include large areas of sky with the sun behind a cloud; and, of course, sunsets.

Flare and halation must either be accepted as symbols of radiant light and creatively incorporated into the picture design, or avoided. The latter is often more difficult than the former and possible only if circumstances permit the photographer to shield his lens from direct light—by waiting until a passing cloud temporarily covers the sun, or by using the shadow cast by the trunk or limb of a tree, an arch, a doorway, an advertising sign, a canopy or such to prevent direct light from striking the lens. Under certain conditions, the p. 60 light-source can even be hidden by the subject itself. A lens shade provides adequate protection against halation and flare only if the light-source is outside the picture area, provided the lens shade is sufficiently long, a requirement which few lens shades fulfill. For larger cameras, unsurpassed in regard to efficiency is a bellows-type lens shade, which, because it expands or contracts as circumstances require, affords the best available flare control.

The exposure must be calculated in accordance with the *light* colors of the subject. For example, if the subject is a sunset sky, forget about detail in the landscape, take a light-meter reading of the bright areas of the sky at a moment when the sun is hidden behind a cloud, and expose your film accordingly. Parts of the picture, particularly in the foreground, will go black. But this darkness, far from being objectionable, will actually enhance the effect of the rendition through contrast between light and dark. If the exposure were "averaged," because of excessive subject contrast, parts of the scenery would be underexposed anyway and thus appear black; but in addition all the subtle colors of the sky would be burned out through overexposure, the colorful

sunset effect would be lost, and the photographer would only have succeeded in combining under- and overexposure in the same picture.

Light creates designs of light and dark

Brightly illuminated subject areas appear very light and areas in deep shade appear black. Between these extremes lies the range of intermediate colors and tones. Contemplated as abstract design, the graphic effects produced by light are as important to the effect of the picture as the space- and mood-suggesting qualities of light.

In analyzing the graphic and emotional effects of black and white, one finds that white is dominant and aggressive, black passive and receding. In a photograph, since white (or light areas) attract attention first (exception: bold dark silhouettes), they can be used to lead the eye of the viewer to points of major interest. An effective way to draw attention to the subject proper is to deliberately keep it light and "frame" it with dark areas along the margins of the picture. White (or a transparency in light colors) suggests lightness, gaiety, happiness, youth. Black (or a transparency in dark colors) suggests strength, solidity, and power, but also grimness, age, sorrow, and death. To make white appear as bright as possible it must be contrasted with black. Similarly, to make black appear as dark as possible, it must be contrasted with white.

A convincing demonstration of the potentialities of light as a design control can be had by performing the following experiment: With a single photo-lamp (preferably an adjustable spotlight), illuminate and photograph a white plaster statue in front of a white background in five different ways: (1) Using flat frontlight, illuminate the statue and the background so that both appear as white in the picture; to do this, you must increase the exposure as indicated by p. 122 an exposure meter accordingly, or expose in accordance with data determined with the aid of a Kodak Neutral Test Card. Your properly lighted and exposed photograph should show both the statue and the background as white. (2) Repeat the shot under identical conditions but this time expose in accordance with the data established by the light meter. Your picture should now show a gray statue in front of a gray background. (3) Take a third shot under identical conditions, but with the diaphragm aperture decreased by three full stops. This time you will get a rendition which shows a nearly black statue in front of a nearly black background. (4) By using a combination of front and overhead light with appropriate shielding by means of a piece of cardboard, arrange the light so that the statue appears fully illuminated and the background in the

shade. A correctly exposed negative will yield a white statue in front of a nearly black background. (5) Use more or less the same arrangement but direct the light so that the background is fully illuminated while the statue is in the shade. This time, you should get a picture in which a nearly black statue appears in front of a white background.

As this experiment proves, through skillful use of light it is possible to create design effects as different as white against white; gray against gray; black against black; white against black, and black against white. Isn't this a convincing demonstration of the creative potential of light?

The functions of shadow. As the above experiment shows, light and shadow are like positive and negative, two equally important forms of the same element although of opposite values, complementing and reinforcing one another through the contrast of their characteristic qualities. But whereas most photographers pay considerable attention to the quality and distribution of the light in their pictures, they commonly neglect the shadows, not knowing or caring that, as far as graphic picture impact is concerned, shadow fulfills three functions:

Shadow symbolizes depth. To appreciate the importance of shadow as a symbol for depth make the following experiment: Take three "head-on" photographs of a bas-relief. Illuminate the first view with shadowless front light; the second with low-skimming light coming from the upper left-hand corner of the picture; and the third with low-skimming light coming from the lower right-hand corner of the picture. Compare the effects of the three photographs. Notice that the first picture appears "flat"—absence of shadow means absence of depth; that the second one appears "natural" insofar as it gives the impression of "depth"; and that the third also seems to have "depth," but depth is reversed—forms that in the original were elevations appear as if they were depressions, and forms that were depressions appear to stand up in high relief.

The same effect can be seen in aerial photographs of mountainous landscapes taken from directly above. Such photogaphs have, of course, neither "top" nor "bottom." If they are held vertically, with the shadows pointing more or less downward and toward the lower right, the scenery will appear true to reality. However, if the picture is held "upside down,"—that is, so that the shadows point toward the upper left, the situation will be reversed—a mountain will appear as a crater and a valley as a mountain range.

In a landscape photograph that includes mountains, the shadows of passing clouds can be used to make the scenery stand out in bold relief. By waiting until the position of the cloud shadow is right—one range in shadow and the other in light—a photographer can indicate the interval between neighboring ridges and thus create an effect of greater depth in his picture.

Shadow as darkness. The value of the shadow lies in its depth of tone. It serves through its own darkness to make color appear more saturated and intense, giving white additional brilliance. You can easily prove this to your own satisfaction by placing a frame cut from a piece of black paper or cardboard over a color illustration: the color will immediately appear brighter. Subsequently, place a similar but white frame over the same picture and notice how its colors now seem dulled: white, being brighter than any color, in contrast to its own brightness makes color appear not only darker, but also less intense—producing exactly the opposite effect from black. It is this quality of black—of darkness and shadow—which the good color photographer utilizes to give his transparencies added brilliance and luminosity.

Darkness—shadow—in conjunction with lighter picture areas, creates graphic contrast from which comes strength, impact, and power. In addition, it provides forceful accents upon which the entire design of a photograph can sometimes be based, as in the case of a silhouette, or a semisilhouette—that is, a strong dark form which exhibits traces of color and detail within its darkness. Furthermore, darkness suggestively symbolizes intangible concepts such as power, drama, strength, poverty, suffering, or death. And it is the most effective means for creating a serious, somber, or mysterious mood.

Shadow as form. Grotesque shadows that repeat in distorted form the shapes of the subject by which they are cast can be used to create strong interpretative pictures and, like a caricature, through exaggeration emphasize a subject's qualities in a highly expressive form.

Although shadows with forms strong enough to be the principal subject of a photograph are rare, the main shadows within the field of view of the lens should be observed and analyzed since imaginative use of shadows can give a photograph a feeling of greater power and distinction. In the early morning and late afternoon, long slanting shadows can assume a strange life of their own. Certain bird's-eye views of people hurrying along a street full of weirdly distorted shadows, fantastically elongated by a low-riding sun, express in almost surrealistic intensity the hectic way of life in a big city. And I'll never forget an aerial photograph of a bombed city made by Margaret Bourke-

White. It was taken straight down from a low altitude in late afternoon, and the shadows cast by the roofless empty-windowed houses formed a macabre black-and-white pattern of hollow squares that reflected in the form of a "city of shadows" a mood of horror and senseless destruction impossible to forget.

COLOR

Color is a psycho-physical phenomenon induced by light. Its effect in terms of color sensation depends upon three factors:

The spectral composition of the incident light
The molecular structure of the light-reflecting or transmitting substance
Our color receptors, eye and brain

The nature of color

Color is light. In the absence of light—in darkness—even the most colorful objects appear black. They lose their color. This is the literal truth. It does NOT mean that their color still exists but cannot be seen because of lack of light. It literally means that *in darkness color ceases to exist*.

The fact that color is light is easily proved: in daylight, a white building is white; illuminated at night with red floodlights it looks red; illuminated by blue, it looks blue. In other words, its color changes with the color of the light by which we see it.

But what about pigments, paints, and dyes—the stuff that gives objects their colors—are they not absolute, existing as colors in their own right?

No—the colors of such substances are also produced by light. Consequently, they are subject to change with changes in the color of the illumination. Any woman knows that dyed fabrics and materials appear different in daylight than in incandescent light and change again in fluorescent light. Why? Because of the different colors of the light: daylight is "white," incandescent light yellowish, fluorescent light deficient in red.

You need only examine an array of pigments or paints in differently colored lights (cover a lamp with sheets of cellophane in different colors) to prove this for yourself. The paints will change color each time the color of the light is changed. Why? Because color is light.

The spectrum. Any high-school student today knows that what we perceive as "white" light is not a homogenous medium but a mixture of many different wavelengths that can be separated from one another and made visible individually with the aid of a prism or a spectroscope. The result is a "spectrum"—a band of brilliant color in which light of different wave lengths manifests itself in the form of different hues.

The most familiar example of a spectrum is a rainbow. Its colors are produced by sunlight that is dispersed due to refraction by innumerable droplets of water suspended in the air. The most spectacular rainbows occur in the late afternoon immediately after a thundershower, when the sun breaks forth and projects a rainbow against a background of black clouds. Always look for a rainbow directly opposite the sun. The lower the sun, the higher and more arched the rainbow.

Other natural spectra are produced by sunlight dispersed by the prismatic edges of cut glass and mirrors, or by rays of sunlight hitting a jeweler's display where the refracting substance of gems produces a shower of sparkling color.

The classic Newtonian spectrum distinguishes seven different colors: red, orange, yellow, green, blue, indigo, violet. In reality, of course, the number of different colors is infinitely larger since even a small change in wavelength produces a new and different color. However, as far as human color perception is concerned, all colors can be classified as variations and combinations of six basic colors: red, yellow, green, blue, white, black. These are called the "psychological primaries." Actually, in conjunction with modifying adjectives these color names are sufficient to describe all other colors. Orange, for example, can be described as red-yellow, and violet as blue-red.

The only colors that are pure in the scientific meaning of the word are the colors of an actual spectrum. While all other colors are mixtures of several colors in various proportions, each one of the hundreds of colors of an actual spectrum is produced by light of a single wavelength. Because of its unearthly clarity and brilliance, the contemplation of a large spectrum is one of the most profound, moving, and exciting of all visual experiences.

"Invisible light." A physicist might define "light" as the form of radiant energy which, by stimulating the retina of the eye, produces a visual sensation in an observer. This automatically precludes the concept of "invisible light." All light is visible. If it is not visible, it is not light. We sometimes read or speak about "ultraviolet light" or "black light." Scientifically, these terms are not correct. Since ultraviolet is invisible to the human eye (although certain

animals, insects, and photographic emulsions are sensitive to it), it cannot properly be called light; the correct term is "ultraviolet radiation." The same applies to infrared, which in turn is not a type of light but a form of energy closely related to radiant heat.

How color is produced

Color can be produced in many different ways, most of which are governed by a common principle: only those colors that exist in latent form in the spectrum of the light by which they are observed can be seen and photographed. If the spectrum of a certain type of light does not contain those wavelengths which, for example, produce the sensation "red," then an object which appears red in sunlight will not appear red when viewed under such illumination. For example, light emitted by a mercury-vapor lamp has a spectrum which lacks most of those waves that produce the sensation "red." Anyone who has taken a sunbath under a mercury-vapor lamp knows that its light gives lips and fingernails a cadaverous appearance. They appear purplish black because this type of light contains almost no red.

Here is a list of some of the processes which can produce color:

Absorption — all body and pigment colors
Selective reflection — all metallic colors
Dispersion — the rainbow, the spectrum
Interference — oil slicks on asphalt; opals
Diffraction — the colors of diffraction gratings
Scattering — the blue color of a cloudless sky
Electric excitation — colored neon signs
Ultraviolet excitation — fluorescent minerals

With very few exceptions—the spectral colors produced by dispersion or diffraction—colors as we commonly see them are not pure; that is, individual colors are NOT produced by the light of a single wavelength or a narrow band of wavelengths. Instead, most colors are mixtures of several often very different colors like blue and red, or red and green. We'll prove this in a moment, but first, to avoid initial confusion, we must clarify the situation by making a clear distinction between two things: color as we see it—that is, the personal and private experience of color within the brain; and the colored surfaces or objects, which give rise to this sensation. Color is based upon subjective feeling

and is beyond analytical investigation; colored surfaces are physical objects which can be analyzed with suitable scientific means. Let's distinguish between the two by referring to them in different terms:

Color — the private psychological response to color within the brain
Colorant — the colored objects that give rise to the sensation "color"

To study the interaction between light and a colorant, you need only look at colored objects through differently colored filters. For instance, if you look at a blue object through a red filter, the object will appear black. This is because the red dye of the filter absorbs the blue component of "white" light—blue light is not transmitted. This, of course, explains why in black-and-white photography a red filter darkens a blue sky and thus brings out white clouds: by selectively *absorbing* the blue component of the skylight, this filter reduces the exposure of the blue sky proportionally more than it reduces the exposure of the white clouds, the light of which also contains red and yellow, which are transmitted by a red filter. Therefore, it increases the contrast between the clouds and the sky.

The effect of any colorant is to *absorb* light of certain wavelengths from the incident light, NOT to add its own color to it. In other words, what we perceive as color is what remains of the incident light after it has been modified by the colorant. For example, in daylight, green leaves appear green because chlorophyll strongly absorbs the blue and red components of white light but rejects green, which is reflected; similarly, a red automobile appears red because its colorant absorbs the blue and green components of white light but rejects red, which is reflected.

The light-modifying effect of a colorant is, of course, the same whether the colorant reflects the light (as a surface does) or transmits it (as a filter does). If we look at the sun *through* a green leaf we see the same green as that which we see if we look at the leaf in sunlight. And if we were to paint a thin coat of red on a sheet of glass, we would see the same color if we looked at it or through it. This is because color is produced by the interaction between light and the molecules of the colorant, the atoms of which either absorb, or do not absorb, specific wavelengths (colors) of the incident light. It is those wavelengths that are *not* absorbed that we see as color.

This explains why an object can have only those colors which are present in latent form in the spectrum of the illuminating light. Thus, an object that

appears red in daylight (which is rich in red-producing wavelengths) appears black when illuminated by green light (which does not contain light of red-producing wavelengths) or when seen through a green filter (which absorbs red). Fluorescent light is so unflattering because it is deficient in red-producing wavelengths: the objects it illuminates often look "unnatural" in comparison with their familiar appearance in daylight, which is richer in red; in fluorescent light, a rare roast looks positively putrid, and a pink complexion assumes a corpselike hue. Even more "unnatural" are the effects of sodium and mercury-vapor illumination, which, being almost monochromatically amber and blue-green, makes everything appear either amber or blue-green, an effect no filtration can appreciably change. Renditions of this kind appear totally "unnatural" in color photographs.

All the colors we encounter in daily life—painted surfaces, colored textiles, the color reproductions in this book, color transparencies and color prints, color TV, and so on—are formed in accordance with two basic processes:

Additive color mixture
Subtractive color mixture

Either one of these processes makes it possible to produce a very large number of different colors from the mixture of only *three basic colors*. The first process applies to mixtures of colored lights, the second to mixtures of colorants—pigments and dyes.

Additive color mixture

We know that with the aid of a prism, "white" or colorless light can be broken down into its color components and made to produce a spectrum. We are now going to reverse this process and see how light of different color can be combined to produce other colors and ultimately white. To do this, we need three sources of light. Slide projectors are best, but flashlights will also do provided their batteries are fresh and the light they produce is strong and white. We also need three filters in the colors red, green, and blue. These colors are called the primaries—more specifically, the "additive primaries" since, mixed in the proper proportions, they add up to make white.

In a darkened room, we proceed by placing the red filter in front of one of the three light-sources and projecting it onto a sheet of white paper. This paper

will now appear red. Next, we place the blue filter in front of the second light-source and project it onto the same paper. Where red and blue overlap, a new color appears: a blue-red or purple, which is called "magenta." Finally, we place the green filter in front of the third light-source and project it onto the paper. Where green and blue overlap we get a blue-green color called "cyan." Where green and red overlap, we get yellow. And where all three primaries are superimposed we get white. Those who may not have an opportunity to actually perform this experiment can get an idea of how the result would look from the following diagram:

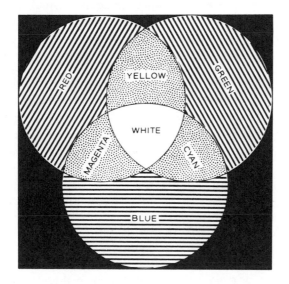

The above diagram graphically illustrates the principle of additive color mixture reduced to essentials. By varying the relative intensity of one, two, or all three of the colored light beams involved, virtually any desired color can be produced, plus any shade of gray and, reducing all three intensities to zero, black. That the colors blue and red should combine to form magenta (purple) was to be expected; likewise, that green and blue should form cyan. But that a mixture of red and green should produce yellow comes as a surprise. Actually, however, yellow is a mixture of all the colors of the spectrum *except blue*. Even if none of the yellow-producing wavelengths of light were involved in the production of this yellow color, such a mixture would appear yellow because equal stimulation of the red and green color receptors of our eyes produces the sensation "yellow." As a matter of fact, all yellow body or pigment colors are

produced through surface absorption of blue. Red and green are reflected and, by equally stimulating our red and green-sensitive color receptors, produce the sensation "yellow." If a surface reflected only the yellow-producing wavelengths from 575 to 590 mμ, which represent only a minute percentage of the incident light, it would appear almost black.

Subtractive color mixture

We have seen how light in the three primary colors, red, green, and blue, can be added to produce three new colors—magenta, yellow, and cyan—and ultimately white. Similarly, by mixing these primaries in different proportions, almost any other color can be produced, including colors that do not even exist in the spectrum—for instance, the purples, magentas, and browns.

This process of additive color mixture, however, has one serious disadvantage: since it applies only to colored light—NOT colorants—it necessitates the use of three separate light sources. We could *not* have produced any of our colors by placing three color filters in front of a single light-source. Why? Because each filter would have absorbed practically all the light transmitted by any one of the other two. Filters in the primary colors are mutually exclusive and, used in conjunction with each other, absorb all visible light. The result, of course, would have been black.

However, the problem of producing color by mixing colorants can be solved if, instead of working with the additive primaries, red, green, and blue, one uses filters in the new, primary-created colors, magenta, yellow, and cyan. These are the subtractive primary colors, and filters in these colors transmit not one-third but approximately two-thirds of the spectrum:

> Magenta — transmits red and blue — absorbs green
> Yellow — transmits red and green — absorbs blue
> Cyan — transmits blue and green — absorbs red

Consequently, filters in magenta, yellow, and cyan can be used in conjunction with a *single light-source* for the production of other colors, since each filter pair has one of the additive primaries in common: magenta and yellow both transmit red; yellow and cyan both transmit green; and magenta and cyan both transmit blue. As a result, where any two of these filters overlap, they produce one of the additive primaries by subtracting from the white transmitted light the other two additive primaries: color is produced by subtraction of color—hence the name "subtractive color mixture." Where all three of the

subtractive primaries overlap, of course, no light is transmitted and the result is black. The following diagram illustrates in graphic form this process of subtractive color mixture.

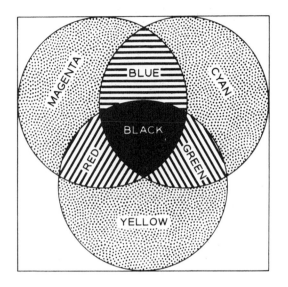

By varying the densities of the three filters in the colors magenta, yellow, and cyan, virtually any desired color can be produced. Anyone wishing to try the experiment can easily do so by using three sets of Kodak Color Compensating p. 68 Filters in the colors magenta (CC-M), yellow (CC-Y), and cyan (CC-C). Each set contains filters of six different densities. Or you can use ordinary pigments—watercolors or oils—in the subtractive primary colors, magenta, yellow, and cyan.

Colorants	Absorb	Produce
magenta plus yellow	green and blue	red
yellow plus cyan	blue and red	green
cyan plus magenta	red and green	blue
magenta yellow cyan	green and blue and red	black

All modern photographic color and photo-mechanical reproduction processes are based upon the principle of subtractive color mixture. And all the colors in our transparencies are mixtures of the three subtractive primaries, magenta,

yellow, and cyan. This can easily be verified by tearing apart (not cutting) a color transparency with a twisting motion so that a ragged edge results. In many places the different layers of the transparency will then become separated so that their individual colors show, revealing only three: magenta, yellow, and cyan.

Complementary colors

In our first experiment with colored light beams, each pair of (additive) primary colors produced a new color through overlapping ("addition"): red plus blue produced magenta; green plus blue produced cyan; red plus green produced yellow. If any of these "combination colors" (magenta, cyan, yellow) is added to that particular primary color (red, blue, green) which did *not* contribute to the combination color, the result will be white light.

As we have seen, as long as the three additive primaries, red, blue, and green, are present in approximately equal proportions, the end result will be white light. Consequently, if we combine three primaries, or one primary and that combination color which represents the sum of the other two primaries, the result will be the same. Any two such colors which, in combination, add up to produce white light form a "complementary-color pair." Such complementary-color pairs, as we can now easily deduce, are:

> **red** and **cyan** (cyan is the mixture of blue and green)
> **blue** and **yellow** (yellow is the mixture of red and green)
> **green** and **magenta** (magenta is the mixture of red and blue)

The complementary color to any given color is that color which, when added to the given color, will produce white light. This principle of complementary colors is utilized, among others, in color filters, since a filter transmits light in its own color and absorbs light in the corresponding complementary color; a yellow filter, for example, absorbs blue and transmits yellow, which, as we now know, is a mixture of red and green—that is, a yellow filter transmits yellow, red, and green. And when we work with negative color film, we produce in the color negative a picture that is made up of colors which are complementary to those of the actual subject. Subsequently, in printing, we again reverse the colors and produce a positive color print on paper the colors of which are complementary to those of the negative and therefore, at least theoretically, identical with those of the subject. (Note, however, that the overall orange tone of Kodacolor and Ektacolor negatives has nothing to do

with the colors of the subject but is due to the presence of unused color couplers, which remain in the film after development and provide automatic masking for color correction.)

A note of clarification. It is unfortunate that, in speaking of color, the term "primary colors" or "primaries" can have different meanings to different people. The following should help clarify the situation:

The psychological primaries are: red, yellow, green, blue, white, black.

The additive primaries are: red, blue, green. These are the physicist's primaries and apply only to colored light. When superimposed in the form of colored light, they add up to make white.

The subtractive primaries are: magenta, yellow, cyan. There are the complementary colors to the additive primaries and apply to pigments and dyes. They might also be called "the modern color photographer's and engraver's primaries" since all *modern* photographic color processes and methods of photo-mechanical color reproduction are based upon them.

The artist's primaries are: red, yellow, blue, white, black. These primaries apply to pigments and paints but are really not true primaries since, unlike the subtractive primaries, they don't combine to form a multitude of other colors unless the red is modified to become purplish red, or *magenta,* and the blue to become blue-green, or *cyan.* In other words, the so-called artist's primaries are in fact identical with the psychological primaries except that they don't include green, which artists don't consider a "pure" color because they can produce it by mixing yellow and blue. The artist's "primaries" are called primaries only because they represent apparently "pure" colors that are uncontaminated by other hues.

Summing up our findings in diagrammatic form we arrive at the following picture:

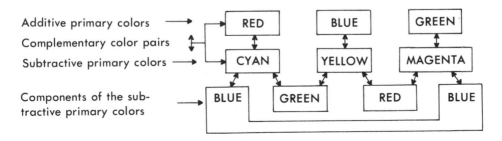

The terminology of color

If we want to be scientifically correct, we must attribute color not to an object itself, but only to the light reflected from that object. Remember that in red light a white object appears red, and that color appears different in artificial light than it does in daylight.

However, it is both customary and practical to speak of the "surface color" of objects. In that case, of course, it is usually understood that the object colors are described as they appear in white light, the standard of which is "daylight"—that is, a combination of sunlight and light reflected from a clear blue sky with some white clouds. Otherwise, color cannot be described in definite terms, since any change in the color of the light by which such color is observed would make a definite description meaningless.

To describe a specific color, three different qualities must be considered. In the terminology of the Optical Society of America (OSA), the standard terms for these qualities are hue, saturation, and brightness.

Hue is the scientific counterpart for the popular word "color." Red, yellow, green, and blue are the major hues; orange, blue-green, and violet are secondary hues. Hue is the most noticeable quality of color; it is the factor that makes it possible to describe a color in terms of wavelengths of light. Under the most favorable conditions, the eye can distinguish about two hundred different hues.

Saturation is the measure of the purity of a color. It indicates the amount of hue a color contains. The more highly saturated the color the stronger, more brilliant, and vivid it appears. Conversely, the lower its saturation, the closer a color approaches neutral gray.

Brightness is the measure of a color's lightness or darkness. In this respect, brightness corresponds to a gray scale in black-and-white photography, light colors rating high on the brightness scale, dark colors rating low.

Unfortunately, in popular language, the meaning of the term "bright" often differs markedly from its color-technical definition. A "fire-engine red," which commonly would be called bright, actually does not rate very high on the color technician's brightness scale. On the other hand, a grayish pink is, scientifically speaking, a bright red of low saturation, while popularly this same color would probably be called dull.

Besides these three terms, two other terms are frequently encountered in color specifications:

Chroma. This term corresponds essentially to "saturation" as defined above.

Value. This term corresponds essentially to "brightness" as defined above.

The nature of color perception

Up to now we have studied color from the viewpoint of the physicist. We have learned that color is light and that light is a form of energy. We have examined the different forms which this energy can take; how it is produced and modified. We have acquired knowledge which will prove invaluable when the time arrives to execute technically a color photograph. But we still have no satisfactory explanation of why eye and color film differ so often in their response to color.

The answer to this question is just as important to the creation of effective color photographs as, for example, the color of the incident light is to the quality of color rendition in the transparency. After all, color is as much a psychological factor as it is a physical quality; and color photography, like any other work of a creative nature, is a mixture of technique and art. The impact of a color transparency is as much dependent upon the psychological effect of its colors as it is upon the skill with which these colors are rendered. We have studied color quantitatively and have acquired a basic understanding of the physical aspects of color. To be able to put this knowledge to practical and creative use, we must now investigate the physiological and psychological aspects of color—we must study color qualitatively. To do this we must begin at the beginning, with the eye.

The eye

If I were to tell you that your eye is so sensitive that it can distinguish millionths of an inch, would you believe me? And yet, it is true. Color vision in most people is so acute that they can distinguish between colors whose wavelengths differ by as little as one-millionth of an inch. As a result, the normal human eye can perceive close to a hundred and fifty different hues, many of which may appear in more than a hundred different stages of saturation, each stage in turn manifesting itself in over a hundred variations from light to very dark. All in all, the number of different colors, shades, and tones which we can see probably exceeds one million.

How we see. In terms of the camera, the human eye has a four-element zoom lens with a focal length that varies from about 19- to 21-mm, giving it a focusing range from approximately 8 inches to infinity. Focusing is accomplished with the aid of delicate muscles attached to one of the elements which change the shape of the lens instead of the distance between lens and "film"—here, the retina. The "speed" of this lens is about f/2.5, but a built-in "automatic" diaphragm, the iris, stops down the lens as needed in accordance with the brightness of the incident light, reaching its minimum aperture at about f/11. As far as total vision is concerned, the angle of view of the eye is close to 180 degrees but, since the "quality" of its lens is rather poor, it suffers badly from sharpness fall-off toward the edges; as a result, we see sharply only those objects that are at or near the center of our field of vision. However, similar to a photographic lens, the lens of the eye improves with stopping down and, in bright light with the iris aperture decreased, we see considerably better than in dim light, when the iris is "wide open."

The image formed by the lens of the eye falls upon the retina, which corresponds to the film in the camera. The retina consists of millions of tightly packed nerve endings which, like microscopic photo-electric cells, transform light impulses into electrical impulses. Two types of these light-sensitive cells exist which, in accordance with their shapes, are called cones and rods. The cones, of which there are some 7 million in each eye, get more plentiful toward the center of the retina—the ½-mm-diameter fovea—which consists entirely of cones. The cones, characterized by high resolution but comparatively low light-sensitivity, function only in relatively bright light and enable us to distinguish fine detail and perceive color. The rods, of which there are some 170 million in each eye, are more plentiful toward the edges of the retina and completely absent from the fovea; they are much more light-sensitive than the cones but believed to be insensitive to color, which they register only as brighter or darker shades of gray. The rods enable us to see when the light gets too dim for the cones to function and are particularly sensitive to movement. Thus, in effect we have two different types of vision: day vision (phototopic vision), and night vision (scotopic vision).

Day vision. Cones and rods function together. If we wish to resolve fine detail (reading), we must look directly at the thing we want to see clearly (central vision). In this way, the lens of the eye projects the image upon the fovea, which consists entirely of cones. But when we cross the street and have to watch out for traffic, we rely mostly upon the rods, which, though unable to produce sharp images, are particularly sensitive to movement and therefore enable us

to notice approaching cars out of the corner of the eye (peripheral vision).

Night vision. Only the rods function. The cones don't work because of lack of light. As a result, nothing we see appears really sharp. Instead, objects seem blurred and indistinct. This general unsharpness is due to the fact that vision now is based entirely upon the rod-type cells, which are unable to resolve fine detail. Furthermore, if we look directly at a small *faint* object it seems to disappear because its image is cast upon the fovea, and the fovea is not sensitive enough to respond to very faint light. This, incidentally, explains the fact that when we look directly at a faint star the image disappears, whereas if we look at it askew, from the corner of the eye, we see it fairly distinctly.

So far we have been dealing with facts. However, these facts comprise only what might be called the first phase of seeing. Much more complicated phenomena are involved. The following "explanation" seems to be supported by experimental evidence but remains unconfirmed by the dissecting microscope. This is what scientists believe occurs:

Color vision starts with the cones.* In order to explain the actual process of color vision it is assumed that three separate light-sensitive systems exist, of which the retina forms only a part, with the remainder being situated somewhere within the fantastically complicated nerve circuits which connect the eye with the brain. Each of these three systems is supposed to be sensitive to one of the primaries, red, green, and blue. The sensation of color is assumed to be produced, in accordance with the laws of additive color mixture, through simultaneous, and unequal, stimulation of the receptors of these three color-sensitive systems. This hypothesis seems to be supported by the fact that we can "see yellow" although virtually no yellow-producing wavelengths are present to excite the color receptors of the eye.

Up to this point, seeing can be explained by this reasonably likely hypothesis. However, this hypothesis comprises only what might be called the second phase of seeing. To account completely for all the known effects, still other phenomena, belonging to a third phase, must be involved, and of the nature of these phenomena we know nothing at all. In simplified form, here are the two main questions for which we have no answers:

As in any simple optical system, the image projected by the lens upon the retina

*This is known from the microscopic examination of animal eyes in conjunction with experiments with live animals which showed that animals having only the rod-type cells can distinguish only degrees of brightness but do not react to differences in color, whereas those that have both rods and cones also react to variations in color.

is upside-down. This is a fact. Why, then, don't we see everything upside-down? Or do we, but without knowing it—that is, do we subconsciously correct this state of upside-downness, as clinical evidence based upon certain disturbances of the nervous system of the eye seems to indicate?

Radiant energy, of course, has no color. What, then, is that unfathomable, inconceivable process which, somewhere within the brain, converts electromagnetic impulses into color-sensations, and makes us aware of color? How do these fantastically precise sensors which can distinguish between wavelengths only millionths of an inch apart operate?

Summing up, we realize that seeing is a fabulously complicated process of which we know nothing except the most rudimentary facts. These facts point to the existence of a system which operates at three different levels: the eye, the brain, and the mind. Of these three, only the eye can be more or less satisfactorily explained in terms of optics (the lens), mechanics (the focusing mechanism and the operation of the iris), and chemistry (the "visual purple"—a fluid covering the retina which, through a continuous cycle of chemical destruction [bleaching] and reconstruction, contributes to the transformation of light impulses into nerve impulses).

The brain and the mind, however, are at present largely beyond our understanding. All we can say about them must be confined to vague generalizations which describe little and explain nothing. What we might say is that the brain, through its extension, the optical nerves, receives the impulses generated by the action of the visual purple and, somehow, converts them into—what? sensations?—which the mind (what is that?) interprets (how?) in terms of color.

Subjective seeing

The practice of comparing the eye to a camera has had an inhibiting effect upon a proper understanding of the fundamental differences between human and camera "seeing" in the larger sense of the word. The concept of the "camera eye" leaves out the fact that the camera-film combination represents a complete system, whereas the eye-retina combination is only one part of a larger system, playing the subordinate role of a receiver of information which collects light impulses and relays them to the brain, where they are "processed" and interpreted in the light of such diverse factors as memory, previous experience, mood, susceptibility, momentary interest and attention, fatigue, and so on. The importance of these psychological factors alone should be

sufficient to make it obvious that, despite the striking mechanical similarity between eye and camera, the phenomenon of human color perception must be very different from the process of photographic color reproduction, with similarities confined to a very superficial level. Even if it were possible to develop a perfect color film, which would reproduce color exactly, it would still be impossible to produce color transparencies or color prints that would appear "natural" no matter what the conditions under which they were made. For the basic inescapable difference is that the color film renders color objectively, whereas the eye sees color subjectively.

Adaptation to brightness

Everyone knows that the iris contracts in bright illumination and that, like the diaphragm of a lens, it regulates the amount of light that falls upon the retina. Less well known is the fact that the retina itself also has the ability to vary its sensitivity. In dim light, the sensitivity of the retina increases; in bright light, it decreases. As a result, within reasonable limits, we are able to see equally well, whether the light is bright or dim. Like a camera with only a single shutter speed, the scope of our vision would be quite limited without this very useful property which is called "brightness adaptation."

General brightness adaptation. We have all experienced the sudden effects of stepping out of the darkroom into bright light, and the necessary adaptation to the new level of brightness. And the opposite: of going from bright light into a dimly illuminated room in which we initially see almost nothing. In the latter case, as our eyes adjust to the dimness, objects appear more clearly, and after a while the dim room seems nearly as bright as the brightly lit space from which we came. Indeed, every photographer who has had to load or unload filmholders in improvised "darkrooms" knows that a closet which at first appeared completely black is actually "full of holes" and, within a few minutes, there is light enough to read the label on the film box.

In instances like the above, brightness adaptation occurs under circumstances which make it easy to recognize consciously the effect. However, at most times, brightness changes in the illumination occur gradually, and the eye adapts itself without our becoming aware of such changes. But even brightness changes which are great enough to be consciously noticed generally seem less dramatic than they actually are, because the eye adapts so well to different levels of illumination that the ease of seeing remains practically the same. As a result, levels of illumination which actually are very different may appear

nearly or completely identical; and if a photographer were to guess an exposure, unless guided by previous experience he might easily make a serious mistake. Brightness adaptation of the eye is the factor which makes it advisable always to determine exposures with the aid of an exposure meter. This is particularly necessary in color photography, in which accurate rendition of color can be expected only if exposure is within half a stop of "perfect."

Two other factors which further contribute to misjudgment of overall brightness are contrast and color saturation. As a rule, flat, contrastless lighting appears less bright than contrasty lighting although, in terms of overall brightness, the opposite may actually be true. And a scene containing mostly highly saturated colors appears brighter than a scene in which the colors are more diluted with gray, even though in the latter case illumination may actually be brighter. For example, a modern interior at night in which vivid colors are contrastily illuminated by electric light generally appears much brighter than an outdoor scene on an overcast day when contrast is low and colors are dull. But a check with an exposure meter would undoubtedly prove the outdoor scene to be several times as bright as the interior.

Local brightness adaptation. The same phenomenon of brightness adaptation occurs on a local scale. For example, if we walk in a forest, our eyes constantly adjust to the brightness level of whatever spot we look at. If we look at a sunlit spot on the ground, the iris immediately contracts and the sensitivity of the retina decreases, while if we look at the dark bark of a tree trunk deep in the shade, the iris opens up and the sensitivity of the retina raises to its highest level. As a result, contrast as a whole appears lower than it actually is. But if we were to check its range with an exposure meter by taking readings of the brightest and darkest parts of the scene, we probably would find that actual contrast by far exceeds the contrast range of the color film.

Somewhat similar conditions prevail in portraiture. Familiarity with the normal appearance of a face, in conjunction with local brightness adaptation of the eye, frequently makes photographers overlook the fact that shadows around the eyes and mouth, beneath the nose and chin, and the brim of a hat, are actually so dark that subject contrast considerably exceeds the contrast latitude of the color film. As a result, such shadows photograph "too black" and the portrait appears unnatural. Photographers who are aware of this phenomenon of brightness adaptation notice this effect *before* they make the exposure and decrease contrast with the aid of fill-in illumination.

Another frequently encountered mistake, underlighting of the background, is

due to the same cause. Again, the eye adjusts its sensitivity in accordance with the respective brightness levels of subject and background, causing significant differences in intensity of illumination to appear so small that corrective measures are not even considered. The only way to guard against such self-deception is to check the contrast range with an exposure meter.

Simultaneous brightness contrast. Most photographers know that a light subject appears even lighter if placed against a dark background; that dark subjects in a picture appear even darker when contrasted with white; and that a white border around a color print tends to make the adjoining light colors of the print appear muddy and dull. These phenomena are caused by "simultaneous brightness contrast." They can be explained as follows:

When we look at a bright object or area, the sensitivity of that part of the retina on which the image of the brightest object or area has been projected by the lens of the eye decreases. However, this decrease in sensitivity is not confined to the exact image area, but extends somewhat beyond its border into that part of the retina upon which the image of the adjacent darker area is projected. As a result of this decrease in sensitivity, a dark area next to a lighter one appears even darker, and a light area next to a dark one appears even lighter, than they actually are.

Similar value changes through contrast occur, of course, in the field of color. For example, a medium blue-green by itself may seem to have a specific and unalterable quality. However, by performing the following experiment, any-one can easily prove that, as far as the psychological effect of this or any other color is concerned, this is not the case. Purchase an assortment of papers in the colors yellow, blue-green, dark green, green, blue, and black from an artist's supply shop. Cut a square from a blue-green paper and place it successively in the middle of each of the colored papers. Observe how its color seems to change in quality, particularly in regard to hue and brightness. Against yellow, the blue-green will appear considerably darker than if placed against the dark green. Against green, it will appear bluish; against blue, it will appear much greener. Against white, it will appear much duller than when placed against black, where it will appear vivid and bright.

Brightness constancy. Without realizing it, we constantly deceive ourselves in regard to actual brightness of objects. For example, a white object will appear white under almost any circumstances, even if it is in the shade and its actual brightness only equivalent to a medium gray. Similarly, many familiar objects, and particularly the faces of people, appear in more or less constant brightness regardless of the actual intensity of the illumination.

309

Brightness constancy—that is, the tendency to see familiar objects and colors in terms of brightness as remembered (reflective power) rather than in terms of actual brightness (effective reflection at the moment of observation) is one of the main causes for overcontrasty color photographs due to uneven illumination. Particularly in an interior shot, familiarity with the pervading colors and the actual brightness values of the scene tends insidiously to dull a photographer's critical faculties and trick him into relying on memory rather than observation when he arranges his illumination. Once again, it cannot be sufficiently stressed that checking the actual brightness of different parts of the scene with particular consideration of dark-colored objects, or areas that are remote from the light or windows, and the background, is extremely important to the successful outcome of the transparency.

Adaptation to color

As might be expected, the eye reacts subjectively not only to brightness, but also to saturation and hue. Thus, we constantly see color the way we think it ought to be, and NOT as it actually is, and as it is rendered by the color film.

General color adaptation. Unless the illuminating light-source is definitely and strongly colored, the eye adapts its color sensitivity in such a way that it sees a scene as if it were illuminated by white light. As a result, object colors appear as remembered—that is, as they would appear in average sunlight. In this way, objects seem more familiar and more easily recognizable than if their appearance were constantly changing in accordance with the color of the incident light.

While brightness adaptation must be considered the most common indirect cause of overcontrasty and underexposed photographs, "color adaptation" is usually to blame for color that in the transparency seems distorted by a color cast. However, whereas the pitfalls of brightness adaptation can easily be avoided with the aid of a light meter and, if necessary, corrected with the aid of fill-in illumination, the dangers resulting from color adaptation are much more difficult to avoid. If the cause of the color distortion is due to a colored light-source, a checkup with a color-temperature meter might conceivably lead to its detection; in that case, correction with the aid of the proper filter is usually not difficult. But if the color cast is caused by light other than that emanating from an incandescent source (for example, fluorescent light), or by light which is colored by filtering (through window glass, green leaves, and so on), or by reflections from colored objects (a brick wall, colored walls in a

310

room, or such), the color-temperature meter is useless. In such cases, only an awareness of the problem followed by a close inspection of the purity of subject colors can prevent a distorted rendition of color in the transparency.

The classic example of unsatisfactory color rendition due to color adaptation of the eye is the case of the color portrait taken in the shade of a big tree. By skillfully utilizing the softly diffused, beautifully modeling light, the photographer has every reason to expect a particularly successful transparency. But what actually happens? Instead of the natural-appearing portrait he anticipated, he gets the picture of a face in which a healthy tan has been transformed into a greenish color cast that frankly makes his model look seasick.

What has happened is this: owing to the presence of large amounts of green light reflected and filtered by the foliage of the tree, and blue light reflected from the sky, at the moment of exposure the face *actually* was just as it later appears in the color shot. However, on seeing the transparency, the photographer refuses to accept its colors as "true" because his "color memory" holds an entirely different conception. In most people, color perception is not developed to such a degree that they *consciously* notice minor aberrations from the memorized "normal" colors of familiar objects. As a result, they judge color by memory rather than by eye. And if actual colors differ from the norm—which automatically happens when the illumination is not "pure white" (green reflected from the foliage, blue reflected from the sky)—they fail to notice the resulting color distortion. Color film, however, renders color shades, at least theoretically, more or less as they are. Whenever a correctly exposed and processed color photograph strikes us as unnatural because its colors appear distorted, it is usually *not* the fault of the color film but that of our own persistent color memory which prevented us from seeing colors as they are in reality. To return to the example given: the conclusion we are forced to draw is that, in color photography, a rendition may be rejected as "unnatural" *precisely because its colors are true*.

To convince himself of the degree to which the eye can adapt to colored light and still regard it as white, the reader might perform the following experiment: Take a few light-balancing or color-compensating filters in pale shades and, for half a minute at a time, look through them at the view outside the window. Obviously everything seen through a pale blue filter, for example, will at first appear slightly blue. However, within a very short time, the eye will adapt itself to the bluish light and object colors will appear once more as if the light were white. Then, put the filter down, and everything will look decidedly yellow-pink—the complementary to pale blue—and it will take a little time

before the eye is back to normal again and sees color as if the light were white.

Conversely, observed through a pink filter, at first everything seems bathed in rosy light. But quickly the eye adapts itself to this new light, and the colors of the view appear normal. But when you put the filter down, you will be surprised to see that suddenly everything looks blue; however, it will take your eye no more than a few moments before it sees color again as if the light were white.

Approximate color constancy. Color memory or, as it is scientifically called, "approximate color constancy," causes us to see color as we think it should look, not as it actually is. For example, because we *know* that snow is white, we see it as white at all times, even in the open shade where it might be distinctly blue because it is illuminated only by blue skylight, or late in the afternoon when it is rosy in the light reflected from a reddish sunset sky. Similarly, because we have definite conceptions of the color of human skin, we expect to see the skin of people in color photographs rendered in a certain way; otherwise, we are likely to reject the picture as "unnatural," no matter how accurately it may actually represent the skin tone as it appeared at the moment the picture was taken—as, for example, in the case of the previously mentioned portrait made in the shade of a tree.

While the untrained eye consistently fails to notice the changes of color that constantly occur around us, painters have long been aware of this fact. In 1886, the French novelist Emile Zola, in his book *L'Oeuvre (The Masterpiece)*, wrote about this conflict between actuality and appearance in a scene in which he describes the reaction of a young wife to the "impressionistic" paintings of her husband:

> And she would have been entirely won over by his largesse of color, if he had been willing to finish his work more, or if she had not been caught up short from time to time by a lilac-toned stretch of soil or a blue tree. One day when she dared to permit herself a word of criticism, on the subject of a poplar tree washed in azure, he took the trouble of making her verify this bluish tone in nature itself; yes, sure enough, the tree was blue! But in her heart she did not accept this; she condemned reality; it was not possible that nature should make trees blue. . . .*

In a similar way, color photography can open our eyes to the true nature of color. Often, in looking at a transparency, we are dismayed and think that a

*Copyright 1946 by Howell, Soskin, Publishers, Inc. Used by permission.

certain color could not possibly be true. But if we take the trouble to check the subject under conditions which are similar to those that prevailed at the moment of exposure, we will find that all too often it is we who are mistaken. And learning from this we will become more observant, and more fully aware of the changing aspects of our ever-changing world.

The psychological effects of color

To be effective, a color photograph must be efficacious. This may sound self-evident, but only as long as we don't try to answer the question: What is that elusive quality that makes a color photograph effective? Is it accuracy of color rendition, verisimilitude? Not necessarily, as proved by the case of the portrait taken under a tree which was rejected precisely because its color was "true." Is it beauty? Perhaps—but can you give a simple yet meaningful definition of the concept of beauty? Is it surprise value? Sometimes yes, sometimes no, because a surprise can be unpleasant as well as pleasant. Shock value? Same comment. Even if we analyze specific color photographs and try to nail down that elusive quality that makes them "effective" we'll have trouble reaching valid conclusions because different people will react to them differently or, for that matter, may not react at all although we may feel strongly . . . which brings us back to where we began . . . efficacy . . . which is no help at all. . . .

However, we'll have better success if we tackle the problem from the other end and start with those qualities which are likely to lead to effective color photographs. Using this approach, we might arrive at the following conclusions:

We must begin by accepting as a fact that color is the most powerful quality of any picture. It is stronger than outline and form, stronger even than content and design. For example, in contemplating the picture of a green nude, most people would comment first on the green before they comment on the nude; and the color photograph of a gory event has greater impact because the blood is red than a black-and-white rendition in which the blood is black. Consequently, a color photographer must give maximum attention to the colors which will appear in his pictures and, as far as possible, choose colors for their associate values. He can do this in three ways:

He can choose his subject for its color. For example, a blonde girl instead of a brunette; a pink sunset sky under which to shoot a certain landscape

instead of a sky that is blue; a white automobile instead of a red one (if choosing a white, or "colorless," subject for a color photograph seems strange to you, keep reading; you still have much to learn).

He can choose specific colors as supplementary picture elements. For example, a blue-green scarf; red shoes; a vase with yellow flowers; a pale gray background; a purple pillow; a deep blue sky.

He can choose the mood-setting color for a picture. For example, he can shoot in "warm" and golden sunset light instead of working with "cold" blue-white noontime light; he can change the color of the incident light by taking the picture through the appropriate light balancing or even color compensating filter; he can place colored gelatins in front of the photo lamps.

To be able to choose colors in accordance with the mood and meaning of his picture, a photographer must be familiar with the psychological effects of color. This, of course, is a vast, complex, and controversial field which I can touch upon here only briefly.

p. 302 As noted earlier, the three dimensions of color are hue (color), chroma (saturation), and value (brightness). Between these qualities, certain relationships exist which divide colors into groups. Each of these groups evokes specific psychological responses which can be used advantageously to produce specific effects. To examine the hereby-created possibilities, let's start with the Munsell Color Wheel.

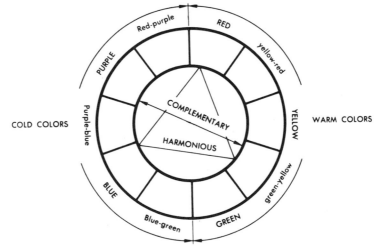

The Munsell Color Wheel is divided into five major hues: red, yellow, green,

blue, purple; and five intermediate hues: yellow-red, green-yellow, blue-green, purple-blue, red-purple. Although these are the only colors indicated in the drawing, it must be understood that in the original Munsell Wheel each intermediate hue is further subdivided into ten hues so that the complete circle encompasses 100 different hues. The following relationships between these hues and groups of hues can be observed:

Complementary colors. Any two colors directly opposed on the color wheel form a complementary-color pair; for example, red and blue-green. Esthetically, complementary colors enhance one another and, similar to black if contrasted with white, make each other appear more brilliant—a red rose against a background of blue-green leaves makes a striking color composition. If a photographer wants to create maximum impact in the most direct way, his best chance is to use a color scheme based upon highly saturated complementary colors. The explanation of this fact lies in a phenomenon called the *afterimage,* something most of us have experienced after having looked at a bright source of light, for example, the sun: closing our eyes, we immediately seem to see the light source floating in space against a dark background; but within a short time, the afterimage will reverse itself into the negative and we seem to see a blue-black sun against a lighter background. The first kind of afterimage is called "positive," the second "negative."

A similar phenomenon occurs when we look at a patch of strong color. For example, when we take a concentrated look at the picture of a red rose, our eyes adapt to the color "red," and if we now turn away quickly and look at a sheet of white paper we will see on it a "negative afterimage"—that is, the picture of a blue-green rose—blue-green being the complementary color to red. The reason behind this explains why any color appears more brilliant in juxtaposition to its complementary than when combined with any other color: when we look at a color, our eyes become prepared to "see" in the form of a negative afterimage its complementary color; hence, having looked at red, we are prepared to see blue-green, and if we actually see it in a color photograph, it appears more intense than it would have appeared had our eyes not been "sensitized" for this particular hue by having first looked at its complementary color.

Related colors. Colors that are neighbors on the color wheel, or groups of neighboring colors, are interrelated. For example, red, yellow-red (orange), and yellow are related because they share a common factor: they are "warm" colors. Similarly, blue-green, blue, and purple-blue are related by the fact that all three share the color blue; and so on. Compositions in related colors

automatically acquire a unity and a feeling of "rightness" which is lacking in aggregates of unrelated colors. In addition, they exert a quiet and soothing effect upon the eye and mind—exactly the opposite from the active and exciting effect of compositions based upon complementary colors.

Harmonious colors. Any three colors connected within the circle by an equilateral triangle are said to be harmonious, which means they go well together, like the individual tones that form an accord in music.

Warm colors are those that contain yellow: red, yellow-red (orange), yellow, green-yellow, green—one half of the color circle. The "warm" feeling which these colors evoke is probably due to associations with the sun, incandescent metal, or fire—all of which radiate heat and are also rich in light waves which create the sensation "yellow." In a color photograph, this feeling of "warmth" can usually be created, if necessary, by shooting the picture through the appropriate "warm-up filter"—a Series 81 or CC-Y filter in the right density.

Cold colors are those that contain blue: blue-green, blue, purple-blue, purple, red-purple—the other half of the color circle. The "cold" feeling which they evoke is probably due to the fact that blue is complementary to yellow and yellow-red—the "warmest" colors—and also to associations with "blue ice" and a deep blue, cold, northern sky. In a color photograph, the feeling of "coldness" can usually be created, if necessary, by shooting the picture through an appropriate "cooling-down filter"—a Series 82 or CC-B filter in the right density.

Highly saturated colors—colors undiluted by black, gray, or white—create vigorous and aggressive impressions, emphasizing strength and power, creating joyous and positive moods. These are the colors most easy to reproduce accurately on color film because even relatively large deviations will normally pass unnoticed. Underexposure by the equivalent of one-half f-stop accentuates the brilliance of highly saturated colors in the transparency.

Pale colors and pastel shades—colors highly diluted by white or gray—are particularly suitable for the creation of sophisticated and delicate effects and to suggest more pensive and languid moods. These are the colors most difficult to reproduce accurately on color film since even the slightest deviation will cause a noticeable change. Overexposure by the equivalent of one-half to one and one-half f-stop decreases color saturation and may be used for the creation of pastel color shades in the transparency.

Color monochromes are color photographs that consist largely of one color

in different shades of chroma and value, like the different color samples on a single card of a Munsell color solid. Telephotographs in color, for example, often turn out as virtual monochromes in blue. But whereas such monochromes are usually disappointing due to lack of contrast, color monochromes that are skillfully arranged and controlled—for example, in fashion photography—can be extremely striking, particularly if additional contrast is introduced into the color scheme by incorporating black and white.

Black and white play an important role in color photography. They enable a photographer to give his picture a high-contrast effect without having to pay the penalty in the form of light colors that are overexposed and dark colors that are underexposed; since contrast is now provided by black and white, the photographer can limit his colors to those of medium brightness. And because it is impossible to underexpose black or overexpose white, exposure can be calculated accurately for best possible rendition of color. White, incidentally, is the "color" most difficult to reproduce accurately in a color photograph since even the slightest suggestion of a color tint destroys the impression of "whiteness."

Color by association. Many colors have specific connotations which sometimes can be used to give a color photograph additional impact and significance. For example:

Red is the most aggressive and advancing color of the spectrum, active, exciting, and therefore widely used for advertisements, book jackets, and posters. It suggests blood and flames and is associated with danger (warning signals are usually red). It is also the symbol of revolution, violence, and virility (we speak of "red-hot" temper and "red-blooded Americans").

Blue, at the opposite end of the spectrum from red, is the most passive and receding of all colors, restful, remote, and "cool." We speak of a "blue" mood, and the French have their *l'heure bleue,* the blue hour of dusk, a time of relaxation. One has "the blues"—one feels low, the opposite of excited, as in "He saw red."

Yellow has two connotations: it is associated with pleasant feelings—the sun, warmth, cheerfulness, and spring (yellow baby chicks and daffodils)—but also suggests cowardice and disease (someone is said to have "a yellow streak," he is "yellow-bellied"; the yellow flag of quarantine, the yellow color of a sick face).

Orange, the color between yellow and red, is "hot," somewhat less hot in

feeling than red but hotter than yellow, which is only a "warm" color. Orange brings to mind pumpkins, witches, and our celebrations of Thanksgiving and Halloween.

Brown suggests earthiness and the soil, autumn and falling leaves, tranquility, serenity, and middle age; someone is in "a brown study."

Green, the dominant color of nature, is the least "artificial" of all colors. It seems neither aggressive nor passive, neither hot nor cold, neither advancing nor receding; it is neutral without being dull.

Violet is either mildly active or passive depending on its red or blue content: as purple (high red content) it is often associated with the Roman Catholic Church and royalty; as lavender (high blue content) it suggests old ladies.

White is the color of innocence, and **black** is the color of death.

Three different approaches to color

Experienced photographers know that there are no infallible "rules" for the production of good color photographs; that the color experience is subjective and, consequently, what pleases one person may leave another cold; that "accurate" color rendition is not necessarily equivalent with "good" color photography; and that a picture may be rejected as "unnatural" precisely because its color is "true." However, although no single infallible approach to color photography exists, experience has shown that color rendition may be accepted as "good" for three different reasons:

> **Color rendition appears natural** but may not be accurate
> **Color rendition is accurate** but may not appear "natural"
> **Color rendition is effective** but obviously "unnatural"

Color rendition appears natural but may not be accurate. Subject color in the transparency will appear natural if it matches the color of the subject "as remembered," which usually means as it appeared in standard daylight. In addition to correct exposure, the main prerequisite for a natural-appearing rendition is that the spectral composition of the illumination is identical with that of the light for which the respective color film is balanced. If it differs, the appropriate light-balancing or color-compensating filter must be used. If the color of the incident light is wrong in regard to the color film and a corrective filter is not used, or cannot be used, it is not possible to make a natural-

p. 85

pp. 67, 68

318

appearing color rendition as defined above with positive (reversal) color film. If negative color film is used, however, the effects of fairly large deviations from the recommended illumination can be successfully corrected in printing.

Light-sources which are strongly deficient in any part of the spectrum cannot be "corrected" with the aid of filters and made to yield "natural-appearing" color photographs; the most common are: mercury-vapor illumination, daylight after sunset, certain types of fluorescent lamps, mixtures of daylight and fluorescent light, and underwater light without auxiliary illumination.

To produce a natural-appearing transparency, it may become necessary to "falsify" subject color. As mentioned earlier, photographed in the shade of a large tree, a face would acquire a greenish tint. Although this color would be true to reality because it would match the color of the face at the moment of exposure, it must be corrected with the aid of a reddish color-compensating filter—that is, *falsified*—to make the face appear as we remember it, in other words, as it would have appeared in "white" light. In this connection, it is interesting to note that most people prefer in a tranparency, and deem more "natural," skin tones that are somewhat more yellowish than the actual pinkish or reddish tones of the original—further proof of the "subjectivity" of our way of seeing.

Whether or not a color photograph *appears* natural depends, of course, to a large extent on the personal judgment of the observer, and pictures that are accepted by one may be rejected by another. To the untrained eye, a shadow that is even slightly blue may seem "unnatural," and color renditions that experienced photographers, observant persons, and those with artistic training accept as natural may appear exaggerated and "false" to others.

Natural-appearing color rendition is particularly desirable in scientific and utilitarian photography, in copying, portraiture, and in photographing people.

Color rendition is accurate but may not appear "natural." Subject color in the transparency matches the color of the subject as it appered at the time of the exposure. Example: the "green" face photographed in the shade of a large tree. This approach to color preserves the identity of the occasion by accurately reflecting the conditions which existed when the picture was made. It represents a welcome relief from standardized "natural-appearing" color and gives a better idea of the immense diversity in regard to light and color of our world.

Accurate color rendition usually (but not infallibly) results if photographs in daylight and outdoors at night are made on daylight-type color film without benefit of filters of any kind, and indoor photographs in incandescent light on Type A or Type B color film, again without benefit of filters. However, as indicated above, because of the particular spectral response of color film, color rendition may not always match accurately the colors of the subject as we saw them at the time of exposure. Occasionally, if a photographer feels that a slightly more natural-appearing color rendition would be in the best interest of the picture, he can use a filter which *partly* corrects the light and makes the subject appear somewhat less unusual yet still manages to preserve the typical character of the illumination—for example, the yellowish warmth of ordinary incandescent light.

Accurate color rendition is particularly desirable in documentary photography and reporting since it provides a factual basis for a more objective evaluation of the depicted subject or event.

Color rendition is effective but obviously "unnatural." Subject color in the transparency is thought-provoking and significant although obviously neither natural-appearing nor accurate. As an example, I'd like to mention a picture I once saw, the color photograph of a snow scene in which the sky was a deep and velvety purple, creating an imaginative fairy-tale scene of great power.

Whereas it is easy to lay down rules for natural-appearing color rendition and possible to give advice for accurate color rendition, it is hopeless to tell a photographer how to create *effective* color photographs that are beyond naturalness and accuracy without looking contrived or gimmicky—sorry examples of effect for effect's sake. However, the following suggestions might provide some starting points:

Shoot smack into the source of light and hope that the resulting flare and halation will produce patterns that effectively symbolize the intensity and brilliance of direct light.

Use CC filters to change the color of the illumination in accordance with the spirit and mood of the subject or event. Usually such overall tints are most effective if they are subtle; the mood-creating color should be sensed rather than seen.

Use colored gelatins in front of photo lamps. Whereas a filter in front of the lens tints the entire photograph, filters in front of individual lamps (Roscoe Theatrical gels) enable a photographer, if necessary, to treat the illumination

of different areas differently. The advantage of this method is that by limiting the effect of colored light to certain sections of the picture, natural-appearing and fantastic color can be used side by side. For example, the foreground of a scene might be rendered moody and blue, the middle distance "natural," and the background rosy and gay. In this respect, the more white a subject or scene contains, the greater the potential of artificially colored light.

Combine different types of light. For example, in conjunction with daylight-type color film, use daylight (window light, or blue flash or blue photoflood illumination) and incandescent (tungsten) light together, but *do not mix* these different types of light. Instead, use each to illuminate its own section of the picture with the least possible overlap. Notice that one type of light appears blue and "cold," the other yellow and "warm." Use this difference between warm and cold color creatively, for example, to symbolize the "coldness" of outdoors (as seen through the windows) and contrast it with the warm and cozy feeling of the interior space.

Use actual colors (not only colored light) to symbolize mood and feelings. In motion pictures, Antonioni painted automobiles, buses, houses and entire sections of a street in strong colors to achieve specific effects. On a smaller scale—in the studio, at home, in a tabletop arrangement—anybody can do similar things. Or drape your model in brilliant colors, or subtle colors, as the case may demand, combine colors for harmonious—or clashing!—effects, invent, imagine, dream. The field of creative photography is unlimited and offers exciting opportunities to anyone who dares to "break the rules."

Color rendition in terms of black and white

Although black-and-white films automatically translate color into shades of gray, the form which this translation takes is not unalterable; it can be controlled by the photographer. Such control may be desirable for one of the following reasons:

To increase the accuracy of color translation. As mentioned before, all black-and-white films are overly sensitive to blue and all orthochromatic films are insensitive to red. All panchromatic films are somewhat less sensitive to green than to other colors, and some are overly sensitive to red. As a result, there is as yet no black-and-white film that automatically translates all colors into shades of gray that match in brightness the brightness of the colors they represent. Consequently, if color has to be translated into gray shades of

precisely corresponding brightness, the photographer must control the trans-
lation by using panchromatic film in conjunction with the right correction filter.

To improve tonal separation. Colors different in hue (for example, red and green) but similar or equal in brightness (light red and light green), which appear well differentiated to the eye, may be rendered as similar or equal shades of gray in an uncontrolled black-and-white photograph. As a result, objects of different colors that appeared well differentiated in reality might merge and their outlines be lost. To prevent this, color translation must be controlled with contrast filters.

The following chart, which applies only to *panchromatic films*, lists the more important filters used in black-and-white photography together with their uses and factors which, however, are only approximate inasmuch as they have to be modified in accordance with the filter manufacturer's instructions.

Filter	Principal purpose	Factor
Light yellow	The effect of this filter is so slight that I consider it useless for all normal purposes.	1½ × (open up ⅔ stop)
Medium yellow	A good all-around filter which slightly darkens a blue sky, slightly lightens green foliage, and slightly reduces the veiling effect of haze.	2 × (open up 1 stop)
Dark yellow	The effect is similar to that of a medium yellow filter but more pronounced. This filter makes skin tones appear somewhat too light.	3 × (open up 1⅓ stop)
Light green	Slightly lightens green foliage, slightly darkens blue sky. If filtration is required, this is the best filter for close-ups of people because it does not make skin tones appear too light.	4 × (open up 2 stops)
Red	Strongly darkens blue sky and reduces veiling effect of blue haze. Excellent for long-distance views and aerial photographs. Unsuitable for close-ups of people because it renders skin tones much too light, producing a chalky appearance.	8 × (open up 3 stops)

The following table lists the filter factors that apply to Kodak Wratten

Filters in conjunction with most *panchromatic* films. Filters made by other manufacturers may have slightly different factors; consult the instruction slips that are packed with each filter.

Filter color	Light yellow	Medium yellow	Light green	Medium green	Orange	Medium red	Deep red	Blue
Wratten designation	K1	K2	X1	X2	G	A	F	C5
Filter factor — sunlight	1.5	2	4	5	3	8	16	5
Filter factor — tungsten	1.5	1.5	3	4	2	4	8	10

The next table shows the relationship between exposure factor and diaphragm stop. The figure below each factor indicates *the number of stops the diaphragm must be opened* when a filter of this factor is used, if underexposure is to be avoided:

Filter factor	1.2	1.5	1.7	2	2.5	3	4	5	6	8	12	16
Open diaphragm by the following number of f-stops	$\frac{1}{3}$	$\frac{2}{3}$	$\frac{2}{3}$	1	$1\frac{1}{3}$	$1\frac{2}{3}$	2	$2\frac{1}{3}$	$2\frac{2}{3}$	3	$3\frac{1}{3}$	4

If the filter factor is very high, it is often advisable to divide the required exposure increase between the f-stop and the shutter speed settings. For example, if the required exposure without a filter is, say, 1/100 sec. at f/16 and the filter has a factor of 8, instead of opening the diaphragm 3 stops and exposing 1/100 sec. at f/5.6 (which might make the zone of sharpness in depth unacceptably shallow), or shooting 1/12 sec. at f/16 (which might cause unsharpness through camera or subject motion), the photographer can "split the difference" and expose 1/50 sec. at f/8 or 1/25 at f/11. The easiest way to find the best equivalent combination of diaphragm stop and shutter speed is with the aid of the exposure meter: if the meter-indicated dial setting is reduced by the respective number of f-stops, any indicated combination of f-stop and shutter speed will automatically take the filter factor into consideration and yield a correctly exposed negative.

The working rules for the use of these filters have already been given. This

information, however, is useless unless one has a feeling for color and color effects—when to make a certain color lighter and when to translate it into a darker shade of gray. If two colors are different in hue but equal (or very similar) in brightness, the best effects are usually achieved if the more active, aggressive, and warmer color is rendered as a lighter shade of gray and the more passive, receding, and cooler color is rendered as a darker shade of gray.

Active, aggressive and warm colors	Neutral colors	Passive, receding, and cool colors
red	green-yellow	blue-green
orange	green	blue
yellow	magenta	violet

CONTRAST

Satisfactory subject rendition can only be expected if the subject contrast does not exceed the contrast range of the film. Therefore, an awareness of contrast is just as important for the making of good photographs as an awareness of light and color.

Contrast is the difference in brightness between the lightest and darkest parts of the subject. If contrast is too high, simultaneous correct exposure of both the lightest and the darkest parts of the subject within the same negative or color transparency is impossible. Either the brightest areas will be overexposed, or the darkest areas underexposed. In practice, control of contrast is desirable for the following reasons:

To produce transparencies or prints of normal contrast range. If subject contrast is too high or too low, contrast must be controlled. Contrast is most often too high in subjects photographed in bright sunlight at distances of less than 15 feet, too low in most long-distance telephotographs, aerials, and pictures made in very dim light.

To increase graphic impact by rendering the subject either more or less contrasty than it would normally have been rendered.

In color photography to avoid situations where subject contrast is so high that simultaneous satisfactory rendition of the lightest and darkest colors is impossible.

Contrast control can be exercised at three levels:

> By influencing the **contrast of the subject**
> By influencing the **contrast of the negative**
> By influencing the **contrast of the print**

Contrast control at the subject level

Usually, the only practical way to control the contrast range of the subject is with light. In daylight one can either wait until the illumination is suitable or, if the subject is relatively close and not too large, reduce its contrast with auxiliary fill-in illumination. Indoors, subject contrast can easily be controlled by controlling the brightness, distribution, and light-to-subject distance of the lights.

Subject contrast is the product of two factors: lighting ratio and reflectance (reflected-light) ratio. For example, let's assume we have to photograph a painting illuminated by perfectly even light, perhaps outdoors in the sun. To check the *lighting ratio*, we must use a *gray card*, hold it flat against the painting in different places, and take meter readings which, in this particular case, will be identical: lighting ratio—that is, the ratio between the parts of the painting that received maximum and minimum illuminations—is 1 : 1 since lighting was assumed to be uniform, which means that all parts of the subject receive equal amounts of light.

However, if we take a second set of meter readings, this time *without* benefit of a gray card, by measuring directly the brightness of the lightest and darkest colors of the painting, the values which we'll get will, of course, be different, representing the reflectance ratio of the subject (that these will be *true* reflectance values was assured by our initial assumption that all parts of the subject received equal amounts of light). Let's assume that the highest reading is 2½ stops higher than the lowest, corresponding to a reflectance of 2½ : 1. Now, since subject contrast is the product of lighting ratio and reflectance ratio, in this case, since lighting ratio was 1 : 1, subject contrast would be 2½ : 1 which is still well within the limits for satisfactory black-and-white and even color rendition.

If the subject is not flat but three-dimensional, matters are slightly more complicated since spatial characteristics introduce a new element—shadow—which, of course, influences the lighting ratio. As an example, let's

take the case of an indoor portrait that is to be made with the aid of two photo-lamps of *equal wattage* (this is a "must" for our demonstration), a main light and a fill-in light. These lamps should be placed at *equal distances* from the subject: the main light at an angle of approximately 45 degrees to the subject-camera axis, and the fill-in light as close as possible to the camera.

Lighting ratio (this is the difference between the maximum and mimimum amounts of light that illuminate the subject—the span from highlights to shadows). Under the above assumed conditions, subject areas illuminated by *both* lamps receive *twice* the light that areas in the shadows cast by the main light receive which are illuminated by only *one* lamp, the fill-in light. Under these conditions, the lighting ratio is 2 : 1. In relation to the fill-in light, if the main light were placed at *half the distance* from the subject, it would throw *four times more light* on the subject than the fill-in light does, since the brightness of illumination is inversely proportional to the square of the distance between subject and light source. In such a case, the subject areas illuminated by *both* lamps would receive *five* units of illumination and the shadows still receive only one; consequently, in that case, the lighting ratio would be 5 : 1.

Reflectance ratio (this is the difference in brightness between the lightest and darkest colors of the *uniformly* illuminated subject). To establish the reflectance ratio, *uniformly* illuminate the entire subject with shadowless front light. Check the evenness of the illumination by taking meter readings off a Kodak Neutral Test Card held at different positions within the picture areas and be sure that all the readings indicate the same value; if they don't, arrange the illumination accordingly. Then, *disregarding black and white*, measure the reflectance of the lightest and darkest subject colors with the light meter. Let us assume that you find a ratio of 4 : 1—that is, that the lightest color reflects four times as much light as the darkest. This ratio of 4 : 1 would represent the reflectance ratio of the subject.

Subject contrast (this is the product of lighting ratio and reflectance ratio). In our example, in which the lighting ratio was 2 : 1 and the reflectance ratio 4 : 1, the lightest colors of the subject, which are illuminated by both lamps, were 4 times as bright as the correspondingly illuminated darkest colors, and 2 x 4, or eight times as bright as the darkest-colored parts of the subject, which received their illumination only from the fill-in light. Therefore, the subject contrast ratio would be 8 : 1.

In color photography, for natural-appearing color rendition, the lighting ratio of subjects with average reflectance ratios should normally not exceed 3 : 1.

326

However, if the subject reflectance ratio is lower than average—that is, if *all* the subject colors are *either* light, or medium, or dark, and therefore light and dark colors do not occur together, the lighting ratio can be increased to 6 : 1 without subject contrast exceeding the contrast latitude of the color film. In this respect, transparencies intended primarily for viewing and projection can stand a somewhat higher contrast ratio than transparencies from which prints or four-color engravings are to be made.

The f-stop substitution method. A simple way for calculating lighting contrast ratios in portraiture and other fields of near-distance photography in conjunction with a lighting scheme in which two identical photo lamps function as a main light and a fill-in light, respectively, is to think of lamp-to-subject distances in terms of f-stop numbers. This concept works because the inverse-square law applies equally to f-stop numbers and lamp-to-subject distances. p. 261 For example, if the f-stop number is *doubled,* say from f/4 to f/8, a photographer must expose at f/8 *four times* as long as at f/4 if the color rendition in both transparencies is to be the same. Similarly, if the subject-to-lamp distance is *doubled,* say, from 4 feet to 8 feet, exposure at 8 feet must be *four times* as long as at 4 feet if the color rendition in both transparencies is to be the same because at twice the subject distance the effective brightness of any (point-type) light source is only one-fourth. Accordingly, it is possible to establish specific lighting contrast ratios by thinking of the lamp-to-subject distances of the main light and the fill-in light in terms of f-stop numbers and comparing the differences. Utilizing this concept, we arrive at the following table:

Equality of f-stop numbers is equal to a 2 : 1 lighting contrast ratio
a 1-stop difference is equivalent to a 3 : 1 lighting contrast ratio
a 1½-stop difference is equivalent to a 4 : 1 lighting contrast ratio
a 2-stop difference is equivalent to a 5 : 1 lighting contrast ratio
a 2½-stop difference is equivalent to a 7 : 1 lighting contrast ratio

To give an example, let's go back to our first setup, in which main and fill-in lights were placed at equal distances from the subject, say, each 8 feet. Seen in terms of f-stop numbers, this would correspond to f/8 and f/8 for the two lights—that is, equality of f-stop numbers, corresponding to a lighting contrast ratio of 2 : 1 (which of course, is the same value as that at which we originally arrived).

Next, let's see how well our second example, in which we placed the main light

at *half the distance* from the subject as the fill-in light, fits in with our new formula. Half the distance of 8 feet is 4 feet or, seen in terms of f-stop numbers, equivalent to f/8 and f/4, a difference of two full stops (f/4—f/5.6—f/8). According to both the above table and our previous demonstrations, such a main light to fill-in light distance ratio corresponds to a lighting contrast ratio of 5 : 1. The same result would, of course, have been accomplished if the main light had been placed at a distance of 5.6 feet and the fill-in light at 11 feet, or 8 and 16 feet, respectively, or X and 2X feet—because in all these cases the difference in terms of f-stops would have been equivalent to two full stops.

Conversely, of course, any desired lighting contrast ratio can be established on the basis of the following table:

Desired lighting contrast ratio:	2 : 1	3 : 1	4 : 1	5 : 1	6 : 1
Fill-in light distance factor:	1	1.4	1.7	2	2.2

To establish the desired lighting contrast ratio, place the main light at the most advantageous distance from the subject. Multiply this distance in feet by the fill-in light factor which, according to the above table, corresponds to the desired lighting contrast ratio, and place the fill-in light at this distance from the subject, as close as possible to the subject-camera axis. Note, however, that both *these tables apply only if identical lamps in identical reflectors are used for the main light and the fill-in light,* whether they are photoflood lamps, flashbulbs, or electronic flash. Incidentally, this "f-stop substitution method"

p. 283 does not preclude the use of an accent light or a background light as described before, since neither one has an effect upon the lighting contrast ratio of the subject.

How to control contrast outdoors

In bright sunlight, the contrast range of nearby subjects frequently exceeds the contrast latitude of film. To avoid the possibility of inky shadows and burned-out highlights, photographers have three ways to reduce excessive contrast:

p. 262 **Front light.** As mentioned before, frontlight casts proportionally less shadow than light from any other direction ("pure" frontlight—for example, light emitted by a ringlight, an electronic flash tube encircling the lens—is completely shadowless and therefore particularly well suited for shadow fill-in);

328

consequently, frontlighted subjects *appear* generally less contrasty than side- or backlighted subjects—the reason manufacturers of color films generally recommend shooting color pictures "with the sun looking over your shoulder." Although this appearance is often illusory—contrast between illuminated and shaded areas may very well be just as great as in sidelighted views—the actual shadow areas are proportionally so small that they seem insignificant in comparison with the well-lighted areas of the subject, which can easily be rendered in natural-appearing color. Therefore, unless other considerations prevail—perspective, depth-illusion through light and shadow, need for good texture rendition, or simply the impossibility to shoot in frontlight—choosing frontlight instead of light from another direction is often the easiest way to satisfactory color rendition.

Reflectors. Complete contrast control of outdoor subjects at a distance up to 10 feet is possible with the aid of suitable reflectors which permit a photographer to lighten inky shadows with reflected sunlight. Unlike flash as a provider of fill-in light, reflectors have the great advantage that one can see the result *before* the picture is taken and, if necessary, make the appropriate adjustments in distance and direction which may be required to reduce contrast without eliminating it entirely—excessive shadow fill-in is the most common fault of pictures made with the aid of daylight-flash.

The most effective reflectors consist of thin plywood boards covered with crinkled aluminum foil; they should not be smaller than approximately 20 x 30 inches. But reflectors can consist of almost any white material (colored material would reflect colored light upon the subject and might cause a color cast)—white cardboard or paper, a bed sheet, a towel, a handkerchief, a whitewashed wall . . . and on the beach, of course, clean sand; although sand is usually slightly colored, the warm yellowish light reflected by it will only enhance the warm glow of suntanned skin and provide excellent shadow fill-in.

Daylight-flash. Since the purpose of fill-in illumination is to bring subject contrast into balance with the contrast latitude of the film, the flash intensity must be related to the brightness of the main light—outdoors: the sun. The problem is to lighten shadows sufficiently to bring out detail and color without destroying the effect of sunlight through overlighting the shadows. Fill-in illumination that is too strong obliterates all shadows, causes the subject to appear as flat as if only frontlight had been used and, since the range of the flash is limited and exposure adjusted for flash, often shows the subject unnaturally light in front of an unnaturally dark background.

To find the correct exposure, take an overall brightness reading of the subject and set the diaphragm aperture and shutter speed accordingly. To find the correct distance between the subject and the fill-in flash, use the guide number for the particular combination of flashbulb or speedlight, film type, and shutter speed, and divide it by the f-stop number to be used. For example, the light-meter reading chosen is 1/100 sec. at f/16. The flash guide number is, say, 80. To find the flash-to-subject distance, divide 80 by 16 (the f-stop number) and get 5 as the result. Placed at this distance from the subject, the flash would, however, *produce a fully exposed* negative or color transparency devoid of shadows. This, of course, is not what is wanted, and to retain part of the shadow effect of the sunlight, flash intensity must be reduced accordingly. This can be done either by increasing the distance between flashbulb and subject by 50 to 100 percent, or by draping one or two thicknesses of a white handkerchief over the reflector. Some photographers prefer to fill in shadows to a higher degree than others, and each must establish his own formula by test.

Contrast control at the negative level

In black-and-white photography the contrast range of the negative can be controlled with the following means and techniques which have previously been discussed in detail. The greatest changes in contrast are, of course, achieved by combining several of these methods.

p. 77 **Choice of film.** To decrease subject contrast use a film with soft gradation. To increase contrast use a film with hard gradation. An almost pure black and pure white rendition can be made by photographing the subject on high-contrast film such as Kodalith.

p. 144 **Choice of developer.** Rapid and high-contrast developers produce negatives of harder gradation, and fine-grain developers produce negatives of softer gradation than standard developers.

Exposure in conjunction with development. Increasing the exposure beyond the meter-indicated value and developing the film for a shorter than normal time leads to negatives of softer than normal gradation. Conversely, the contrast of the negative can be increased by shortening the exposure and prolonging the time of development. Exposure increases of 500 percent and decreases of 50 percent from standard, and development increases of 100 percent and decreases of 30 percent from standard, are normally the boundaries within which extreme though still satisfactory results can be expected.

Choice of filter. Contrast in the black-and-white negative can usually be increased through use of the appropriate contrast filter. Only occasionally will it be desirable to decrease contrast. For example, in copying a document or photograph stained by yellow or reddish-brown spots, if a red filter and panchromatic film are used such stains will not appear in the print unless they are unusually dark.

p. 65

Copying. Maximum contrast increases can be achieved by producing a diapositive by contact-printing or enlarging the negative on high-contrast film such as Kodalith and contact-printing the diapositive on Kodalith film to produce a second negative. This negative will be so contrasty that prints made from it will consist entirely of black and white and resemble woodcuts.

Masking. Maximum reduction of contrast is achieved by masking. To make the mask—a low-contrast diapositive—contact print the negative on film of soft gradation. To facilitate registration of negative and diapositive in making the final print, diffuse the diapositive image slightly by inserting a Kodapak Diffusion Sheet between the negative and the film before contact-printing. By appropriate adjustment of exposure and development, a diapositive of any desired contrast gradient can be produced. The more the contrast of the original negative must be reduced, the more contrasty the diapositive mask must be. After the diapositive is dry, to further increase diffusion *tape it in register to the base side of the negative* and enlarge the "sandwich" as you would enlarge an ordinary negative. This method of contrast reduction can be used with both black-and-white and color negatives.

Contrast control at the print level

The contrast range of a print can be changed with the following means and techniques which have previously been discussed in detail:

Paper gradation selection. To increase contrast, print the negative on paper of hard gradation. To preserve the contrast of the negative, use a paper of normal gradation. To decrease contrast, print the negative on paper of soft gradation. For photographers who use negative color film, Agfa offers Agfa-color paper in two different gradations.

p. 149

Dodging. As noted earlier, contrast can be controlled on a local scale during enlarging by "burning in" and "holding back" negative areas that are respectively too dense or too thin. This method is normally used to reduce contrast but it can, of course, also be used to increase contrast in the print. It is applicable to both black-and-white and color photography.

p. 173

331

p. 173 **Deviations** from normal procedure in exposing and developing the print previously described can be used to change overall contrast as well as contrast on a local scale.

SPACE AND DEPTH

Creating an illusion of space in a photograph is easy; creating *the right kind* of space illusion may require some work and thought. Anybody who ever photographed a heroic landscape and ended up with a picture in which the grandeur of the scenery was lost; anybody who tried to convey the feeling of rush-hour traffic jamming a downtown street and found himself with a picture of six people blocking the view; anybody who attempted to capture the spatial experience of a great architectural work and got only a picture of a building with leaning walls—anybody who has ever had such an experience knows what I am talking about: although, when photographing a three-dimensional subject, it is impossible *not* to get some kind of space-impression in the picture, this chance-presented space-impression is frequently inadequate to tell the *whole story convincingly*. The desired effect can be achieved only if the photographer carefully and knowingly chooses those space symbols which are best suited for translating his intentions, his feelings, into graphically expressive forms. This is so because "depth" cannot be rendered directly within the two-dimensional plane of a photograph but can only be indicated symbolically. The symbol of depth is contrast between near and far; in terms of photography, this contrast can be expressed in several forms:

contrast between **light and shadow**
contrast between **large and small**
contrast between **sharp and unsharp**
contrast between **light and dark**

Contrast between light and shadow

Take any flat surface and hold it up to the sun. You'll find it impossible to destroy the "flatness" and evenness of the illumination or to cast a shadow on this surface without interposing a second object between surface and sun; but by this very act you already introduce an element of spatiality into the setup. What we can learn from this experiment is this: an even illumination suggests flatness and two-dimensionality; an uneven illumination—a combination of

332

light and shadow—is graphic proof of three-dimensionality: depth, volume, space.

I have already discussed the function of light as a symbol for space and depth but will add the following: symbolically, light is positive, aggressive, advancing, and implies convexity; conversely, shadow is negative, passive, receding, and implies concavity. p. 282

The standard of light is the sun—a single light-source positioned overhead casting a single set of parallel shadows in the direction of the ground. Consequently, any lighting scheme employing multiple light-sources casting several sets of shadows pointing in different directions, as well as any light-source pointing upward and illuminating the subject from below, will *ipso facto* appear artificial and often "unnatural." Such lighting schemes must therefore be used with particular discrimination and skill.

As a rule, predominance of shadow over light within the picture area creates a stronger spatial effect than the reverse. It is for this reason that backlighted photographs generally produce particularly strong impressions of depth. The explanation of this phenomenon probably goes back to the fact that uniformity of illumination suggests "flatness"—two-dimensionality, absence of depth; that shadows suggest three-dimensionality and depth; and that abundance of shadows is equated with abundance—that is great extent—of depth.

Contrast between large and small

A nearby person appears larger than a person farther away, while a person far in the distance appears minute. It is this phenomenon called *diminution* which forms the basis of *perspective*—that is, the representation of three-dimensional objects with two-dimensional means.

The essence of perspective is *distortion*. Whatever we look at, and no matter how we do so, with very few exceptions we see things distorted. A nearby person appears larger than the same person farther away. Looking along a railroad track, the ties appear to diminish with distance and the rails seem to converge; this also is distortion because, actually, all the ties are, of course, equally long and the rails are parallel. Seen at an angle or, as we say, "in perspective," a wheel appears elliptical and a window as a trapezoid; this, too, is distortion because, in reality, wheels are round and windows rectangular. And so on.

Now, some readers might object and maintain that, as far as they are concerned, most photographs appear distortion-free because they show things as we see them, and that "distortion" is a phenomenon restricted to pictures taken with the more extreme kinds of wide-angle lenses. They are wrong. Without exception, all renditions of three-dimensional objects by two-dimensional means are "distorted," and the difference between a "normal-appearing" picture and one in which objects appear "distorted" is only a difference of degree—some forms of perspective involve higher degrees of distortion than others.

p. 51 The explanation of why most photographs appear distortion-free is that they were made with lenses of standard focal lengths which, as far as "perspective" is concerned, produce images that closely resemble those produced by our own eyes. This, of course, does not imply that they are distortion-free—it merely means that we are so familiar with this particular form of distortion that we are no longer aware of it. A truly distortion-free rendition is possible only if the depicted subject is two-dimensional and flat, and if its position relative to the camera is such that it is parallel to the plane of the film. For example, photographed head-on, a painting or a stone wall not only will *appear* distortion-free, but also *be* distortion-free; right angles will be rendered as right angles, and parallel lines will be rendered parallel. But if parallelity between subject and film is disturbed—that is, if the photographer tilts or turns his camera and takes the picture "at an angle," be it ever so slight—depth becomes involved and will manifest itself in the photograph in the form of distortion: right angles will no longer measure 90 degrees, and actually parallel lines will converge.

By now, two things should be obvious: (1) Only a two-dimensional and flat subject can ever be rendered distortion-free in a photograph, and only if it is parallel to the plane of the film. (2) Only one side of a three-dimensional subject can be rendered distortion-free in a photograph, and this only if it is flat and in such a position that it is parallel to the plane of the film; the other sides, seen "in perspective"—that is, in terms of receding lines and planes—*must* appear distorted. However, the form which this distortion will take—the degree of diminution, the extent of foreshortening, and the angle of con-vergence of actually parallel lines—is subject to the photographer's control.

Rectilinear perspective

When we speak of "perspective," we usually think of rectilinear perspective and not of cylindrical or spherical perspectives, two other forms which will be

334

discussed later. Rectilinear perspective occurs in two forms, academic and p. 346 true. Here are the rules of academic rectilinear perspective:

1. All straight lines must be rendered straight.

2. All two-dimensional forms parallel to the plane of the film are rendered distortion-free. For example, parallels are rendered parallel, circles are rendered round, angles are rendered in their true forms.

3. All actually parallel lines which are not parallel to the plane of the film, *with the exception of verticals,* converge toward vanishing points. If such receding parallels are horizontals, their vanishing points are located on the true horizon, whether or not the horizon appears in the photograph.

4. All vertical lines must appear vertical and parallel in the picture.

True rectilinear perspective is identical to academic rectilinear perspective in regard to points one, two, and three; it differs in regard to point four: verticals are rendered parallel *only* if they fall under point two. If the film is *not* parallel to the verticals—that is, if the camera is tilted either upward or downward—verticals must converge in the picture. Although this convergence may seem "unnatural" and be objectionable in the photograph, it is nothing but the perfectly natural manifestation of perspective in the vertical plane. If unwanted, this phenomenon can be avoided by proceeding as follows:

Control of vertical lines on the film. To preserve parallelity of vertical lines in the transparency, the film inside the camera must be parallel to the vertical lines of the subject. This condition is fulfilled if the photograph is made with the camera in level position. Unfortunately, if the subject is a building and the picture taken from street level, the consequence of this basic condition is often that the top of the building will be cut off in the photograph and the foreground appear unproportionally prominent. On the other hand, if the camera is tilted, the top of the building would be included and the amount of foreground reduced but vertical lines would converge in the picture. The only way to achieve satisfactory results is to use a view-type camera *equipped with a rising front and a lens of sufficient covering power,* or a 35-mm SLR camera equipped with a Nikkor PC (perspective control) or Schneider PA-Curtagon lens, and proceed as follows:

If a 35-mm SLR camera equipped with a Nikkor PC-lens or a Schneider PA-Curtagon lens is used, the shot can be made hand-held; if a view-type camera is used, the camera must be mounted on a tripod because after all the adjustments are made the viewfinder image no longer coincides with the image

registered on the film. Tilt the camera upward until the entire subject is included in the view and focus as usual, observing the image on the groundglass: the vertical lines will converge toward the top of the picture. To avoid this, tilt the camera forward until it is level.

In this position, the vertical lines will appear parallel, but the top of the building will be cut off and the foreground appear excessively prominent. To correct these shortcomings, without altering the camera position in any other way, elevate the lens by raising the movable front of the camera (or the Nikkor PC or Schneider PA-Curtagon lens) until the entire building appears on the groundglass (or in the viewfinder). As long as the camera remains level, vertical lines will remain parallel.

Control of vertical lines in the print. Any negative in which verticals converge can be enlarged to restore verticals to parallelity in the print. How p. 172 this is done was described earlier.

Perspective control in two dimensions. Above we examined ways to control perspective in one dimension—height. If perspective must be controlled in two dimensions—height and width—the photographer must use a view-type camera equipped with a complete set of "swings"—individual front p. 42 and back adjustments—and a lens of more than average covering power. Here is a rundown of the functions of the different "swings":

The back-tilts and swings are primarily intended for controlling the "perspective" of the photograph, assuring, among other things, that vertical lines will be rendered parallel in the picture. In addition, this equipment can be used to p. 338 extend the zone of sharpness in depth in certain types of oblique views.

The front-tilts and swings control overall sharpness and, under certain conditions, can be used to extend in the picture the zone of sharpness in depth.

The vertical and lateral front and back adjustments (slides and rises) control the position of the image on the film.

Before a photographer attempts any kind of perspective control he must realize two things:

Only flat surfaces parallel to the plane of the film can be rendered distortion-free. Therefore the side of the subject that must be rendered distortion-free must be parallel to the film. This can be accomplished in one of three ways:

1. The camera must be positioned in such a way that it faces the subject "head-on"—that is, the lens axis must be perpendicular to the side of the subject that is to be rendered distortion-free.

2. The subject must be placed in such a way that the side which is to be rendered distortion-free is parallel with the film.

3. If neither 1 nor 2 is possible, parallelity between the side of the subject that is to be rendered distortion-free and the film must be accomplished by turning the swing-back of the camera accordingly, regardless of the direction in which the lens is pointed.

If neither one of these conditions can be fulfilled, distortion-free rendition in the film is impossible.

The lens must have sufficient—that is, more than average—covering power. p. 42 Otherwise, because the front of the camera may have to be adjusted in such a way that the lens axis no longer points at the center of the film, part of the film may be outside the sharply covered area and, as a result, the transparency may be either partly unsharp or blank. To avoid this, experienced photographers, instead of using a standard lens designed merely to cover the respective film size, use a wide-angle lens of similar or slightly longer focal length capable of covering the next larger film size, thereby making sure they have sufficient leeway for utilizing the full potential of their camera's "swings."

To familiarize himself once and for all with the principles and techniques of perspective control, I recommend that the interested reader who also owns a swing-equipped view-type camera set himself the task of photographing, for example, a large cereal box (or similar boxlike subject) in such a way that three of its sides are visible in the picture, one of which—the front—must be rendered distortion-free—that is, its vertical lines parallel, its horizontal lines parallel, and its angles 90 degrees. He should proceed as follows:

1. Mount your swing-equipped view-type camera on a tripod and position it to

show two sides of the subject—the box—and high enough to provide an oblique view of its top. Keep in mind that there are limits to perspective control and, if the side that is to be rendered distortion-free is positioned at too sharp an angle relative to the camera, mechanical and optical limitations will make it impossible to adjust the camera for complete correction of distortion. With the diaphragm wide open and the front and back adjustments in neutral position, center the image of the box on the groundglass.

2. Tilt the adjustable back of the camera backward until the film is parallel with the vertical lines of the box. In this position, the vertical lines of any subject will be rendered parallel instead of converging. The image will, of course, be partly out of focus; disregard this unsharpness temporarily.

3. Should any of the required camera adjustments result in an objectionable displacement of the image of the subject on the groundglass, *do not change the camera position*. Instead, center the image again by using the vertical (rising) and lateral (sliding) adjustments of the lens.

4. Swing the adjustable back of the camera laterally until it is parallel to the front of the box. In this position, the horizontal lines of the front of any subject will be rendered parallel instead of converging. In making this adjustment be careful not to upset the parallelity between the camera back and the vertical lines of the subject. The image will now appear very unsharp.

5. Refocus as best you can; then tilt and swing the lens to further improve overall sharpness. This is a delicate adjustment because only very small deviations from the neutral position of the lens are required. As adjusting the lens improves sharpness, keep on refocusing until you get the sharpest possible image. Although all these adjustments will not bring the entire depth of the subject into sharp focus, they will improve overall sharpness to a point where stopping down the diaphragm will be sufficient to produce a critically sharp rendition of the entire box.

How to extend the zone of sharpness in depth with the aid of "swings." An added bonus of camera swings is that they enable a photographer to extend enormously, without having to resort to undesirably small diaphragm apertures, the sharply covered zone in depth in *oblique shots of relatively flat subjects*. To learn how to take advantage of this I recommend the following experiment:

Mount your swing-equipped view camera on a tripod, tilt it forward at an angle of 30 to 40 degrees from the horizontal, place a few pages of newsprint

in front of it flat on the floor, and focus on a line of print more or less in the center of the test object. The line on which you focused will appear sharp, but the lines closer to the camera as well as those further away from it will, of course, appear blurred, increasingly so, the farther they are from the sharply rendered line.

Next, without changing the position of the camera itself, slowly tilt the adjustable back of the camera backward while observing the change on the groundglass. If the tilts of your camera are "on axis"—that is, if the pivoting points of the front and back are located at the height of the optical axis—you will observe that the entire area of the newspaper-covered floor will appear sharp without the need for refocusing or stopping-down the lens, as soon as a certain tilt-angle of the back has been reached. If the tilts of your camera are *not* "on axis," however—that is, if front and back pivot near the camera bed—you will have to refocus the lens while you tilt the back of the camera backward in order to achieve uniform overall sharpness. The back-tilt is correctly adjusted if imaginary lines drawn through the planes of the film, the diaphragm, and the subject, if prolonged, would meet in a common point, as shown in the following drawing:

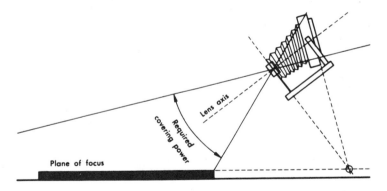

The same gain in sharpness can, of course, be achieved by tilting the lens forward instead of tilting the back of the camera backward, to the point where imaginary lines drawn through the planes of the film, the diaphragm, and the subject, if prolonged, would meet in a common point. This method must be used when the back of the camera must be kept vertical to render vertical lines within the picture area parallel in the picture instead of converging (for example, a building at the far end of a plaza the ornamental pavement of which is the subject proper of the photograph). However, in comparison with

the method described above, tilting the lens instead of the back of the camera has the disadvantage that it throws the lens axis off the center of the film, as shown in the following drawing:

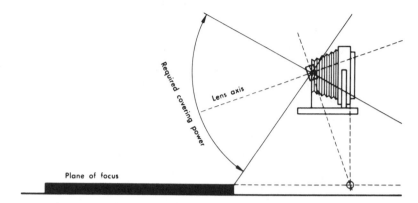

If the covering power of the lens is insufficient, this would cause partial unsharpness or vignetting in the photograph (vignetting manifests itself in the form of underexposed or completely blank corners in the picture). This danger can be avoided by raising the back of the camera and lowering the lens until the lens axis points again at the center of the film, as shown in the drawing below:

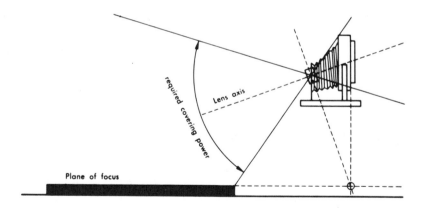

The flatter the subject that must be photographed obliquely, the better the method of extending the sharply covered zone in depth with the aid of a camera "swing" works. In this respect, of course, it makes no difference whether the subject is in a horizontal position (like a rug on a floor) or in a vertical position (like a bas-relief set into a wall) except that in the latter case

the back of the camera (or the lens) must be swung around a vertical axis instead of being tilted around a horizontal axis. As long as the camera is correctly adjusted, sharpness in the picture will extend all the way from the nearest to the farthest point.

If the subject is *not* entirely flat, however, or if parts of it project beyond the inclined plane to which the camera is adjusted, a certain amount of stopping-down the lens is required to bring such protruding parts into focus. But even in cases in which such additional stopping-down is necessary, the overall gain in sharpness achieved by using "swings" is so great that not only the entire depth of the subject can be rendered sharp with considerably less stopping-down than would otherwise be required, but subjects of such great extension in depth that they could never be covered sharply merely by stopping-down the lens can be rendered sharp in their entirety.

Perspective control in three dimensions. What we call "perspective" is the combined effect of four graphic picture aspects:

> **Scale of rendition**
> **Angle of view**
> **Angle of foreshortening**
> **Degree of diminution**

Virtually complete control over these aspects, and therefore over perspective itself, is possible through making the appropriate choice in regard to two factors:

> **Camera position**
> **Focal length of the lens**

Scale of rendition. The size of the image on the film, say, the height of a human figure, is controlled by two factors: subject-to-camera distance, and focal length of the lens. The shorter the distance between subject and camera, and/or the longer the focal length of the lens, the larger the scale of rendition; and vice versa. Consequently, if the subject appears too small in the viewfinder or on the groundglass, shortening the distance between subject and camera, or switching to a lens of longer focal length, or a combination of both, will increase the image size.

However, if the focal length of the lens is *relatively* short (wide-angle lens), shortening the distance between subject and camera may lead to excessive

"distortion." In such a case, switching to a lens of longer focal length is the better choice.

Angle of view. The angle of view included in a photograph is controlled by the focal length and covering power of the lens relative to the film size: the shorter the focal length, the greater the covering power, and the larger the film size, the larger the rendered angle of view. Other factors being equal, angle of view and scale of rendition are inversely proportional: making the photograph with a lens which encompasses an angle of view twice as large as that included by another lens, produces a picture in which the subject appears only half as large—more is shown, but what is shown is shown in smaller scale. Wide-angle lenses encompass large (60 to 100 degrees and more), standard lenses medium (45 to 60 degrees), and telephoto lenses small (30 degrees and smaller) angles of view. Some photographers make the mistake of confusing the effects of subject-distance and angle of view encompassed by the lens: increasing the subject-to-camera distance will, of course, include a proportionally larger part of actual scene in the picture; but unless the lens is also exchanged for one of different focal length, the angle of view will remain the same regardless of subject distance. The *only* way of controlling the angle of view in conjunction with a specific film size is through the focal length of the lens.

Angle of foreshortening. It makes a great difference whether we photograph, say, an automobile, from the side or in a three-quarter front view. In the first case, we would get a virtually distortion-free picture of the car whereas in the second case, seen "in perspective," the car would appear more or less "distorted" insofar as its front would be rendered larger than its rear. Furthermore, the first view would show only *one* side of the car, the second view, *two*. And if a third picture were made from the same angle but a higher vantage point than the second, it would show *three* different sides of the car—front, side, and top—the maximum number of sides of any three-dimensional object that can be shown within a single view. This aspect of perspective is controlled through appropriate choice of camera position relative to the subject.

Before a photographer makes this decision he should consider the following: Photographing a three-dimensional subject at an angle of view of 90 degrees to one of its principal planes (front, rear, right side, left side, bottom, top) has two important consequences: (1) the subject will appear virtually or completely distortion-free, and (2) it will appear relatively or entirely "flat."

Seen in a head-on view, a cube, for example, appears (1) distortion-free and (2) "flat"—that is, indistinguishable from a square, a two-dimensional form—because only one of its six sides would be visible. Photographed at an angle—shown in foreshortened form—however, it would acquire "depth" in the picture because two or even three of its six sides would be visible, making its three-dimensionality obvious. Its actually parallel edges would, of course, be rendered converging and its actually right angles more or less acute; but it is precisely this "distortion" which in the photograph creates the illusion of three-dimensionality—distortion is a symbol for "depth." Similarly, photographed "head-on" a circular form appears round—undistorted—and "flat"—lacking "depth." But seen "in perspective," or photographed "at an angle," a circular form will be rendered as an ellipse—that is, "distorted"; and it is precisely this "distortion" that creates the illusion of "depth." Here, as so often in photography, a photographer must make a choice: on the one hand, he has the choice of a "distortion-free" rendition; on the other, he can create an illusion of "depth." Unfortunately, these two picture aspects are mutually exclusive, although both are subject to the same control: appropriate choice of camera position relative to the subject.

Degree of diminution. We have learned that the scale of rendition is controlled by two factors: subject-to-camera distance, and focal length of the lens. I have also stated that ". . . if the subject appears too small in the viewfinder . . . shortening the distance between subject and camera, or switching to a lens of longer focal length . . . will increase the image size." This seems to imply that these two controls are interchangeable. They are— under certain conditions; other times they are not. For example: to reproduce a painting, it makes absolutely no difference whether we make the shot with a lens of 2-inch focal length from 6 feet away, or with a lens of 4-inch focal length from 12 feet away—the two photographs would be identical. And the reason they are identical is that, strictly speaking, "perspective" is not involved—there is no question of *diminution* because the subject has no "depth."

p. 341

When depth becomes involved to any noticeable degree, matters are somewhat different. For example: a photographer intends to photograph his wife standing in a plaza against a background of old historical buildings; the image of the figure should fill the height of the picture. His camera is equipped with a lens of 2-inch focal length, but he also has a 4-inch telephoto lens. He is going to make one shot from the appropriate distance with the 2-inch lens, then double the distance between wife and camera and make a second shot with the 4-inch lens. Under these conditions, both pictures would show the figure in

identical scale, but the "perspectives" of these two shots would be different. In the first picture, the buildings in the background would appear relatively small and insignificant; in the second, they would be almost twice as high and prominent as in the first. Why? Because now we are dealing with a subject that has "depth"—*diminution* is involved, and *the degree of diminution is controlled by the distance between the subject and the camera*. The two pictures were taken from different subject distances, and differences in subject distance cause differences in the rate of diminution which cause differences in the impression of "depth."

This brings us to one of the most consistently misunderstood aspects of space symbolization with photographic means: the fallacious assumption that changing the focal length of the lens will effect a change in the perspective of the picture. This is simply not true, and anyone willing to take the trouble to perform the following experiment can prove it: mount your camera on a tripod, set it up near a window and, without changing the camera position, take two shots down the street, the first with a wide-angle lens, the second with a moderate telephoto lens. Subsequently, project the two slides onto a large sheet of white paper in such a way that the scale of rendition is the same for both; then trace the outline of the main forms of the rendition with pencil on the paper screen. To do this you must, of course, project the wide-angle shot from a greater distance than the telephoto slide, and a considerable part of the image will fall outside the screen. However, that part of the wide-angle slide which corresponds to the view encompassed by the telephoto shot, if projected in identical scale, will exactly match the telephoto rendition in regard to scale, angle of view, angle of foreshortening, and degree of diminution. In other words, as far as *perspective* is concerned, there is absolutely no difference between the two. They are identical because they were made from the identical camera position; and it is the camera position which controls the "perspective" of the photograph. As long as the camera position remains the same, perspective remains the same, no matter whether a wide-angle, a standard, or a telephoto lens is used.

The typical wide-angle perspective is characterized by a high rate of diminution—that is, in the photograph, objects of actually identical size located at different distances from the camera are rendered in markedly different scale, with nearby objects appearing unproportionally large and distant objects appearing unproportionally small. This discrepancy becomes increasingly pronounced the wider the angle of view of the lens, the shorter the distance between subject and camera, and the greater the subject's depth.

344

Familiar examples of this kind of "distortion" are hands and feet extended toward the camera, which appear in the picture unproportionally large while the head and body appear unproportionally small. To the untrained eye, this kind of perspective appears unnatural and objectionable because it shows familiar things in unfamiliar forms. Actually, however, it is the natural manifestation of "nearness," expressed in the picture with graphic-symbolic means: excessive "distortion." Photographers who dislike this form of perspective can easily avoid it by photographing the subject from a greater distance with a lens of longer focal length.

The typical telephoto perspective is characterized by a low rate of diminution—that is, in the photograph, objects of actually identical size located at different distances from the camera are rendered with relatively small differences in scale. The rate of diminution decreases proportionally the longer the focal length of the lens and the greater the distance between subject and camera. Familiar examples of this kind of perspective are, among others, photographs taken during an automobile race in which the competing cars appear to sit on top of one another and go crabwise; television-screen images taken in convention halls in which people in the second and third rows appear bigger than those in the front row; and city scenes in which space appears "compressed" and the buildings seem to have unproportionally little "depth." Personally, I find this form of perspective particularly beautiful because it preserves, as far as this is possible in a photograph, the natural size-relationships between the depicted objects. In a waterfront scene taken with a standard lens from a relatively short distance, for example, the ships in the foreground dwarf the much larger buildings in the background, whereas in a telephotograph taken from farther away, the ships appear relatively small and the buildings huge and dominating. The natural proportions of the subject or scene are preserved in the picture, and the effect of the photograph reflects the essence of the scene.

Through appropriate choice of subject-to-camera distance in conjunction with a lens of suitable focal length, a photographer can create whatever form of perspective he desires. If he wishes to preserve as much as possible the natural proportions of objects to one another in depth, avoid "distortion," emphasize the background, and prevent things in the foreground from unduly dominating the scene, he must take the picture from a great subject-to-camera distance with a lens of relatively long focal length. If he wishes to emphasize the foreground, create a feeling of nearness, relegate the background to secondary importance, or produce particularly strong impressions of depth, he must

take the picture from nearby with a lens of relatively short focal length. By taking the picture with a standard lens he can approximate the images as seen by the eye; by using wide-angle and telephoto lenses from appropriate subject distances he can create emphasis through exaggeration. He has complete control over the space impression of his picture.

Nonrectilinear perspectives

The fact that we see things in rectilinear perspective must not mislead us to assume that this is the only "correct" way of seeing, that other forms of perspective are "wrong" because they "distort." We know, for example, that certain birds, fishes, and insects have eyes that encompass views of 300 and more degrees and produce visual sensations which must be radically different from anything we are able to experience. As a matter of fact, one might even say that rectilinear perspective too is "wrong" because, strictly speaking, horizontals are not straight but curved and verticals are not parallel but diverge. If you question this statement, the next time you look at a globe imagine an enormously long building stretching all the way from New York to San Francisco. Its walls, of course, are vertical everywhere, whether in San Francisco or New York. Verticals, by definition, are lines perpendicular to the horizon that, if prolonged, would pass through the center of the earth. Now do you see why a vertical line in San Francisco cannot be parallel to one in New York? Or, for that matter, why even within the same building one wall cannot be *exactly* parallel to another wall if *both* point *precisely* at the center of the earth—a geometrical point through which it is impossible to draw two parallel lines?

And now visualize the floors in this immense building which, at whatever point you may check them, would be level—that is, horizontal. But can you imagine a "horizontal" line stretching from San Francisco to New York that is "straight"? Obviously not, since it must conform to the curvature of the earth. But if a 3,000-mile-long "horizontal" line is curved, doesn't it follow that each section of it is also curved?

Although these phenomena have nothing to do with photography, I mention them here because I believe that thinking along these lines can help a photographer to understand the significance of two strange "new" forms of perspective, cylindrical and spherical, which have been made accessible to him in recent years by the introduction of two "revolutionary" pieces of equipment: the panoramic camera, and the fish-eye lens.

A panoramic camera produces pictures in which perspective is *cylindrical*—that is, only those actually straight lines that run parallel to the scanning axis of the lens are rendered straight in the picture. All other actually straight lines must appear curved, increasingly so the farther from parallelity with the plane of scanning of the lens they are.

A fish-eye lens produces pictures in which perspective is *spherical*—that is, *all* straight lines are rendered more or less curved *except* those that radiate from the center of the picture like the spokes of a wheel; in the photograph, these lines are rendered straight.

At first, seeing lines one "knows" to be straight rendered in the form of curves may seem unnatural—a "fault" of the picture that makes "reading" such photographs correctly difficult or impossible. On further consideration, however, it will be seen that whenever abnormally large angles of view must be shown within a single rendition, this curving is not only perfectly natural but inevitable. To understand this phenomenon, let's consider the following hypothetical case:

Imagine that you have to photograph in side view an enormously long low building that stretches from horizon to horizon, encompassing an angle of view close to 180 degrees. Not having a 180-degree fish-eye lens, you decide to take the picture in two parts, each including an angle of view of 90 degrees. To photograph the first part, you turn your camera 45 degrees toward the left. Since now the front of the building is no longer parallel to the film, it will be rendered "in perspective"—that is, "distorted" insofar as its roof and base lines will not appear parallel in the picture (as they actually are), but converging toward the left side of the photograph. Subsequently, you turn your camera toward the right and take the other half of your future composite picture; this time, the roof and base lines will, of course, converge toward the right. This convergence of actually parallel lines will seem perfectly normal until you join the two picture-halves together. Then you will find that the roof and base lines of the building, which in reality were straight, form an angle in the center of the composite picture which did not exist in reality.

To avoid this objectionable angle right in the middle of your photograph, you might decide to make another composite picture of the building consisting of *three* separate parts. This would enable you to eliminate the break in the middle by taking the center shot at an angle of 90 degrees, which would have the added advantage of rendering this section distortion-free since then the front of the building would be parallel to the film. But the two other compo-

nents of your composite picture—the views toward the right and left—being "angle shots" would be rendered "in perspective" and their roof and base lines converge toward vanishing points. Consequently, when you assemble your triptych, you will now have two angular breaks in the actually straight roof and base lines of the building instead of only one.

Theoretically, of course, such breaks can be avoided by taking an infinite number of pictures, each taken at a different angle. In this way, by subdividing the overall view into an infinite number of segments, each break in the roof and base lines of the building would be infinitely small and therefore unnoticeable: the "straight" lines of roof and base would be rendered as curves. And this is precisely the form in which a panoramic camera would show this building.

That this curving is inevitable and not merely some form of "optical distortion" becomes clear if you look at it in this way: directly in front of you, the building has a certain height; seen at an angle, either toward the right or the left, this apparent height diminishes more and more until finally, where the immensely long building dips beyond the horizon, its apparent height is reduced to zero. Now, if you were to take sight-measurements of the apparent height of the building at different angles from the camera position and plot them in the form of a graph, you would get a number of points representing the apparent height of the building at different distances from the camera. If you now connect these points by a line, you get a curve—which shouldn't surprise you since the only line that can extend from the left horizon across the top of the building in front of you and from there on to the right horizon *without a break or angle* is a curve. And this is precisely the form in which a photograph taken with a panoramic camera would show the immensely long building in a right-angle view: its roof and base lines would appear as curves—perspective would be "cylindrical."

Now you may rightfully ask why, in the center-part of your three-section composite picture, the roof and base lines appeared straight and parallel instead of curved although, as we just concluded, the laws of "natural perspective" demand that rendition be curved? The reason is that this is the way we see (or think we see) such lines, and that most photographic lenses are "corrected" to duplicate this view. However, had you made the picture with an "uncorrected" meniscus lens (for example, an ordinary magnifying glass), the straight lines would have been transformed into curves and, strictly speaking, the resulting perspective would have been truer to reality than a rectilinear rendition, although few people might agree to this.

It seems only logical to ask at this point whether this peculiar curving of actually straight lines should be limited to horizontals or apply to all straight lines regardless of their direction, including verticals. The latter, of course, is correct. With the exception of the artificial "academic" form of rectilinear perspective, the respective laws that govern any particular form of perspective do not distinguish between horizontal and vertical lines, or, for that matter, lines running in any other direction. Consequently, in any "natural perspective," vertical lines must also appear as curves. And this is precisely the form in which a photograph taken with a fish-eye lens would show the subject—perspective would be "spherical."

p. 335

A simple way to visualize how a specific view would look if rendered in spherical perspective by a fish-eye lens is to study its reflection in a mirrored sphere—a Christmas tree ornament or one of those large mirror-plated glass spheres designed for use as lawn or garden ornaments. This will clearly show the gradual transition from the virtually distortion-free central portion of the image to the violently curving distortions near the periphery of the circular picture. Photographing such a reflection can sometimes substitute for taking a picture of the view itself with a fish-eye lens, particularly if conditions permit the photographer to hide himself and his camera behind some suitable object; otherwise, both would be featured prominently right in the center of the view.

That we normally don't see the apparent curving of actually straight lines is due to the fact that the angle of our sharp vision is rather narrow, and within this narrow field of view the amount of curvature is too small to be noticed. But there is a way of becoming aware of it: stand across an alley formed by two tall buildings with parallel walls and, with a stick held horizontally at arm's length, measure the apparent width between the two walls first at street level, then at roof level. Obviously, the apparent width will be shorter at roof level than at street level, proving that the walls cannot *appear* parallel. But if we don't see them as parallels they must appear to converge, and the question is only whether this convergence is straight or curved. If the walls appear to rise in the form of straight lines, the angles which they form with the street must, of course, be smaller than 90 degrees. This is obviously not the case—each angle is 90 degrees. Therefore, the only alternative is that we see the walls rise from street level at right angles and then curve inward. And this is precisely the form in which they would be rendered in a photograph made with a panoramic camera with the lens scanning the subject vertically.

Cylindrical and spherical perspectives are relatively new forms of photo-

349

graphic expression—so new in fact that many photographers still consider them gimmicks rather than useful means for symbolizing space. The reason for this is lack of understanding—they haven't yet learned how to "read" such images correctly. They look at fish-eye pictures as if they were ordinary photographs instead of views encompassing the fantastic angle of 180 degrees. They don't consider that such pictures show at one glance what in reality might necessitate a full turn of the head. To learn how to "read" such views I recommend studying them one section at a time, turning the picture into the appropriate position for each separate section. In this way, each part of the view can be "read" easily and thereafter related to the rest, and after a while the whole makes sense because it will be seen as a unit. Not before a photographer has reached this point will he be able to utilize successfully the enormous potential of cylindrical and spherical perspectives for showing certain relationships between a subject and its surrounding space with greater clarity and emphasis than was previously possible, and thereby depict more tellingly specific aspects of his world.

Space definition and scale

Creating a feeling of space in a photograph is often not enough to make the rendition effective. Unless the depicted space is also defined in terms of size—how big? how small?—the impression made by the picture may be incomplete. Anyone who ever tried to come to grips with the immensity of certain landscapes—the Grand Canyon, Niagara Falls, the redwood forests—knows what I mean: his photographs were inadequate because they lacked one of the subject's most important qualities—bigness.

Bigness is another one of those elusive subject qualities which ordinarily cannot be rendered directly in a photograph—how often do we have the chance to make a photomural? And reduced to the size of a snapshot—or even an 11 x 14-inch print—most things which in reality excited us by their size appear no larger than the surface on which they are seen. This is one of the reasons why the same kind of landscape that when projected at home looks deadly dull "comes to life" when seen on a Cinerama theater screen.

Obviously, size is a quality which rarely can be rendered directly in a photograph—actually only when the scale or rendition is 1 : 1 (rendition in natural size). In all other instances, if size is an important subject quality, it can only be indicated symbolically: by giving the picture scale.

The essence of scale is comparison. By comparing a subject of unspecified

dimensions (a landscape, a tree trunk, a rock formation) with a subject of known dimensions (the human figure, the botanist's foot rule, the geologist's hammer), we relate the unknown to the known and see how big or small the former really is. Now, in creative photography, it would obviously be a mistake to indicate, for example, the hugeness of a redwood tree by tacking a foot rule to its trunk, or the size of a rock formation by including a hammer in the picture. These are the accepted methods of the scientist—uncompromising, precise. The creative photographer's methods of imparting scale to his subject are more sophisticated. Scale must be used as if it were an integral part of the picture, unobtrusive, subtle, yet instantly effective. In the case of the redwood, for example, scale can be provided through juxtaposition of the immense redwood trunk and an ordinary spruce; the spruce—a tree familiar to every-one—makes the redwood look huge. And instead of using a hammer, a photographer could give scale to an interesting rock formation by including in his picture some wildflowers that grew naturally from a crack. In both cases, the unit of measure, the provider of scale, the spruce or wildflower, would be actual parts of the scene yet instantly disclose its size.

A large variety of objects of familiar dimensions exist to provide a photograph with scale. Heading the list is, of course, the human figure. For close-ups, a hand is often excellent; for super close-ups, a pair of fingertips. Other units of measure familiar to all are automobiles, telephone poles, cows and horses, farm houses and machinery, windows, ships. . . . For example, seen from afar, the high-rise buildings of a city appear like toys on a hazy day when their windows are obscured by mist, but huge on a clear day when hundreds of windows give them scale. And the distant silhouette of an ocean liner on the horizon will in contrast to its own smallness make the sea appear immense.

This is the whole secret of scale: to make something appear big, contrast it with something small—if not small in reality, then small in the picture. For example, in comparison to a landscape, the human figure is very small; but placed too near the camera in a photograph it can swallow up the landscape. Only if the figure appears small enough in the picture—that is, if it is placed far enough from the camera to be *rendered small,* appearing as a solitary speck in the immensity of space—can it fulfill its purpose as a unit of measure and be effective as a graphic device for making the landscape look big.

However, the purpose of scale is not always to make the depicted subject appear big. Occasionally, a photographer may wish to provide his picture with scale in order to indicate an unfamiliar subject's actual size, or to make it

appear smaller than it actually is. In commercial photography, for example, it might be desirable to make a new product look as small as possible; if this is the case, the unit of measure which gives it scale must, of course, be relatively large. Therefore, in a close-up, instead of choosing the small hand of a girl as a scale indicator, it would be advantageous to use a man's large hand which, in contrast to its bigness, would make the subject of the photograph appear even smaller than it really is.

By controlling the actual or apparent size of his scale indicator, a photographer can control the space impression of his picture. However, although lack of scale is a common cause of the ineffectiveness of many landscape photographs, *scaleless close-ups* can make some of the most fascinating pictures. In particular, small objects of nature—insects, flowers, crystals, shells—are well suited to scaleless rendition and, if shown in many times natural size on the projection screen, precisely because they lack scale, can surpass all else in structural beauty, ornamental design, and sheer fantasy of form.

Contrast between sharp and unsharp

Human vision is such that we can focus sharply on only one point in space at a time; everything else, although we are still aware of it, appears more or less indistinct. With *both* eyes open, take a look at the opposite wall in your room: you see it clear and distinct. Then, without shifting focus, interpose your index finger by holding it straight up some 8 inches in front of your face: the finger will appear indistinct and "transparent" with the view of the wall shining through. Next, focus on your finger: now it is the wall which will appear indistinct. Finally, try to see simultaneously both finger and background sharply. You cannot do it because the depth of field of the human eye is too shallow. As a consequence, whenever we see one thing distinctly and other things in more or less the same line of sight indistinctly, we know subconsciously that these various objects are located at different distances from us: contrast between distinct and indistinct evokes the sensation of depth.

With the aid of a technique known as *selective focus*, photographers can evoke similar depth sensations in their pictures: by using a high-speed lens, focusing carefully upon a preselected plane in depth, and making the shot with a large diaphragm aperture, they can limit sharpness of rendition to one specific depth zone, making everything in front of or behind this zone appear more or less blurred. And by doing this—by juxtaposing something distinct

and something indistinct—they create impressions of depth: contrast between sharp and unsharp is a symbol of space.

Contrast between sharp and unsharp will be the greater and therefore the impression of depth the stronger, the larger the relative diaphragm aperture, the longer the focal length of the lens, and the shorter the distance between subject and camera. As a result, through appropriate choice of these factors, a photographer can control in his pictures the extent of sharpness in depth and thus make space appear deeper or shallower in accordance with his ideas and the nature of the subject.

The technique of selective focus is most effective if in the photograph the subject can be rendered sharply in its entirety and the background and foreground blurred—that is, if the subject itself has relatively little depth and no transitional zones of sharpness to unsharpness exist between it and objects shown blurred in the picture. For example, the photograph of a face or a sculpture, well out in front of the background and separated from it by a relatively large zone of empty space, in which the face or the sculpture are rendered sharply in their entirety and the background appears completely blurred, will produce a stronger feeling of depth than the oblique view of a long building in which the near side is sharp and the far side blurred with a zone of transition existing in the middle.

A photographer may wish to use selective focus for one of three reasons:

To symbolize depth. Juxtaposition of sharp and unsharp is graphic proof of depth—it is impossible to render a two-dimensional subject simultaneously sharp and unsharp unless, of course, it is photographed at an angle; but then, any angle view automatically involves depth.

To draw attention to a specific part of the picture by showing it in sharp focus while the rest is rendered unsharp and hence, by inference, unimportant. For example, by differentially treating subject and background, a photographer can emphasize the first and play down the second. This might become desirable if the background is overly prominent in color or design, in which case its graphic aggressiveness can be toned down by blur.

To achieve graphic separation between objects located at different distances from the camera which otherwise might blend into one. Although this eventuality is more likely to occur in black-and-white than in color photography, there will always be cases in which the colors of different objects are so

similar that the simplest way to effect a clean separation between them is through selective focus.

Contrast between light and dark

Air is not a completely transparent medium. It contains varying amounts of impurities and droplets of water which form haze and impede the passage of light. The effect of haze is cumulative: the thicker the air mass which light must penetrate, the more light is scattered, with the result that objects seen through large masses of air appear different than when seen close up. This phenomenon is called "aerial perspective." Since it is directly connected with distance, rendered in photographic form it is a symbol for depth.

Aerial perspective manifests itself in three ways: as distance from the observer increases,

> objects appear increasingly lighter,
> contrast decreases,
> color appears increasingly distorted toward blue.

In black-and-white photography the effect of aerial perspective can be controlled either *through emphasis* to increase the feeling of depth in a picture, or *through reduction* to render distant subjects more clearly than they appeared to the eye. The first approach is primarily used to strengthen a mood in a landscape photograph, the second to improve the clarity of rendition in long-distance and aerial photographs. The following controls are available:

Choice of color filter. Outdoors, as distance increases, color appears increasingly distorted toward blue. This bluish tone makes it possible to control the effect of aerial perspective with color filters. A blue filter intensifies, and yellow, orange, and red filters increasingly reduce, the haze effect of aerial perspective. Accordingly, in a comparison series shot through different color filters, the photograph made with the blue filter would produce the strongest, and the one made with the red filter, the weakest, impression of depth. In the blue-filtered shot the distant parts of the landscape would be lost in haze whereas in the red-filtered shot, unless the haze was exceptionally dense, they would be clearly visible.

Choice of film. When maximum haze penetration is desirable, a photographer should use infrared-sensitized film and the appropriate filter. In this

way he can produce pictures with good contrast and detail even of views that are more or less invisible to the eye. However, two things must be kept in mind: only haze (which is bluish) can be penetrated by infrared radiation; fog (which is whitish) cannot. And photographs taken on infrared film through a filter which absorbs all visible light render green foliage as white and water as black—an "unnatural" effect that may not always be acceptable.

In color photography, control of aerial perspective is limited to controlling the degree of bluishness of the distance, but contrast cannot be changed. If aerial haze is not too pronounced, particularly when photographing in high mountains and from the air, an ultraviolet-absorbing filter is often sufficient to p. 68 reduce blue to an acceptable level. Reddish or yellowish color compensating p. 68 filters will partially or completely eliminate the bluish tone of haze, but no amount of filtering can restore the actual colors of the subject. Under certain conditions, a polarizer can be used to somewhat darken a pale blue sky near p. 68 the horizon. Its effect can be checked visually.

Distribution of light and dark. Although *contrast* of light and dark—or light and shadow—always produces illusions of depth, the effect varies with the *distribution* of light and dark in the picture. If light and dark are more or less evenly distributed over the entire picture area—as is normally the case if sidelight is used—although objects appear three-dimensional, the picture as a whole may not evoke particularly strong impressions of depth. But if light and dark are distributed in such a way that *all* distant objects appear light and *all* near objects dark—in other words, if we imitate the effect of aerial perspective in our picture (which may even have been taken indoors)—compelling impressions of depth result. Precisely the opposite happens if the order of light and dark is reversed, the foreground rendered light and the background dark, as is the case in photographs taken with single flash at the camera. Such pictures do not only appear to have no "depth," but also make an artificial or unnatural impression because the "natural" order of light and dark is reversed: the distance, instead of being light, is dark, while the foreground, instead of being dark, is light. The validity of this observation is confirmed by backlighted p. 262 scenes where the order of light and dark is reversed again: the sides of objects that face the camera, that are close, that comprise the foreground, are dark; those that face the other way, toward the distance, that comprise the background, are light. Hence, the distribution of light and dark in backlighted scenes is the same as that familiar to us from aerial perspective and it is not surprising that backlight creates illusions of depth more effectively than light from any other direction.

MOTION

Mobility is an important quality of many photographic subjects, but, as we have noted, motion can obviously not be rendered directly in a still photograph. Realizing this, many photographers simply blunder along, rendering subjects in motion as best they can without considering that, although motion cannot be rendered directly, the feeling of motion can very well be evoked with graphic means. Others try indiscriminately to "freeze" every moving subject and render it as sharply as possible, thereby often negating the very reason for making the picture. Such simplistic approaches are bound to lead to ineffective pictures.

Since motion cannot be rendered directly in a photograph, it must be implied through symbols. This can be done in several ways. Which symbol a photographer should choose depends on the following:

The purpose of the picture
The nature of the subject
The kind and degree of motion

The purpose of the picture

Years ago, a car magazine ran the photograph of a racing car trying for a new speed record on the Bonneville Salt Flats in Utah. According to the caption, at the moment the picture was shot, the speed of the car exceeded 500 miles an hour, and it was pointed out with pride that, despite this tremendous speed, the photographer had succeeded in stopping the car's motion in his picture. And indeed he had—both the car and the background were rendered perfectly sharp—with the regrettable result that the picture seemed to show the car standing still. How sad to think that, given the chance to capture a life-and-death drama on film, the photographer was so insensitive and engrossed in his photo-technicalities that his only interest was in getting a sharp picture. The fact that he could get all the sharply detailed technically informative pictures of the world's-record car either before or after the run apparently never occurred to him; nor did it occur to him that the reason for making his shot was to give the reader of the magzine an impression of the almost inconceivable speed of this car. To him, blur, a symbol of motion, apparently was the mark of the amateur, the poor duffer toting a box camera whereas he, the great professional, works with equipment which enables him to "stop" the fastest motion. The fact that, in this particular case, the duffer with his box would

probably have come up with a more significant picture than the technician with his five-hundred-dollar outfit is something which obviously was beyond the latter's comprehension.

I mention the above to demonstrate that it is the underlying purpose of the picture which decides the form in which motion should be indicated. In this particular case, the purpose of the picture was to illustrate "speed"—an intangible subject quality that can be rendered only symbolically. In other instances, the purpose may be to furnish a precise record of the behavior of the subject in motion; if this is the case, motion must obviously be "stopped" in the photograph and rendition be clear and sharp. Therefore, mapping his approach to a subject in motion, a photographer must be clear as to aims: what exactly does he want his picture to say? He has the choice of three different possibilities:

To show the moving subject itself as clearly as possible. A typical case would be a motion study of an athlete with the aim of analyzing his performance and form. This would require that every detail is clearly visible, necessitating that motion in the picture is "stopped" and the subject rendered sharply.

To show that the subject is in motion. This requires graphic "proof of motion." Such proof can be furnished in two ways—either through symbols, or through the action or position of the subject itself, as will be shown later. An p. 358 important requirement is that the subject remains recognizable in the picture—that is, not, for example, rendered so blurred that it becomes unrecognizable.

To create the impression of motion. Here the subject proper of the picture is an intangible: speed. The actual subject is merely the medium by which intangible concepts like motion and speed can be expressed in picture form. In such a case, only a symbolic treatment can express the essence of the subject and the intentions of the photographer.

The nature of the subject

As far as the influence of motion upon the physical appearance of the moving subject is concerned, a photographer must distinguish between two types of subjects:

Subjects which appear different in motion than when at rest. Examples are people (a person with one foot off the ground is obviously walking or

running, hence in motion), animals, breaking waves, wind-bent trees, and such. Since motion becomes apparent through changes in the physical appearance of the subject, it does not necessarily need to be expressed in graphic-symbolic form unless, of course, the photographer wishes to *emphasize* the fact that the subject moves: the slightly *blurred* picture of a running horse creates a *stronger* impression of motion than a perfectly sharp rendition, although, in the case of a horse, the latter would also show that the subject was moving when the shot was made.

Subjects which appear unchanged whether they are in motion or at rest. Examples are automobiles, airplanes, ships, many kinds of machinery. Since the motion of such subjects is not evident through changes in their appearance, it can be indicated in the picture only through a symbolic treatment. Frequently, however, "proof of motion" is furnished indirectly: although the sharp photograph of an automobile in motion is in no way different from one at rest as far as the subject itself is concerned, proof of motion may be evident in the form of a dust cloud raised by a car traveling over a dirt road; likewise, the bow and stern waves of s speeding motorboat as well as its position in the water would be convincing proof of motion although the hull itself appears the same whether in motion or at rest. And a flying airplane is obviously moving although, when shown in the form of a sharp photograph, the picture will not evoke the feeling of "speed."

The kind and degree of motion

"Proof of motion" is not the same as "impression of speed." The sharp picture of an aircraft in flight, by the very fact that the plane is airborne, contains *proof* of motion, but it cannot evoke the *feeling* of motion. If this impression is important, the motion of the plane must be indicated in symbolic form—through blur either of the image of the plane or the landscape below it. Without such blur, the plane will *appear* to stand still although we *know* that it moves. Likewise, a horse photographed above a hurdle is obviously in motion, but if the picture is sharp, the animal *appears* to be suspended in midair; to evoke the *feeling* of motion, the rendition must contain a degree of blur. This is the difference between a sharp and a blurred picture: the first may or may not contain proof of motion; but only the second can convey the sensation of speed.

To be able to create convincing impressions of speed, a photographer must consider the *degree* of motion: how fast? how slow? In this respect, it is useful to distinguish between three different degrees of motion:

Slow motion. Motion is so slow that the moving subject can be seen clearly and in full detail. Examples are people walking, moving sailboats and motorboats, trees swaying in the wind, clouds drifting in the sky. In such cases, a sharp rendition is usually called for since a symbolic treatment of motion might easily evoke impressions of speed incompatible with the concept of *slow* motion. Proof of motion is either furnished by the appearance of the subject (the bow wave of a motorboat) or, as in the case of drifting clouds, where motion is unimportant, simply ignored.

Fast motion. Motion is so rapid that the subject cannot be seen clearly in every detail. Examples are fast-moving athletes, running and flying animals, speeding automobiles seen at relatively close range, rapidly moving machine parts. In such cases, effective characterization of the subject usually requires that the photograph evokes the sensation of motion: motion must be indicated in symbolic form.

Ultrarapid motion. Motion is so fast that the subject becomes nearly or entirely invisible. Examples are whirling propeller blades, the wing beats of a hovering hummingbird, projectiles in flight. It is impossible to convey the feeling of ultrarapid motion. Special equipment and techniques are usually required to photograph such subjects and the resulting pictures can obviously never appear "natural."

The symbols of motion

The sensation of motion is a relative experience. Seen from the ground, an aircraft flying at an altitude of five miles and a speed of 600 miles an hour appears to move more slowly than an automobile passing us at only one-tenth that speed. This difference in impression is due to differences in *relative* speed, the so-called *angular velocity*, which plays an important role in the photography of anything that moves: the closer we are to the moving subject, the faster it appears to move; and vice versa. Angular velocity also explains why, for example, an approaching automobile seems to move more slowly than the same car passing at the same speed at right angles to our line of vision. This phenomenon, of course, is the reason why most tables of minimum shutter speeds required to stop the motion of specific kinds of subjects in a photograph give three different sets of data for each subject applying, respectively, to motion toward or away from the camera, motion at approximately 45 degrees to the optical axis, and motion more or less at right angles to the optical axis.

Motion in the first direction requires the slowest, and motion in the last direction the highest, shutter speed to "stop" a subject moving at a uniform rate of speed. Consequently, consideration of the angular velocity—speed relative to the distance from the camera and the direction in which the subject moves relative to the camera—is the first prerequisite for effective motion symbolization.

The second prerequisite is answering the question whether subject motion should be "stopped" or indicated symbolically. In the first case, a sharp rendition is required; in the second, it is necessary to consider the subject's "speed" as it should appear in the picture. For the graphic symbols of motion can be varied to evoke different impressions of speed—from slow to fast—enabling a knowledgeable photographer to create precisely the feeling he wishes to express. He has the choice of the following:

"Stopping" motion. The photographer times his shot so that he captures the most significant moment out of the flow of motion and "freezes" it on the film by one of two techniques:

Electronic flash. The moving subject is "stopped" in the picture by momentarily illuminating it with a high-intensity flash of extremely short duration. In this case, it is the flash that "freezes" the motion, not the shutter, which usually is set for a relatively low speed, particularly if the camera has a focal-lane shutter which, unlike a leaf-type (between-the-lens) shutter, can be synchronized for electronic flash only at speeds that, depending on the respective design, range from 1/30 to 1/125 sec. This may create a problem: if the existing light is relatively bright, the permissible shutter speed may not be high enough to assure that the image produced by the existing light will also be sharp. In that event, a secondary, blurred "ghost image" will be superimposed upon the sharp, speedlight-produced image of the subject. The only way to avoid this is either to take the shot with a camera equipped with a leaf-type shutter in conjunction with a sufficiently high shutter speed, or to use electronic flash for stopping fast motion only in relatively dim surroundings, such as indoor sports arenas, or outdoors after sunset.

High shutter speed. The picture is made with a shutter speed high enough to "stop" the subject's motion in the photograph. Actual shutter speed is determined by three factors: the speed at which the subject moves, the distance between subject and camera at the moment of exposure, and the direction of the motion relative to the camera. The higher the subject's speed, the shorter the distance between subject and camera, and the more nearly at right angles

360

to the optical axis the direction of motion, the higher the shutter speed necessary to "stop motion" in the picture. The following table contains approximate data to give the reader an idea of what is involved:

Speed of subject	Subject distance	Direction of subject motion		
		toward or away from camera	at 45-degree angle to optical axis	at 90-degree angle to optical axis
5–10 mph (people, children, sailboats, pets, etc.)	25 ft	1/125 sec.	1/250 sec.	1/500 sec.
	50 ft	1/60 sec.	1/125 sec.	1/250 sec.
	100 ft	1/30 sec.	1/60 sec.	1/125 sec.
20–30 mph (athletes, motorboats, city traffic, etc.)	25 ft	1/250 sec.	1/500 sec.	1/1000 sec.
	50 ft	1/125 sec.	1/250 sec.	1/500 sec.
	100 ft	1/60 sec.	1/125 sec.	1/250 sec.
Over 50 mph (racing cars, trains, airplanes, etc.)	25 ft	1/500 sec.	1/1000 sec.	pan*
	50 ft	1/250 sec.	1/500 sec.	1/1000 sec.
	100 ft	1/125 sec.	1/250 sec.	1/500 sec.
	200 ft	1/60 sec.	1/125 sec.	1/250 sec.

*"Pan" means: use the technique known as *panning* which is discussed below. Generally, panning at the here-indicated shutter speeds will produce still sharper pictures of the moving subject (although the stationary background will appear blurred) than holding the camera motionless while making the shot. If a camera doesn't have the here-recommended shutter speeds, the one that is closest to it should be used; any difference in sharpness will be negligible.

Directional blur. By fixing one's eyes upon a moving object and following its motion, unless such motion is *excessively fast*, one can see the object sharply although the stationary background will appear blurred. Conversely, by fixing one's eyes upon the background in front of which an object moves, one can see the background sharply and the object is blurred. But it is impossible to see simultaneously a moving and a stationary object sharply—if one appears sharp, the other must appear blurred, and vice versa: blur is both proof and symbol of motion. Consequently, in a photograph, contrast between sharpness and blur evokes the impression of movement.

Speaking as a photographer, I feel it is necessary to distinguish between two

types of blur: blur which has nothing to do with motion but is the result of accidental or deliberate out-of-focus rendition, and blur which has nothing to do with out-of-focus rendition but is the result of movement of either the subject or the camera. In this book, I refer to the out-of-focus type of blur as *unsharpness* and to the motion-caused type of blur as *blur*.

Effective motion symbolization through blur depends upon timing: the photographer must choose a shutter speed that is slow enough to produce blur, yet not so slow that excessive blur makes the subject unrecognizable. In other words, shutter speed must relate to the *apparent* speed of the subject—its angular velocity—which in turn is the combined result of actual speed, distance from the camera, and direction of motion relative to the optical axis.

A correctly chosen degree of blur not only provides proof of motion, but is also a clue to the moving subject's speed. The more pronounced the blur is in the picture, the faster the subject seems to have moved in reality. Consequently, a photographer has complete control over the desired speed-effect: motion can be made to appear either fast or slow simply through choosing the appropriate shutter speed.

The contrast between sharpness and blur and therefore the illusion of motion in the picture will be most effective if the sharp picture areas are *perfectly* sharp. Accordingly, if shutter speeds that are too slow to be safely hand-held must be used to produce the required degree of blur, to avoid confusing blur caused by inadvertent camera movment the camera must be steadied by being pressed against a solid object or mounted on a tripod.

Panning. Since it does not matter for the "speed-effect" whether the moving subject or the stationary background is rendered sharp—as long as one is sharp and the other blurred—the feeling of motion can effectively be evoked also be reversing the normal conditions and rendering subject matter in motion sharp and subject matter at rest blurred. The obvious advantage is, of course, that the subject proper of the picture, even though it moves, can be shown in sharp detail; that the less important background is made to appear even less significant by being rendered blurred; and that, despite this reversal in the form of rendition, the feeling of motion is preserved in the picture. The necessary technique, which is called *panning*, requires that the photographer use his camera the way a hunter uses a shotgun on a flying bird: he must center the image of the approaching subject in the viewfinder, hold it there by following through with the camera and, at the moment the subject passes him,

release the shutter while swinging. Some of the most striking effects are obtained with relatively slow shutter speeds of 1/8 to 1/15 sec. Since panning holds the image of the moving subject more or less stationary on the film during the exposure while the background moves, the outcome will be a picture in which the subject appears sharp in front of a background streaked in the direction of motion. This technique is particularly recommended in cases in which a subject moves at a uniform rate of speed in a straight line across the field of view of the observer.

A related technique, limited in application but of great expressiveness, is to take pictures from a moving automobile at relatively slow shutter speeds. I have been particularly successful using a 90- or 100-degree wide-angle lens in conjunction with a shutter speed of 1/5 sec. I made pictures of the highway and oncoming automobile traffic by shooting through the windshield of my car moving at a fairly high speed along a tree-lined road, with the camera pointed straight ahead and including the front end of my car (while another person was driving). Because of differences in angular velocity, which ranged from virtually zero to very high, objects at and near the center of the picture were rendered sharp and objects near the periphery blurred, increasingly so, the closer they were to the edges of the film. The general effect was that of an explosion—streaks of blur radiating in all directions from the center of the picture, with oncoming traffic and the front end of my own car rendered sharp.

Motion graphs. If we expose a bright moving dot very briefly, it will appear on the film in the form of a dot; if we prolong the exposure, it will be rendered as a line in the width of the dot, its length depending on the duration of the exposure and the speed with which the image of the dot moved across the film. This is the principle of all motion graphs: mount your camera on a tripod, open the shutter, leave it open for a certain length of time depending on how long you wish the resulting line to be, then close the shutter and develop the film.

A prerequisite for the successful completion of a motion graph is that the moving subject be relatively bright—either in its entirety or in part—and the background dark; if conditions were reversed, the light background would "burn out" the dark image of the subject. Familiar to all are time exposures of automobile traffic at night in which the headlights and tail lights of the moving cars trace traffic patterns that look like linear designs. Other applications of this technique are photographs of fireworks, pictures of lightning strokes, and time exposures of the clear night sky showing the circular tracks of wheeling stars.

This type of photograph fulfills its purpose through association. The moving subject itself is normally invisible in the picture, only its motion is revealed in the form of a graph. But because we know that the graph was made by, for example, automobile lights, we experience the feeling of traffic flowing although no automobiles are shown.

Combination time and flash exposure. If the fact that a motion graph does not show the moving subject itself makes this technique unsuitable for a specific task, the following method can perhaps be used which enables a photographer to superimpose a sharp picture of a moving subject on a graph of its motion: in darkness or very dim light, a motion graph of the moving subject is made against a very dark background. At a significant moment, perhaps when the subject crosses the center of the picture, an electronic flash is fired at the subject, momentarily "freezing" its motion and superimposing a sharp image of the subject on its track. The shutter, of course, must be open before, during, and after firing the flash and not be closed until the subject is outside the field of view of the lens.

To be successful, this technique requires that several conditions be fulfilled. For example, the moving subject must be bright and its image small relative to the size of the film; otherwise, instead of leaving a clean-cut track, it will only leave a smear. Since the number of subjects fulfilling these requirements is small (good examples are distant automobile headlights and the stars), many otherwise unsuitable subjects can be made suitable by equipping them with battery-fed flashlight bulbs. To my knowledge, the inventor of this technique is Gjon Mili, who fastened battery-operated flashlight bulbs to the hands and feet of a skater to trace her graceful movements on the ice, then, at the height of a leap, superimposed her picture upon this light-track by illuminating her with action-stopping electronic flash. Another prerequisite is, of course, that the background be sufficiently dark to enable the luminous tracks to stand out clearly. And finally, the light emitted by the flash must illuminate the subject but not the background because, in that event, the light-track might be "burned out" and the flash-illuminated image of the subject merge with the background.

Picture sequence. Instead of trying to express the essence of a subject in motion through a single photograph, a photographer can subdivide motion into a number of phases and show each in a separate picture. This technique is particularly suitable in cases in which it is difficult to choose a single phase out of the flow of motion as the one "most typical." For example, during an

automobile race, a car has an accident, takes to the air, flips over, hits the ground, and bounces several times before it comes to rest. In such a case, a sequence of pictures taken in rapid succession would give a more effective impression of the event than a single photograph showing the car "frozen" in midair. For this kind of photography, the use of a motorized camera is advisable and may even be necessary. Several 35-mm cameras and at least one 2¼ x 2¼-inch SLR can be equipped with spring-driven or battery-operated electric auxiliary motors which automatically advance the film and cock the shutter at a rate of up to five exposures per second. For higher rates, special cameras are available.

Picture sequences are particularly suitable to depict effectively subjects that move slowly or change gradually. Examples are sailboats tacking, the berthing of a great ocean liner, the gestures and expressions of a speaker, children at play, the emergence of a piece of pottery from a lump of clay in the hands of the potter, the "growth" of a building under construction for progress documentation, the unfolding of a flower, the emergence of a butterfly from the pupa, or the seasonal changing of a landscape. For best results, the camera position must be the same for all pictures of the sequence, so that the subject's changes can be evaluated in reference to the unchanging background.

Multiple exposure. Occasionally it is possible to record a subject's progress in space and time in the form of a single picture by exposing the same piece of film a number of times in succession. In most cases, prerequisite for success is a controllable environment in which the subject can be shown light against a dark background. The camera must always be tripod-mounted and its position remain unchanged until the entire series is complete. If subject motion is slow (for example, the motions of a growing plant, or the movements of the sun or moon during an eclipse), the individual exposures can be timed with the shutter. More often, however, an electronically controlled light-source will be required—repetitive (stroboscopic) flash—which automatically times and spaces the individual exposures. Since the shutter remains open during the entire sequence, to avoid ghost-like streaks and smudges on the film caused by the moving subject, such pictures must be taken either at night or in a darkened room, and care must be taken that the light which illuminated the subject does not strike the background, or the image of the subject might "burn out." Masters of this technique are its inventors, Dr. Harold Edgerton and Gjon Mili, whose stroboscopic motion studies should be familiar to most readers.

Multiple printing. Virtually the same effect as that of multiple exposure can be obtained by multiple printing—that is, photographing individual phases of

a motion on separate sheets of film and subsequently combining them in a single picture. Drawbacks are that only relatively slow motion can be depicted in this way, and that the number of phases shown together is limited normally to four or five. Advantages are considerably greater freedom in the compilation of the series: if one phase of the motion is rendered unsatisfactorily, it does not necessarily spoil the entire sequence; the sequence can be arranged *visually* to form the most effective pattern; and pictures shot at different occasions as well as pictures of different subjects or backgrounds can be combined. However, the techniques involved are complex and beyond the scope of this text.

Composition. Unless motion is random and chaotic in character, like that of choppy water, it has direction. By graphically emphasizing this direction through a dynamic arrangement of the picture components, a photographer can create the illusion of motion through composition.

Unlike a static composition which is characterized by a framework of horizontal and vertical picture elements within which the subject is more or less centered, a dynamic composition consists of tilting lines and off-center arrangements. Frequently, merely tilting the image of the moving subject is sufficient to evoke a feeling of motion, whereas the same subject, rendered level, would appear at rest. Other times, placing the subject along one of the picture's diagonals, or near one edge or corner, will evoke illusions of motion. For example, take the photograph of an approaching sportscar shot during a race: placed at the center of the picture the car is "neither here nor there" and no feeling of motion results. Placed in one of the upper corners of the picture with plenty of empty track ahead of it, the car will seem to approach—to be in motion. And if it is placed in one of the lower corners with the empty track behind it—the distance already covered—the photograph will suggest arrival, which likewise implies motion. Even if motion is already symbolized by controlled blur, such placement would intensify the impression that the subject has moved.

TIMING

The most decisive step in the making of a photograph is pressing the shutter-release button. NOT because this is the operation that "makes the picture"—it isn't, because, as I pointed out earlier, the picture existed already in conceptual form in the photographer's mind *before* he made the exposure—but because it is irrevocable. Until he presses that fateful button, the photographer is free to choose and change, select and reject, improve and correct—he can do anything he wants, whatever he feels is necessary to give his pictures purpose, meaning, and power of conviction. But once he has taken that decisive step and pressed the shutter-release button, the die is cast, for better or worse, and there is very little he can do afterward to change the appearance of his picture. This is the reason why *timing*—choosing the moment when to release the shutter—is the most consequential step in the making of a photograph.

No matter how well chosen his equipment or flawless his "technique," unless his timing is also right a photographer is in danger of producing pictures that are technically unassailable yet ineffective. For experience has shown that, no matter how much criticism a photograph may deserve on the score of inadequate technique, if the subject matter is interesting, the presentation imaginative, and the timing right, the picture will not fail in its purpose, because most people know very little about photo-technique and care even less, although they care a great deal about whether a photograph means something to them.

Admiring an especially dramatic or exciting picture, people often exclaim, "What a lucky shot!" Perhaps they are right that the photographer got the picture by luck alone; more likely, it was a well-deserved reward for hard work. But no matter whether a good photograph was produced accidentally or according to a plan, a large part of its success is usually due to correct timing.

The purpose of timing is to capture what Cartier-Bresson, the master of the well-timed picture, aptly calls "the decisive moment"—the peak of action, the highlight of an event, the most significant gesture or expression; but also the moment when all the picture components fall into place to form the perfect graphic design.

As far as a photographer is concerned, this requires the ability to observe, to concentrate, and to anticipate. Power of observation is necessary in order not

to overlook some seemingly insignificant detail which, in the end, may make or break the picture. Concentration is necessary in order to be ready when the significant moment arrives. Anticipation is necessary because action is often so fast that by the time the photographer realizes "this is it," it is already too late to shoot. In sports photography, for example, the photographer must start pressing the shutter-release button a fraction of a second *before* the climax is reached to allow for the unavoidable time-lag between the action and the exposure, which is caused by the photographer's own reaction time and the mechanical inertia inherent in his equipment.

The best insurance against missing the "decisive moment" is to take a large number of pictures. Amateurs often misunderstand this, complaining that if they took as many pictures as most professionals they, too, would have occasional "hits." This is not the point. Such large-scale shooting is not done indiscriminately. Each of these shots was carefully timed and made as possibly the final climactic picture. But then another more significant moment occurred, invalidating the previous photograph; and another, and another. Most professional photographers realize this and act accordingly. It is precisely because they are *professionals* that they cannot afford to miss, due to faulty timing, the one climactic shot they were assigned to get.

In regard to timing, a photographer must consider the following factors:

> **The psychological moment**
> **Motion relative to composition**
> **Light, weather, and season**

The psychological moment

Every drama, every action, every event, has its climax—the moment when tension reaches the breaking point, when nervous strain is released, when the inevitable happens, tempers explode, or collapse sets in—the moment of victory or defeat; Ruby shooting Oswald; Khrushchev at the UN pounding the desk with his shoe. . . . Recognizing and capturing such obviously dramatic moments as the above is usually not difficult. However, many poignant moments are *not* obvious—the abandoned Chinese baby sitting forlorn at the railroad station; the Frenchman crying at the defeat of France. . . . To capture moments like these also requires timing, but here it must be reinforced by a special kind of awareness.

One of the most difficult things to time correctly is a smile. And by "smile" I

don't mean the dental displays shot by commercial photographers at the command "Say cheese"—the smiles without joy or pleasure, as meaningless as the spurious claims and "testimonials" they promote. No—a genuine smile is an emotional response to a tender or humorous situation that reflects in the eyes and transforms the entire face—a precious moment in time, gone almost as soon as it began, which can be captured on film only by perfect timing.

Motion relative to composition

We live in a world of motion: people and pets, cars and planes, breaking waves and drifting clouds. And even when things are static, the photographer himself moves, and with every step he takes he sees his subjects from different angles, in different apparent sizes, and in different relationships to their surroundings. No wonder the difference between a successful and an unsuccessful photograph is often a difference in timing.

For instance, earlier I discussed the importance of positioning correctly a p. 366 subject in motion within the frame of the picture: as far as the impression of motion is concerned, we learned that it makes a great difference whether the image of a racing car is placed near an upper corner of the picture, at the center, or near a lower corner. Placing this image correctly in a photograph is a function of timing.

Another connection between timing and motion stems from the fact that many subjects change in appearance as they move. As an example, take a picture sequence of a person walking. Doubtless, in some of the pictures the subject will look as if he is stumbling over his own feet whereas in others he will appear to move along with a free-and-easy stride. In other words, depending on their timing, some of the pictures may look clumsy while others convey the essence of flowing motion. Or consider the movements of a flag in a light breeze: at one moment scarcely moving; at another, ponderously flapping or briskly rippling—constantly changing form. Whether a photograph conveys the feeling of a limp rag or the proud symbol of a nation depends again on timing.

Let's take another example: a photographer wanting to photograph an approaching group of people. As the people come closer, their apparent size increases—at which moment should the shutter be released? The larger the image of the people, the more detail can be seen and the more important the figures become in comparison with the surroundings—the street, the buildings, other people, cars, the sky. . . . But only up to a point: if the people are very

close, they can be rendered only in part—a head-and-shoulder shot, a close-up of a face, eyes and nose. In other words, the character of the picture changes with relative subject size—from overall shot to street scene to people to portrait to close-up to unsuccessful shot to missed opportunity. Which view a photographer gets depends again on his timing.

Some time ago I stalked a fascinating-looking young couple in New York's Greenwich Village trying to get a good shot. Up and down the streets they went, past houses and fences and trees, now standing out clearly against a wall, now merging with the pattern of doors and windows, now obscured by passing people. Color and design of the background changed constantly—mostly unsuitable, too busy, wrong color—automobiles interposed themselves between subject and camera just when things began to look good, sunlight alternated with shade, frontlight with side- and backlight according to the direction of the walk. Although my subject, the couple, remained the same, the pictures which I got were as different as night and day because of the differences in timing.

Although this example covers a very simple situation it contains the main picture aspects determined by timing: apparent subject size, subject-to-background relationship, phase of motion depicted, character of illumination, juxtaposition of colors and forms, overlapping of subject matter, and position of the subject within the frame of the picture. Accordingly, *before* he finalizes his picture by releasing the shutter, a photographer must consider the following questions: What is the momentary relationship between the subject and the rest of the picture elements? How do the various picture components affect one another in respect to clarity of rendition? Does one component cover, impair, or blend with another in some undesirable way? How do they affect one another in regard to composition? Do the main masses in the picture balance one another? Do the colors harmonize? What are the proportions of light and dark? And what about subject distance and image size, and subject position within the frame of the picture?

What timing means is recognizing when all conditions are right, when the picture components combine to form a good design, and being able to capture that moment.

Light, weather, and season

Changes as consequential in regard to the appearance of the subject—and

370

the picture—as those brought about by motion are caused by differences in light, atmospheric conditions, and the seasons. Choosing the precise moment when these external factors are in harmony with the character of the subject and the purpose of the picture is also a form of timing.

The effects of some of these factors are obvious, those of others subtle. For example, seasonal effects, like differences in the appearance of the same landscape or tree in summer and winter, are clear; less obvious to the untrained eye are differences in character and direction of light. For example, a textured wall may look dull all day long except for fifteen minutes when sunlight strikes it at just the right angle. The shadow of a mountain, a house, or a tree may fall in a pictorially unfortunate direction in the morning but in a favorable direction in the afternoon. For outdoor portraits, light from a hazy or overcast sky is preferable to direct sunlight, and the experienced photographer will time his outdoor portraits accordingly. Photographed in sunshine, a badly run-down neighborhood can appear "quaint" instead of realistically squalid, as it would look in pictures taken on a gray and rainy day.

As a rule, the moment the average photographer sees a subject that appeals to him, he shoots it, rarely considering the possibility that the picture might be more effective at a different time of day, in a different light, or under different weather conditions. Often, of course, the reason for such immediate action is lack of time—it's either now or never. Indeed, this is one of the most frustrating experiences of many photo-journalists—the fact that deadlines and limited expense budgets compel them only too often to finish their work in a hurry and do the best they can although conditions are not at their best. Unfortunately, without sufficient time, no photographer can "time" his shots effectively. For to achieve their full potential, outdoor photographs in particular must be timed in accordance with requirements which may entail a long wait: if sunshine is needed for best results but the sky is gray; if a soft and misty mood is required but the air is clear; if storm clouds are necessary to dramatize a scene but the sky is serene—then a photographer must make a choice: either he compromises, perhaps finds a new solution, and does the best he can with available means. Or, if he is a perfectionist who is aware of the importance of proper timing, he waits, returns at a more opportune moment, or saves his films for a worthier project.

Even such unlikely factors as air temperature and relative humidity can on occasion change the effect of a picture and influence timing. For example, photographed on a warm day, steam locomotives in a switchyard and geysers in Yellowstone National Park yield pictures that appear pallid and dull; but

when temperatures are low and frost is in the air, these same subjects appear dramatic and "alive," belching forth immense clouds of steam which could not condense in warmer air. To realize the importance of such factors, to have the patience to wait until conditions are right, to reject the unsuitable moment rather than compromise and settle for second-rate pictures—that, too, is timing.

COMPOSITION AND STYLE

There is little doubt that the majority of photographers consider "composition" one of the most intriguing, mysterious, and challenging aspects of photography. There is good reason for his interest: "good composition" is universally and rightly regarded as one of the essential requirements of any "good" photograph. But although much has been written about this subject, most of it is a rehash of obsolete academic rules and the rest, with few exceptions, either too esoteric or too personal to be of real help to the student photographer. However, the importance of the subject seems to me to justify one more attempt at clarification, however personal it may be.

According to my dictionary, composing means giving form by putting together. Giving form to what? The intentions and conceptions of the photographer. Putting together what? All the elements that constitute the picture: sharpness and blur, color arrangement, perspective, subject position, picture proportions—in short, all the *graphic* components of the photograph that play such an important role in creating the impression which the picture is going to make upon the beholder. This should make it clear that composition is NOT something that can be taken care of at the last moment or, like "cropping," introduced as an afterthought, but something which must be considered from the instant the picture is conceived.

What is this elusive "something" that must be considered? The answer depends in large degree on whom you ask. This is what makes "composition" such a difficult and esoteric subject. Unfortunately, there are no "rules"—or rather, most of the existing rules are not universally accepted. And even the few "accepted" rules are subject to numerous exceptions and furthermore likely to change with the changing standards of the times—they evolve, and are ultimately replaced by others. Today's young photographers have totally different concepts about composition from the previous generation, whose ideas in turn are different from those in vogue fifty years ago. And even among groups

of photographers of relatively similar outlook individuals often disagree on specific points, and defend their personal viewpoints heatedly. So it should not come as a surprise that my own interpretation of the meaning and essence of "composition" is highly personal. Still, in the final analysis no one can please everybody, different people react differently to one and the same photograph, and, in the end, the only lasting satisfaction lies in making pictures that please oneself. Because no matter how much the critics may praise your work, if you know that it is not the outgrowth of your own convictions, ideas, and creativity, but the result of sheer luck or plain imitation, you cannot truly enjoy your triumphs. Only a photographer of integrity and conviction can make pictures with pleasure and show his work with pride.

Clarification and organization

I start "composing" the moment I conceive the idea of a photograph. It was Edward Weston who said that "good composition is merely the strongest way of seeing things," to which I fervently add: amen. Consequently, my first concern is with organization: how can I create order out of the natural chaos of my surroundings, where things interact, blend, overlap, and compete with one another for attention, where a riot of forms and colors vie for the interest of the beholder—how can I separate the wheat from the chaff, isolate my subject, simplify my picture, and present what I feel and see in the graphically most effective form?

Again, as so often in photography, it is impossible to give orderly step-by-step instructions on how to proceed. Too many aspects must be considered simultaneously, and an improvement in one respect is only too likely to create new problems in another. To give an example: I wish to photograph a large outdoor sculpture. I don't like the background, so I walk around my subject to frame it against a different and more suitable background. But from the new angle the sculpture looks quite different, and the angle of the incident light is different too—perhaps better, perhaps worse. Let's say the new angle of view and background are satisfactory but the light is not. In that case, I can either wait until the light is right (if I have time), or go back to my first camera position, where everything was fine except for the background. I can perhaps tone the background down by throwing it out of focus—shooting the picture with a larger diaphragm aperture than originally planned. This, of course, would affect the exposure. Alternatively, I may be able to shoot from a lower angle, or from much closer with a wide-angle lens; the first possibility might eliminate most of the undesirable background by showing the sculpture against the sky;

the second possibility would render the background in much smaller scale relative to the sculpture; but both would involve considerable changes in "perspective" which might or might not be acceptable. And so on.

However, no matter how numerous and complicated the steps involved, my first objective is always clarification. Usually, this means simplification—exclusion of extraneous picture elements by getting sufficiently close to the subject, using a lens with a relatively long focal length, subordinating the background through appropriate selection and treatment, and generally presenting the subject with straightforward photographic means. In this approach, I often find myself in disagreement with photographers who prefer a more emotional or "expressionistic" approach, characterized externally by conspicuous use of unsharpness, blur, graininess, and halation. I have no quarrel with this latter approach as such, as long as it is in agreement with the nature of the subject or event, expresses the intentions of the photographer, and is compatible with the purpose of the picture; and although it is not my way of working, I greatly admire some of its results. But it also seems to me that this *avant-garde* approach is often used merely as a disguise for photo-technical incompetence and editorially fuzzy thinking, and I suspect that many pictures of this kind are palmed off as "art" with the implication that if a person doesn't "understand" them, such a reaction is an unflattering reflection of that person's sensitivity and education rather than a sign of the photographer's incompetence. But, once again, each must follow his own conscience and abide by his own nature and, to me, simplicity and clarity are unquestionably the prime elements of good composition.

Picture proportions. My next consideration is usually to decide whether to make a horizontal, a vertical, or a square picture. This, of course, depends entirely on the nature of the subject and, if applicable, its motion, actual or implied. The soaring rise of a tree or a building for example, can be experienced as motion in latent form if liberated by graphic means: here a narrow vertical format, slim and tall, and composition along diagonal lines. Indeed, the proportions of the picture play an important role in establishing its effect, even in color photography, where transparencies can be masked to get away from the monotony of the camera format. Photographers working with square film formats should especially keep this in mind; but even if you work with a standard 35-mm camera your slide show will gain in interest if you vary the proportions of your transparencies imaginatively. As far as possible, these proportions should be established, in concept if not in fact, at the moment of conception of the picture.

Static or dynamic. The photographer not only can choose between a horizontal and a vertical picture, he can select between a static and a dynamic composition as well. And, just as there are innumerable intermediate proportions between extreme horizontal and extreme vertical formats, so innumerable intermediate degrees exist between outspokenly static and dynamic compositions. Which of these a photographer should choose depends, like so many decisions in photography, on the nature of the subject, the way it affects the photographer, and the feeling he intends to evoke with his picture.

A static composition is one that is graphically in equilibrium. Equilibrium implies stability, and the most stable line is the horizontal, the most stable form the horizontal rectangle or the square. Vertical lines are also lines of stability because they are "in equilibrium," although they are somewhat less stable than horizontal lines; one always has the feeling that a tall vertical line or form might topple and fall—motion is, if not implied, at least hinted at.

A static composition suggests quietness, security, solidity, latent power. It is well suited to pictures taken on a calm day, the immensity of the sea, the serene beauty of a lovely face, or the presence of controlled power. Any head-on view, any "distortion-free" rendition, and most shots made with extreme telephoto lenses, are almost automatically more "static" than pictures taken "at an angle," "distorted" views, and most photographs made with wide-angle lenses. Likewise, photographs in which a specific subject is more or less centrally located are more static than pictures in which the subject proper is placed more or less off-center—that is, more toward one of the edges or corners.

A dynamic composition is one that is graphically unstable, one in which lines and forms seem to slide, topple, or move. The most dynamic of all lines is the diagonal, the line of action, the longest possible line in any photograph. Forms become dynamic when they are tilted, placed at a slant, or jagged and irregular; subjects make a dynamic impression when they are "seen in perspective" instead of "head-on," or when they are rendered "distorted"—that is, with their proportions exaggerated or changed from what is accepted as "normal." For example, photographed on a *horizontal* plane, a skier appears *static* to the point of standing still, photographed on a *tilting* plane—a slope —he appears to slide down the incline and through implication of motion becomes "*dynamic*." All angle shots are dynamic because they involve tilting forms, diagonal lines, and "distortions" in the sense discussed earlier in this book.

A dynamic composition suggests motion, action, passion, excitement, violence, and sheer power. If the nature of the subject or event includes these qualities, or if a photographer wishes to evoke them through his pictures, his compositions must be essentially dynamic.

Subject position. Distinguish between two basically different types of subjects: those which, like a landscape or a view along a street, fill the entire picture; and those which, like a portrait or a group shot of people, constitute only part of the picture while the remainder is filled by "background." In the latter case, positioning of the subject proper is an important part of composing. The composition will be more or less static or dynamic depending on whether the subject mass is placed more centrally, or more toward one of the edges or corners of the picture.

Subject placement also affects the graphic balance of a photograph. Placing the subject-mass high within the frame of the picture can become an effective means for creating tension—the composition appears top-heavy, it seems precariously balanced, the subject is lifted off the ground—and the resulting feeling of lightness and excitement effectively amplifies with graphic means the excitement generated by the subject itself. Quite the opposite happens if matters are reversed and the subject is placed low. Then it seems to rest firmly on solid ground, a feeling of security and stability replaces the previously encountered mood of elation, and the impression of the picture is one of heaviness, dullness, and complacency.

Even the depth-effect of a photograph is affected by subject-placement. For example, the small-scale image of a human figure placed high within a landscape photograph will seem farther way from the camera, and therefore create a stronger impression of depth, than the same figure in the same scale placed closer to the bottom edge of the picture.

Framing. Compositionally, the purpose of framing is twofold: by contrasting the relatively close object which acts as the "frame" with subject matter farther away, a photographer, through contrast between near and far, creates illusions of depth. And using the "framing" subject matter as an organic boundary for his picture provides him with an effective means for condensing interest and presenting the subject in the form of a self-contained unit.

Subject matter suitable to serve as a frame can be found almost anywhere: arches and doorways; tree trunks and branches; wrought-iron grillwork; traffic and advertising signs; structures and constructions; abstract sculpture; open-

376

ings formed by objects of any kind and description. However, a word of caution is in order: precisely because framing is such an effective compositional device, it has been overdone and the "framed view" has become a cliché. The Vermont church framed by birches, the rodeo shot through the paddock fence with a pair of booted and spurred cowboy legs dangling from the top rail, the backlighted country road seen framed by the tunnel of a covered bridge— these and other stereotypes have given framing a bad name. To avoid the stigma of imitation and triteness, photographers must find new ways of using the frame.

Contrast and shock. One of the most powerful means for commanding attention is contrast based on shock—the unexpected hidden in the commonplace. A single white flower in a bunch of blue ones; a small patch of brilliant color in a sea of grays and white; a tiny child in a crowd of grownups. But stronger still than these more familiar examples are the incongruous juxtapositions and superimpositions so effectively employed in certain types of "experimental" photographs: the glowing nude in the decaying shack; soft skin overlaid by cracked and peeling paint—a memento of the transience of all flesh. Or the striking way in which Bill Brandt contrasts human and natural forms, making the female body appear as monumental as the rocks, and the rocks as rounded as woman—showing us new perspectives of reality as well as of thought, opening new vistas of awareness. To use such powerful tools, sensitivity must be guided by understanding, and daring cautioned by restraint. For in this area of composition, only a hairline separates the sublime from the absurd.

The horizon. If present at all, the horizon is one of the most consequential picture elements. Compositionally, it divides a photograph into two parts— ground and sky—the proportions of which greatly influence the effect of the picture.

Evaluated in symbolic terms, the ground represents nearness, intimacy, and earthy qualities, the sky remoteness and spiritual qualities. Consequently, by composing his picture to include either more ground, or more sky, a photographer can at will make his photograph appear heavy or light, more earthly or more spiritual in accordance with the nature of the subject and the feelings he wishes to express.

If the horizon divides the picture into two equal parts, a feeling of conflict may ensue since neither half clearly dominates the other. However, depending on circumstances, such a state of equilibrium may also evoke impressions of

tranquility or monotony and, in cases in which these qualities must be implied, become a legitimate and valuable means of composition, notwithstanding obsolete academic rules to the contrary.

As far as the dividing line itself is concerned, a *straight and horizontal horizon* suggests equilibrium, serenity, and permanence—typically static qualities. A *tilted horizon*, by introducing the element of instability into the composition, makes the picture dynamic and suggests motion and change. A *wavy or jagged horizon* evokes feelings of dynamic fluidity, action, and drama.

Symmetry and asymmetry. Symmetry is one of the highest forms of order, exemplified by the design of classic temples, the equality of the two sides of a butterfly, and the patterns of many flowers. But precisely because of this perfection, symmetry can also evoke feelings of monotony and boredom, as is generally the case when the horizon divides a photograph into two equal parts.

However, other forms of symmetry exist as well, comparable, perhaps, to the state of balance between the two pans of a scale loaded identically but with weights of different forms: in the left pan, say, a one-pound weight; in the right pan, a half-pound and two quarter-pound weights. The graphic equivalent to such an arrangement, which might be called "dynamic symmetry," also exists in composition, where different picture elements can "balance" one another if arranged on the two sides of an imaginary axis without being mirror images of each other. Imagine, for example, the photograph of a farm depicting, on one side, the farmhouse overshadowed by a group of large old trees, on the other side the cluster of barn and silos. Such a photograph can be said to be in dynamic balance and therefore will evoke feelings of stability, permanence, and peace although, strictly speaking, the composition is asymmetrical.

On the other hand, true asymmetry is always dynamic, tension-filled, dramatic. The vast majority of photographs are asymmetrically composed, a fact which doubtlessly contributes to the often chaotic impression of many pictures. Particularly if asymmetry is combined with complexity, the effect is almost invariably disorganized and confused. However, asymmetry in conjunction with simplicity in regard to subject matter and composition can produce outstandingly beautiful, compelling effects.

Patterns and repetition. A favorite pastime of most pictorialists is making pattern shots—photographs in which the same kind of subject or picture element repeats itself in an orderly way to form a geometric overall design. Although this kind of photograph contains a very high degree of order, it is

usually exceedingly boring—order amounting to mechanical perfection can be very dull. Typical examples of this kind of photograph are pictures showing large numbers of identical machine parts stacked in even rows in a warehouse. However, the moment this monotony is broken, pattern shots can "come to life." For example, an aerial shot of a building development in which identical houses are arranged in straight rows is deadly dull; but if some of the streets curve irregularly and the houses differ slightly in design, although the pattern-effect is maintained, the impression is considerably more interesting and can even have a certain kind of abstract beauty. Similarly, the parking lot of an automobile-manufacturing plant filled with rows of identical cars waiting for shipment is dull subjectwise, whereas the parking lot of a supermarket, partly filled with cars that differ in shape and color, can make a "pattern" which, if shot from afar with a telephoto lens to minimize perspective distortion, combines beauty with interest.

An analogy between photographic and mechanical perfection comes to mind: many objects of daily life such as textiles, wooden salad bowls, ceramic vases, blankets, and rugs are available in either machinemade or handmade versions. But when he has a choice, a discriminating buyer usually prefers the handmade article and willingly pays the often considerably higher price—precisely because small irregularities and imperfections "break the monotony" and make the object more interesting, give it character and individuality, make it *unique* and therefore desirable—a one-of-a-kind item. Photographers who use patterns as elements of composition should remember this.

Faults and fallacies

As should be clear from the above, it is virtually impossible to list specific pitfalls and "faults" which a photographer must avoid when "composing." Likewise, it is impossible to formulate a set of "rules" for "good" composition except, perhaps, in the most general terms since exceptions can be found for every rule. Subjects, situations, and techniques that would spell unmitigated disaster to duffers may form the basis for stimulating photographs when handled by experts.

Nevertheless I do feel that the following guidelines are valid. In my opinion these are the "faults" of composition which are likely to lead to unsatisfactory pictures: disorder; overcrowding of the picture with subject matter that should have been treated separately; lack of separation in regard to tone, color, and

form; unfortunate overlapping and juxtaposition of different picture elements; compositional imbalance (which is not the same as asymmetry); color dissonances; garish, loud, and overdiversified color; distracting picture elements of no particular purpose; insipidity, triteness, "artiness"—novelty for novelty's sake; a gimmicky approach to composition.

At the same time the vaunted academic rules of composition should be viewed with suspicion. Theorizing about "leading lines" which are supposed to "lead the eye of the viewer to the center of interest" has long since been disproved by qualified investigators: the eye roams in a totally unpredictable way over the photograph, focusing on what is of momentary interest to the viewer, then jumping to some other point of attraction, completely disregarding those carefully prepared "leading lines." The famous "S-curve"—the main justification of innumerable academic compositions—has through overuse become almost a symbol of triteness and epitomizes the photographic cliché. And "triangular compositions" exist mostly in the minds of academic photographers and are rarely appreciated by the average viewer of the picture, who normally doesn't even recognize the triangular arrangement unless it is pointed out to him—and then he couldn't care less. In my opinion, all those pretty line-diagrams "explaining" the compositional structure of accompanying textbook illustrations are nothing but window dressing or padding to attract a buyer and confuse rather than aid the student photographer. This is not what is needed. The purpose of a textbook is not to encourage childish exercises to please teacher. If only one looks long enough, or crops a little bit here and there, any photograph can be made to fit some preconceived idea of "composition." But this is attacking the problem from the wrong end. Composition is a means, not an end—the most perfect composition does not justify a meaningless picture. Composition is a tool designed to sharpen the impact of photographs. Equality of subject interest and photo-technical treatment provided, a well-composed photograph makes a stronger impression than one in which composition is weak. It is as simple as that.

Self-criticism and analysis

Self-criticism is a vital part of learning. It enables a photographer to see his work in perspective, to draw conclusions, and to ask: Where do I stand? Am I making progress? How can I further improve my work?

The basis of any constructive self-criticism is honesty. Anybody can fool others, but no one can fool himself, at least not for long. On the other hand, indulging

in maudlin self-accusations of the "I'm no good, I'll never make it" kind is pointless too. Only a dispassionate, computerlike approach is likely to be fruitful. It should start with taking stock of one's merits and faults.

Merits and faults of a photographer. In my opinion, the greatest asset a student photographer can have is enthusiasm. Unless he truly loves what he is doing, he may just as well do something else, preferably something more remunerative. Next in importance seems to me a sense of wonder and an almost childlike desire to explore things—people, feelings, objects, images. It is this precious sense of awareness unspoiled by preconceived ideas and prejudicial learning which is the secret of youth and explains why it is usually the young photographers who come up with new ideas and produce images that astound us by their freshness and poignancy. Having been neither confused nor dulled by too much learning and living, they are still free to go about their work with an innocent unconcern for "how things ought to be done." Having no "reputation" to lose, they can only gain by being unconventional, disregarding photographic taboos and attempting the unattainable. As long as a photographer keeps on working in this spirit he is on the right track, no matter how much he still may have to learn in regard to photo-technique. Anyone who makes the effort can acquire technical proficiency; but a sense of wonder and exploration is a precious gift which, once it has been blunted, is spoiled forever.

To my mind, the greatest fault a student photographer can have is lack of self-confidence. A man without confidence in himself and his abilities invariably looks elsewhere for guidance. And inevitably, this passive form of searching leads to imitation, the meaningless cliché, the frustrating life of a hack. Equally, the greatest fault a photographer who has "arrived" can have is to repeat himself.

To a certain extent, of course, imitation is an unavoidable part of the learning process. Every young animal and every growing child learns by imitating his elders, and photographic beginners are no exceptions. But eventually there must come a moment where the paths of teacher and student part. Unless he is satisfied to play the lifelong role of a second-rater, the young photographer must grow up spiritually and develop in harmony with his own personality. He must discover his interests and form his own opinions in accordance with his convictions. He will continue to look at the work of others and may be influenced by it, but in a more mature way. No longer will he slavishly imitate what attracted him; instead he will analyze this attraction, discover the underlying cause, and use it creatively in his own manner—imitation is subli-

mated and transformed into constructive stimulation. When he has reached this point, the former student has grown up to become a photographer in his own right.

The personality of a photographer. Personality is the sum total of one's traits. These traits determine not only a photographer's growth potential, but also his limitations. Self-analysis is therefore an important step in the development of any photographer: What kind of person am I? What are my interests? What do I want to do?

But almost more important than discovering one's good qualities as I see it, is the need to discover one's weaknesses and limitations. Because it is these qualities that can effectively thwart a photographer's career: unless he is adventurous, he should not travel, no matter how romantic the life of a photo-journalist working for a national picture magazine may seem to him; unless he feels compassion for humanity, he should not photograph people, because he would never be able to do it well; unless he is methodical and precise, he should not attempt to work in the fields of industrial, architectural, or scientific photography; if he is deliberate and slow by nature, sports photography (or a 35-mm camera) is not for him.

Having ruled out what he should NOT do, a photographer can then give his attention to the problem of deciding what he SHOULD do. Ideally, unless economic or other considerations rule otherwise, the choice should be made in accordance with his interests: which field of photography, what kind of photographic subject matter, is most attractive to him? The importance of interest as the decisive factor in choosing a career lies in the fact that any good photograph is *more* than a mere reproduction of the subject—it is an interpretation by the photographer in the light of his own experience: what he felt and thought about the subject, what it meant to him, how he intended others to see it. This presupposes knowledge and understanding, which are natural outgrowths of interest but hard to come by if the respective subject leaves one cold. Knowledge and understanding in turn furnish the basis for a personal opinion expressed in the form of photographs which, beside showing what the subject looks like, through the way in which it is shown gives the viewer the benefit and enrichment of the photographer's special knowledge and insight.

Analysis of a photograph. Self-criticism should not be restricted to one's personality but must extend to one's work. Here are some of the most important questions that must be answered:

Motivation: Why did you make this photograph? Did the subject interest you? move you? excite you? Did you make the picture because somebody else had made a similar photograph which you admired? gave you the idea? had been published? had received a prize? Or did you make it simply because the subject was there and you felt it might make an "interesting picture"? Interesting to whom? Yourself? your family? friends? members at the photo club? the public at large? Was it a planned picture? a grab-shot? a lucky accident?

Value: Do you still think the subject was worth photographing? Why was it worth photographing? Or do you feel now that this picture is neither particularly beautiful, interesting, informative, moving, and actually in no way superior to countless other pictures of similar subjects taken by other photographers? Are you glad you made the picture or do you wish now that you had saved your film?

Purpose: What did you expect to accomplish when you made this photograph? (The answer to this question is particularly important in order to find out how well you did—meaningful criticism of any photograph is possible only in relation to its purpose.) Did you wish to produce a record as a memory aid—a snapshot, a photographic sketch? Is this picture a form of self-expression—a graphic statement communicating what you felt in the presence of the subject . . . a move of protest . . . a call to action . . . reform . . . revolt? Did you wish to express the beauty of the subject . . . its sensuality . . . perhaps a special quality, such as monumentality, nonconformity, desolation, squalor, cold . . . or love, hate, trust, disgust, or despair? Did you wish the photograph to be informative, funny, educational, shocking? Is your picture a straightforward or a symbolic rendition—should it be taken at face value or is there a hidden meaning? Does it really have a purpose, or did you make it without thinking anything beyond the fact that there was the subject, and how could you best get it on the film?

Execution: Are you satisfied with your picture in regard to photo-technique—sharpness, blur, exposure, color, contrast, light? How well do you think it succeeds in fulfilling its purpose? (By the way, what *was* its purpose?) Is its execution personal and original, or hackneyed, trite, a photographic cliché? And if the execution is different from the run-of-the-mill kind of photographs of similar subjects, in what respect does it differ? Is is better (why?), more artistic, or perhaps only arty? Does this difference contribute to making the photograph more beautiful, informative, emotionally stirring, graphically interesting, or is it merely a gimmick to attract attention?

Reaction: What is your honest reaction to this picture? Does it make you feel happy, curious, excited, angry, disappointed, bored? Frustrated—because it does not "give enough" and should have been much better? Ashamed— because you know it is only an imitation of somebody else's work? Proud— because you truly succeeded in depicting what you felt in the presence of your subject? How do other people react to it—your family, friends, other photographers, strangers? Were their reactions more or less unanimous, divided, flattering, disapproving? Did they understand what you wanted your photograph to say? Did they care?

Personality and style

No two photographers are exactly alike in regard to personality, background, education, interests, taste, and degree of sophistication. Consequently, we might assume that, if we were to compare representative bodies of photographic work by several photographers, their personal differences would be reflected in their pictures in terms of subject selection and treatment, composition, style, and so on. Unfortunately, such distinctions are extremely rare, mainly because similarities in thinking are stronger than differences of personality, creating an almost "brainwashing" effect brought on by the corrosive influence of group activity combined with lack of courage to "buck the trend." To resist these negative forces must be the first consideration of any photographer who hopes to produce original work.

Anybody who ever accomplished anything of lasting value was an individualist—unafraid to break new ground, buck the trend, and go his own way willing, if necessary, to fight for his convictions. This is exactly the opposite from the current tendency for "togetherness" as exemplified by the photo club, the "school," the "group," or some "movement." Photographers who identify with any specific body of people united by a common cause— people who agree among themselves on most major points and "think alike"—don't get the stimulating exchange of ideas which any human being needs for his intellectual and artistic development. Having "an idea" is not the same as having to defend this idea against a clever opponent or putting it down on film. The first condition is vague and dreamy—everybody has "ideas"; but only the second stage can prove the feasibility and value of the idea—or disprove it. Photographers who are not willing to assert themselves lose their freedom as artists and atrophy. Living is almost synonymous with fighting— against outside influences as much as against one's inner self. This fight is much

more than merely a struggle for physical existence in a competitive field. It is a fight for survival on a higher plane, a fight for one's integrity and pride, the silent fight of the mind against one's own inertia (Why try so hard? No one will notice the difference!); against one's feeling of inferiority (I wish I were like such and such a person!); against the corroding influence of public opinion (What will other photographers say? What will my editor think?); against the temptation to get quick recognition by imitating the successful style of others (After all, who doesn't steal ideas?). Only by winnng this fight can anyone ever become a photographer in his own right. And only by becoming a photographer in his own right can he ever develop a distinctive style of his own.

A personal style—the coveted mark of individuality—distinguishes a photographer's work from that of other photographers. And just as an art expert can recognize a painting by Picasso or a sculpture by Henry Moore without looking at the signature, so any experienced photo editor, without having to look at the stamp on the back, can recognize a typical photograph by such distinctive stylists as Edward Weston, W. Eugene Smith, Richard Avedon, Yousuf Karsh, Erwin Blumenfeld, Ernest Haas, or Art Kane. I deliberately say "typical" because only when a photographer is free to express himself can he make pictures that carry the seal of personality; photographs made to specifications set by clients or editors may, of course, be partly diluted by such outside influences.

A prerequisite for the development of a personal style is knowledge of oneself and self-criticism—style evolves from an individual's personality. A photographer who is highly organized in his habits and thoughts will, of course, express this orderliness in the form of pictures that are sharp and precise in execution as well as in meaning. If these are combined with an unassuming nature, profound respect for all living things, and a deep love of outdoor life, it becomes clear why Edward Weston worked in the way he did. The man, his character, his interest, his feeling and thinking, his way of seeing and expressing himself, all fuse into one, manifesting themselves in his personal style.

Take a look at the work of W. Eugene Smith, whose brooding character, preoccupation with human problems, and uncompromising integrity are clearly reflected in his dark and moving photographs. His is a style that evolved through suffering, insight, and compassion for humanity.

Consider the work of Richard Avedon, the modern romanticist, glorifier of all that is elegant and feminine. His sophistication, his sense of color and motion, his unconventionality, daring, and taste combine to produce a style that is unmistakably his own.

In contrast to Avedon who, after many years at the top, still can surprise us with his inventiveness, Karsh seems to have settled into a groove. His mastery of light and texture are still admirable, his compositions as well worked out as ever. But his habit of repeating himself has caused him to stand still, with the result that his style, though still unmistakable, begins to seem dated.

Where color is the main criterion, Erwin Blumenfeld, Ernest Haas, and Art Kane are first among those who have won fame by their pioneer work in this still relatively new medium. And yet—how different their individual styles: Blumenfeld—inventive, capricious yet sensitive, immensely daring, smashing old taboos with his sophisticated use of color. Haas—fascinated by motion symbolization, whipping up a storm in a "still" through superbly controlled use of blur heightened to the utmost by the addition of color. Kane—the "designer photographer," using color with unrestrained abandon, creating poster effects of such striking boldness that they have won him wealth and fame.

To emulate these examples, a photographer must keep in mind three things: Only complete *honesty* with himself can get him ahead. The moment he gives way to temptation, takes the easy way, and tries to work with forms of expression alien to his nature—the moment he starts to imitate—he warps his personality and puts a crippling crimp in his artistic growth that may take a long time to rectify, provided the damage is not permanent.

To a certain degree, *specialization* can become an aid in the development of a permanent style. Each of the photographers mentioned above is a specialist in a more or less sharply defined field. Specialization is the result of interest—the creative mind is always interested in specific subjects while more or less disregarding those that are of lesser interest. Interest, of course, leads to proficiency—knowledge, improvements, inventions, and discoveries—the ingredients of a personal style.

The pitfall of trying to be *original for originality's sake*—the bane of the overambitious—must be avoided. In our age of the gimmick it is only too easy to become known as, for instance, "the photographer who makes those queer distortions," or "the man whose work can be recognized by the way he photographs hands." In my opinion, such peculiarities are trademarks rather than evidence of creativeness—ruts in the road to success ready to bog down the photographer before he reaches his goal.

Not every photographer will, of course, be able to develop a personal style. Unless one is fired by conviction, sparked by interest, gifted with sensitivity,

and powered by drive, he will not be able to rise above mediocrity. And even gifted photographers may be held back by imitating the work of those they admire. Instead of looking within themselves, they look toward others in a misguided form of hero-worship. Admiring their idol's accomplishments, they fail to give themselves a chance. Equally, acclaimed photographers often fail to develop their full potential through endlessly repeating the style that brought them fame. Only one thing is certain: a personal style cannot be forced. It must grow from within, an inevitable reflection of oneself.

Index